A SINGLE STATISTICIAN • THE NEW YORK TIMES: APOCALYPSE NOW, PAGE A1 • CULTURE IS NOT ALWAYS POPULAR • THE FLAT GRANDEUR • IT'S A MAN'S WORLD • COLOR ME KHAKI • EDWARD FELLA: THE DISPASSIONATE STATISTICIAN • INFORMATION ANXIETY • LOOKING EUROPEANS • GRAPHIC DESIGN AND THE NEW CERTAINTIES • IMPLAUSIBLE FICTIONS • UNNECESSARY REVIVAL • ON VISUAL EMPATHY • MARK LOMBARDI AND THE ECSTASY OF CONSPIRACY • MISSING SLEEVE NOTES • REMEMBER PICELJ • RED SPECIES OR UTOPIAN UPRISING? • SHALLOW WATER DICTIONARY • ADBUSTERS IN ANARCHY • A BIG POEM, PART 1 • DESIGN URLS • ERROL MORRIS BLOWS UP SPREADSHEET, THOUSANDS KILLED • NOTES ON EXPERIMENTAL JETSET • MIND THE GAP • THE FORGOTTEN DESIGN LEGACY OF THE NATIONAL LAMPOON • ADOLF Wö LFLI INVENTS DESIGN BRUT? • VLADIMIR NABOKOV: FATHER OF HYPERTEXT? • STEPHEN GILL: BEHIND THE BILLBOARD • THE SPAN OF CASUAL VISION • RATIONALIZING A DESIGN • THE SINS OF ST.PAUL • ROB ROY KELLY'S OLD, WEIRD AMERICA • YOU'RE GOING TO HOLLYWOOD, BABY • UUT, UUP AND AWAY • CALL FOR ENTRIES: PERIODIC TABLE OF THE ELEMENTS • NEVILLE BRODY REVISITED • THE FINAL DECLINE AND FALL OF THE AMERICAN MAGAZINE COVER • THE CRISIS OF INTENT • TYPOGRAPHY AND DIPLOMACY • INFORMATION DESIGN AND THE PLACEBO EFFECT • BRUCE MAU: THE AURA OF POWER • DEFAMILIARIZATION: A PERSONAL HISTORY • REGARDING THE PHOTOGRAPHS • ARTIFACTS OF REVOLUTION • ANNALS OF TYPOGRAPHIC ODDITY: MOURNING BECOMES HELVETICA • THE DNA OF AID: AMPERSAND AS MYTH AND METAPHOR • GEORGE KENNAN AND THE COLD WAR BETWEEN FORM AND CONTENT • BLANKET STATEMENTS • HOW MTV CHANGED MY LIFE • JAN VAN TOORN: ARGUING WITH VISUAL MEANS • MICHAEL MCDONOUGH'S TOP TEN THINGS THEY NEVER TAUGHT ME IN DESIGN SCHOOL • ANNALS OF TYPOGRAPHIC ODDITY NO.2: SPACESHIP GOTHIC • THE LYING GAME • STANLEY KUBRICK AND THE FUTURE OF DESIGN • THE TWO CULTURES OF DESIGN • THE LYING GAME NO.2 (OR VIETNAM REDUX) • HOW TO SAY WHAT YOU MEAN • EL LISSITZKY FOR PESACH • GRAPHIC FLANERIE • I HEAR YOU'VE GOT SCRIPT TROUBLE: THE DESIGNER AS AUTEUR • "ONE PERSON, ONE VOTE, ONE MRI?" • CATHARSIS, SALESMANSHIP, AND THE LIMITS OF EMPIRE • CRITICS AND THEIR PURPOSE • BETTER NATION BUILDING THROUGH DESIGN • TIME WAITS FOR NO FAN • <i>LEARNING FROM LAS VEGAS</i> : THE BOOK • BREATH AWAY • ANNALS OF ACADEMIA, PART 1: WHAT I DIDN'T LEARN IN GRADUATE SCHOOL • INDIA SWITCHES BRANDS • ANNALS OF ACADEMIA, PART II: GRAPHIC DESIGN AND THE NEW OPTIMISM • MCSWEENEY'S NO.13 AND THE REVENGE OF PRINT • MOMA: DESIGN ON DISPLAY • DESIGNER BY DAY, CATWOMAN BY NIGHT • THE IDEALISTIC CORPORATION • BARTHES ON THE BALLPOINT • THE TYRANNY OF THE TAGLINE • TAKE TWO LOGOS AND CALL ME IN THE MORNING • WHERE ARE THE DESIGN HEROES? • GOLD AWARD FOR DESIGN GOES TO GOD • EDWARD TUFTE: THE DISPASSIONATE STATISTICIAN II • POSTED WITHOUT COMMENT • ASK NOT WHAT YOUR TYPEFACE CAN DO FOR YOU: ASK WHAT YOU CAN DO FOR YOUR TYPEFACE • ED RUSCHA: WHEN ART AND DESIGN COLLIDE • IDIOCY • EERO SAARINEN'S FORTY YEAR LAYOVER • AN INSTRUMENT OF SUFFICIENTLY LUCID COGITATION • LADISLAV SUTNAR: MECHANICAL BEAUTY • THE RENDERING AND THE REALITY • WHAT IS DESIGN FOR? A DISCUSSION • THE GRAPHIC DESIGN OF THE REICH • READING: AUGUST 2004 • UNDER THE MICROSCOPE • FONT FORENSICS, OR WHETHER GEORGE W.BUSH IS HIDING SOMETHING • MAGAZINE WITHOUT A NAME, BRAND WITHOUT A PROMISE • GRAPHIC DESIGNERS, FLUSH LEFT? • GENTLEMEN PREFER BLONDE • ON THE RODNEYDANGERFIELDIZATION OF GRAPHIC DESIGN: PART I • DOES ASPEN HAVE A FUTURE? • WHAT WE TALK ABOUT WHEN WE TALK ABOUT ARCHITECTURE • ON MAKING THINGS • FEAR AND LOATHING AT THE DESIGN MUSEUM • COLORAMA • ANIMAL DREAMS • WHO'S OUT OF THE DICTIONARY • FIRST PERSON SHOOTER • THE DESIGNIBLES • THE WORLD IN TWO FOOTNOTES • LOGOGATE IN CONNECTICUT, OR, THE RODNEYDANGERFIELDIZATION OF GRAPHIC DESIGN: PART II • MY COUNTRY IS NOT A BRAND • DONALD TRUMP AND THE NOT THE REAL THING • THE WHOLE DAMN BUS IS CHEERING • TIME, SPACE AND THE MICROSOFT COLONIALISTS • INTRODUCING THREE NEW WRITERS • JUST SAY YES • PLEASURES AND PATHOS OF INDUSTRIAL RUINS • THE OTHER RAND • CODE (PM) • AN ARRESTING IN REMEMBRANCE OF SUSAN SONTAG • A BIG POEM, PART II • 2004 BOOK RECOMMENDATIONS • UNDERSTANDING AND ACTION • MYSTERIOUS DISAPPEARANCE OF CAROL HERSEE • BIRD IN HAND: WHEN DOES A COPY BECOME PLAGIARISM? • PERIPHERAL VISION • THE I.D.FORTY: WHAT ARE LISTS FOR? • A REVIEW OF A SHOW YOU CANNOT SEE • NEW YEAR'S HOUSECLEANING • THE BEST ARTIST IN THE WORLD • PARIS DISPATCH: A LONG WAY DOWN • THE VICE DESIGN ISSUE • ALL RISE! • THE CONSTANT PARKER: LA JETÉE • AUTHENTICITY: A USER'S GUIDE • THE STRANGE COMMERCIAL • THE IKEA RIOT: UNSATISFIED EXCESS? • CHRISTO'S AGENT ORANGE • RISE AND FALL OF ROCK AND ROLL GRAPHIC DESIGN • THE NEW PAPER CHASE: CYBERSPACE ON THE MOVE • OLD FLICKR • THE GATES • THE GATES • OUR BODIES, OUR FONTS • STOP THE PLANT: THE FAILURE OF RENDERING • DESIGNING UNDER THE INFLUENCE • FEAR AND LOATHING IN PEN AND INK • THE AURAL AS AN ARCHITECTONIC CHALLENGE • MEDIATION • TASTING THE AXUM OBELISK • WHY ARCHITECTS GIVE ME THE WILLIES • SCRAPBOOKING: THE NEW PASTE-UP • A PICTOGRAPH IS WORTH A THOUSAND WORDS? • DOT DOT DOT DOT DOT DOT DOT DOT DOT • THE DESIGN POLICE • "DESIGN" (1936) • NO HEADLINE • PENDS MORE TIME WITH HIS FAMILY • HOMAGE TO THE SQUARES • WISCONSIN DEATH TRIP: A PSYCHIC HISTORY • THE SCOURGE OF "TUSCAN" • LEISURAMA: DESIGN WITHIN REACH • TEN YEARS OF DESIGN LEADERSHIP: RICHARD GREFé • THE SUBLIME IMPOSSIBLE WORLD OF BRUCE MCCALL • EXTREMELY YOUNG AND INCREDIBLY EVERYWHERE: THE PUBLIC ART OF JONATHAN SAFRAN FOER • ME AND MY PYRAMID • EDUARDO PALOZZI, 20TH CENTURY IMAGE-MAKER • THE DESIGNER AS BUFFOON • NO FRESH FRUIT IN FOREIGN PLACES • GETTING LOUDER: CHINESE DESIGN ON THE MARCH • A DESIGN ANNUAL CAPTURES 1968 • ON (DESIGN) BULLSHIT • MATERIAL ISSUE • REDESIGNDESIGN • BUT DARLING OF COURSE IT'S NORMAL: THE POST-PUNK PERIOD OF DESIGNING: THE PARADOX OF MODERN DESIGN EDUCATION • A DESIGNER REMEMBERS THE WRITER GUY DAVENPORT • MAPS OF CYBERSPACE • MEVIS AND VAN DEURSEN: RUEFUL RECOLLECTIONS, RECYCLED DESIGN • THE MAN WHO SAVED JACKSON POLLOCK • COLDPLAY'S X&Y • THE CUT: WHEN LIFE IMITATES ART (I MEAN DESIGN) • IN MEMORIAM: MY MANUAL TYPEWRITER • CALL ME SHITHEAD, OR, WHAT'S IN A NAME? • THE ADVENTURES OF CYNIC BOY AND DESIGN MOM IN 3D • CATASTROPHIC IMAGINING • REITER THE OBVIOUS, SHUNNED BY SO MANY, IS SUCCESSFULLY AVOIDED ONCE AGAIN • WE ARE ALL EDITORS NOW.OR ARE WE? • EXHIBITIONS BY RENZO PIANO AND 2X4 • NEW MODELS FOR DESIGN EFFICIENCY: INTRODUCING OTIS • MY FAVORITE BOOK • WHAT IS IT? • RICK VALICENTI: THIS TIME IT'S PERSONAL • CREDIT LINE GOES HERE • SIGNS OF RELIGION IN THE AMERICAN SOUTH • VLADIMIR'S HOUSE AND GARDEN OF EARTHLY DELIGHTS • WHY BUGS DON'T BELONG ON TV • SELF-INITIATED HOUSE MUSIC • FOLDERS • SMALL TOWN MEETINGS • THE DARWINIAN IPOD • A MOSAIC OF VISION AND MEMORY • EVERY NEW YORKER IS A TARGET • SUBLIME LITTLE TUBES OF DESTRUCTION • READING THE NEWS&CHARTING DEATH • MARTIN VENEZKY'S BEAUTIFUL MESS • NOBODY BE A WINNER • EYE OF THE STORM • KATRINA: DESIGNER NEWS&RESOURCES (9.08 UPDATE) • KATRINA: DESIGNER NEWS&RESOURCES (9.1 UPDATE) • FOUR YEARS AFTER • REMEMBERING HENRYK TOMASZEWSKI • THE GUARDIAN'S NEW EUROPEAN LOOK • WHO ARE THE DESIGN CRITICS? • CAN YOU MAKE THE TYPE BIGGER? • JOHN STOSSEL ON GRAPHIC DESIGN • ON CITIZENSHIP AND HUMANITY: AN APPEAL FOR DESIGN REFORM • LOOKING FOR CELEBRATION, FLORIDA • THE GREAT NON-AMBER-COLORED HOPE • BAND-AID: RETHINKING NOSTALGIA • THE FINAL DAYS OF AT&T • ON CONSIDERING THE SOURCE • DESIGNING TWYLA THARP'S UPPER ROOM • EMIGRE: AN ENDING • DAVID HUGHES: CARICATURIST OF OUR TIME • INNOVATION IS THE NEW BLACK • THINK REGIONALLY, ACT LOCALLY • AND DESIGN • 2005 HOLIDAY READING LIST • BARTLEBY™ • FACE VALUE • CHARLES DICKENS AND THE BBC • CALLING ALL ANGELS • THE UNBEARABLE LIGHTNESS OF FRED MARCELLINO • GOOD FONT, SHAME ABOUT THE REPORTING • EDWARD HOPPER, VISUAL FACT • TYPOGRAPHY: THE POWER AND THE FURY • D.I.Y.: DESIGN IT YOURSELF • ROBERT BROWNJOHN AND THE BIG IDEA • WILSON PICKETT, DESIGN THEORIST, 1942-2006 • WHAT DESIGN REALLY NEEDS IS A GOOD SCANDAL • THE D WORD • FREEDOM OF SPEECH • THE NEW LAW OF EMINENT LO-MEIN • SEPARATED AT BIRTH: METHOD? OR MADNESS? • DESIGN BY COMMITTEE • WHAT WE TALK ABOUT WHEN WE TALK ABOUT DESIGN HISTORY • I DON'T KNOW MUCH ABOUT DESIGNING RUGS • DWELLING ON DESIGN • FRANCE: GIVE ME PRIVACY OR GIVE ME AN ID CARD • BROADCAST VS.BROADBAND • GOOGLE AND THE TYRANNY OF GOOD DESIGN • LANGUOROUS BODYSCAPES • WARNING: MAY CONTAIN NON-DESIGN CONTENT • SANTA FE DIARY • IN A SENSE OF <i>NEW YORK</i>'S HIGH PRIORITIES • MEET ME IN ST.LOUIS: THE PULITZER FOUNDATION FOR THE ARTS • A SEQUENCE IN TIME • WHEN DESIGN IS A MATTER OF LIFE OR DEATH • THE PROPENSITY FOR DENSITY • THE INTERNATIONAL SYMBOL FOR THE GAS GUZZLER? • REPORT: 53 DEGREES F.HEAVY SNOWFALL PREDICTED • THE ART OF THINKING THROUGH MAKING • IN REMEMBRANCE OF RICHARD ECKERSLEY • WACKY PACKAGES OF THE GLOBAL ECONOMY • DISASTER RELIEF 101: NO DOOR HANGER LEFT BEHIND • THINKING INSIDE THE BOX • FONT ERRORS TO HOLD US BACK • WE'RE ALL STELLAR DESIGNERS, NOW • I AM A PLAGIARIST • WHY SCIENTOLOGY IS GOOD FOR HOLLYWOOD • THE PHOTOGRAPHY OF MARK ROBBINS • EIGHT-AND-A-HALF BY ELEVEN • ANNALS OF ACADEMIA: THE NEW EXOTICISM • SALAD DAYS • THE AESTHETICS OF WIND FARMS • DESIGN OBSERVER @ 10, 0, 0 PARTY • THE GOOD CITIZEN'S ALPHABET • I'M NOT READY TO MAKE NICE • CHEAP MUSIC AND COMMERCIAL ART • THE ILLUSION OF CERTAINTY • THE OTHER MONOCLE • THAT (OTHER) WORLD • FINDING SCOTLAND • LOST, O LOST • JEAN BAUDRILLARD DIES • THIS IS NOT MY DESIGN LIFE NOW • COMEDY OF ERRORS: GRAPHIC DESIGN ON WIKIPEDIA • ART DIRECTOR KEN • HEYDAY • GOOD AT ART • INTERNATIONAL POLAR YEAR • ANNALS OF EPHEMERA: THE QUICK AND THE LIKE THE NEW NEW TYPOGRAPHY • DANCING TO THE SOUND IN YOUR HEAD • OUR LITTLE SECRET • KOOLHAAS AND HIS OMNIPOTENT MASTERS • JULIE IOVINE • ARE JPEGS THE NEW ALBUM COVERS? • THE NAZI TRIANGLE • IN SEARCH OF STOCK (V) PHOTOS • MANIFEST DESTINY • WHAT IF APPLE IS BAD FOR DESIGN? • SMALL POTATOES • DESIGN'S ETHNOGRAPHIC TURN • THE BANDWIDTH OF BOOKS • LANGUAGES AS DESIGN OBJECTS • THIRTEEN WAYS OF LOOKING AT A TYPEFACE • AD REINHARDT, GRAPHIC DESIGNER • NO TO SUB-ANTARCTIC ISLANDS • WHY A BOOK? • MY DIRTY LITTLE SECRET • AL GORE FOR PRESIDENT • ANDREA CREWS: FASHION PROVOCATEUR • THE 2012 OLYMPIC LOGO ATE MY HAMSTER • ON THE SQUARENESS OF MILK CONTAINERS • MY LIFE WITH A LOGO • WEBER IN THE THIRD DIMENSION • SUN RA, STREET PRIEST AND FATHER OF D.I.Y.JAZZ • WHY IS THIS FONT DIFFERENT FROM ALL OTHER FONTS? • SILAS H.RHODES, FOUNDER OF SVA • ONE MAN'S LITERARY COMPASS • OFF THE GRID • REMEMBERING SOL LEWITT • ON NEW CONTRIBUTING WRITERS • HARRY POTTER AND THE ENCHANTED LETTERFORMS • LEON FRIEND: ONE TEACHER, MANY APOSTLES • DONAL MCLAUGHLIN'S LITTLE BUTTON • PROJECT M • BARNBROOK BIBLE: A GRAPHIC AUTOBIOGRAPHY • THE FONT OF DOCTOR VS.THE WALL OF SOUND • CONFESSIONS OF A BOOK CATALOG READER • THE PRESIDENTIAL RASH • TONY WILSON: THE POSTMODERN MYTHMAKER • FLAT, SIMPLE AND FUNNY: THE WORLD OF CHARLEY HARPER • WHY DESIGN WON'T SAVE THE WORLD • BRILLIANTLY DEBUNKED • DESIGN CRITICISM'S WINDING ROAD • THE DESIGNER AS GUMSHOE • OLIA LIALINA&RELICS OF THE LOST WEB • AWARELESSNESS • SO SO INTELLIGENT • BACK TO SCHOOL • CONEY ISLAND BIN LADEN • WALLACE BERMAN'S GHOST • THE AGE OF ASAP • DESIGNERS AND DILETTANTES • MAY I SHOW YOU MY PORTFOLIO? • DECORATIVE BOOKS: THE END OF PRINT • BURMA (MYANMAR), 1989 • STAN BRAKHAGE: CAUGHT ON TAPE • WOOD THAT WE COULD • A PLEA TO THE NEW YORK TIMES: IN YOUR FACE, HERBERT MUSCHAMP • DESIGN OBSERVER PARTY: DENVER, OCTOBER 12 • TOPANGA, I HARDLY KNEW YE • SCIENCE AND DESIGN: THE NEXT WAVE • DÉJÀ VU ALL OVER AGAIN • BABEL'S NOBEL • THE DESIGNER'S VIRUS • STEPHEN DOYLE: A FEW WORDS • WHO WANTED YOU? • EXCEPT YOU • TYPE MEANS NEVER HAVING TO SAY YOU'RE SORRY • HOW TO BE UGLY • MODERNISM IN THE FLY-OVER ZONE • SPAM CARTOONS • CURSE OF THE "D" WORD • DISCIPLINE AND DESIGN • DESIGN THINKING, MUDDLED THINKING • WHITHER NEW GRAPHIC DESIGN HISTORY? • TAKING THINGS SERIOUSLY • TWO NEW CONTRIBUTING WRITERS • TAKING THINGS SERIOUSLY II • TAKING THINGS SERIOUSLY I • GRAPHIC EDITORSHIP • IT'S EASY TO CRITICIZE...NOT • THE MOST HATED HOLIDAY SONG • TWO THINGS SERIOUSLY III • WHAT'S IN A NAME? • TAKING THINGS SERIOUSLY IV • TODAY, 01.03.09 • REMEMBERING PAUL RAND • TAKING THINGS SERIOUSLY • WILL THE REAL ERNST BETTLER PLEASE STAND UP? • IS APPLE SOFT ON CRIME? • POLLING PLACE • THE WORK OF TASK • BETH DANIELS: TAKING THINGS SERIOUSLY VI • ART ROGERS VS.JEFF KOONS • WILHELM DEFFKE: MODERN MARK MAKER • LEARNING FROM NORTH PHILADELPHIA • GONE, BABY, GONE (THINGS, PART II) • WOODY ALLEN'S TYPOGRAPHIC HALL OF FAME • POLLING PLACE PHOTO PROJECT ON SUPER TUESDAY • LOOK AND FEEL/NIP AND TUCK • CHIKA AZUMA: TAKING THINGS SERIOUSLY VII • THE SMARTEST LOGO IN THE ROOM • ANIMAL MAGNETISM • LOST AMERICA: THE FLAMINGO MOTEL • IT'S ABOUT AN INQUIRY • ANY BASEBALL IS BEAUTIFUL • BOOKS RECEIVED: WINTER 2008 • TAKING THINGS SERIOUSLY VIII • SWASTIKA HUMOR? • THE LEARNERS • DESIGN OBSERVER JOB BOARD • WOULD IT KILL YOU TO SMILE? • MARC RABINOWITZ: PROSE AND POETRY • SLAUGHTERHOUSE WRITING AWARDS 2008 • FAIL AGAIN, FAIL BETTER • VIEWER DISCRETION ADVISED • THE MAGIC OF THE PEACE SYMBOL • TAKING THINGS SERIOUSLY IX • THE CUCKOO BIRD AND THE KEYBOARD • THE (FAUX) OLD BALL GAME • BLAST-DOOR ART OF THE NUCLEAR ERA • 100.00% • UNDERGROUND MAINSTREAM • TAKING THINGS SERIOUSLY X • THE NEXT PAGE: THIRTY TABLES OF CONTENTS • THE DESIGN OBSERVER PLAYLIST • ODE TO MY TOASTER • THE PASSION OF GEORGE LOIS • ERROL MORRIS'S PROBLEM • WHEN TWO LINES ALIGN • SLIDE SHOWS ON DESIGN OBSERVER • THE SKY IS FALLING • NATIONAL SCRAPBOOKING DAY • CHICAGO INTERNATIONAL POSTER BIENNIAL • A LESSON FROM SPIROGRAPH • NATIONAL DESIGN AWARDS • FITTING • TAKING THINGS SERIOUSLY XII • THE SCREEN BEHIND THE SCREEN • CREDIT WHERE CREDIT IS DUE...OR NOT • O.H.W.HADANK • CRANBROOK COMMENCEMENT ADDRESS • REFLECTIONS ON THE EPHEMERAL WORLD, PART ONE: INK • A CRITICAL VIEW OF GRAPHIC DESIGN HISTORY • IF ONLY I COULD • GRAPHIC DESIGN AT THE MUSEUM • OVER THE RAINBOW • BRANDING YOUTH IN THE TOTALITARIAN STATE • THOUGHTS ON DEMOCRACY, JULY 4 2008 • CITY AND SUBURB: WORLDS AWAY? • WHEN I WAS A VERY SMALL BOY • THE TYPOGRAPHER'S DREAM • WE FOUND IT AT THE MOVIES: PART I • WE FOUND IT AT THE MOVIES: PART II • BOOKS RECEIVED: SPRING 2009 • TAKING THINGS SERIOUSLY XIII • REFLECTIONS ON THE EPHEMERAL WORLD, PART TWO: FOOD • TAKING THINGS SERIOUSLY XI • HOMAGE TO A PIECE OF BOOKS RECEIVED: SUMMER 2008 • VANITY FAIR TYPE: 1930 STYLE • STEAMPUNK'D, OR HUMBUG BY DESIGN • FOLK PHOTOS • I WAS A MAD MAN • ANNALS OF EPHEMERA, PART III: AGING 2 • COLLECTIONS OF NOTHING • IT'S HOW YOU SAID IT • MY HANDS WERE DIRTY • THE WAY WE DRIVE THE WAY WE DO • THERE IS NO WHY • CLIPPING ART, ONE ENGRAVING AT A TIME • SLIDE SHOWS ON DESIGN OBSERVER • FIRST IN A SERIES: CARTOPHILY • ATHOS BULCÃO, THE ARTIST OF BRASILIA • CANNED LAUGHTER • DESCRIBING PAINTINGS • WHERE HAVE YOU GONE R.COBB? • A LAYPERSON'S GUIDE TO GRAPHIC DESIGN • A LOOK BACK AT ASPEN, 1970 • HURRICANE WATCH: GUSTAV EMERGENCY RELIEF • REMEMBERING YVES ST.LAURENT • WHOSE FLAG? • DAVID FOSTER WALLACE, BRANDED • SECOND IN A SERIES: COMPLETIONS • BREAKDOWNS: A REVIEW • BOOKS RECEIVED: FALL 2008 • LEHMAN'S BANKRUPTCY STATEMENT • DESIGN OBSERVER'S ANIVERSARY PARTY: 11.05 • INTERVIEW WITH BRIAN OAKES • GO WEST, YOUNG ART DIRECTOR • LOGO POSTER BIENNIAL • THE INVENTOR OF THE COWBOY SHIRT • MAD MEN: PITCH PERFECT • DESIGNERSFOROBAMA.ORG? • CHARLES PEIGNOT: MAN BEHIND THE FACES • THE POSTERS OF PADUA • TODAY, 10.03.08 • SUBCONSCIOUS WARM-UP • BOOKS RECEIVED: HOLIDAY LIST 2008 • THE WORK OF TARA DONOVAN • TODAY, 10.11.08 • 26 YEARS, 85 NOTEBOOKS • POLLING PLACE PHOTO PROJECT ON NOVEMBER 4, 2008 • DESIGN BY NUMBERS • DESIGN OBSERVER T-SHIRT • THE UNIVERSAL DECLINE POINTS • TODAY, 10.18.08 • FANFARE FOR THE COMMON COMMUTER • THE FOUR LESSONS OF LOU DORFSMAN • TODAY, 10.25.08 • IN PRAISE OF THE ANTHROPOMORPHIC • A YEAR OF POLITICAL BANNER ADS • TODAY, 11.01.08 • TOWARDS RELATIONAL DESIGN • GRAPHIC DESIGN SPAM • TODAY, 11.08.08 • HISTORY OF AGGRESSIVE DESIGN MAGAZINES • TODAY, 11.15.08 • OBSESSIVE BRANDING DISORDER I • TODAY, 11.22.08 • WHAT I'VE LEARNED • TODAY, 11.29.08 • A DESIGN-ORIENTED NATIONAL ENDOWMENT • SCHOOLS OF COMMERCIAL ART • MY DADA • TODAY, 12.06.08 • 10 REASONS TO BUY A DESIGN OBSERVER T-SHIRT • TALK IS CHEAP • TODAY, 12.13.08 • BOOKS RECEIVED: WINTER 2009 • TEN THINGS THAT NEED TO BE REDESIGNED • BARNEY BUBBLES • TODAY, 12.20.08 • HOW THE WEST WAS LOST • DESIGNING THROUGH THE RECESSION • A HORRIBLE MACHINE • PRACTICE DOES NOT MAKE PERFECT • TODAY, 12.27.08 • NEW YEAR'S GREETING • MEMORIES OF YANKEE STADIUM • YANKEE STADIUM FEAST • TWO DUTCH LOGOS • MALCOLM AND ALEX • DESIGN HATES A DEPRESSION • UNCHOPPING A TREE • LE CORBUSIER: TRES GRAND • COMPLAINT DEPT. • TODAY, 01.10.09 • IF THE WIRE CAST WAS A FOOTBALL TEAM • MOOSES • WHO NEEDS TWITTER? • ON THE COVER • CURIOUS CASE OF THE BETTER ADAPTATION • A BABYLON OF SIGNS • POLLING PLACE PHOTO PROJECT • PAPER, PLASTIC, OR CANVAS? • REBOOTING THE FESTIVAL MARKETPLACE • A LETTER TO THE PRESIDENT • THAT PESKY TELEVISION • AD BOOKS • COMPLAINT DEPT. (REDUX) • TODAY, 01.24.09 • DUMB AND DUMBER 2 • TODAY, 01.31.09 • A RESPONSE TO "A BABYLON OF SIGNS" • JULIE LASKY&ERNEST BECK JOIN DESIGN OBSERVER • PASTRAMI ON RYE • THE REAL THING • TODAY, 02.07.09 • EPIC FAILURE • TODAY, 02.14.09 • ANNALS OF BRANDING, REDUX • MICHAEL JACKSON, AUTOMOTIVE DESIGNER • DEFENDING ALICE • PLANET M • SAVE THE LIBRARY • TODAY, 02.28.09 • AFTER PETER PAUL RUBENS (LONG AFTER) • STANDARD OPERATING PROCEDURE • AGAIN — A MANIFESTO • CATS AND THEIR DESIGNERS • SAVE THE LIBRARY REDUX • THE BEST OF YOU: YOURS TRULY • TODAY, 03.07.09 • SEATTLE PI: RIP • MY FACEBOOK, MY SELF • UNTITLED BY ANONYMOUS: AN ODE TO BRANDING • SPLENDOR ON THE GRASS • I BELIEVE IN DESIGN • A PLACE FOR RIBS • VISITING THE LIBRARY IN A STRANGE CITY • ACCESS DENIED • THE YEAR PLAYBOY DIED • TODAY, 03.21.09 • FISHIN' FOR GLORY • A BABYLON OF SIGNS • JAPANESE FACE MASKS • DE MEESTER VAN DE SCHADUW • PARADOXES • UNMONUMENTAL • WILLIAM KLEIN: CONTACTS • TODAY, 04.04.09 • WIRETAPPED! • LOOK BOTH WAYS: ON THE STREETS OF PHILADELPHIA • THOMAS JEFFERSON: (HENPECKED) JEWISH PRESIDENT • WHAT'S THE STORY? • BRONX CHEER • BOOKS RECEIVED: SUMMER 2009 • LAND IN CRISIS: THE ANTELOPE VALLEY STORY • THEIRS GO TO TWAALF • 13TH ANNUAL WEBBY AWARDS • TIDAL POOLS: PHOTOGRAPHS BY JASON ORTON • WILL BURTIN: DESIGN AND SCIENCE • AUCTION BLOCK • ON PAUL AUSTER • CASINO STRIKES AGAIN! • TODAY, 04.18.09 • SUSAN BOYLE AND THE BEAUTY OF CROCHET • INVASION OF THE NEUTERED SPRITES • CEDARS • FATHER OF SHREK, GRANDFATHER OF TWEET • INTERNALLY YOURS • FRIENDSHIP'S OFFERING • TODAY, 04.25.09 • THE MYSTERY OF PETER ZUMTHOR • TODAY, 05.02.09 • TRUMP, THE LOGO • TBILISI'S HOTEL IVERIA: A DEFENSE • IF YOU FOLLOW ME, I WILL FOLLOW YOU BACK • TODAY, 05.09.09 • OLIVE DRAB: BKLYN DESIGNS 2009 • BACK TO THE FUTURE • CULTURED GONE • WHICH IS THAT ARTIFACT IN THE WINDOW? • TRIUMPH OF THE WILL (OR, EVERYTHING OLD IS NEW AGAIN) • DESIGN OBSERVER AUDIENCE SURVEY • TODAY, 05.16.09 • ON MUSES • ANNOUNCING PROJECT M AT WINTERHOUSE • ONE WORD, PLASTICS • W, A, R AND WHAT FOR • THIS END UP: RENZO PIANO'S MODERN WING • TODAY, 05.23.09 • MEMORIAL DAY • URBAN CAMOUFLAGE • HOT TICKET • A CONVERSATION WITH DAVID BARRINGER • TODAY, 05.30.09 • BEA REPORT: 10 FALL BOOKS (+1) FOR YOUR LIBRARY • WHY THIS BOOK IN THE BEACH? • BOOKS RECEIVED: JULY 2009 • ONCE OUT OF CHAOS • PERSONAL SPACE • EVIL MS • OPEN LETTER TO DESIGN STUDENTS EVERYWHERE • WORST CASE SCENARIO • WALTER DEXEL COLLECTION • TORMENTED YOUTH • DOG DAYS • TODAY, 0 SELLS • ROMANCE IS DEAD • AUTO PILOT • FREE BOOKS • ALL IN THE FAMILY • DICKENS IS FUNNY • MOSCOW'S JEWISH MUSEUM • RED STAR • LOST LOVES • WHY PLANT YOUR OWN? • THE BEAUTY OF A PARK • BOTTOM OF THE NINTH • TEXTILE PSYCHOLOGY • HOME FRONT • AD NAUSEAM: A SURVIVOR'S GUIDE TO AMERICAN CONSUMER CULTURE • ALOYSIUS IS MISSED • THE BEAUTY OF A PARK • WHEN DESIGN GETS IN THE WAY • PEOPLE IN NEW HOUSES... • TODAY, 06.20.09 • SPOILER ALERT! OR, HAPPY FATHER'S DAY • AMSTERDAM • KENNEH IN ANTWERP • TAKE ME OUT TO THE OLD YANKEE STADIUM • SPOILSPORT • PIET ZWART COLLECTION • PAUL SCHUITEMA COLLECTION • THE MOST BEAUTIFUL CRAPPER IN THE WORLD • BREAKING UP IS HARD TO DO • MAS MACHO • JAMES ENSOR • NO MORE NEON ON THE NOVY ARBAT • CARS R US • PRE-BLOG WORK • CHILD'S PLAY • REALLY GREAT GATSBY • DELAYED GRATIFICATION: ON ARCHITECTURAL CRITICISM • IN SPITE OF MYSELF • OVID: ON PICKING UP GIRLS (LITERALLY) • LINES • REPORT FROM HALE COUNTY, ALABAMA • NOSTALGIA TRIP • ANTWERP CENTRAL • WHEN SATIRE WAS MORE THAN FUNNY • NAZDOROVYE! • ARCHITECTURE FOR SALE (WRIGHT VS.JOHNSON) • LITTLE DICTATORS ON THE STREET IN TOKYO • SITTING MAN • TODAY, 07.11.09 • HANDMADE • DESIGN YOUR LIFE • NEGLIGENT WORLDICIDE • A DEAL'S A DEAL: SIGNIFICANT OBJECTS • NUMBERS GAME • SEX OR BIKING? • COLD COMFORTS • LIVE FAST, DIE YOUNG • A PLEA FOR CRAZY IN ARCHITECTURE • MOBILE CLINIC • RIPPLE EFFECT • EZRA&JULIUS • ADVANCE PRAISE FOR MASTER OF SHADOWS • 22ND AMENDMENT • MORE PERFECT UNION • ARTICLE 2 (FOR BHO) • POLLING PLACE PHOTO PROJECT • PLAY BALL: THE LAST WORD ON NEW YORK'S NEW BALLPARKS • PAGRAPHS OF SZE TSUNG LEONG • TODAY, 07.25.09 • BLRIOT! THE CENTENNIAL OF A HISTORIC FLIGHT • KROON HALL • DESIGN OBSERVER 3 • WAITING ON THE DREAM • WRITING&CALLIGRAPHY • HUNGARIAN RHAPSODY • ONCE MORE WITH FEELING: A NATIONAL CAN GRAPHIC DESIGN MAKE YOU CRY? • KURT ANDERSEN AND DOUGLAS RUSHKOFF: PART I • PEACE+JOY • REMEMBERING JULIUS SHULMAN • ONCE OUT OF CHAOS: PAULINE GALIANA • JAN TSCHICHOLD — MASTER TYPOGRAPHER • A GOOD TRADEMARK • THE BLUE NOTE • ON COMMENTS • WHEN WORLDS COLLIDE • DESPERATE TIMES/DESPERATE MEASURES • CHANGE OBSERVER: HOW, AND WHY NOW • ENGLAND'S NEXT TOP MODEL • BALLPARKS REDUX • SUMMER AS A VERB • COOKED • CLIMATE CHANGE • ANDERSEN AND DOUGLAS RUSHKOFF: PART II • D.I.Y.: BELGIUM • A NOTE ON THE TYPE • SPEECHLESS • GOING COASTAL • QUESTION BOX • TODAY, 08.08.09 • ARKS OF KNOWLEDGE • PLEASE TURN ON YOUR CELL PHONE • THE CURIOUS ARCHITECTURE OF A BROWNFIELD • OUTSIDER ART • COVERING THE GOOD BOOKS • FASHION PLATES • A SHORT MANIFESTO ON THE FUTURE OF ATTENTION • FLAP BAG • DESIGN OBSERVER PARTY: MEMPHIS, OCTOBER 9 • BETWEEN BUILDINGS • TODAY, 08.15.09 • SHELF LIFE • SIGNIFICANT OBJECTS: DAVID PLATE • IS THERE BAUHAUS IN IKEA? • SIGNIFICANT OBJECTS: ELVIS CHOCOLATE TIN • SIGNIFICANT OBJECTS: #1 MOM HOOKS • SIGNIFICANT OBJECTS: PORCELAIN SCOOTER • SIGNIFICANT OBJECTS: MARINES (UPSIDE-DOWN) LOGO MUG • REARRANGEMENT COMPULSION: WHERE OBJECT MEETS ANXIETY • TOO MUCH STUFF • TEDDY BLANKS ON FIGURINES • HELL IN A HORSE CART • UNDER COVER • EYE ROLL FOR ICE CREAM • A THOUSAND POINTS ON LIGHT: PART I • MASTER OF SHADOWS: THE JACKET • READING UNDERWEAR • BARRINGTON FAIR • IF YOU CAN'T SAY SOMETHING NICE... • A THOUSAND POINTS ON LIGHT: PART II • TODAY, 08.22.09 • ON "MASTER OF SHADOWS" • NO PLACE LIKE HOME • BLACKBOARD JUNGLE • ROUGH-CUT REDUX: AMAZON MAKES A CHANGE • RAINFALL IS LIKELY TO OCCUR • SHINY AND NEW • AN OPEN LETTER TO NICOLAI OUROUSSOFF • EMERGENCE • AUTO-MATIC ABSTRACTION • COOKING FOR CROWDS • THE CAMERA IS NOT A MACHINE GUN • FAMILY BUSINESS • MY FIRST TASTE OF POWER • BE DONE WITH GOVERNORS ISLAND? • THE OM IN HOME: KRIPALU'S NEW DOWN • TODAY, 08.29.09 • THE LION OF BELGIUM • TRIPLE-DIGIT INFLATION • FIRE AT RUBENS'S ST.CHARLES BORROMEO • SUSPENDED ANIMATION • THE TIGERTONES • PIZZA FAILURE • AGAIN • WECOMMUNE • PRESSED INTO SERVICE • TODAY, 09.05.09 • FIRST FLIGHT • GROUNDED • HEALTHY HOME • THE DOERS CLUB • CHULHA STOVE • AUSTRALIANS ALL LET US TEXT • PIG 05049 • NEW WORDS ON THE BLOCK • PARADISE FOULED • KISS KARMA • MARKET • THE ART OF PSYCHOGRAPHICS • JUST LOOKING • TODAY, 09.12.09 • HIGHER AND HIGHER • THE BIG SCREEN IN BIG D • ON THE GRID • WHITE COLUMNS • PEEPOOBAG • TODAY, 09.19.09 • CRAFTING A CITY • A STITCH IN TIME: A REVIEW OF 9 • UNDERGROUND NOTHING RUNS LIKE A...• PEOPLE OF THE BOOK • FREEPLAY FETAL HEART RATE MONITOR • BETTER PLACE • RON ARAD AT MOMA • WHERE'S THE BEEF? • THE GOODS THAT MAKE US BETTER • THE PLAIN BEAUTY OF WELL-MADE THINGS • MY IDEA OF HELL • DESIGN DO THAT LOOK WILL NOT SAVE THE DAY • THE FIGURE/GROUND RELATIONSHIP • LOST RESEARCH • TODAY, 09.26.09 • D/R RISING • SKIN • WHAT IS DESIGN THINKING ANYWAY? • NEW GRUB STREET • @ • CUTTING REMARKS • PEOPLE IN GLASS APARTMENTS • SUSTAINABILITY... • THE KINDNESS OF STRANGERS • TIEPOLO PINK • WHITE KNIGHT • TODAY, 10.03.09 • (WOMEN AND) CHILDREN FIRST • EMERGENCY RESPONSE STUDIO • NOT THE SAME OLD SAME OLD • BETTER WORLD BY DESIGN POSTER • THE LADIES' PARADISE • THE EAST ANGLIANS • ASPEN DESIGN SUMMIT: PROGRAM DESCRIPTION • IRVING PENN, 1917-2009 • WHY IS GOOGLE GIVING US THE FINGER? • 100 COLORS, 100 WRITINGS, 100 DAYS • HOME RANGE • TODAY, 10.09.09 • A BIBLIOPHILE'S REVELATION • THE WHALE VANISHES • UNHAPPY HOMES • THE VALUE OF EMPATHY • O TANNENBAUM! • SMALL WONDER: 41 COOPER SQUARE • THE SOUND OF WAVES • RAMPARTS: AGENT OF CHANGE • GARDENS AND THEIR DESIGNERS • ARCHITECTURE IN TRANSIT • LONG LIVE CHARTING THE FIGURINES • EXPOSURE TIME • PETER PAUL RUBENS: GRAPHIC DESIGNER • BUY IT NOW • MASTER OF SHADOWS — IN STORES NOW — NEW YORK EVENT • THE STONEWORK OF JON PIASECKI • HOUSES OF THE FUTURE • MASTER OF SHADOWS • OBAMA: BIRDS OF A FEATHER • LOVE&ARCHITECTURE • MEDELLÍN, COLOMBIA • GOOD MORNING CLEVELAND! • PETTING ZOO • DESIGNING OBAMA • SMALL WONDER: 41 COOPER SQUARE • START ASKING: A PROJECT BY RYAN FITZGIBBON • ALL THINGS SOMETHING DING MORE HELL (BEIGE EDITION) • D/R LOVE • TABLEAUX VIVANTS • THE NABOKOV COLLECTION • RENEWAL • 88BIKES • TODAY, 10.31.09 • THE SHADOW MASTER — LIVE ON HALLOWEEN EVE • BAUHAUS+BETSY • KICK4LIFE • MASTER OF SHADOWS: HIGH RESSANCE WHO DUNNIT • NO SMALL MATTER: SCIENCE ON THE NANOSCALE • FROM BAUHAUS TO MY HOUSE • WHY DOES JOHN BAEDER PAINT DINERS? • FROM<i>CABINET</i>: JACKET REQUIRED • BACK TO SCHOOL • HOT TIMES IN THE OLD TOWN • HEAD IN • TODAY, 11.07.09 • KICKING DOWN THE DOOR • DAWN OF THE DEAD MALL • WORD ON THE STREET • STONE RIVER: THE PASSION OF JON PIASECKI • ADORATION: LIBRARY JOURNAL ON MASTER OF SHADOWS: "AN EXCEPTIONAL BOOK" • THE BIG STATE • LOVE&ARCHITECTURE • TODAY, 11.14.09 • THE BAUHAUS AT MOMA • SMALLER WONDER: BROOKLYN CHILDREN'S MUSEUM • DESIS • PAPER REVELATIONS • METABOLIC DARK CITY • D/R ON WGBH • HOLIDAY BOOKS 2009 • ASPEN DESIGN SUMMIT: CAPITALS • MILKING IT • TODAY, 11.21.09 • ANOTHER NEW YORK • ASPEN DESIGN SUMMIT: PARTICIPANTS • ASPEN DESIGN SUMMIT REPORT: HALE COUNTY RURAL POVERTY PROJECT • ASPEN DESIGN SUMMIT REPORT: CDC AND HEALTHY AGING • STUFFED REPORT: SUSTAINABLE FOOD AND CHILDHOOD OBESITY • THIS IS JUST TO SAY • ASPEN DESIGN SUMMIT REPORT: MAYO CLINIC AND RURAL HEALTH CARE DELIVERY • ASPEN DESIGN SUMMIT: CORE77 REPORT • TODAY: HOLIDAY CARDS 2009 • DANKWERE DESIGN SUMMIT: BACKGROUND • SEE THE USA • ASPEN DESIGN SUMMIT REPORT: UNICEF AND EARLY CHILDHOOD DEVELOPMENT • LOOK AGAIN • ASPEN DESIGN SUMMIT REPORT: UNICEF MENSTRUATION CHALLENGE • XL • SKATING ON THE EDGE OF TASTE • DINER • ASPEN DESIGN SUMMIT: DESIGNMATTERS REPORT • "COMPELLING"&"IMPORTANT": THE L.A.TIMES PRAISES MASTER OF SHADOWS • BUSTED BY COLOMBO, OR, THE IMPEDIMENTS OF STYLE • CHRISTMAS SCHMALTZ • ASPEN DESIGN SUMMIT: WRITING ULYSSES: FAST TRACK TO 1934 BEST SELLER • DWR=D/R? • MAKING KIDS MODERN: OR IS IT THEIR MOMS? • ASPEN DESIGN SUMMIT: 30 PHOTOS • CHICAGO WELCOMES YOU • DOUBLEX: KID MADE MODERN REVIEWED • CO2 CUBES • IN PRAISE OF SHADOWS • DUMBING DOWN DIY • MASTER OF SHADOWS: A TELEGRAPH BOOK OF THE YEAR • EYEWRITER • UN, NOW AND THEN • BIGSHOT CAMERA • THE CITY IN PICTURES • WHERE HAVE ALL THE TYPE GEEKS GONE? • SEASONS GREETINGS • TODAY, 12.12.09 • IN THE ST.AUGUSTINE SCHOOL CHICKEN PROJECT • NOTES ON BEING BORN ON SOIL • HARSH WORDS FROM T.M.CLELAND • "Q" • PLAYING HOUSE • BRASS KNUCKLES AND BETTER IDEAS • MAKING A LIST... • TALKING RUBENS WITH LEONARD LOPATE • STUFFED REMAINS • THE ROAD TO WELLVILLE • GOOD NIGHT OLD FRIEND: ID MAGAZINE CLOSES AFTER 55 YEARS • WANT TO MAKE AN ARCHITECT CRY? • TODAY, 12.19.09 • RUBENS FOR THE HOLIDAYS • EXCITING MULTI-GENERATIONAL MOMENT • THE WOMEN OF DO, WITHOUT NOTEWORTHINESS • AFTER BUILDINGS • LAST POST OF 2009: INTERVIEW, CASEY JONES • CRITICIZING THE CRITICS • ANNOTATED AVATAR • TODAY, 01.02.10 • SIZE M • ABOUT A BOY • THE BLEATING EDGE • I HEART HUXTABLE • RALPH RAPSON • DESIGN MERCH • ON DO: SKATING ON THE EDGE OF TASTE • I.D.'S EXECUTIONERS • A PRESIDENT AND HIS DOG, PART 2 • DREAM JOB: INTERVIEW WITH FILM GRAPHICS DESIGNER ERIC ROSENBERG • HOWLING AT THE MOON: THE POETICS OF AMATEUR PHOTOGRAPHY • NEVER FOR THE BART MAP • TODAY, 01.09.10 • IT'S NOT JUST ME • BIG CITY, BIG GAMES • MOSHE SAFDIE • SNIP SNIP SNIP • DESIGNING THE UNTHINKABLE • LOGORAMA • THE YUCK FACTOR • INAPPROPRIATION • RISING CURRENTS • TODAY, DOWN MEMORY LANE • IN A STATE OF SHELTER • BIG BOOK, SMALL REWARD • A REAL MODERN MONUMENT • HANDS-ON: THE GROPIUS TOUCH • PREPARED FOR HAITI • BUILDINGS THAT AREN'T THERE • WHY NOT IN MY BACKYARD? • TODAY, 01.23.10 • PAY NO ATTENTION TO THE SCREEN (NOT) BASIC TRAINING • MORE! WOMEN! ARCHITECTS! • LEFT ME SPEECHLESS • WHO OWNS STUDENT WORK? • WRITE WHAT YOU KNOW • THE MYSTERIES OF RETAIL • GLOBALTAP • 101,000 • WIVES OF THE ARCHITECTS • DESIGNING CHANGE

Culture
Is
Not
Always
Popular

Edited by
Michael Bierut
Jessica Helfand
with
Jarrett Fuller

Culture Is Not Always Popular

Fifteen Years of Design Observer

The MIT Press
Cambridge, Massachusetts
London, England

This book was set in Neue Haas Unica.
Printed and bound in Canada.

Library of Congress Cataloging-in-Publication Data
Names: Bierut, Michael, editor. | Helfand, Jessica, editor.
Title: Culture is not always popular : fifteen years of Design observer / edited by Michael Bierut and Jessica Helfand.
Other titles: Design observer.
Description: Cambridge, MA : The MIT Press, 2018. | Essays originally published in Design observer. | Includes index.
Identifiers: LCCN 2018011907 | ISBN 9780262039109 (hardcover : alk. paper)
Subjects: LCSH: Design--History--20th century. | Design--History--21st century. | Design--Social aspects--History--20th century. | Design--Social aspects--History--21st century.
Classification: LCC NK1390 .C85 2018 | DDC 745.409/04--dc23 LC record available at https://lccn.loc.gov/2018011907

10 9 8 7 6 5 4 3 2 1

Contents

03. Will and Whimsy

04. Reason and Responsibility

05. New Vernaculars

About This Book

The website *Design Observer* launched in October 2003 with no mission more explicit than the five words that sat at the top of its homepage: Writings About Design and Culture. Fifteen years and 6,700 articles, 900 authors, and nearly 30,000 comments later, the legacy of that mission is impossible to capture in a single book, no matter how thick. So consider this not an authorized history but a combination primer, celebration, survey, and—perhaps—valediction to a certain moment on the Internet.

How did we edit? From thousands of articles we picked sixty-seven (yes, just about one out of one hundred). These choices were deliberately meant to highlight the site's determined eclecticism, its wide range of contributors, and its unique and always shape-shifting definition of "design and culture." Comments, especially in the site's early days, were thoughtful, erudite, and long, sometimes longer than the articles that inspired them. We included just a fraction of them to hint at the kind of debates that would rage online in the days before 280-character limits.

And whole categories of articles were left out, including the groundbreaking pieces on design for social causes made possible by a grant from the Rockefeller Foundation and commissioned under the rubric "Change Observer," and the thoughtful essays on architecture, landscape and urbanism published on our platform by the journal *Places*. These deserve their own books, and, in a just world, one day will get them.

It's worth noting, too, that *Design Observer* was more than just essays. Not shown here are the site's special projects, which ranged from the Polling Place Photo Project, a prescient collaboration in citizen journalism and crowdsourced image making with the *New York Times*, to the Ezra Winter Project, a visual biography told in twelve chapters over as many months, to Paris One Forty, a poetic visual diary of twenty weeks in the French capital. Offline, *Design Observer* created several small books, one magazine, and two one-day conferences. Finally, people these days are just as likely to know us for our podcasts: *The Observatory*, and *The Design of Business | The Business of Design*, and *Design Matters* with Debbie Millman. Clearly, the ongoing conversation about design and culture—only hinted at in this relatively modest volume—will never stop seeking the medium of the moment. We hope you continue to join us.

Michael Bierut and Jessica Helfand

ORIGINALLY PUBLISHED
2018

Jarrett Fuller
A Conversation with Michael Bierut and Jessica Helfand

Jarrett Fuller: I think a good place to start is to look at what the world was like fifteen years ago, because I think both the world at large, and the design world specifically, look very different than they do today. What was the cultural context that *Design Observer* was born into?

Michael Bierut: In the biggest context, those days felt very post-9/11. There was a heightened awareness of America's role in the world and the fact that there was a big, interconnected world out there. I think there was a lovely, comforting insularity from the Clinton years but suddenly, with a single traumatic incident, America's place in the world was repositioned. So it really did feel a little bit like a greater purview. I'm not saying that that motivated the founding of *Design Observer* but I do think that provided a little bit of a context.

Jessica Helfand: When you asked that question, Jarrett, the first thing I thought of was also 9/11 and how the world—certainly the Western world—felt an increased sense of vulnerability following it. The design world was not inured from that.

MB: And certainly the Internet had been around for a while, but I can still remember really clearly getting an email from Bill [William Drenttel] saying he wanted to do something that in those days was called the "blog roll," a list of sites that we liked and just wanted to co-promote. I remember being stymied, trying

to think of websites that I visited a lot. There just wasn't a lot that was interesting and even the esoteric sites made a fairly short list. Even though the Internet is a limitless purview and real estate is free and it just can stretch in all directions infinitely, it's funny how much that territory felt like a small pioneer town. It really did feel underpopulated.

JH: I love that answer, Michael, because it makes us sound like swashbucklers! I can't look back at the design world and divorce it from technology. In 2003, Rob Walker wrote this piece for the *New York Times Magazine* called "The Guts of a New Machine." It was all about this thing called the iPod and how we were we were still dealing with MP3 players and that we still had CD covers. So when I think about the blog roll and vulnerability and why we felt a moment had come for blogs as a community destination for design criticism and culture, I think that we saw ourselves as part of a tapestry that was about more than design—that it included technology, politics, and all these other things. I think all four of us founders were intellectually restless. My concern was that design blogs were going to only cater to the design community.

JF: So how'd the site come together? What did the first inkling of that idea look like?

JH: I think I can actually take credit for naming it. We had a long list of names—some of them were too newspapery, some of them

sounded too pretentious, some of them sounded too design-centric—but I loved the idea that observation was at the core of what we all did, that there was this tacit commitment to a visual and cultural scrutiny that would bind us together as a community. I think a big part of the draw for starting something amongst these four friends—William Drenttel, Rick Poynor, Michael, and myself—was very much fueled by the community incentive. It's hard to explain now how exciting it was that people were really having these multi-layered conversations in real time, through commenting.

MB: It really was you and Bill who had the original idea, right? Do you remember the moment it arose and what specifically provoked it?

JH: It was one of those things that was fueled by the fact that we lived in the middle of nowhere. Bear in mind, this was long before social media! I think particularly for Bill, who was an incredibly social person, the idea that we could be at the epicenter of a conversation that was conceivably global was just the most intoxicating concept. So whether that was driven by ego or hubris or loneliness, I can't really say. We were also really interested in having a practice that involved writing, publishing, and engaging in a written testimony around ideas, and this idea that writing could become its own catalyst for critical engagement with the design community. When blogs came along and they had this fundamental writing component, that was a big thing.

JF: I think there were three main things that really made blogs unique. The first is tone and how there was a certain conversational style to blogging. Then there was a freedom to it. For the first time, you could write something that was one hundred words long or ten thousand words long and you weren't paying for printing and paper. But also freedom in that you could write about any topic that you wanted to write about. The final one was this immediate feedback—this community—in that as soon as you hit "publish," you could get a response right away. I'm curious how these things—tone, freedom, and community—influenced the early days of the site?

JH: I love that you broke it down that way, and I think you're absolutely right. And, of course, those things branch on to other things: free-

dom, as you say, is about economics, but also an economics of means by which you choose to articulate things. If you think about how we traffic in social media today—in the currency of "likes"— this was not so different. We would routinely refresh our screens to see who was logging in to read what we'd written, but their responses weren't just thumbs and emoticons. They were real content. They were actual disagreement.

I remember writing sometime in the early 2000s about David Hockney talking about photography, and the comments were about "Is photography truth?" and "'How is evidence truth?" and "How is evidence a point of view?" This was years before a national dialogue about fake news. Some of these comments were mini essays within the essays. We had conversations where some of the comments were longer than the original post.

MB: And that was blog culture at the heart of it. And one of the things that was intoxicating about blogs—particularly for the four founders of *Design Observer*, all of whom had written for print publication prior to starting the site—was their immediacy. If you got the assignment to write for *Eye* magazine or *AIGA Journal*, you'd spend time working on it, you'd submit it, some edits would come back, and you'd go back and forth, and it would be approved. Then it would be in this limbo state that could last as long as weeks. You'd write something and it could be a full two months before you'd see it in print.

JH: There was no way for it to be newsworthy.

MB: But with blogs, there was this immediate feedback loop.

JH: And sometimes the response was so much better than what we wrote! I once wrote a short essay about ampersands and here's a quote that Dmitri Siegel writes in his comment: "Was there some cabal of grizzled typographers, who decided to leave behind the Latin letterforms despite the ink-stained finger-wagging of their colleagues and the accusations of blasphemous formalism?" That's one sentence of a three-paragraph response that is so much better than what I wrote! The comments weren't just idle chitchat; they were really content-specific and really laden with all kinds of wisdom and originality and voice.

ABOVE *Design Observer* version 1, 2004–2006

JF: How long into the run of the site did you realize that the community forming around the site was as important as the contributors?

JH: Early. But, of course, there was a moment of reckoning when the comments were completely usurped by social media.

MB: I would qualify that by saying the four founders each had separate, slightly different ideas about the role the comments were meant to play in response to specific articles and in terms of the overall tone of the blog. I think Rick always had this utopian idea that these Socratic conversations would happen between informed people and he did his best to instigate that. He was a very faithful commenter on articles that we would write and would always raise provocative issues that would steer the overall tone to something that was pretty enlarging.

At the same time, it was obvious that as our readership grew to the hundreds of thousands, the commenters comprised a tiny, almost infinitesimal, fraction of the number of people visiting the blog. I think I would vacillate between thinking that the function of *Design Observer* wasn't to provide props for spirited comment exchanges, but it was to get ideas out there; some of which would lend themselves to the commenting format, some of which would not necessarily.

JF: This idea of a community forming around the site is really interesting. I'm thinking about when I first visited the site and found a group of people talking about things that I was really interested in. Before, there hadn't been a way for people all over the world interested in design and visual culture to find others who also liked these things. *Design Observer* was this place where people could come together and talk about them. It became this social thing.

MB: What I find interesting about that is that if you think about *Design Observer* and the other blogs that burgeoned in the same era, there was a very specific window that opened and then closed that permitted that to happen. I think the opening of it was the spread of the Internet and the availability of blogging

software like Blogger, Movable Type, and Wordpress. They created the pretext for the community. What's more, the community for that kind of robust exchange really benefited from this sense of insularity that designers felt. I think that people who came to the site, like you, like many people in the audience, and, I dare say, like me, felt this. These were things I care about. Hardly anyone I know talks about these things and I could count the people who like to have these conversations with both hands. Then, suddenly, there's this large community all over the world of people exchanging ideas.

One of the things that happened at the far end of that window as it was closing—or was turning into something new, let's say— wasn't just the rise of Twitter and other forms of social media, but also that sense of insularity—that only we care about this—vanished. In the early days of *Design Observer*, when we'd write something that was reacting to the news, you could do it with the assurance that you alone would be meekly pointing out that such a thing might be interesting to a few other like-minded people. I'm always reminded of

the very first piece I wrote. I was so confused about how to get started and Jessica said, "Pretend you're writing a long email to a friend who you don't get to see very often and you think this thing is cool." I decided to write about the *New York Times* changing its headline style to a single typeface family, Cheltenham. I think I wrote about it a week or two after it happened and I am sure I was the only person that wrote about it other than the *New York Times*, who had a box where they announced it and a little article where they described it. But it was not commented on by anyone else. If that that happened now, there would be an article in *Slate*, there'd be an article in *Fast Company*. It might even escalate to the *Huffington Post* with an article about what the *New York Times*' new typography tells us about Trump or something like that! It would get there within twenty-four hours and people would just be kind of weighing in. The three of us might get emails from various reporters trying to get angles on this bit of news. It's based on this assumption that normal people are meant to care about design now. That certainly wasn't the assumption fifteen years ago.

BELOW In 2009, thanks to a generous grant from the Rockefeller Foundation, *Design Observer* launched a redesign that expanded its scope to include the dedicated channels, Change Observer and Places.

JF: How did you navigate that change in culture where design is something everyone is aware of and has opinions on?

MB: I think adding more writers beyond the original four founders helped create dedicated areas to things like social design and architecture. I'm thinking of people like Mark Lamster, Alexandra Lange, and Julie Lasky.

JH: And these were people who weren't coming out of design. Like Julie Lasky, who was an editor at *Print* and is now with the *New York Times*, but also people like Tom Vanderbilt, Rob Walker, Paul Polak, and Eugenia Bell. Maybe we fancied ourselves big enough as an editorial imprint to be able to reach out to people whose work wasn't always design-driven but could connect it to what they were already interested in. It also helped us reignite our commitment to our tagline, "writings on design and culture." It was the "culture" part that I think was important.

JF: And that's related to this idea of design being this thing that everyone's supposed to care about now. I think *Design Observer* anticipated that; not only that design is something that people should care about, but also that the very definition of design is broader now. When the site expanded to include Places and Change Observer, that was almost ahead of the moment we're in now where every publication has some sort of "design" vertical.

MB: And I constantly encounter writing in venues that aren't even in a designated "design" vertical that I would call design criticism. I read food writing and writing about fashion or style that I think of as the kind of thing that we would have provided a home for on *Design Observer*. People are debating fake news or the digitization and automation of the transfer of information that happens on a global scale and those are things that we would have easily considered design stories in in 2008, and now can appear anywhere from the *New York Times* to *New York* magazine to *Chowhound*, which I think is fantastic. There are a lot more people writing perceptively about design refracted through so many different lenses now or are writing about so many different things refracted through a design lens.

JF: I want to talk about social media. We've already talked about how it changed com-

menting and shifted the community. But I'm also interested in how inherently visual social media is and how that, I think, had a big impact on the culture and how we talk to each other. This obviously comes back to design and to the things that that you were writing about on *Design Observer*.

JH: Social media shifted the coordinates around publishing for us—and for everyone. I found my writing to be more visually driven than idea-driven. So two major things happened. One, much shorter attention spans, and two, much more visually driven content. But I would say two and a half is that by 2006–07, every phone had a camera that was pretty decent. And because of Twitter and Facebook, we now find ourselves dealing with an audience that, if it had been visually sophisticated before, is visually sophisticated and visually impatient! So I wanted to do more video. I wanted to do more interactive things. One of the reasons I did my year-long project on Ezra Winter was right around a time when I really wanted try to explore the idea that if a picture was worth more than words,. are pictures that move worth more than pictures that are static? What happens when you have an episodic story to tell? Can you get people to come back week after week?

So I was trying to understand how to tell a story that was visually compelling but still true to my interests as a design historian and somebody interested in theory and speculation and experiment. This is when we started doing Observed, our link list. We started doing slideshows and publishing visual essays by John Foster and Eric Baker. What social media did was help us see that people entered into content in different ways. And still do.

JF: I think one of the ways the site has sustained this constantly changing media landscape is that you've added new formats and ways of communicating, whether that's slideshows or conferences. The focus now seems to be podcasting. Obviously, Debbie Millman's *Design Matters* has been a part of *Design Observer*, but now you have *The Observatory* and *The Design of Business | The Business of Design*. A lot of those old-school bloggers talk about how the feeling around podcasting is very similar to the feeling around early blogging, but I'm also thinking about that conversational tone and how the podcast literally is a

conversation. When I put my headphones on, I feel like I'm listening to two friends talking.

JH: What I liked about the podcast idea was that it was a way to return to the nucleus of where we began. We were inspired by the format of *Slate's Culture Gabfest*. Around 2014, I got really interested in podcasts as a way to go back to where we started with conversations between two people about design in the world. I think you're right to say this, Jarrett, about the tone and the intention that we originally had.

It doesn't allow you to polish yourself quite so much. I think I'd say we are very much beholden to not only Blake Eskin, our wonderful producer who has really done most of the legwork, as well as Miranda Shafer, Annette Heist, and Julie Subrin, who are our producers and editors making us really sound a lot better than we do when we're coughing and swearing and mispronouncing things right and left.

MB: And I think our goal from the very beginning has been the same. If you think that design is interesting and you think that one's understanding of design is enhanced by the challenge of articulating your ideas about it, one way of articulating ideas is writing, either in long form or even participating in various forms of publishing that other social media platforms can afford. And I think that podcasting goes to the roots of the blog, as you implied. Bill and Jessica obviously talked to each other a lot. I always liked talking to them and to Rick Poynor. We always like the process of conversation. One of the things we were trying to do is just have those conversations in a slightly more public way.

JF: What is it about *Design Observer* that has allowed it to sustain and navigate this ever-changing terrain?

JH: The short answer is we're cranky and old and we don't give up easily!

MB: It's funny because we didn't have any particular goal when we started, outside of the pleasure of doing it. I have to give the late, great Bill Drenttel huge amounts of credit for this. He was always the first one who would be ready to say, "Why don't we change that up by doing this? Why don't we change it up by doing that?" I thought he was an inveterate tinkerer and was interested in just seeing what would happen if we did this. I think Jessica and I certainly have carried on in that same spirit. Could it be a podcast? Could it have had more participants? Could it have had these sort of things as part of it? And I think it's neither necessarily about keeping *Design Observer* the way it's always been nor is it on some trajectory that has a clear destination.

JH: The whole thing has been a kind of giant social experiment. It's been like a studio lab environment in the sense that we could take chances and we could collaborate with people. We could write about Ai Weiwei or Christo or a scientist building something in a petri dish. We could follow the things that interested us, which included music and art and politics and drama. Whether I was doing a yearlong visual biography of Ezra Winter or Michael was writing about Errol Morris or one of our writers was really interested in writing about something from another part of the world that none of us would ever get to, it allowed for an incredible expansiveness. None of us predicted that design would become something that many people beyond our little tribe would care about. So we were able to ride that wave and embrace some of that complexity and contradiction, and it allowed for different kinds of experimentation and different opportunities for expansion. That this blog would enter into a whole new world is not something any of us could have predicted. We just never gave up.

RIGHT The fifth, and current, redesign of *Design Observer* launched during the summer of 2016.

Design Observer

Presented by **AIGA**

Steven Heller | Opinion

Should Designers Be Design Critics? Why Not?

Michael Bierut + Jessica Helfand | Audio

S4E10: Abbott Miller

Abbott Miller is a partner in the design firm Pentagram....

Debbie Millman | Audio

David Spergel

Debbie talks to astrophysicist David Spergel about the origins of the universe....

Nakita M. Pope | Interviews

"Black Creatives Aren't Just Around in February": An interview with Maurice Cherry

2018 Steven Heller Prize for Cultural Commentary recipient Maurice Cherry talks design education, diversity in design, his advocacy work, and personal inspirations....

Doug Powell | Opinions

Better, Faster, Stronger? Design Thinking Gets a New Study

Proof of the value of design thinking is good news for practicing designers....

Michael Bierut, Jessica Helfand | Audio

S4E9: Karin Fong

Karin Fong is a founding member of Imaginary Forces, a creative company specializing in visual storytelling and brand strategy....

Debbie Millman | Audio

Edel Rodriguez

Debbie Millman talks to Edel Rodriguez about his

Observed | April 25

Two years after dropping a controversial family crest, Harvard Law School is struggling to introduce a new seal. (via James I. Bowie) [BV]

AIGA Design for Democracy: Building Community Power needs you. And you need to have your design on the NASDAQ screens in Times Square during NYCxDESIGN week. Submit by the end of the month. [BV]

Observed | April 24

"If our taste is dictated by data-fed algorithms controlled by massive tech corporations, then we must be content to classify ourselves as slavish followers of robots." [BV]

Do you know Susan Kare? It's likely you see her work every day. Alexandra Lange's thoughtful profile of the woman who designed the suite of icons that made the Macintosh revolutionary, and who made it smile. [BV]

Observed | April 20

Is the selfie dead? (You wish!) [BV]

Observed | April 19

Rube Goldberg got tech right. [BV]

Design and obsession. [JH]

Observed | April 18

Design and icons. [JH]

Observed | April 16

Eric Markfield's Real MTA map reflects the current (woeful) state of the New York subway system in real time. Only lines with good service (no delays, no service changes or planned work) are shown. [MB]

Design and euthanasia. [JH]

Observed | April 13

What are you listening to? How? A fun look back at old-school headphones. [BV]

Opening next week check: Jade Doskow's Lost Utopias, documenting the remains of World's Fair sites, at the Front Room Gallery in NYC. [BV]

Observed | April 12

A day in the life of Mike Katz, the last of a dying breed: 70mm film projectionists. [BV]

The Accessible Icon began as a street art project and is now a rival to the 1968 Wheelchair Symbol. (via James I. Bowie) [BV]

Observed | April 09

"Will Burtin's contributions to design can be characterised as important as Albert Einstein's contributions to science." [BV]

Observed | April 06

01.

Critical Commentary

At its core, criticism is the art of cultural investigation, a process of inquiry and circumspection that shoots deep and spins wide. A good critic goes under the hood and pokes, probing, examining, and scrutinizing the detritus before it vanishes. Criticism itself is a minefield of shifting expectations and unintended consequences, a journey of doubt as well as discovery. It's lonely. It's hard. And it's necessary.

Design criticism goes one step further, because design is inherently more than the sum of its parts. Ideological, speculative, often controversial and inevitably oppositional, design criticism also tends to be highly visual, which quickly leads to responses that are personal, even prickly. (Online criticism can quickly become a blood sport.)

If our writers were strong-willed ambassadors of their own ideas, they were also willing to embrace the opinions of others—online, in public, often in real time. We might publish a manifesto, or a monologue; a riff, or a remembrance. A critical essay itself might be framed as a visually-driven analysis or positioned as an image-free rant. We went high and low, wide and deep, between disciplines, across boundaries, from the personal to the political and back again. Over time, the practice of criticality became an expression of community vitality that none of us could have anticipated.

"Whatever the discipline," Rick Poynor once wrote, "the critic is engaged in a process of interior and exterior discovery." On our watch, that process has also been humbling. We are all cultural investigators now.

Jessica Helfand
Why Write About Graphic Design?

When I first began to study graphic design in the early 1980s, I was puzzled as to why there was no theory, no substance or depth to the discussions that seemed so overwhelmingly grounded in formal language. Back then, we didn't speak of social missions or sustainable goals; there was no "user" and when we spoke of audience, it was our way of nodding gratuitously to the demands of broad-based demographic research. (Obviously, long before the facility with which Google makes this achievable, this meant a trip to the library. Usually on foot.)

I longed for something more—something meatier—to qualify the choices I was making, to help me reflect upon and rationalize decisions that so quickly seemed to find their way into concrete choices. Architects had theory, so why didn't designers? Perplexed, I lobbied my advisors to consider giving me a degree in graphic design and architectural theory, claiming that, in the absence of real ideas—real books to read, true primary sources to guide my research—graphic design had no ideological grounding. They agreed, and granted my request, and off I went into the working world, hoping it would make a difference.

In truth, it made absolutely no difference in my chances to find employment. But it made all the difference in the world in my perspective which was then, as now, rooted in something more than visual appeal. Five years later I returned to Yale for grad school, and encoun-

tered similar obstacles. Reading was the enemy, I was told: it will hold you back so that you get so caught up in ideas, you can't make anything. I disagreed, and headed to the library, sketchbook in hand. Reading and writing and drawing were, and have remained, the most utterly companionable activities I can imagine.

Today is our graduation day at Yale, and marks thirty years since my own commencement. We call it commencement because it is just that—a beginning—but where I began as a graphic designer and writer bears little resemblance to the way we think about and practice design today. I have always felt that writing was a way into design; and that design, in turn, was a way into writing. This double approach characterizes both my teaching and my studio practice, although for many years, this philosophy was seen as grim and onerous by the majority of my graduate students. Then blogging took hold, and suddenly, writing meant discussion. Writing meant social engagement. Writing became a way to collaborate, to develop an idea and move it—and by conjecture, yourself—forward. Now, everyone sees writing as a way in. (And sometimes, as a way out.) Today, graphic design is no longer a function of pictures and words on paper, because graphic design is no longer only about being graphic. It operates on multiple formal platforms, and its boundaries are porous and flexible, cultural and dynamic—visual and yes, verbal.

12 **Culture Is Not
Always Popular**
Critical
Commentary
Why Write About
Graphic Design?
Jessica
Helfand

Today, we know that the audience is us, because graphic design both belongs to and is produced by everyone, inhabiting everything from Swiss dogma to skateboard graffiti. It resists definition, because it is everywhere, which means it is nowhere.

If there is a problem, the problem is this: once graphic design belongs to everyone, the role of the critic is tricky. Is it possible to both consume and contribute? To contribute and critique? Is it possible that our greatest critics might be most committed makers?

As a thirty-year veteran of making and writing, I think it is not only possible but imperative that we strive to do both. Let's teach our students to think about language. Let's ask tough questions about why we make things. Let's support the role of writing, the opportunity in reading, the value of a second language, the need for engaged criticism. Let's remember that graphic design is about ideas, and ideas mean words—beautiful, descriptive, analytical, and magical words. We write about graphic design, quite frankly, because we can.

Jessica
Helfand

Why Write About
Graphic Design?

Critical
Commentary

**Culture Is Not
Always Popular**

13

Rick Poynor
Where Are the Design Critics?

ORIGINALLY PUBLISHED
09.25.05

COMMENTS
70

This weekend I participated in a couple of panel discussions about design criticism jointly organized in London by the Rhode Island School of Design and *I.D.* magazine. The aim was to understand the state of criticism by first examining the relationships between design history, theory, and criticism, and then discussing how criticism is handled in the UK press. Julie Lasky, editor of *I.D.*, was cochair of both panels, along with Jessie Shefrin and Roger Mandle of RISD.

The venues for these events said something in themselves. Friday night's discussion of criticism's role in design education took place within the sedate, establishment walls of the Royal Society of Arts, far from the hurly-burly of everyday commercial design. Saturday's better-attended event about the design press, with Marcus Fairs, editor of *Icon*, and Vicky Richardson, editor of *Blueprint*, took place at the 100% Design fair at Earls Court in London. In the hall outside, throughout the discussion, we could hear the hum of fashionable young Londoners swarming over the latest floor tiles, wallpapers, top-of-the-range kitchen units and sofas. The conversations, as you might expect, took very different directions.

There was one fundamental question that neither panel really got to grips with, although the point arose immediately in opening remarks made at the RSA by Glenn Adamson, head of graduate studies at the Victoria and Albert Museum. Adamson observed that design

writing was so deeply entrenched within the design field, so closely tied to its professional goals, that the writing's ultimate effect would always be promotional rather than critical. None of the other panelists engaged fully with this crucial point, but any discussion of criticism is bound to start here. What do we mean by criticism? There is a tendency, especially among journalists, to blur and confuse definitions of journalism and criticism. Journalism should, of course, be skeptical and critical; it should take nothing for granted, ask awkward questions, and aim to reveal what is really going on rather than what those with vested interests want us to believe. Whether design journalism lives up to this ideal most of the time is another matter.

But criticism, in the deeper, historical, more self-aware sense that Adamson used the term, possessed a larger ideological purpose. Its role was oppositional and it was often identified with the Left. It took issue with capitalism and sought the transformation of society. The point arises in the latest issue of *Prospect* magazine, which has followed up its list of the one hundred top British intellectuals, subject of an earlier *Design Observer* post, with a list of one hundred global public intellectuals. As previously, the representatives of visual culture make a poor showing. Rem Koolhaas is the only architect, Robert Hughes the only art critic. There are no artists, film-makers, or designers.

that model under the banner of feminism, postcolonial theory, etc. Because of this history, current day theorists in these arenas have a rich array of positions to draw upon in defining their own practice. In the case of design criticism this history seems to have been largely absent, which accounts for the present dilemma.

One last point I would make is one that I made at the panel, and one that perhaps addresses Jessica Helfand's question: is it possible that we do have a rich practice of design criticism in front of our eyes, in the works of contemporary artists who engage with design? One thinks of artists as diverse as Andrea Zittel, Jorge Pardo, Matthew Barney, Yinka Shonibare, and Takeshi Murakami as offering an account or use of design that is productively discursive. Alex Cole's recent book DesignArt surveys this activity usefully; Rick, in his review of the book earlier this year, rightly says that it "ends up confirming that art remains the dominant term in the relationship." It may be that this is inevitable, though--that when a designer or design theorist becomes sufficiently "critical," they pass inevitably into the realm of contemporary art and are otherwise unrecognizable to critics and the public alike.

Ellen Lupton
10.19.05 10:15
Maybe design criticism would become more interesting and vital if it directed itself not at the insider world of the design profession but at the people who see, read, use, discard, ignore, and otherwise interact with what designers do. Rather than assuming that responsible criticism is "oppositional" in the leftist sense, we could start looking at why, how, and if design is a universal human value that should be accessible and understandable to everyone on the planet.

Film criticism is not just for film makers. But then, people from all walks of life actually care about movies. Let's make them care about design.

In an accompanying article, writer and television producer David Herman points out how different in emphasis the list would have been thirty years ago. An older generation of public intellectuals and critical thinkers identified with the political Left—exemplified in the global list by Noam Chomsky—is now over seventy and has not been replaced, although Naomi Klein does make the cut. Herman suggests, citing the views of the late Edward Said, that "the great tradition of the oppositional intellectual" is coming to—or has already come to—an end.

Clearly, it is still possible to take an oppositional stance in regard to design and we see this most clearly in the sphere of visual communication. Designers who engage in "the design of dissent" do exist, but design's default position, which most designers accept, whether they create products or graphics, is to grease the wheels of capitalism with style and taste, as CalArts teacher and type designer Jeffery Keedy once put it. Design is deeply implicated. It is one of the ways in which capitalism is most obviously expressed, and never more so than today when design is widely regarded as a miracle ingredient with the power to seduce the consumer and vanquish less design-conscious competitors.

There is no reason why design criticism should not take a critical view of design's instrumental uses and its wider social role, or the lack of it, but there seems to be little motivation to produce this kind of criticism. In this respect, design writing appears to reflect the larger intellectual trend identified by Herman in his analysis of the *Prospect* list. Who, in Britain—since this is where these two panel discussions happened to take place—is producing an oppositional design criticism and where can we find it? The most revealing aspect of the debates was that none of the participants, on either panel, volunteered the names of any writers that they considered to be significant contemporary design critics. Instead, among the academics, there was vague talk about "criticality" as a desirable goal. But criticality in relation to what? And to what end? How are designers going to become critical in any serious way if they are not exposed to sustained critical thinking about design in the form of ambitious, intellectually penetrating criticism? If design educators think as critically as they like to claim, why aren't more of them producing this kind of writing in an attempt to shape public awareness?

There has to be a coherent basis for critical thinking, a considered position according to which a piece of criticism can be understood, and writing remains the best medium in which to develop this. Let's stop kidding ourselves. Without the writing, it isn't going to happen.

Rick
Poynor

Where Are the
Design Critics?

Critical
Commentary

**Culture Is Not
Always Popular**

15

Jessica Helfand
Open Letter to Design Students Everywhere

ORIGINALLY PUBLISHED
06.3.09

COMMENTS
65

My freedom thus consists in my moving about within the narrow frame that I have assigned to myself for each one of my undertakings. I shall go even further: my freedom will be so much the greater and more meaningful the more narrowly I limit my field of action and the more I surround myself with obstacles. Whatever diminishes constraint diminishes strength. The more constraints one imposes, the more one frees oneself of the claims that shackle the spirit. —Igor Stravinsky, The Poetics of Music

June, which so famously heralds the beginning of summer, also marks the conclusion of the academic year—and with it, calls and emails from students trying to make sense of what to do, where to go, how to reconcile the various components of their education that lead to greater self-knowledge, better work, more challenges, and maybe, just maybe, an eventual opportunity to begin paying back those student loans.

And so, they come to see me. I look, carefully. I listen, hard, to see what, if anything, I have to offer them. I am aware, extremely aware, of the generational gap that divides us (perhaps one of the few benefits of my getting older) and I try to remain vigilant about that distance in time and space, resisting any comparison from their orbit to my own, now comparatively antediluvian education. And yet they are—like I was, and all students are—overwhelmed by the embarrassment of riches framed by the astounding prospect of two to three years of

uninterrupted study, a period culminating, for many, in the development of a thesis.

While the definition of a thesis varies from school to school, one thing remains startlingly undisputed: how can you possibly narrow your focus when the world is truly your oyster?

And that's just the beginning in what seems, more often than not, to be a series of paradoxical propositions. If you're graduating in the middle of a recession, it's likely that an arc of despair trumps the impending thrill of your newly-liberated station in life. Conversely, though, I can't imagine a better time to get out of school. Nobody's hiring, but why let that stop you? While the mechanics of, say, having a roof over your head suggest that a little modest income might be a good thing, the actual economics of making work no longer depend on an actual employer. The portfolio no longer means a big black suitcase schlepped around from studio to studio. Get your work online, put your videos on YouTube, and get busy.

On the other hand, if you've selected the work-for-someone-else route, concentrate on having as many conversations as you can with as many people as possible. (Bonus points for people smarter than you: isn't your tennis game supposed to improve if you choose a better opponent? The same holds true for interviews.) Never leave an interview without at least three names of other people to go see. Don't be afraid to ask them about their choices,

Lorraine Wild
06.04.09 11:15
I want to underline something Jessica says here as being counter-intuitive, but really important: the "less is more" version of a thesis definition. I remember thinking that this piece of advice was literally painful when I was a grad student: how could simplicity be of value when I (thought) I would be inciting design revolution with the brilliance and complexity of my ideas? And yet, to get something done that meant something, I had to edit and edit and edit again. I've been working with grad students on developing their thesis projects now for eons of time, and the principle of simplicity—along with specificity—has never faded.

Rob Henning
06.04.09 12:55
Great advice, even for us older folks. Makes me want to go back to school. For employment seekers, I would add that prior to going on an interview, even prior to asking for an interview, and even prior to making first contact (phone call, sending that email, cover letter, resume, whatever) learn everything you possibly can about the person/ firm with whom you are trying to land an interview. It's not hard to do this homework, and doing it can demonstrate that you are interested in your interviewer, which in turn might spark his/ her interest in you.

Failure to do this little bit of research spells certain death. I get letters every year addressed to "Dear Human Resources Manager," which go straight in the bin, regardless of their content, because the salutation instantly demonstrates the person hasn't bothered to learn anything about my little one-person company.

too. Ask them to tell you what they think you should read. And assume that they're as busy as you are, we're all even busier, so send a link to your work ahead of time. Arrange your interviews by email. And afterward, go that extra step and send a thank you note.

If you're heading to school in the fall as a first-timer, you're likely to be truly overwhelmed by a level of option paralysis which is, arguably, unlike anything you've ever experienced— which is an even more persuasive reason for you to find ways to focus your energies. If you don't already do it, start keeping a notebook. Travel everywhere with it, as you do with things like your camera and your cell phone: consider the notebook an extension of your mind and of your studio. Do not wait to get back to your desk to write things down or, better yet, to draw them. If you draw something every day, you will find, over time, that your facility with the pencil is a huge boon to thinking visually. If the notebook is with you all the time, you can afford to be a little unfocused. Later on, you'll look at what you wrote and saved and drew and you will realize that without even trying, you created a time-capsule that is, itself, a manifestation of what mattered. Instant, retroactive focus. Go to the head of the class.

Students returning in the fall, especially seniors and final-year graduate students, face a somewhat different challenge: how to narrow the frame of investigation (deciding on a topic, or a method, or a principal focus for your final investigations) while still leaving the door open to think broadly and widely and deeply? How to be specific—and here, I will go to my grave insisting that each and every one of you find the elevator version (also known as the Hollywood logline) of your topic, that expresses in a smart and pithy fashion WHAT YOUR THESIS IS—while at the same time, opening yourself up to as many ways of producing work that reflects and extends and amplifies your central idea.

So here it comes, with apologies for the been-there-done-that sound of the following disclaimer: less, in fact, is more. Less in the sense of fewer words to describe your idea. (Refer to "elevator version," above.) Less in the sense of less ambitiously framed, but not one speck less ambitious in its intellectual rigor and its craft and clarity and intent: so if you're looking at the big implications of the big world of big public space and the big, undefined audiences that inhabit it—well, maybe you want to start with something more specific, as a module that can be defined and then scaled, torqued, re-examined but that originates as a more specific and controlled organism. Less with regard to less immediate interventions: less stuff, fewer fonts, smaller expressions. Start simply, and go from there. There's plenty of time to get complicated later.

With structure comes freedom. And freedom, let's not forget, is what education is all about. It is a great time to be a student. Go out and make great things, things that help us, inform us, enlighten and change and impact the world in millions of meaningful and glorious ways. Your education will not end the day you graduate: on the contrary, what you're doing is learning how to learn, and how to think, and how to visualize the ideas that percolate in your brain. So here's what you do: never stop thinking. Never stop asking questions. Never, never stop reading, looking, imagining what else can be done. And don't be afraid to start small. You'll get there, eventually. And when you do? Send somebody a thank you note.

Adrian Shaughnessy
The Politics of Desire and Looting

The riots that ripped through English cities during four days in August were more ferocious and catastrophic than similar outbursts in the recent past. They have caused a prolonged and unprecedented bout of soul searching amongst all strands of British society. How could this happen? What caused it? Who is to blame?

Blame has been heaped mainly on the cuts-obsessed, expenses-fiddling politicians; the Metropolitan Police who inadvertently triggered the rioting by shooting a man in the street; the nation's under-funded education system; and city councils who rushed to close youth centers in the wake of the global economic crises.

Opprobrium has also been directed at the parents of rioters (special venom is reserved for single mothers—the great bogey figures of the British right wing press); role models in entertainment and sport; the despised and greedy bankers; even British rappers have had accusatory fingers pointed at them.

One group has so far escaped blame: designers. Hardly surprising—who could possibly think that we mild-mannered individuals are somehow responsible for murder, theft, arson, and civil disobedience on an apocalyptic scale? And yet, a salient feature of these riots has been the fact that the main target of the attacks has been the shops of the major retail brands of British commercial life.

In previous modern-day riots, the aim has been to expose grievances relating to social injustice. And although the young of multicultural urban Britain have many genuine social grievances, on this occasion they made their objective the acquisition of free stuff.

The principal target was a highly successful chain of shops called JD Sports. It sells fashionable streetwear. Other popular targets included mobile phone shops, electrical goods stores, and outlets of leading UK fashion brands.

All of these shops spend huge amounts of money on branding, store layout, window displays, and slick advertising. Their ads leap at us from newspapers, magazines, TV, radio, and the Internet. Celebrities endorse their products. They are little shrines of desire.

Despite one or two gleefully publicized cases, the majority of the rioters came from poor homes in the least desirable, least well-resourced areas of England's major cities. They come from places with low achievement rates in education, and where employment prospects are low.

These young people are not poor in the sense in which we understand poverty in the undeveloped world. They have BlackBerrys (the encrypted BlackBerry messaging system was used extensively to coordinate attacks), fashionable jeans, and cool footwear: but they are

adam
08.16.11 08:22
I'd just like to address Adrian's last point about an emergence of a generation of designers looking to follow in Ken garland's First things First footsteps.

I know Adrian has been a great advocate of the design for positive change community and salute him for that—But we have to stop underplaying the size or influence of the group! I work as a designer in a comms agency who work exclusively on positive change projects www.forster. co.uk and since starting work here the one thing that always astounds me is how big our discipline has got.

Of the 200 odd people I follow on twitter the vast majority of them are positive change designers working in the UK and I'm still finding new ones daily—what about the existence of this blog or the hundreds like it? I'd say the new generation isn't emerging it has emerged.

Metahaven
08.17.11 02:21
So, dear commenters, on what media diet were you living besides Design Observer before you began venting your equal share of courteous due diligence on the author and the flaming youth of the UK? Did you straddle the pages of Unbeige, Fffound, and Coroflot?

Were you in your right mind, and had you followed any credible political reporting from the United Kingdom in the past years, the "social policies" of the Cameron government would have been no secret to you and you could have spared everyone here your thinly veiled contempt for poor and marginalized

people. Those people who we would love to think are so different from we the "brilliant and talented"—the designers. Those calling the rioters "barbarians," "violent criminals" and "lowlifes" may then also approve of the Mubarak-style persecution which the British government and its judiciary have—unsurprisingly—unleashed on their citizens. The measures include 4-year prison sentences for inciting to non-existent riots on Facebook, eviction of rioters' families from council housing, a targeted social media ban without court order, and "extra powers" for the police, all to protect your local Footlocker. The police has extra-legally involved MI5 to help crack open BlackBerry messages, as if Osama Bin Laden and his entourage had just been sighted in Birmingham with a thermonuclear suitcase…

Then, look at the visual and physical side of things. The Flickr page of the Metropolitan Police has tons of surveillance portraits of the rioters, uploaded so that you, the public, identify them (participatory design via social media). Many look exhilarated, happy, and alert. As if they were living under Ceausescu and the Iron Curtain had just been lifted. (They look quite different from the average design hipster trying to seem asymmetrically cool on a fixed gear bike and all that.)

With free sneakers, having one over the authorities and the alarm-protected chain stores, the riots became a moment of freedom in the neoliberal gulag of Cameron and Clegg. And of course designers are complicit in creating and maintaining that gulag. But mostly they are, like everyone else, employed in it.

The social projects and higher moral purposes advocated in the FTF Manifesto are a little abstract as an alternative to advertising jeans and other ways of making cash. The question how we all make a living is legitimate and the answer to that question is always concrete. In their bare-bones reasoning—designers sell their services to clients, we all work in the marketplace, etc.—some commenters inadvertently affirm the spirit of the looters, who did not advocate a political or social cause, but simply followed their instincts on what would make their life tangibly better immediately. Not a co-creation project for participatory social change, but food, drink (Monster and Armagnac), and clothes. That said, this post's most hawkish commenters about both the riots and the design profession warrant a prediction that may surprise them and surprises even us: designers, despite their self-proclaimed high standards, are not insensitive to the economic spirit of looting and may even, given certain circumstances, participate in it.

poor enough to have a sense of being excluded from the great orgy of consumer acquisitiveness that is flaunted in front of them daily.

Specifically, they are excluded from the world of desire and consumption created by the brand owners, advertising agencies, art directors, graphic designers, photographers, product designers, retail designers, architects, stylists, retouchers, and copywriters.

I'm not advocating a puritan revolution. I don't want to ban advertising, or return to the bad design that characterized British shops in the 1970s—they were brown, musty, and unwelcoming. Nor do I think a single designer has ever gone to work thinking, "Today I must create something that drives the underprivileged youth of modern Britain mad with desire and envy."

But for the past three or four decades the major role of graphic design has been to create the branding and collateral of desire. For those who can afford entry into this world—no harm is done. For those who can resist the blandishments of this world—no harm is done. But for those who have neither the education nor emotional maturity to deal with this, immense harm is done.

Some designers have been warning about the unwanted side effects of the design revolution, most notably Ken Garland. As far back as 1964, he launched his First Things First manifesto; and more recently, designers such as Jonathan Barnbrook and the supporters of Adbusters have issued similar caveats.

These warnings are often mocked as "idealistic" and "naive." But from now on, it's going to be hard for critics to dismiss them. There really is a price to pay for creating the seductive tropes of modern commerce. We've seen what happens when you create a beautifully manicured world of desire, and then say to a big chunk of the population, "No entry." Seductive design is emphatically not the main cause of the riots, but it is a contributing factor, and we'd be dishonest to deny our part in it.

What is to be done?

Interestingly, for some time now, I've watched the emergence of a generation of design students and young designers who don't want to become the agents of commercial seduction. They are looking for a new role—one where social value is the new capital, not the sales charts of brand owners. Suddenly, they seem like the only acceptable future for design.

Adrian
Shaughnessy

The Politics of Desire
and Looting

Critical
Commentary

**Culture Is Not
Always Popular**

19

Michael Bierut
Designing under the Influence

ORIGINALLY PUBLISHED
02.26.05

COMMENTS
278

The other day I was interviewing a young designer, just nine months out of school. The best piece in her portfolio was a packaging program for an imaginary CD release: packaging, advertising, posters. All of it was Futura Bold Italic, knocked out in white in bright red bands, set on top of black and white halftones. Naturally, it looked great. Naturally, I asked, "So, why were you going for a Barbara Kruger kind of thing here?"

And she said: "Who's Barbara Kruger?"

Okay, let's begin. My first response: "Um, Barbara Kruger is an artist who is ... um, pretty well known for doing work that ... well, looks exactly like this."

She said: "Really? I've never heard of her."

At first I was speechless. Then, I started working out the possibilities. One: My twenty-three-year-old interviewee had never actually seen any of Barbara Kruger's work and had simply, by coincidence, decided to use the same typeface, color palette, and combinational strategy as the renowned artist. Two: One of her instructors, seeing the direction her work was taking, steered her, unknowingly or knowingly, in the direction of Kruger's work. Three: She was just plain lying. And, finally, four: Kruger's work has been so well established for so many years, that it has simply become part of the atmosphere, inhaled by legions of artists, typographers, and design students everywhere,

and exhaled, occasionally, as a piece of work that looks something like something Barbara Kruger would do.

Let's be generous and take option four. My visitor isn't alone, of course. Kruger, who herself began as a graphic designer, has created a body of work that has served as a subtle or not-so-subtle touchpoint for many designers over the past two decades. Occasionally the reference is purposeful, as in my own partner Paula Scher's cover for Suffragettes to She-Devils, which uses Kruger's trademark typeface for a book that surveys a century of graphics in support of women's rights, although in this case the Futura is turned sideways and printed in shocking pink. Similarly, the late Dan Friedman's square logo for Art Against Aids deploys Futura (Extra Bold) and a red and white color scheme in a way that is both effective and evocative.

Farther afield, the brand identity for the Barbican Art Gallery uses the same typeface and, controversially, applies it (usually at an angle to render the italic strokes dead vertical) to every exhibition that appears there. Sometimes it seems appropriate: when the subject is the work of Daniel Libeskind, the onrushing italics seem to evoke his urgent, jagged forms. Other times, the connection is more remote, or downright nonexistent. But, of course, searching for any connection at all is purely a parlor game. The goal of the One Gallery, One Font philosophy is not to serve any particular exhibition, but

for something more than an awkward moment between the student and Mr. Bierut. Many of my friends who have gone on to teach are horrified by the positions and practices of their fellow teachers—especially in contrast to how they were taught themselves in art or design school.

On the other hand, if the student was lying (about "appropriating" Kruger), this brings up a far more troublesome set of issues, some of which have been touched upon in some degree already in this thread. And again, it's not about originality or whether a style should or shouldn't be appropriated. It's that the person would appropriate and then choose to lie about it. "I never took steroids and I resent the implication that I did" (until grand jury testimony is leaked and the lie is made public). If a student lies about her acquisition of an idea, any acquisition of an idea, and begins to feel that this is a practice that one can "get away with," then where does that lead ultimately? Certainly the implications go beyond the argument over style or influence or appropriation. If there is a concern here, I'd say that speaks to it more directly.

Think industrial espionage (at the extreme), or the undermining of a colleague or coworker. This is the substance of ethics and ethical practice—not whether she knows or should know who Kruger is.

to create a unified identity for the Barbican Art Gallery, which it certainly does. I wonder, however, what would happen if the Barbican ever mounted an exhibition on Barbara Kruger? Would the collision of typographic matter and antimatter create some kind of giant vortex as the snake ate its own graphic tail?

We've debated imitation, influence, plagiarism, homage, and coincidence before, and every time, the question eventually comes up: is it possible for someone to "own" a graphic style? Legally, the answer is (mostly) no. And as we sit squarely in a culture intoxicated by sampling and appropriation, can we expect no less from graphic design? I remember my disorientation several years ago, when I first saw the new American Apparel store down in Greenwich Village. A banner bearing the store's resolutely hip logo hung out front: the name rendered (American Airlines style) in cool Helvetica, paired with a stripy star symbol that effortlessly evoked the reverse hip of seventies American style. And no wonder: it was the very logo that Chermayeff and Geismar's Bruce Blackburn had designed for the American bicentennial back in 1976.

Today, Blackburn's logo is gone from the American Apparel identity. A lawsuit? Or, more likely, the great zeitgeist wheel has turned once

again, rendering the 1976 logo too outré to bother plagiarizing? No matter. We've arrived at a moment where all that has preceded us provides an enormous mother lode of graphic reference points, endlessly tempting, endlessly confusing. Does Barbara Kruger own Futura Bold Italic in white and red? Does Bruce Blackburn own stripy, five-pointed stars? How much design history does one have to know before he or she dares put pencil to paper? Picture a frantic land grab, as one design pioneer after another lunges out into the diminishing frontier, staking out ever-shrinking plots of graphic territory, erecting Keep Out! signs at the borders: This is mine! This is mine!

I remember seeing an Esquire cover about ten years ago: the subject was radio personality Howard Stern. What a rip-off, I thought, seeing the all-too-familiar Futura Italic. To my surprise, it turned out to be a Barbara Kruger cover illustrating a Barbara Kruger article. Who would have thought: she's a Howard Stern fan. And the lesson? If anyone can rip you off, you may as well beat them to the punch.

Michael
Bierut

Designing under
the Influence

Critical
Commentary

**Culture Is Not
Always Popular**

21

Rick Poynor
Jan van Toorn: Arguing with Visual Means

ORIGINALLY PUBLISHED
03.21.04

COMMENTS
18

Jan van Toorn, subject of a meticulously researched retrospective that opened today (March 21, 2004) at the Kunsthal in Rotterdam, is one of the most distinguished and provocative figures in an exceptional generation of Dutch graphic designers. Van Toorn's social and political concerns, and his way of talking about them, set him apart, even among such colleagues as Wim Crouwel, Anthon Beeke, Gerard Unger, Swip Stolk, and Hard Werken founder Rick Vermeulen, who all attended the opening celebration. Van Toorn has described himself as someone interested in the history of ideas, who also happens to be a practical person, a designer, and this is how he comes across. The observations that follow are based on a talk I gave at the opening ceremony.

I first met Van Toorn in the early 1990s. He had recently been appointed director of the Jan van Eyck Academie and I traveled to Maastricht to interview him for *Blueprint* magazine about his plans. The whole experience made a powerful impression. Designers and design watchers in other countries have always viewed the achievements of Dutch graphic design with envy, and the 1980s had been a highly creative period. Now here was Van Toorn about to embark on what promised to be an unusual attempt to unite art, design, and theory within a small institution blessed with a handsome building, plenty of equipment, a fine library, luxurious amounts of space, and some promising-looking teachers. Frankly, I felt envious of the students—or participants, as they were always

called at the Academie. Who wouldn't want to spend time in such a haven, pursuing their personal researches? The appointment of a designer to head a center of postgraduate study that also covered art and theory seemed like something that could only happen in the Netherlands. It recalled Willem Sandberg's role as director of the Stedelijk Museum in Amsterdam and Wim Crouwel's position as director of Museum Boijmans van Beuningen in Rotterdam.

During his time at the Jan van Eyck Academie, Van Toorn and his staff initiated a series of conferences and related publications. These included *And justice for all...* (1994) and *Towards a Theory of the Image* (1996), culminating in Van Toorn's final project at the end of his time as director, *Design beyond Design* (1998), based on one the most stimulating conferences I have ever attended. Looking at this activity from the outside, and knowing just how much effort is involved to make these things happen, it seemed extraordinary that such a small institution could generate so many worthwhile contributions to debate. In the 1990s, I taught for several years at the Royal College of Art in London, a much bigger establishment than the Academie. During the same period, the RCA produced nothing comparable in terms of ambitious academic events and publishing. This was another sign of Van Toorn's commitment to critical analysis, dialogue between the disciplines, and the exploration of ideas.

William Drenttel
03.27.04 08:52
Rick, I'm intrigued by your post: it makes me feel like I imagine many of our American-oriented posts must make you feel. I can place Paul Rand against a backdrop of New York social history, or world history, or even against the development of (American) graphic design. I cannot place Jan van Toorn, with an American perspective, as easily.

I do have one personal experience with JVT, and it confuses me because I cannot connect it to the history you present. This is one person's experience over one day, but I feel compelled to raise it within the context of your observations here.

In 2001, I was a year-end critic at the Rhode Island School of Design graduate program in graphic design. As one of only two outside critics, there was a lot of pressure to say something responsive to each student's work. I found this difficult because the work was defined so personally that it often seemed to preclude comment. While the MFA program was run by Thomas Ockerse, it was my observation that the spiritual center of the program seemed to be Jan van Toorn. He was cited by every student as an inspiration, and seemed to be the main advocate for these personal explorations.

You can understand my confusion.

There was none of the social comment and engagement you describe: "Everything is possible, you can quote everything, you can use every style, but

where are the arguments that are really contributing to a fundamental change in our social conditions?" What I instead encountered was a deep engagement with a different kind of laboratory: worlds filtered through personal experience so myopic that larger interests in social or political issues were absent.

Thus, my question is a simple one. Did Jan van Toorn's social engagement continue into recent years? My (limited) experience would suggest otherwise.

Peter Bilak
03.31.04 09:27
Hello. It is easy and often tempting to romanticize the design culture in the Netherlands. Small countries receive lot of praise often because there is nothing else to admire, and it is easier to direct attention elsewhere than becoming involved in own environment. In the NL there are also awful clients, posters, corporations, though it is true to it easier to build on the foundation laid by the great ones. I guess the difference is like playing football (soccer) in Real Madrid as opposed to some smaller provincial team. It is easier to play in a good team. Similarly, having the support of the design institutions, relatively prosperous economy, being able to receive grants and subsidies for non-market oriented project yields its results. The Dutch feature which is probably connected to this, (other than the often stereotyped tolerance, openness, etc.) is their perverse need to be criticised. Design became one of the tools for this criticism, and the fact that it keep receiving generous funding is both astonishing as well as admirable. But it seems that in long term the support of design pays off.

It was his achievements as a designer, though, as well as his experience as a teacher, that made the Jan van Eyck venture possible. Van Toorn has often remarked that he wanted to approach communication design as a form of visual journalism. In other words, the designer could function as a kind of reporter—investigating, reflecting, editing, shaping, and delivering his findings in the form of a visual outcome. He spoke of his wish to use design as a way to "argue with visual means." If you compare the publications and posters Van Toorn produced in the late 1960s and 1970s with typical approaches today, his deliberately dissonant work can look astonishingly direct and uncompromising. This was, of course, a period of loosening and liberalization when every kind of social convention was being challenged, and matters of politics and ideology were central concerns for many people within Western societies. For a short, heady spell in the 1960s, revolution was in the air and to a designer with Van Toorn's inclinations it must have seemed entirely natural to bring this spirit of social questioning into the "laboratory situation"—as he called it—of his own work.

Consider, for instance, his series of calendars for the printing house Mart Spruijt. This kind of calendar is produced as a promotional item

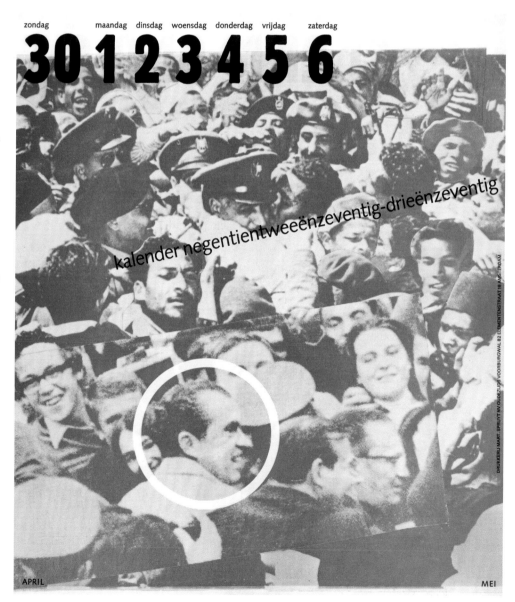

RIGHT Cover of the 1972/73 "People calendar" for Mart. Spruijt. Designed by Jan van Toorn.

because the company hopes it will act as a reminder to use its services. Anyone who put Mart Spruijt's 1972–73 calendar on the wall would have been reminded, every week of the year, of the complex, contradictory, troubled nature of the contemporary world. Van Toorn's calendar showed black and white portraits of women shoppers in an Amsterdam street market, color photos of women in bras and corsets from underwear catalogs (an ironic feminist commentary), and references to the war in Vietnam. There was a recurrent emphasis in his work on the ordinary—on everyday situations and the experiences of real people—as well as allusions to the political realm. A poster insert for a PTT Dutch post and telecommunications company report presented an informal, entirely unglamorous montage of postal workers. It couldn't be further from the kind of glossy PR shots used so often in company literature since then. A cover design for *Museumjournaal* in 1979 confronted curators and scholars with a photograph of seven chubby, naked men chatting in a shower. Another *Museumjournaal* cover, which would be unimaginable in institutional publishing in the United States or Britain, showed a man's horribly mutilated naked body laid out on some wooden planks. This was an astringent visual sensibility that refused to flinch from even the least pleasant aspects of human experience and required the viewer, as a moral imperative, to see.

Some of these communications are not without humor, but, like Van Toorn himself, they are utterly serious and purposeful. What they embody, above all, is an idea about citizenship. Their unapologetic realism is underpinned by a deep strain of social idealism. They address viewers not as consumers with tiny attention spans who must be perpetually entertained and flattered if they are not to grow bored, but as critical, thinking individuals who can be expected to take an informed and skeptical interest in the circumstances of their world. Even in the 1970s, this was a very strict demand to make of design practice, but by the 1980s, with Reaganomics, Thatcherism, the rise of

neo-liberalism, and the doctrine of the free market, it was becoming much harder to function as a designer in this way. Van Toorn continued to produce some challenging work, such as his series of posters for the De Beyerd art center, but he found fewer opportunities for the kind of critical practice at which he excelled. Design, as he often noted, was increasingly part of the problem. As he told *Eye* in the early 1990s: "Everything is possible, you can quote everything, you can use every style, but where are the arguments that are really contributing to a fundamental change in our social conditions?" Becoming director of the Jan van Eyck Academie was one way of helping to encourage young designers to examine this question for themselves.

In 2004, we confront essentially the same question: where, in visual communication, are the arguments that are contributing to a fundamental change in our social conditions? To make such arguments, you must first believe that social conditions require change, and you must possess a clear sense of the kinds of change that are necessary and possible. But, despite the global crisis caused by terrorism and our responses to it, these are less certain, less politically motivated times in the wealthy nations, and designers, as a social group, share much the same disengaged outlook as other similarly educated people. In recent years, I have heard few designers express the sort of concerns and convictions that motivated Van Toorn's generation. Nevertheless, the example of his long career is hugely inspiring and the Kunsthal exhibition (until June 20), curated by Els Kuijpers, provides a valuable opportunity to reconsider the possibilities of engaged design. (It may be shown later in the United States at the Rhode Island School of Design, where Van Toorn has been a visiting teacher for fifteen years.) There is every reason to hope that young designers encountering this exceptional body of work for the first time will emerge asking tough questions about the way things are now, and wondering what they, as visual communicators, might be able to do about it.

ORIGINALLY PUBLISHED
04.16.14

COMMENTS
1

Francisco Laranjo
Critical Graphic Design: Critical of What?

Critical graphic design is a vague and subjective term. The meaning of the word "critical" in relation to graphic design remains unclear, resulting in an overuse and misuse in design magazines, books, and websites. The term was popularized by the much-cited traveling exhibition *Forms of Inquiry: The Architecture of Critical Graphic Design* first shown in 2007, and by the Dutch design studio Metahaven, among others. Yet, the ambiguous criteria used by the *Forms of Inquiry* curators to support the term, and designers' struggle to match the ambitions of their political, social, and cultural research with its visual output, indicate a continuing need for critical discussion of critical graphic design.

In recent years, however, there has been disenchantment and even skepticism toward graphic design work that is labeled as *critical*. If we look for critical graphic design online, the first search result is an open-submission Critical Graphic Design Tumblr predominantly filled with humorous responses to design work, designers, publications, and institutions generally associated with the term. Here, we can listen to the designer Michael Oswell's satirical electro track, "The Critical Graphic Design Song," absurdly repeating the names of designer Zak Kyes (cocurator of *Forms of Inquiry*) and Radim Peško, whose typefaces Kyes often uses in his work. Also mentioned is the popular blog *Manystuff*, which disseminates many works commonly described as critical, though its press-release style of presentation is inherently celebratory and uncritical. The tendency to gather and repeat familiar names shapes an echoing, self-referential canon that is automatically self-validated.

An updated post-financial crisis cover created for Adrian Shaughnessy's book *How to Be a Graphic Designer without Losing Your Soul* suggests that criticality is a luxury in the current conditions under which graphic design is produced. Other works include parody photos of Metahaven's three-dimensional representation of Sealand, and images that imitate the visual styles of some of the most celebrated critical designers and academic institutions—Yale is often mentioned. These references seem to have three different goals: (1) to provoke the "critical graphic design" clique exemplified by the participants in *Forms of Inquiry* and the recent exhibition *All Possible Futures*; (2) to express disappointment toward traditional forums for public debate and legitimation—essays, lecture series, publications, and academia; and (3) to challenge the shallow and predictable stylistic approaches used by designers to address critical issues. As the nonsensical critiques, literal illustrations, and animated GIFs appear on the screen, they raise some pertinent questions about critical graphic design: What does this poster or image add to the issues at stake? Where is the critique? How does it contribute to written modes of research? What are the criteria and who makes these decisions?

Francisco
Laranjo

Critical Graphic Design:
Critical of What?

Critical
Commentary

**Culture Is Not
Always Popular**

25

This is not revealed on the Critical Graphic Design Tumblr, nor does there seem to be any intention with most of these responses to construct a coherent argument. Despite their popularity online, these critiques of criticality also remain largely unquestioned. Are these hacks really contributing to a better understanding and questioning of these undebated trends? Or are they merely tickling the clique they intend to provoke? Are LOLZ enough? Can jokes bring down (supposedly) critical design projects? Most of the submissions online reveal an ironic suspicion toward critical design and this attitude will presumably be reflected in the critics' own practice, as they try to avoid doing what they criticize. A clarification of what is meant by "critical" may provide some answers.

In the book *The Reader*, the design researcher Ramia Mazé suggests three possible forms of criticality in design. The first has to do with a critical attitude toward a designer's own practice. The designer makes an effort to be self-aware or reflexive about what he or she does and why. Mazé argues that this can be understood as a kind of internal questioning and a way of designers positioning themselves within their practice. The second form is the "building of a meta-level or disciplinary discourse." This involves what Mazé calls, "criticality within a community of practice or discipline," and trying to challenge or change traditions and paradigms. Designers are critical of their discipline while actively and consciously working toward its expansion and evolution. In the third kind of criticality, designers address pressing issues in society. The critique is not targeted at a designer's own discipline, practice, or even at design in general, but at social and political phenomena. In practice, the three modes of criticality often overlap, intersect, and influence each other.

Mazé's categorization is not new. A direct connection can be made with the Dutch designer Jan van Toorn's view on design pedagogy. As a design educator, Van Toorn tried to raise awareness of the tension between private and public interests. In *User-Centred Graphic Design*, he argues that the "student must learn to make choices and to act without attempting to avoid the tensions between individual freedom, disciplinary discourse and public interest." This assertion of the personal, disciplinary, and public levels that a designer

should always consider anticipates Mazé's three forms of criticality.

Two influential European design schools focus on the development of critical design practice. The Werkplaats Typografie (WT), founded in 1998 by the Dutch designers Karel Martens and Wigger Bierma, bases its educational model on a modernist form of reflexive practice, following the idea of the "workshop" developed by the English typographer Anthony Froshaug and designer Norman Potter. The WT normally concentrates on typography as a point of departure in assignments set either by the school, external clients, or the students; these usually take the form of publications. The WT's type of criticality falls between the first and second definitions put forward by Mazé.

The other Dutch design school with a strong critical orientation is the Sandberg Institute, which emphasizes the third type of criticality. Its design department presents itself as a "think tank for visual strategies," with students seeking critical reflection and engagement through work that explores design's role and potential in relation to public and political issues and public discourse. Some examples of this are Femke Herregraven's *Taxodus*, Ruben Pater's *Drone Survival Guide*, Noortje van Eekelen's *The Spectacle of the Tragedy*, Belle Phromchanya's *The Rise of the Moon*, and Simone C. Niquille's *Realface Glamouflage*.

Despite the rejection of the label "critical graphic design," most notably by the designers Stuart Bailey (in *Dot Dot Dot* no. 20, 2010) and James Goggin (in *Most Beautiful Swiss Books*), the term is still relevant. It emerged at a time when the discipline was in a generally uncritical state, providing a necessary distinction from routine practice and awarding a kind of merit badge to designers or studios who deviated from the norm. For designers who scorn the label, criticality in its many forms is intrinsic to graphic design and therefore a special term is unnecessary and redundant.

The term also highlights an important transition in graphic design practice and education: from the designer as author to the designer as researcher. This is not only a consequence of the maturation of the discipline, seeking legitimacy to be used as an investigative tool, but also the result of an increased importance of the social sciences and humanities

and their multiple research methods being applied, changed, and appropriated by design education and designers. On the one hand, graphic design aims to use its own processes and production methods to contribute new knowledge to the areas it works in. On the other, the absorption of ethnography and data collection methods shows an increasing reliance on other disciplines' methodologies. The widespread presence of "design research" in design's lexicon is a sign of these developments, despite recurrent confusion as to what constitutes research in graphic design.

In the age of *Behance*, of earning badges and appreciations, when one of the most used words in the site's feedback circle is "awesome" and likes and followers are easily bought, graphic design has another opportunity to reexamine its apparently incurable allergy to criticism. Within interaction design, speculative and critical design is now being openly questioned and critical design projects' political accountability and relevance to society is being debated.

As a term, critical graphic design will probably be replaced in the permanent rush to coin the next sound bite. Criticality in graphic design will surely continue to be a topic for discussion, but a design work is not instantly critical just because of the intentions of the designer, or the pressing issue being researched. A talk, song, scarf, flag, web meme, website, installation, or publication may all be valid ways to pose a critique. However, it's time to publicly discuss the means, effects, and especially the quality of the critical design projects, not just to celebrate and retweet them. If that doesn't happen, critical graphic design runs the risk of not being as substantial and meaningful as it could be. Or worse, it will become irrelevant to society. For a discipline that aims to contribute to public debate—let alone social and political change—that would be a disastrously wasted opportunity.

Francisco
Laranjo

Critical Graphic Design:
Critical of What?

Critical
Commentary

**Culture Is Not
Always Popular**

27

ORIGINALLY PUBLISHED
09.02.08

COMMENTS
11

Thomas de Monchaux
Remembering Yves Saint Laurent

What does it mean to design? What does it mean to have been designed? In one sense, the word is entirely superfluous: every artifact of human invention, assembly, adaption, or production, from cathedral to coffee cup, has by definition been designed. Within the discourse of designers, the less obviously an object is the result of willful styling or shaping—the less apparently it has been designed by a designer—the more likely it is to be celebrated as a design icon. Thus Anglepoise trumps Tizio. But this timeless authorlessness leaves us at a loss.

So perhaps a better way to answer the question is from the outside in. If one were to contemplate (brace yourself) which artifacts made more people most aware of the fact of those artifacts having been designed by designers, the answer would be not cities or buildings or furniture or graphics. But surely: clothes. To say "designer," now more than ever in this age of mass class, of media popularization of couture culture, (of America's Next Top Project Model Runway Stylista), is to say "fashion designer." So what can we learn from the presence of fashion within design, and of design within fashion? For example, and more precisely, what can we learn from the work of Yves Saint Laurent, the iconic French fashion designer who passed away this summer?

The trajectory of Saint Laurent's career is well-known. At eighteen, a dress design competition paved the way to an internship with Christian Dior; at twenty-one, Dior's death enabled (and required) Saint Laurent's legendarily acclaimed first collection. That critical triumph launched a lifelong career in haute couture, and (with the introduction in the late '60s of his Rive Gauche label), in the ready-to-wear clothes that did much to establish his legend as an elite populist (and even feminist). His personal affect and sensibility itself framed a kind of template for the persona of the contemporary designer, from Lagerfeld and Jacobs to Libeskind and Diller: a steely frailty, a glittering melancholy, a self-effacing grandeur.

But from that trajectory we can also extract three themes that perhaps transcend the cryptically overdetermined self-referentiality of fashion, and tell us something about design, and what happens when it's unleashed into the world.

* * *

History has always worn clothes: the latest ladies' styles from France, among other things, changed significantly between 1789 and 1812 (less fabric, better posture). But today we're accustomed to the idea that what is stylish in clothes changes every six months or six minutes. The idea is that a sequence of formal transformations both reflects and shapes more intangible shifts in the zeitgeist. Hemlines go down when the stock market plunges, says the legend. More generally, in the tropes of design history consolidated by the latter nineteenth

century and self-consciously enacted there-after, different times and technologies call for different formal languages, from gothic and classical to grunge and mod. It's debat-able whether this is a democratically organic process (wherein the word on the street filters up to the atelier), or a calculating capitalist process of planned obsolescence. Or, natu-rally, both. What seems to distinguish Saint Laurent's work within this theme is that his collections between the mid-60s and mid-70s cemented, if not invented, this phenomenon that we now take for granted: that like clock-work each season we encounter the new new. In Dior's "New Look" of 1947, a suddenly narrow-waisted, low-hemlined dress spoke to the transformation from war to post-war. But Saint Laurent's work especially transformed this singular moment of metamorphosis into a constant recurrence. Timeless timeliness.

More particularly, in Saint Laurent's work, while this change was in part one of fabric and visual reference, it was most significantly one of geometry, of form, of shape, of profile. That first post-Dior collection essayed a sort of trian-gular dress silhouette, followed by something linear, then by something convex, and on and on. One quality that ostensibly distinguishes "designing" from its sister "styling," as modes of applying form to objects, is the seeming constancy of the former, and the seeming changeability of the latter. A good design solution is a good design solution, goes the argument, regardless of the calendar or clock. But as for style, what's lively in April is deadly in September.

Nothing emphasizes the constant qualities of a particular designer's hand or eye more than the continual formal changes in his or her output. Authorship isn't in what changes, but in what doesn't. If the general geometry is always in flux, then we're drawn ever more closely to the details, decisions, and doodads that stay the same. And the idea, perhaps, of where the quality of designed-ness is to be located in an object becomes ever more closely associated with this finer grain: the way a seam is rolled, a corner turned, a detail positioned. The more inconstant the sequence of forms seems to be, the more the work seems to be shaped by some authorless in-the-air trend, then the more visible this other form of constancy, and of authorship, becomes. While it's common-place, especially in fashion, to imagine that the only thing constant is change, Saint Laurent's work suggests that the only thing constant, surprisingly, is constancy.

* * *

The quality of timelessness in Saint Laurent's work is closely associated with his exercises in type. His collections of the 1960s and '70s appropriated the forms and details of certain archetypical garments from, it seemed, beyond the seasonal whims of the fashion system. Thus the safari jacket, the navy peacoat, the black dress, the Bogart trench coat, the tuxedo. Each of these would be thematized into a sequence of erudite remixes. In 1966, for example, Saint Laurent's spring collection recalled a man's tuxedo suit or dinner jacket ensemble, transgendering it into "Le Smok-ing," a slinky feminine commentary. Which is, common wisdom holds, the origin of today's ubiquitous (and recently politically significant) women's pantsuit. That very same year saw the original publication of Robert Venturi's Complexity and Contradiction in Architecture, which essayed the same erudite exercise of cataloging, appropriating, and cleverly mutat-ing a populist/elitist historical canon.

In the 1980s and '90s, Saint Laurent's later work (sometimes suggestively called his "classical" period), saw a further layer of cross-referencing and cross-dressing. Saint Laurent re-appropriated and re-remixed his own appropriations and remixes, so a smoking jacket becomes a commentary on a commentary on a smoking jacket—creating a mannered set of references that, as much as Venturi's clever pastiches, describes whatever we mean by that interesting word, "postmodern." Conversely, the very garments that were the formal foundation for these transformations were chosen, perhaps, because of their universality and uniformity— qualities, associated with, among other things, the notion of modernism in design.

* * *

One trope of modernism in design is an interest in structure, and in the relationship be-tween how something looks, and how it holds itself together. Tectonics in architecture be-comes, perhaps, tailoring in clothes. Highly tai-lored and structured fashion artifacts, such as the Chanel suit jacket, or the very corset from which Chanel was said to have liberated those jacket-wearers, have a shape and structure

independent of their wearers. But for clothes especially, structure is site: the bones are the body. The specific transformation that Saint Laurent applied to that tuxedo was to make it more structurally dependent on the body of the wearer: to locate sites of adherence and movement between fabric and skin that retained something of the original independent profile of a men's suit, but introduced a loose, tight, and dynamic codependence between how the clothes stand up, and how the clothes make us stand. This participation of the body in the structure and performance of the object points to larger ideas: the design of an object doesn't stop at its physical boundary. This is not news to people who think about the ergonomics of chairs and can openers. But it's a tonic to an all-too-common way of looking at designed artifacts as isolated phenomena, rather than as sites of mysterious and intimately anonymous collaborations between maker and user.

To these themes we should add a footnote. On the eve of the upcoming September Fashion Weeks that mark the true beginning of the year, it's worth remembering this: perhaps the most invisible but lasting contribution of Saint Laurent's to the intersections between design, architecture, and fashion was his adoption, along with other designers in the mid-1970s, of the raised runway. Elevating the display of clothes a meter or so above the floor is a gesture we now take for granted, but that redirecting of our gaze changed fashion by changing the way we look at fashion. This slight spatial isolation made it all the more photographable, spectacular, theatrical, and visible. And has something to do with the way that the word, "fashion," now hovers like an elegant ghost, always already before the word, "designer."

ORIGINALLY PUBLISHED
03.23.17

COMMENTS
3

Louise Sandhaus

Her Story Meets His Story: Janet Bennett, Charles Kratka, and the LAX Murals

This is the story of the tiled murals that traverse the long, long, long corridors of Terminals 3, 4, and 6 at Los Angeles International Airport (LAX). The ones that if you haven't seen in person, you've probably witnessed being featured as an iconic LA landmark in the AMC series Madmen, blog postings, or films such as *Point Blank*, *The Graduate*, and *Airplane!* This isn't the typical design story we hear about. This is the story of a woman. And it's a story about who gets credit for large-scale design projects. And of who remembers what and of what gets published and what becomes history. And, perhaps, this is a story not just of a woman, but of women and when their contributions weren't always considered worth mentioning.

In any case, this story is complicated.

Let's begin at the beginning, or rather my own beginning with this story. In 2014, I published a book, *Earthquakes, Mudslides, Fires and Riots: California and Graphic Design 1936–1986*. The book covered the known, the unknown, the sometimes forgotten, and the sometimes unacknowledged graphic design work created in what was considered at the time backwater—a.k.a California. The book was a glimpse of what might characterize these California graphic contributions, ranging from the iconic Day-Glowing *Endless Summer* film poster by John Van Hamersveld to an unrecognized graphic masterpiece for ABC's 1964 to 1965 fall promo by John Urie and Associates as well as

games titles by David Theurer, a genre uncategorized as graphic design. And I devoted an entire quarter of the book to women designers of both familiar and unfamiliar stripes. It was by no means a complete record. And it was by no means perfect.

Included in the book somewhere amidst the known, unknown, or quasiknown works were the mosaic tile murals created for LAX in 1961 and credited to Charles Kratka. The acknowledgement of Kratka as designer of this project wasn't mine alone and the attribution is so long-standing that it had been difficult to trace its origins. But Ethel Pattison (an airport information specialist for the city of Los Angeles who has been cataloging the LAX archives), Kratka's own daughter, and Kratka's *Los Angeles Times* 2007 obituary acknowledged him as the designer of those magnificent geometric compositions that originally lined the five tunnels (of which only three remain).

After the book came out, I received an email from Janet Bennett, claiming to have designed those murals. She claimed that she designed them while working for Kratka, who was her supervisor and head of interiors at Pereira and Luckman (the architectural office responsible for the design of Los Angeles International Airport). She asked me to help establish her as the credited designer of the murals. Believing that somewhere in an archive or record there is likely documentation that irrefutably proves she provided the artistic vision, I was then

Louise
Sandhaus

Her Story Meets His Story:
Janet Bennett, Charles Kratka,
and the LAX Murals

Critical
Commentary

**Culture Is Not
Always Popular**

31

ABOVE The tiled murals at Terminals 3, 4, and 6 at Los Angeles International Airport.

confronted with the myriad of challenges of establishing legitimate histories by ensuring the factual ducks line up.

Finding the considerable time to identify archives that might give credence and then to search them was the first of the hurdles. (Not everything is on the Internet.) Although I discovered some project credits as I traveled back along the road of history, it wasn't customary until more recently to credit a litany of contributors. For example, Saul Bass always received credit for whatever was done in his office, as we saw in Sean Adams's posting on Phyllis Tanner. Were women designers specifically overlooked? Likely, she wasn't specifically overlooked, but that "underlings" weren't acknowledged. There is also the issue of publishing, which is a primary means of establishing the historical record. Unless the project got the attention of the press and can be located today (often difficult because of the lack of digital indexes), proof becomes elusive. Wikipedia, for instance, only accepts entries authenticated by printed publications.

Here's what I know about Bennett and why I believe she did the murals: She tells me her story and, where facts are reasonably at hand, I've been able to confirm them in essential generalities. But probably more significantly, Gere Kavanaugh, a 2016 AIGA medalist, vividly recalls Bennett doing the murals. I was also

able to find an article that appeared in the *Argus* newspaper in 1971 that shows Bennett in front of a mural she designed for BART that includes tiles and a similar geometric abstraction to that of the LAX murals.

According to Janet, she studied sculpture at Cranbrook in the late 1940s and then worked for Victor Gruen and Associates (known as the "father of the shopping mall") in Detroit. It was at Gruen that she seemed to have gained experience with large environmental design projects. As she recalls, "I was sort of an art director designing art for the [Eastland Shopping Mall]. A dream job for a girl in her 20s." She landed in Los Angeles after spending a few months touring the West Coast, and decided to stay. Eventually she was hired at Pereira and Luckman, which was known for prestigious, large-scale architectural projects such as CBS Television City (1952) and the more moderately scaled Disneyland Hotel (1958), and which had been contracted to design LAX.

At Pereira and Luckman, Bennett worked on a number of projects. Recollecting her experience, "To a young artist-designer, the days... were a wonderful and creative time. I seemed to have all the time and freedom in the world to design major art features for the new airport. Looking back on it now, it seems like play." The murals were one of a number of projects she recalls designing for the airport, although

the only one realized. She described how the mosaic murals were meant to provide pleasurable distraction for someone venturing down the tunnels, an idea that came after the original plan of moving sidewalks was scrapped. She "settled upon the experience of flying from ocean to ocean to be the theme as expressed in color and lineal shapes on one entire wall of each tunnel." (Alfonso Pardiñas likely did the exquisite Byzantine mosaic tile work—yet another overlooked but considerable artistic contribution.)

When the terminals were revealed in 1961 and the murals were made public, Bennett was no longer around and didn't attend the unveiling.

Thus, her level of contribution has been even more elusive to trace in history's records.

Bennett's story is not uncommon. But this Women's History Month, the amount of media attention Bennett has received for her uncredited role in creating an iconic Los Angeles backdrop for many TV and film projects has shone a light into the hidden stories of female artists and professionals. Janet Bennett and her story deserve a moment in the graphic design sun. Let them shine.

Louise
Sandhaus

Her Story Meets His Story:
Janet Bennett, Charles Kratka,
and the LAX Murals

Critical
Commentary

**Culture Is Not
Always Popular**

33

Rick Poynor
Did We Ever Stop Being Postmodern?

ORIGINALLY PUBLISHED
10.16.11

COMMENTS
14

The exhibition about postmodernism and design now running at the Victoria and Albert Museum in London ends with a defiant assertion: "like it or not we are all postmodern now." And before Postmodernism: Style and Subversion, 1970–1990 had even opened at the end of September, the novelist and critic Hari Kunzru concluded a preview essay with much the same kind of observation: "We have lived through the end of postmodernism and the dawning of postmodernity."

Do you think of yourself that way—as a postmodern person? Most probably you don't. Postmodernism may have dominated the academy for more than a decade, but it was never a term that commanded much public understanding, let alone affection. I have a file full of semibaffled think pieces published in the British press in the 1980s in an attempt to explain what this then fashionable buzzword was all about. The day the exhibition opened, the *Observer* newspaper dispatched its man to the V&A to find out "exactly what po-mo means." Claiming to have discovered only a mood of "preemptive ennui" and puzzlement among the exhibition's early visitors, he filed his report apparently none the wiser.

It certainly doesn't help that even postmodernism's proponents, who tended to be theorists rather than artists or designers, were always at pains to say how slippery the concept was, and hard to define. The exhibition's curators, Glenn Adamson and Jane Pavitt, offer the same

disclaimer in their foreword to the exhibition catalogue: "the reader will not find anywhere in this book, or the exhibition it accompanies, a single handy definition of postmodernism." That doesn't mean that the book and (in a necessarily simpler way) the show avoid the issue—they offer many rewarding perspectives on the subject. But any attempt to reduce such an intricate set of cultural factors across so many kinds of art, design, and media to a brief, all-encompassing definition would be a misrepresentation. We like to think we are complex people living in a complex world. So why would we expect an explanation of our many-layered culture to be easy?

The added complication is the entirely valid distinction that Kunzru draws between postmodernism as a movement in the arts and postmodernity as an epoch with implications for every area of culture and society. Postmodernism in the stylistic sense might be over as movement, though there was no unitary postmodern style, but postmodernity is arguably still our cultural condition, as Adamson and Pavitt also imply. This divide was always going to be a tricky issue for the curators to negotiate and they make it clear from the outset that their subject is "postmodernism rather than postmodernity in general—that is a set of intentional design strategies, not the overarching condition that made them possible." One probable reason for this decision is that postmodernity is simply too complicated to reference and explain in short introductory wall texts, which

34 **Culture Is Not
Always Popular**
 Critical
 Commentary
 Did We Ever Stop
 Being Postmodern?
 Rick
 Poynor

The fact that all the particularly "postmodern" features of literature and art were already embedded in the most archetypically modern artists (Joyce, Picasso, Wright?) makes me doubtful how significant the rift really is across forms. I think many of the things generally singled out as the particularly postmodern qualities of our current culture are in fact very old. Irony is not new. Allusion is ancient. Stylistic hybridity is unavoidable.

Perhaps architects in the early 20th century were the most stubbornly headstrong about their originality; but I think the New Critics misrepresented the work of their contemporary moderns in a manner equivalent to the way many modern architects misrepresented their own work—if we admit that "pure form" and "timelessness" are basically nonsensical, which we ought to, then their architecture could not be justified in the terms they often gave for it. However, if you think that it still has architectural merit and formal interest then the question becomes, what are the terms? I suspect they're not dissimilar than those of their successors. The question then seems to me, Did we ever stop being modern?

Jameson has been able to make plausible arguments for a significant change in culture in political-economic terms but I have never found efforts to characterize equivalent changes in stylistic or formal terms that didn't grossly overestimate the novelty of current productions.

would have to be loaded with great gobbets of Jameson and Lyotard. Large-scale exhibitions in public museums must always strike a balance between doing a subject adequate intellectual justice and appealing to ordinary visitors who are likely to know little or nothing about the theme.

For visitors of a certain age—my teens and twenties fell within the exhibition's time span—walking around *Postmodernism* is like seeing key signposts in your early cultural life flash before your eyes, though not necessarily in the original order. It's entirely fitting that architecture, one of the strongest and most compelling sections, comes first (there's a terrific room devoted to Venturi and Scott Brown in Las Vegas), but for many visitors it will be pop and rock music, album covers and videos, that first signaled the postmodern "turn." In 1978, I tuned into the retro-constructivist references on the cover of Kraftwerk's *The Man Machine*, the mournful yet oddly exhilarating sense that some version of the future had already occurred, several years before I knew that such a thing as postmodern architecture existed.

A room titled "Strike a Pose"—surely there was more to it than that self-loving line from Madonna implies?—has big screens with performances by Grace Jones (magisterial), David Byrne in his *Big Suit* ("If postmodernism means anything is allowed, then I was all for it"); and an operatic Klaus Nomi sporting black lipstick, a triangular jacket, and pointy po-mo hair. With one eye on sardonic Weimar cabaret and the other on the polymorphous future, Nomi carries off this identity experiment with fabulous assurance; he would have looked right at home lounging in a Memphis living room decorated with George Sowden's all-over black-and-white patterns (though the Memphis section of *Postmodernism* is one point where the curatorial balance seems skewed: there is just too much of it). Back on the video screens there are clips of Kraftwerk, Devo in red "energy dome" hats, Visage (how good "Fade to Grey" still sounds), and Laurie Anderson's monumentally haunting "O Superman."

If this seems like a lot of emphasis on pop music, then I should report that the V&A has released a CD and DVD set to accompany the show, with key tracks from the 1980s and sleeve notes by Adamson, who cautions us against nostalgia—sure!—while proving to be no slouch in the pop crit department. The

curators even use New Order's "Bizarre Love Triangle" music video—"Why can't we be ourselves like we were yesterday?"—at the end as a kind of melancholy, upbeat finale.

Most of the graphic work in the exhibition is gathered in a section titled "Style Wars." This is the aspect of postmodern design I know best and I was one of the advisers consulted early in the process at a study day at the V&A. I also lent some pieces to the show so I can't claim detachment here. As with the music, I encountered many of these designs as they appeared, and any understanding I have is strongly tinted by experiencing firsthand how their stylistic codes communicated at the time. The curators zeroed in on work by Wolfgang Weingart, April Greiman, Emigre, Ed Fella, Paula Scher, Johanna Drucker, Barney Bubbles, Peter Saville, Neville Brody, Malcolm Garrett, and Vaughan Oliver, drawing attention to its bricolage, fragmentation, and use of quotation, while arguing that it seamlessly blends avant-garde influences with the commercial sphere. However, few of these record covers, posters, and magazines are very commercial and their audiences, though still consumers, tended to share the work's ambivalence. Postmodernism was, nevertheless, an integral expression of the late-capitalist economy and the show progresses with inexorable (if depressing) cultural logic toward a section titled "Money."

Little is said about how the graphic pieces were seen in their day as such a controversial departure from the discipline's norms—older designers still loyal to a romantic but outmoded idea of modernism often voiced an almost visceral hatred of these innovations. What do visitors make of these once troubling experiments now? On my third visit, I saw a man on his own looking at Barney Bubbles's cover for *Music for Pleasure* by The Damned. "Oh, wow, that is so cool," he sighed out loud, forgetting himself. A friend told me they had seen someone making a careful drawing of a magazine I had lent. A copy of *New Socialist* magazine with a cover by Brody has been commodified as a T-shirt in the V&A's shop apparently with the designer's approval—postmodern irony in action. I suspect that the graphic exhibits, like other parts of the show, are ripe for postmodern plunder by a new Gaga generation of viewers who will savor these artifacts not in terms of cultural ideas that were absorbed long ago, but as a cookie jar of exciting retro styles that can be dipped into at will because that's the

Rick
Poynor

Did We Ever Stop
Being Postmodern?

Critical
Commentary

**Culture Is Not
Always Popular**

35

kind of sampling and mashing up we do now as a matter of course.

There is a view of postmodernism—Kunzru expresses it in his essay and the show appears to endorse it by ending in 1990—that it is essentially a predigital phenomenon. Concentrating on postmodernism as temporal style rather than postmodernity as a condition that persists makes it easier to sustain this argument, but developments in 1980s postmodern graphic design undermine the thesis. April Greiman and the designers at *Emigre*, Rudy VanderLans and Zuzana Licko, embraced the Macintosh in 1984 as soon as it appeared (as work in the show demonstrates), seeing its possibilities not only for increased control of production but as a tool for generating new kinds of visual communication. As processing power increased in the early 1990s, these experiments became more ambitious and complex and this was the period when postmodern ideas about communication were most intensely debated. In those years, the American designer Jeffery Keedy, who isn't included in the exhibition, was one of postmodernism's most vigorous and polemical champions, and a scourge of "zombie modernists" who, in his view, continued to think and design as though postmodernism hadn't happened.

Is this the moment to try to rethink or reclaim postmodernism? The movement still arouses a surprising amount of disdain, as though it had been entirely indulgent, frivolous, wasteful, aesthetically misconceived, and unnecessary. I confess myself to feeling close to disgust looking at the Alessi tea and coffee services designed by superstar architects—less for the overworked form than for the total vacuity of these over-gilded status symbols. The postmodernism that still seems rich, valuable, and durable can be seen in some of the examples I have mentioned, or in the exhibition's adroitly chosen film clips from *Blade Runner* and Godfrey Reggio's *Koyaanisqatsi*, which portray the city as a sublime illuminated matrix of beauty and terror. The curators' concluding observation that postmodernism was "marked by a sense of loss, even destructiveness, but also a radical expansion of possibilities," feels right to me. At the end of a grim century, we had lost our illusions, our faith in scientific progress, and our belief in the shaping power of "grand narratives." Yet we continue to benefit from and to explore postmodernism's expanded cultural terrain.

Could it be, then, that postmodernism's most basic problem in terms of public perception is the conundrum presented by its name? David Byrne touches on this in a postscript to the exhibition catalogue. "Postmodernism" announces what it isn't, but it doesn't tell you what it is, and what the word appears to say isn't the whole story anyway because, as many theorists have noted, elements of modernism continue within the postmodern. The image it conjures is too negative, while modernism still sounds optimistic and farseeing, like a cause you could join. No one wants to feel like the superfluous inhabitant of an aftermath. It's comforting to believe we are post-postmodernism. But in a digital world, postmodernity has become everyone's inescapable reality—"like it or not." The V&A's show and book are vital investigations of how we arrived here and the part played by design in the journey.

ORIGINALLY PUBLISHED
11.03.08

COMMENTS
59

Andrew Blauvelt
Toward Relational Design

Is there an overarching philosophy that can connect projects from such diverse fields as architecture, graphic design, and product design? Or are we beyond such pronouncements? Should we even expect such grand narratives anymore?

I've spent more time in the field of graphic design, and within that one discipline it is extremely difficult to pinpoint coherent sets of ideas or beliefs guiding recent work—certainly nothing as definitive as in previous decades, whether the mannerisms of so-called grunge typography, the gloss of a term such as postmodernism, or even the reactionary label of neo-modernism. After looking at a variety of projects across the design fields and lecturing on the topic, new patterns do emerge. Some of the most interesting work today is not reducible to the same polemic of form and counter-form, action and reaction, which has become the predictable basis for most on-going debates for decades. Instead, we are in the midst of a much larger paradigm shift across all design disciplines, one that is uneven in its development, but is potentially more transformative than previous isms, or microhistoric trends, would indicate. More specifically, I believe we are in the third major phase of modern design history: an era of relationally-based, contextually-specific design.

The first phase of modern design, born in the early twentieth century, was a search for a language of form that was plastic or mutable, a visual syntax that could be learned and thus disseminated rationally and potentially universally. This phase witnessed a succession of isms—suprematism, futurism, constructivism, neoplasticism, and so on—that inevitably fused the notion of an avant-garde as synonymous with formal innovation itself. Indeed, it is this inheritance of modernism that allows us to speak of a "visual language" of design at all. The values of simplification, reduction, and essentialism determine the direction of most abstract, formal design languages. One can trace this evolution from the early Russian constructivists' belief in a universal language of form that could transcend class and social differences (literate versus oral culture) to the abstracted logotypes of the 1960s and 1970s that could help bridge the cultural divides of transnational corporations: from El Lissitzky's *Beat the Whites with the Red Wedge* poster to the perfect union of syntactic and semantic form in Target's bull's-eye logo.

The second wave of design, born in the 1960s, focused on design's meaning-making potential, its symbolic value, its semantic dimension and narrative potential, and thus was preoccupied with its essential content. This wave continued in different ways for several decades, reaching its apogee in graphic design in the 1980s and early 1990s, with the ultimate claim of "authorship" by designers (i.e., controlling content and thus form), and in theories about product semantics, which sought to embody in their forms the functional and cultural symbol-

Andrew
Blauvelt

Toward Relational
Design

Critical
Commentary

**Culture Is Not
Always Popular**

37

ism of objects and their forms. Architects such as Robert Venturi, Denise Scott Brown, and Steven Izenour's famous content analysis of the vernacular commercial strip of Las Vegas or the meaning-making exercises of the design work coming out of Cranbrook Academy of Art in the 1980s are emblematic. Importantly, in this phase of design, the making of meaning was still located with the designer, although much discussion took place about a reader's multiple interpretations. In the end though, meaning was still a gift presented by designers-as-authors to their audiences. If in the first phase form begets form, then in this second phase, injecting content into the equation produced new forms. Or, as philosopher Henri Lefebvre once wrote, "Surely there comes a moment when formalism is exhausted, when only a new injection of content into form can destroy it and so open up the way to innovation." To paraphrase Lefebvre, only a new injection of context into the form-content equation can destroy it, thus opening new paths to innovation.

The third wave of design began in the mid-1990s and explores design's performative dimension: its effects on users, its pragmatic and programmatic constraints, its rhetorical impact, and its ability to facilitate social interactions. Like many things that emerged in the 1990s, it was tightly linked to digital technologies, even inspired by its metaphors (*e.g.*, social networking, open source collaboration, interactivity), but not limited only to the world of zeros and ones. This phase both follows and departs from twentieth-century experiments in form and content, which have traditionally defined the spheres of avant-garde practice. However, the new practices of relational design include performative, pragmatic, programmatic, process-oriented, open-ended, experiential, and participatory elements. This new phase is preoccupied with design's effects—extending beyond the designed object and even its connotations and cultural symbolism.

We might chart the movement of these three phases of design, in linguistic terms, as moving from form to content to context; or, in the parlance of semiotics, from syntax to semantics to pragmatics. This outward expansion of ideas moves, like ripples on a pond, from the formal logic of the designed object, to the symbolic or cultural logic of the meanings such forms evoke, and finally to the programmatic logic of both design's production and

the sites of its consumption—the messy reality of its ultimate context.

Design, because of its functional intentions, has always had a relational dimension. In other words, all forms of design produce effects, some small, some large. But what is different about this phase of design is the primary role that has been given to areas that once seemed beyond the purview of design's form and content equation. For example, the imagined and often idealized audience becomes actual users—the so-called "market of one" promised by mass customization and print-on-demand; or perhaps the "end-user" becomes the designer themselves, through do-it-yourself projects, the creative hacking of existing designs, or by "crowdsourcing," producing with like-minded peers to solve problems previously too complex or expensive to solve in conventional ways. This is the promise that *Time* magazine made when it named You (a nosism, like the royal "we") person of the year in 2006, even as it evoked the emerging dominance of sites such as MySpace, Facebook, Wikipedia, Ebay, Amazon, Flickr, and YouTube, or anticipated the business model of Threadless. The participation of the user in the creation of the design can be seen in the numerous do-it-yourself projects in magazines such as *Craft*, *Make*, and *Readymade*, but they can also be seen in the generic formats for advertisements and greeting cards by Daniel Eatock.

Even in most instrumental forms of design, the audience has changed from the clichéd focus group sequestered in a room answering questions for people hiding behind two-way mirrors to the subjects of dogged ethnographic research, observed in their natural surroundings—moving away from the idealized concept of use toward the complex reality of behavior. Today, the audience is thought of as a social being, one who is exhaustively data-mined and geodemographically profiled—taking us from the idea of an average or composite consumer to an individual purchaser among others living a similar social lifestyle. But unlike previous experiments in 1970s-style community—based design or behavioral modification, today's relationship to the user is more nuanced and complicated. The range of practices varies greatly, from the product-development methods employed by practices such as IDEO, creators of the famed ABC *Nightline* shopping cart, to the "social probes" of Anthony Dunne and Fiona Raby who create designed objects,

It also reminds me of the working methods established by Sol LeWitt and the Conceptualists—produce a set of instructions and run the program. The specific physical form is professed to be less important than the invariant code. Some call this anti-formalist, but I would argue that LeWitt's move from Minimalism to Conceptualism can still be linked to the philosophical attempt to distill art to its essence (Plato to Hegel and beyond), which underwrote artistic, architectural and design formalism. I get the feeling that the above examples are similar in that the relationships they produce with surrounding factors are incidental to a very traditional reverence for the Designer and the Idea. Much more interesting to me are the examples of open-ended experiences where the "design" is the result of a multiplicity of unintentional developments (e.g., the John/Paul/Ringo/ George meme or Eatock's Utilitarian Poster).

I think there's a lot of important issues to work through around this subject—thanks for a good start!

not to fulfill prescribed functions but instead use them to gauge behavioral reactions to the perceived effects of electromagnetic energy or the ethical dilemmas of gene testing and restorative therapies.

Once shunned or reluctantly tolerated, constraints—financial, aesthetic, social, or otherwise—are frequently embraced not as limits to personal expression or professional freedom, but rather as opportunities to guide the development of designs; arbitrary variables in the equation that can alter the course of a design's development. Seen as a good thing, such restrictions inject outside influence into an otherwise idealized process and, for some, a certain element of unpredictability and even randomness alters the course of events. Embracing constraints—whether strictly applying existing zoning codes as a way to literally shape a building or an ethos of material efficiency embodied in print-on-demand— as creative forces, not obstacles on the path of design, further opens the design process demanding ever more nimble, agile, and responsive systems. This is not to suggest that design is not always already constrained by numerous factors beyond its control, but rather that such encumbrances can be viewed productively as affordances. In architecture, the discourse has shifted from the purity and organizational control of space to the inhabitation of real places—the messy realities of actual lives, living patterns over time, programmatic contradictions, zoning restrictions, and social, not simply physical, sites. For instance, architect Teddy Cruz in his Manufactured Sites project, offers a simple, prefabricated steel framework for use in the shantytowns on the outskirts of Tijuana—a structure that participates in the vernacular building practices that imports and recycles the detritus of Southern California's dismantled suburbia. This provisional gesture integrates itself into the existing conditions of an architecture born out of crisis. The objective is not the utopian tabula rasa of architectural modernism—a replacement of the favela—but rather the interjection of a microutopian element into the mix.

Not surprisingly, the very nature of design and the traditional roles of the designer and consumer have shifted dramatically. In the 1980s, the desktop publishing revolution threatened to make every computer user a designer, but in reality it served to expand the role of the designer as author and publisher. The real "threat" arrived with the advent of Web 2.0 and the social networking and mass collaborative sites that it has engendered. Just as the role of the user has expanded and even encompasses the role of the traditional designer at times (in the guise of futurist Alvin Toffler's prophetic "prosumer"), the nature of design itself has broadened from giving form to discrete objects to the creation of systems and more open-ended frameworks for engagement: designs for making designs. Yesterday's designer was closely linked with the command-control vision of the engineer, but today's designer is closer to the if-then approach of the programmer. It is this programmatic or social logic that holds sway in relational design, eclipsing the cultural and symbolic logic of content-based design and the aesthetic and formal logic of modernism's initial phase. Relational design is obsessed with processes and systems to generate designs, which do not follow the same linear, cybernetic logic of yesteryear. For instance, the typographic logic of the Univers family of fonts established a predictive system and closed set of varying typeface weights. By contrast, a Web-based application for Twin, a typeface by LettError, can alter its appearance incrementally based on such seemingly arbitrary factors as air temperature or wind speed. In a recent design for a new graphic design museum in the Netherlands, Lust created a digital, automated "posterwall," fed by information streams from various Internet sources and governed by algorithms designed to produce six hundred posters a day.

Perhaps the best illustration of this movement toward relational design can be gleaned through the prosaic vacuum cleaner. In the realm of the syntactical and formal, we have the Dirt Devil Kone, designed by Karim Rashid, a sleek conical object that looks so good it "can be left on display." While the vacuum designs of James Dyson are rooted in a classic functionalist approach, the designs themselves embody the meaning of function, using color-coded segmentation of parts and even the expressive symbolism of a pivoting ball to connote a high-tech approach to domestic cleaning. On the other hand, the Roomba, a robotic vacuum cleaner, uses various sensors and programming to establish its physical relationship to the room it cleans, forsaking any continuous contact with its human users, with only the occasional encounter with a house pet. In a display of advanced product development, however, the company that makes

Andrew
Blauvelt

Toward Relational
Design

Critical
Commentary

**Culture Is Not
Always Popular**

39

the Roomba now offers a basic kit that can be modified by robot enthusiasts in numerous, unscripted ways, placing design and innovation in the hands of its customers.

If the first phase of design offered us infinite forms and the second phase variable interpretations—the injection of content to create new forms—then the third phase presents a multitude of contingent or conditional solutions: open-ended rather than closed systems; real-world constraints and contexts over idealized utopias; relational connections instead of reflexive imbrication; in lieu of the forlorn designer, the possibility of many designers; the loss of designs that are highly controlled and prescribed and the ascendency of enabling or generative systems; and the end of discrete objects, hermetic meanings, and the beginning of connected ecologies.

After one hundred years of experiments in form and content, design now explores the realm of context in all its manifestations—social, cultural, political, geographic, technological, philosophical, informatic, and so forth. Because the results of such work do not coalesce into a unified formal argument and because they defy conventional working models and processes, it may not be apparent that the diversity of forms and practices unleashed may determine the trajectory of design for the next century.

Critical
Commentary

Toward Relational
Design

Andrew
Blauvelt

ORIGINALLY PUBLISHED
02.01.14

COMMENTS
6

Alexandra Lange
Criticism = Love

Open Letters, *launched in September 2013 by students at Harvard's Graduate School of Design, is a print experiment that tests the epistolary form as a device for generating conversations about architecture and design. In preparation for the February 14 GSD symposium "What Criticism?," I wrote the following letter to Tina Roth Eisenberg, a.k.a. swissmiss. It was published as Open Letters #07, January 31, 2014.*

Dear swissmiss:

It may seem strange to be bothered by something published on the Internet in 2011. But I am, because that text remains the clearest evocation of an attitude I continue to see on design blogs: that we critics are motivated by hate. This is just plain wrong. Criticism = love.

On October 17 of that year, you quoted your studiomate Chris Shiflett under the heading "Ignore haters":

I always take more pleasure in liking something than in disliking something. That's not to say there aren't some things that deserve to be liked and some things that deserved to be disliked, but I'm never fond of disliking something.

The lesson I've learned is to be wary of those who are. The ones who seem to think that being critical is the same as having good taste. Those people almost never have good taste, so their opinions don't matter.

There's no particular sophistication required to be a critic. We know this, because children often dislike foods they learn to love as adults.

As a child I disliked the Eames LCW chair in my parents' bedroom. I took no pleasure in hating it. My feeling separated me from my mother, whose taste I have always admired. Was Eames a flavor I had to become more sophisticated to enjoy? Perhaps. But that dislike, that gap between us in taste, fueled a productive thought process. I had to figure out what was so great about an object so ugly, so bulbous, so unlike the other (normal) chairs in our house. I had to learn about the Eameses, about bentwood, about cleaning up "the slum of legs." If at the end of that process I still hated the chair, would I have gained less in sophistication? I learned to love the exploration. I love the chair too, even though, due to its age and the innovative industrial means of its manufacture, it is now sculpture rather than furniture.

All my life, criticism has been a gift. Literally. My mom gave me the Eames chair a few years ago. I can wave at it from the desk at which I'm typing.

In high school my mother gave me the collection of Ada Louise Huxtable's essays, *Kicked a Building Lately?*, as an example of what writing about architecture could achieve. The reflected skyline on the cover. The pithy comments within, which hardly required illustration. The rhythm of seeing and thinking and writing. It

Alexandra
Lange

Criticism =
Love

Critical
Commentary

**Culture Is Not
Always Popular**

41

felt fast and it felt just. Can't you imagine Huxtable as Lois Lane, kicking the steel corners of the nascent Park Avenue School of Architecture? It's true, she didn't make the buildings. But, just like Lois, her reporting separated the real Supermen from Bizarro. Her words shaped what came next for New York. She made up names for what was happening to the city and to culture. By naming, she created an arena in which discussion could occur.

My now-husband's first gift to me was another collection of criticism, Michael Sorkin's *Exquisite Corpse*. My education in criticism up to that date had been establishment; this book was made of ruder stuff. It bristles with dislike about some of the very same buildings Ada Louise Huxtable loved, and love for those about which she was lukewarm. The Ford Foundation. The Whitney. My favorite essay in the book is probably the one on the Whitney, an all-too-rare love letter to Marcel Breuer intertwined with a demolition of Michael Graves and his "shitty beaux-arts apparatus." However quotable, I still wouldn't call that hating. Sorkin says Graves can't help it, the apparatus is just his way. It's on the rest of us to save the Whitney. Sorkin is simply giving us reasons why we should. His conclusion is less important than explaining how to get there.

Your blog is clearly a critical enterprise. The mission of *swissmiss* seems obviously analogous to Tattly, which you created to clean up the slum of temporary tattoos. You must get hundreds of emails a day with products, apps, videos, and posters that you deem unworthy of publication. Every time you don't publish something, you are being a critic. Yet you don't share that judgment. That negative determination happens without comment, in the click of the trash button. What I'd like to hear about is what happens in your head between the look and that judgmental click. Why this and not that? What's wrong with that picture?

To be able to say, simply and directly, what is wrong (or not-yet-right) in design is not a child's task. I don't think it is possible to educate about design without talking about the world of wrong, ugly, misguided and oversize. Yes, *swissmiss*, like Switzerland, might be the exception to that world. But it will never be the rule, and accentuating the positive will only reorganize so much territory. Today's Lois Lane cannot avoid the aisles of the grocery store, the app store, or Toys R Us. This Internet of Things: can it be without glitch? Skimming the cream off the top will always generate more clicks (anyone can compare our Twitter followings), but there's more constructive work to be done below, where so many design blogs fear to dive.

You are motivated by a love of design, as am I. Haters are name-callers, body-shamers, trolls. They are destructive. If my fellow critics and I did not love buildings, books, gadgets, and food, there would be no reason for us to do what we do. I really don't get paid enough. But as I move through the world of objects, I have a lot of questions. I can't ignore what I dislike or don't understand. Sometimes I describe the way I choose my topics as scratching an itch: if something bothers me each time I see it, the only salve is investigation. Growing up is doing more than complaining (or, as you have said, coming up with a Twitter hashtag). Let's talk about it—as adults, of course. I would like to save a building or improve a megaproject, but sometimes the critic has to settle for creating a conversation.

Maybe this is just the long way of saying something very simple: Dear Design, I love you. But love isn't blind.

Alexandra Lange, Critic

John Foster

A Street Photographer of Nineteenth Century London

ORIGINALLY PUBLISHED
07.21.13

COMMENTS
2

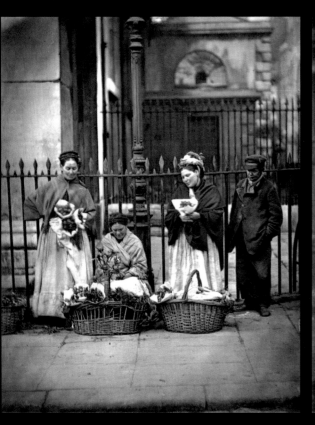

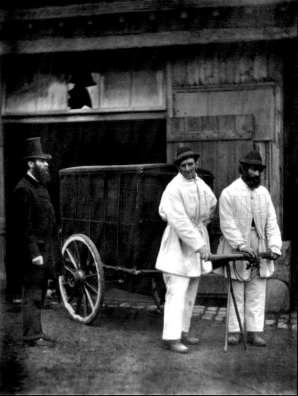

Street photography has always held a special interest for me. I like it because I know it takes a special kind of photographer to be able to put a stranger at ease for a photograph, and that has never been more true than today. With the advent of security cameras and issues regarding privacy, people today are definitely hesitant when it comes to a stranger taking their picture.

Most street photography, however, occurs without the consent and knowledge of the subjects. The movement of people in an environment is frozen in the discovered dynamic found by the photographer's lens. That is the beauty of the great street photographs I know of.

If we look back just forty or fifty years, "modern day" street photographers like Garry Winogrand (1928–1984) or Lee Friedlander (b. 1934) worked the streets, or stood in one spot until the right persons happened to walk in front of their lens for what they saw

as their own "decisive moment." Both shot constantly, quickly, and intuitively, and part of their technique was being quick and non-obtrusive about it. Winogrand, for example, took hundreds and hundreds of images a day, constantly moving and shooting in order to get the shots he wanted.

The street photographer I share with you this week was a man born in Great Britain an entire century before Winogrand and Friedlander. His name was John Thomson (1837–1921) and it is known that he traveled the Far East taking photographs during much of the period between 1860 and 1879. When he returned to London, he began taking documentary photographs of everyday people on the streets of London. Photography during that time was a calculated and time-intensive process with bulky cameras and glass plate negatives. These street photographs had to be taken with care, and in almost all cases, Thomson would have to ask his subjects to pose and stand

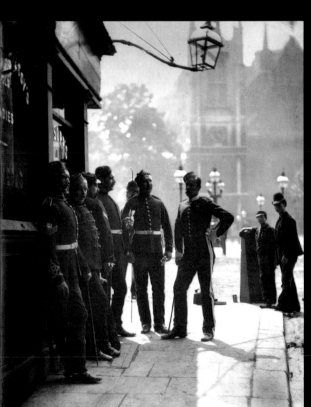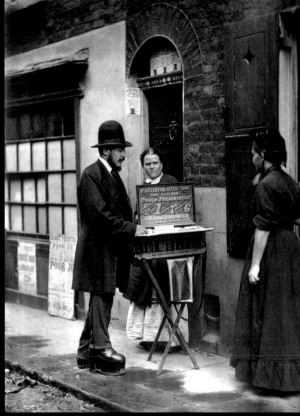

John
Foster

A Street Photographer of
Nineteenth Century London

Critical
Commentary

**Culture is Not
Always Popular**

45

and one other by the pair entitled *Street Incidents*, stand today as a well-respected social commentary on the everyday, working poor of London.

The images and biography about John Thompson come from *Luminous-Lint*, an online labor of love about the history of photography, created by the dedicated Alan Griffiths.

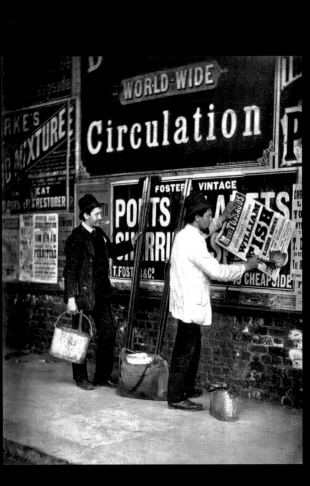

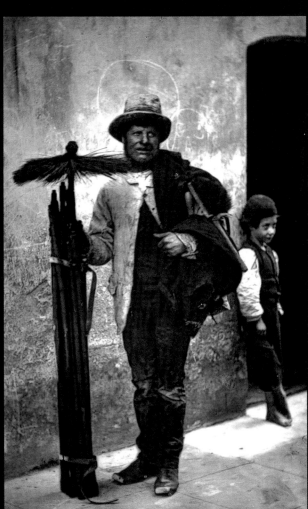

Culture is Not Always Popular Critical Commentary A Street Photographer of Nineteenth Century London John Foster

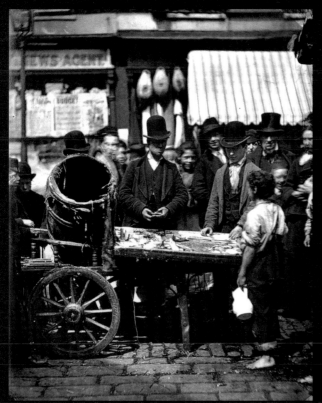

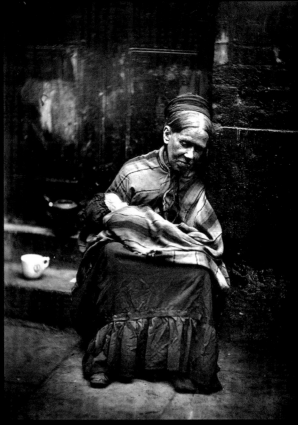

**Culture is Not
Always Popular** Critical
Commentary A Street Photographer of
Nineteenth Century London John
Foster

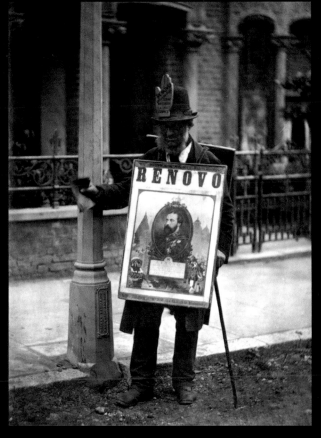
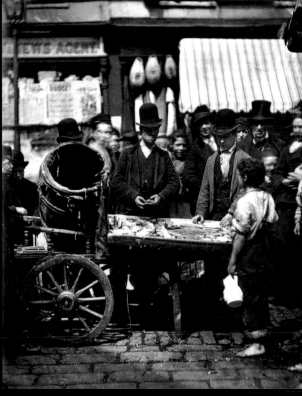

John
Foster

A Street Photographer of
Nineteenth Century London

Critical
Commentary

**Culture is Not
Always Popular**

49

02.

Cultural Investigation

Design Observer had no stated editorial policy when it began in 2003, no board of advisors, no scheduled meetings, no assignments, no deadlines. It grew out of our conviction that the world of design, at a moment when design's status in the world was on the rise, had begun to look inward. Obsessed with process as an end in itself, focused more than ever on "streamlining the sales curve" (as *Time* once wrote of Raymond Loewy), the design community was becoming dismayingly, and perhaps dangerously, hermetic.

At the moment that *Design Observer* was launching, William Drenttel and Jessica Helfand were putting the finishing touches on a presentation that they would deliver one week later at the AIGA national conference. The lecture, "Culture Is Not Always Popular," was intended to be at once a provocation, a challenge, and an invitation. It also was as close to a statement of purpose that *Design Observer* would ever have.

"We want to propose a different view of culture," said Drenttel, "one that presupposes a more expansive view of the world that design inhabits, not limited by form or function, budget or brief, process or style." And, more than anything else, it was this expansive view that would be the signal characteristic of the writers who would contribute to the site over the next fifteen years. Not just graphics, architecture, fashion, and product design, but literature, film, music, politics, and more: no subject was excluded. This absence of boundaries would define its own territory. As Drenttel concluded: "It's that simple. And it's that complicated."

William Drenttel
Jessica Helfand

ORIGINALLY PUBLISHED
10.28.03

COMMENTS
33

Culture Is Not Always Popular

Jessica Helfand: At a faculty meeting not long ago, a colleague of mine suggested that smart designers need to resist the impulse to over-intellectualize things, as though such efforts are counterproductive—if not entirely paralyzing—for the designer seeking to make work. Upon hearing this, I was immediately catapulted back to an episode in high school—which, sadly, had been permanently etched on my memory—when a teacher suggested that in order to be more "popular," I might consider using fewer big words around my peers. Specifically, he noted, around *boys*.

Even for this talk, we were encouraged to be "engaging" and "visual." The implied caution? Don't use big words, don't be too intellectual. Remember, this is an audience of *visual people*.

Where does this come from—this notion that thinking and making are separate acts? That graphic design must be inherently *anti-intellectual* because it is a creative enterprise? And why is being "popular,"—and by extension, participating in "popular" culture—understood somehow as antithetical to an engagement with the larger world of ideas?

William Drenttel: Designers talk about creating a body of work, but they seldom talk about acquiring a body of knowledge. They take pride in being makers, but seldom identify themselves as thinkers. They claim to be emissaries of communication—to give form to ideas. And while we would like to believe this is true, it seems to us that all too often, we, as designers, are called upon merely to make things look good—rather than contributing to the evolution and articulation of ideas themselves. This is an age-old criticism of design, but it seems especially relevant this morning as we talk about the culture of design.

In a recent interview, the British designer Peter Saville was quoted as saying, "graphics is the communications platform for culture." The syntax here is very revealing: Whoever thought we'd be hearing the designer of New Order talking about "graphics," let alone "communications platforms?" So, what is he REALLY saying? That design is a lens onto culture? Or that our culture is only evident and visible through design? Whatever the answer, we're struck by the presumption in this statement that design = culture.

We're not so sure. We believe the "culture of design" has become implicitly about branded culture: culture that we can see, that we can name, that we can buy and sell and package; culture that is synonymous with style; culture that resonates with novelty and which, by conjecture, dismisses history as mere nostalgia; culture that determines and drives our reactions to the constantly changing pulse of modern life.

So this morning, we want to ask three simple questions. Every time the word "culture"

Joseph Michael Essex
10.29.03 03:05
Design is a process. As a process products may be produced . . . or not, aesthetic elements may be included . . . or not. As a process communication will be fostered, knowledge will be promoted and truth acknowledged.

Because design is a process it can be taught, measured, evaluated, owned, learned and improved. As a process, design can be applied in creative ways but does not require creativity. As a process, design also needs information and opinions from those without creative credentials but whose experience and expertise is critical.

Design as a process defines a structure, where possibilities are conceived, nested, nurtured, hatched, fed, weaned, grown, released and rejuvenated. It is where a curriculum can be developed, methods identified, exercises planned, tests given, standards met, graduate and post-graduate degrees earned. It is where certification can happen as well as accreditation, codification and preservation.

Design as a process is a structure without form, agreement without capitulation, collaboration without loss or forfeiture of individuality. It is where the unconceivable is conceived and made whole.

M Kingsley
10.30.03 12:22
An eloquent position that I find a great deal of resonance with. Sadly, I'm not surprised that members of the design community took issue with what, to me, is a no-brainer (bad pun intended).

As a rejoinder to Mr. Essex—yes, design is a process. But isn't it a process of making decisions?

At each step, one is confronted by matters ranging from large to small; from point size to whether a new logo is even needed. This then raises the question of how one makes those decisions. Ahhh, philosophy... There's no need to bring up Kant, thank you, but hopefully one can see where a cultivated mind is an advantage.

marian bantjes
10.30.03 04:17
...I think that you are right in your call for more intelli-gence in design thinking and communication; we have only recently crawled out of the mire of judging by aesthetics, and we still have a long way to go. However, I would hate to see design discourse go the way of art criticism, where the language has become so obscure and exclusive that it has not only alienated the general public but created an elitism within the [art] community that one must either emulate or fake it to be taken seriously.

It is also very important not to confuse intelligence with education. Education enhances and expands intelligence, but a lack of education does not preclude intelligent discourse. You really can express big ideas without using big words, and the bonus is that you reach a wider audience and gain greater acceptance for your ideas. One of the risks you run when you speak in phrases such as "Tufte has invoked the principles of Evelyn Wood speed-reading in his reductivist ad absurdum take on the discipline of Graphic Design." is alienating the very audience you wish to reach.

On the other hand, just because I can never agree with anyone completely, not even myself, I have an understanding that your education and your experience shapes your language and your tools of reference. I've travelled quite a bit, and I used to get the same "who the fuck do you think you are" reaction when I would say, e.g. "This reminds me of something I saw in India ..." ...

I'm not sure where that leaves us in the critical thinking arena. I would hope that there is some middle ground between our "high" and "low" communication skills. I actually think that this lec-ture as written here, has found that balance. I find it interesting and thoughtful without being alienating, whereas the "Tufte" article -- what the fuck?

But of course anytime you say "It's time for intelligent discussion," you are also saying "I am intelligent." and this will get people's backs up as much as if you said, "Us beautiful people need to stick together."—may-be more, because there is an

is used at this conference, we'd like you to ask yourselves:

Whose culture are we talking about?

Is this the culture we want?

Is this the only kind of culture possible?

JH: Almost a decade ago, at an AIGA gathering in Kansas City, designers pleaded for design to be recognized as a powerful force in com-merce and modern life. The consensus was that AIGA should help put design center stage and, on some levels, this desire has largely been fulfilled: today, fewer than ten years later, design is generally acknowledged as a ubiqui-tous element in contemporary culture.

The assumption was that designers influence just about everything—from toothbrushes to television titles, bridges to brochures.

This ubiquity is evident in everything from *corporate* culture, to *world* culture, to *sports* culture, to *media* culture, all adding up to something we call *popular* culture...

And all of these, let's be honest, performing increasingly as functions of a much larger *branded* culture.

Coming full circle, to Vancouver, even "design" has become its own, *well-designed* brand.

WD: Obviously, there are many ways to look at this. One of the benefits of weblogs is the opportunity for ongoing critical discussion. Last week, Jessica and I launched *Design Observer*, a collaborative blog with Michael Bierut and Rick Poynor, as a forum for a broader kind of critical writing on design issues—broader because it's collaborative; because it's international; and because we rarely agree on anything.

In the spirit of such thinking, we'd like to take a few moments to look at design and its impact on culture from a more critical perspective.

I'd like to begin with AIGA—and here, as a former president, I want to commend AIGA for its many dramatic strides forward in increasing the purpose and profile of the profession. But consistent with such strides is a level of critical discourse that seems, in many ways absent, from our conferences and our publications.

For instance, we are troubled by AIGA's gener-ally uncritical endorsement of branding, both as a process and as the primary programmatic focus for the profession. We are troubled by the loose interchangeability between "design-ing" and "branding."

So to revisit the Peter Saville position: design is not only a communications "platform" for culture, but is now vetted by an AIGA approved twelve-step program for problem solving, inno-vating, and generating value.

We are not making a flip attack on an organi-zation we value. We do not doubt that these ideas are appropriate for many design prac-tices. We do not doubt that these concepts will play well in the media as AIGA seeks to gain attention for our profession. And we appreciate the shift from an emphasis on award-winning design artifacts to a deeper discussion about process, participation, and impact.

But we do believe that we are fundamentally restricting the pluralistic character of design by adopting a fixed vocabulary for process. Not everyone in this room sees "generating value" as a rationale for what they do. By expanding the very definition of design, are we simulta-neously narrowing the rich variety that makes design such an exciting profession?

Further, we would hope that creating brands is only one of the many potential outcomes of "designing." "Branding" is primarily a function of the designer's engagement with material culture: again, this is NOT the only culture there is, and it is NOT the only culture in which design can make a difference.

So, we wonder: Why hasn't there been more critical discussion of these issues in the year since the AIGA board adopted this new focus? Such discussions are critical to a mature pro-fession, and imperative if we want to consider and ultimately, contribute to the culture – or cultures—of design that we want to create in the future.

JH: The American writer James Baldwin once observed that it is very nearly impossible to become an educated person in a country so distrustful of the human mind.

Regrettably, the current state of design educa-tion does little to refute this notion: our curricula primarily support the strengthening

William Drenttel
Jessica Helfand

Culture Is Not
Always Popular

Cultural
Investigation

**Culture Is Not
Always Popular** 53

of formal skills and the cultivation of conceptual abilities. Intellectual diversity—and by extension, an understanding of cultural diversity—is less encouraged, but why?

In most design schools, for instance, we discourage learning a second language because it requires too much time in the language lab and therefore away from the studio. Along the way, our young designers aren't expected to really study science or math; history or anthropology; economics, music theory, or literature. They're not even really required to learn to write.

How is this possible?

The state of illiteracy in design schools is staggering, but sadder still, it mirrors a basic scarcity of cultural literacy across the nation. A recent study revealed that when asked to name three boy-bands, 97 percent of the US population had no problem: however, only 17 percent could accurately name three supreme court justices.

So if knowledge is power, isn't what we as designers contribute a function of what we know?

And what is it, exactly, that we DO know?

In an educational context, is the power of design really just a brand itself? Is it the promise of an exciting view of culture? The packaging of design as a lucrative career choice? Or are we talking about…

Power through communication?

Well, there is little in the culture of design education that places a premium on achieving a level of literacy, which in our view, goes hand-in-hand with designers being truly knowledgeable, and capable, and thereby empowered to participate in an increasingly *cross-disciplinary* world.

Power through voice?

Certainly there is an abundance of experimental student work that aggressively critiques corporate rhetoric or denounces commercial culture: work that, if nothing else, is commendable for its sheer gutsiness. Often though, we see voice expressed less as an act of subversive will, and more as a staging of false identity: this work says a lot about designers

wanting to be artists, using "design" as a weak metaphor for "art" and expressing their personal experience without practical context or intellectual foundation.

Power through craft?

While design education has a long and distinguished history of reinforcing formal principles, it is often assumed that a student's "intellectual" development is perhaps of less immediate consequence.

Is it powerful to develop a typeface based on the letterforms taken from one's apartment signage?

Is it powerful to make a video of the dramatic lighting conditions between ramps in a parking garage?

Is it powerful to tabulate the color shifts in a series of expired plastic bread tags over the course of nine months?

Each of these are student projects I have seen over the past few years: exquisitely designed, these projects were meticulously produced as evidence of a kind of working methodology in design. Yet while conceivably empowering to the student, such projects, more often than not, are framed by what the student already knows.

The distinction here is that while such independent work encourages our students to think for themselves, our *narrow-minded* curricula restrict their capacity to use their minds to truly advance their ideas; And in turn, we limit their ability to advance themselves.

WD: This polemic raises many issues, but let's return to the idea of culture. We want to propose a different view of culture, one that presupposes a more expansive view of the world that design inhabits, not limited by form or function, budget or brief, process or style. This notion of culture—which we call intellectual culture—operates from a different premise, and quite possibly, demands a different educational approach: for at its core, it suggests that in order for design to really matter, designers need to think and know more about things besides design.

Our premise is that behind the best design there is not only an intelligent process and

undervaluing of intelligence in North American culture. If there weren't, you wouldn't have George Bush for a president.

Do you need to know the law to design a journal for lawyers? Do you need to understand finances in order to design an annual report? I think it would help, but we can't be and do everything: that's just impossible, so I think it's very important to ask, research and collaborate. That's why we work closely with clients, so that they can bring their piece of the knowledge into the picture. It has to be a collective effort. We would go mad if we tried to do it all.

Cultural Investigation Culture Is Not Always Popular William Drenttel Jessica Helfand

visual solution, but an intellectual foundation based on history and ideas.

To expand upon this premise, we'd like to take a look at one particular set of ideas in our culture—in the realm of science.

In a recent issue of *Emigre*, Jessica and I published an essay on what we call "faux science": it's a cultural critique of the indiscriminate appropriation of scientific imagery for the making of cool things. Along the way, in an effort to understand design as it might relate to real science, we began to do a little research.

In the history of chemistry, we focused on the periodic table of the elements and discovered numerous, and quite varied, examples.

Here's the first publication outside of Russia of the Periodic Table by Mendeleev from 1869.

And a classic wall chart by Henry Hubbard from the 1950s, which went through twelve editions, and hung in thousands of classrooms across the country for decades.

Since the last edition of the Hubbard wall chart, we have discovered sixteen new elements. These discoveries have confirmed the genius of the periodic table as a template that not only summarizes information succinctly, but also provides a system for predicting future outcomes.

Yet for designers, the periodic table, like other areas of science, is often just a genre that's ripe for appropriation, offering an easy visual metaphor and a ready source for imagery:

From art by Damien Hirst—
To an identity program by Lana Rigsby for Strathmore Elements—
To a chart in a recent *GQ*, by Fred Woodward, on nerdiness—
To a self-promotion book by Stone Yamashita—
To a chart on cereal typologies published in *2wice*—
To yet another self-promotion book, this one for *Fold 7* in the United Kingdom—
To type specimens by Test Pilot Collective—
To dingbat specimens by Scott Stowell and Chip Wass—
To a periodic table of desserts—
To a periodic table of sexual positions—
To a periodic table of Turbonium, for Volkswagen.

We celebrate this kind of design—with awards, in publications—yet, such visibility also suggests the degree to which we do NOT see designers thinking about real science: and if we do, we rarely acknowledge or celebrate their contributions.

JH: For the past three years, Julia Wargawski has assigned the periodic table as a studio assignment at the Parsons School of Design in New York City. Her course investigates the process of graphically representing information through mastering the principles of visual organization—but students also learn about conductivity, oxidation and isotopes.

Here's an example of a redesign of the Periodic Table by Purvi Shah, a junior; one from Christian Drury, also in his junior year; in her senior thesis exhibition, Emily Korsmo's project was actually a redesign of Stowe's physicist table of the elements; and an interactive version of the Mendeleev table by Stacie Rohrbach, at North Carolina State University, which is currently featured on the AIGA/Loop site.

Louis Pasteur once said that knowledge belongs to humanity: "it is the torch," he wrote, "which illuminates the world." Why can't designers—as visual communicators, but also as engaged thinkers—be the ones to carry this torch? Why are projects like these more the exception than the rule?

Here, for instance, is the first visualization of the complete DNA sequence published by *Science* magazine in 2001: quite possibly the most important scientific discovery in recent memory. Do any of us know who designed this?

Our point is that genetic mapping is a significant example of a powerful scientific development that will fundamentally change the way people live, if they live, and how they live. Our ability to address and, ultimately, amplify the meaning of this information is only partially based on our skills as visual communicators. This is not about branding; it's about life. It's about whether we, as designers, are going to participate in its scientific and cultural dissemination—and more critically, whether we are even capable of participating.

WD: We're not claiming today that we have all the answers, or that we're even remotely capable of fulfilling the challenges we're proposing

William Drenttel
Jessica Helfand

Culture Is Not
Always Popular

Cultural
Investigation

**Culture Is Not
Always Popular** 55

this morning. In fact, what we're going to show you now will illustrate just how hard this is, and what a struggle it continues to be for us.

It is therefore with some trepidation that we'd like to share a bit of our own experience, as designers, working in the area that we call, albeit a little hesitantly—intellectual culture.

Like most of you, we need to make a living. We work in a small studio with only two employees in the northwest corner of Connecticut.

For the first five years that Jessica and I worked together, we had a fairly traditional practice, including a lot of work we'd classify as branding. We designed interfaces for Internet companies and websites for newspapers.

About eighteen months ago, we asked the question: Could we sustain a practice if we stopped doing brand-driven work and only did projects with some kind of real intellectual content? This definition is a pretty slippery slope—obviously more thematically driven than "intellectually" rigorous—and we are not suggesting that brand-based projects don't have their own value and intellectual challenges. But on a very personal level, we wanted to try to create a different body of work, engaging with different kinds of ideas—and collaborating with different kinds of clients. As we began to work against these criteria,every new project seemed to raise its own questions.

JH: The answers were pretty humbling and almost immediately, we were forced to consider the limits of what we know:

Does an eighteen-foot, accordion-fold book with over three thousand entries charting the evolution of Greek mythology benefit from a knowledge of history?

Does the statistical analysis characterizing econometrics inform the typography on this college textbook?

Does an understanding of the "culture wars" within journalism today benefit the online extension of a university journalism program?

What about student journalism? Can a student newspaper be conceived in such a way as to help redefine educational parameters for the way journalism is actually taught?

What about the role of religion as portrayed in the media?

How much do we need to know about Judaism to promote literacy about Jewish culture and literature?

Or the evolution of American foreign policy since the Vietnam War?

Or the complexities of US diplomacy in the *Arab-Muslim* world for this report to Congress?

How does an understanding of the rampant mutation of flu viruses inform preventative public health initiatives?

What about the history of propaganda, political caricature, and comparatively radical, early forms of medical malpractice?

WD: In our publishing imprint, Winterhouse Editions, we are always looking for projects in which we can exercise such diverse interests, and where the design considerations must be reconsidered in light of subjects with which we have little familiarity.

Jessica's interest in twentieth-century information dials and other kinds of circular media led her to rethink primitive, early forms of navigation.

My interest in the darker side of life often seems to lead me back to German literature. And while Jessica and our children did stop me from naming our puppy Kafka, we co-published this book, *Kafka Goes to the Movies*, with The University of Chicago Press. Faced with an interesting but problematic work of scholarship, the design became a way to fix the book and to deepen its visual narrative.

Last month, I bought the world English rights to this book—a literary description of the destruction of Hamburg in 1943. Probably not a bestseller, but potentially an important book that grapples with the problem of describing—*without* aestheticizing—the horror of urban destruction. In many ways, it resembles certain critiques of writing in the months following 9/11.

Recently, a young historian brought us this Victorian scrapbook—240 pages of newspaper clippings pasted into an old geometry text-

book—meticulously documenting every weird kind of death and murder that transpired over the course of a single year: 1894. The gruesome detail evident in the language suggests a cultural interest in death at the turn of the century that is a new topic in American studies.

JH: This summer, we collaborated with the writer Lawrence Weschler on the design of a new magazine prototype. *Omnivore* is a celebration of what Weschler calls: "A distinctly American innovation … the extended, writerly, not necessarily immediately topical piece of non-fiction reportage … an endangered form of writing that is one of the greatest contributions of American culture to world literature in the twentieth century."

Here in the twenty-first, *Omnivore* pairs unlikely subjects—

From Helen Wilson's photograph of a denuded clementine to a stripped-down billboard in Bucharest, revealing the menacing eye of former Romanian dictator, Nicolae Ceausescu— To discoveries of moons circling asteroids— To work by a remarkable range of writers and artists including Oliver Sacks; David Hockney; and the South African dissident poet, Breyten Breytenbach, among many others.

WD: But if *Omnivore* pushed us by challenging the perceptual juxtapositions between pictures and words, our year spent redesigning the *New England Journal of Medicine* revealed a different set of challenges. In collaboration with Michael Bierut, our process involved working closely with a group of physicians whose view of information design was dictated not only by the expectations of their readers (who are primarily doctors themselves), but more importantly perhaps, by the scientific imperatives of the material itself.

In retrospect, we were able to bring to the journal a more refined typographic vocabulary, as well as some basic editorial insights. But because of our lack of knowledge about real science, I don't know that we ever really understood how to effectively visualize and communicate discoveries and innovations in medical research. Given the journal's seminal, groundbreaking data about personal and public health issues—the outbreak of SARS, for example—did design really contribute anything?

If our experiences in the past year have taught us anything, it is that we do not know enough to participate in any of these projects in the way we might like. The good news is that—and every student in the audience should hear this—we were able to make a living without focusing on strategy or branding or marketing. There are other types of work out there where designers can play a role, and where acquiring a body of knowledge becomes an asset both professionally and personally.

JH: Several weeks ago, two Americans and a Russian shared the 2003 Nobel Prize in physics for theories about how matter can show bizarre behavior at extremely low temperatures. Bear in mind that where we live in the Berkshires, it was twenty-two degrees last week when we were finishing up this lecture: another benefit of science is that now, at last, we have a rationale for the "bizarre" behavior that led us here today.

But it is sobering, nonetheless, to consider how culture awards real contributions. The French cubist painter, Georges Braque, once said that art is made to disturb, while science reassures. Design, it seems, lies somewhere in the middle: it is both and it is neither, playing both ends against the middle; and it is this middle-brow, middle-class, middle-of-the-road intellectual apathy that diminishes the real power of design—its power as a humanist discipline. We believe that to engage that discipline—and the many cultures it serves—means simply being better educated. This has perhaps less to do with culture, and more to do with having a cultivated mind; less to do with technical virtuosity, and more to do with intellectual curiosity. Less to do with popular culture, and more to do with culture—period.

WD: Francis Bacon once said that knowledge and human power are synonymous, and it is in this spirit that true power is perhaps ideally achieved: it is power informed by learning, collaborating, and considering how the ultimate quality of our lives is made, whether in reference to our health or our schools; our environment or our foreign policy; our aspirations in science or in space; or our humanitarian achievements, as people, in war and in peace.

It's that simple. And it's that complicated.

William Drenttel
Jessica Helfand

Culture Is Not
Always Popular

Cultural
Investigation

**Culture Is Not
Always Popular** 57

Steven Heller
The Magic of the Peace Symbol

ORIGINALLY PUBLISHED
03.24.08

COMMENTS
13

The symbol for the Campaign for Nuclear Disarmament is fifty years old this year, and despite all the wars fought since its birth, none of them have been a nuclear war. Perhaps it was the dramatic specter of the mushroom cloud and all it symbolizes that has helped deter the unthinkable.

But just maybe there is some magic in the peace symbol. There was probably no more galvanizing nor polarizing emblem during the 1960s than the upside-down, three-pronged, fork-like mark in a circle that came to symbolize the anxiety and anger of the Vietnam era. And perhaps few symbols have had origins surrounded in as much mystery and controversy.

Although the basic form had roots in antiquity, the peace symbol was popularized during the period in the mid-1950s when H-bomb testing prevailed. It was designed in 1958 by a British textile designer named Gerald Holtom for use by England's Campaign for Nuclear Disarmament (CND). Also known as the "Peace Action Symbol," it was used at the first annual Aldermaston Easter Peace Walk to promote world disarmament. It debuted in the United States in 1961 on protest signs in the cautionary science fiction film about the tragic ill-effects of nuclear testing, *The Day The Earth Caught Fire*. Soon it was universally adopted for use as an anti-war insignia.

The symbol is a composite semaphore signal for the letters N and D, which, of course, stand for "nuclear disarmament," but its basic form also derives from an ancient runic symbol that casts some doubt on whether the ND-semaphore rationale might have been an afterthought. According to an article in a 1969 issue of *WIN (Workshop in Nonviolence)* magazine sponsored by the War Resisters League (one of the 1960s foremost anti-Vietnam war activist groups), the peace sign derived from an initial iteration of a white circle on a black square. This was followed by various versions of Christian crosses drawn within the white sphere, which in turn evolved into the ND form. Referring to the Aldermaston march, *WIN* asserted that for subsequent demonstrations an ND badge was "devised and made by Eric Austen," whose researches into the origins of symbolism underscored that the basic fork-like symbol—what he called the "gesture of despair" motif—was associated throughout ancient history with the "death of man," and the circle with the "unborn child." The reason for calling the upside down fork a "gesture of despair," derives in turn from the story of St. Peter who was crucified upside down sometime between 64 and 68 CE in Rome on a cross designed by Emperor Nero, known thereafter as the "Nero Cross" or the "sign of the broken Jew."

Before Gerald Holtom and Eric Austen, however, there was a still earlier precedent for the symbol. During the 1930s, decades prior to the nuclear disarmament and anti-Vietnam War movements, but on the precipice of fascist

associated with the politics of the far right (the horrors of Nazi Germany in particular) and can "never" be reinterpreted.

Secondly, where Heller usually forecloses in a distinctly binary fashion (usually any symbol that at some point was associated with fascism), here he remains open to transformative possibilities.

Finally, Heller often seeks to utilises his authoritative knowledge as a way to determine, and thus restrict alternative readings (witness Heller's book on the swastika which after so much thoughtful and fascinating research comes crashing down around a personal opinion about the rights and wrongs of its use).

steve heller
03.25.08 01:31
Is the swastika beyond redemption? The title of my book ends with a question mark. The conclusion, however, is indeed a subjectively resounding "yes" in terms of what it symbolizes in the Western context.

I have always called my book a polemic history given my critical (indeed subjective) conclusion regarding this one sign. In the book I argue that because we put so much weight on signs and symbols, one should forever represent Nazi crimes. Sure, this applies to other mark from Nazi iconography, but few of them are as powerful as the usurped swastika.

As for the peace sign's checkered past, in the modern context it was ostensibly benign (even when used by the Nazis). In fact, its appropriation (and re-invention) as the ND symbol effectively rid it of its past meaning. That said, it is considered a symbol of the "left" and, therefore, not favored by the "right," so everything is subject to interpretation.

BTW, the passage of time has a way of altering meaning. In 100 years (or maybe less) it's quite possible—even probable—the swastika will return to his earlier historical standing.

dominance in Europe, a strikingly similar emblem was devised by the English philosopher and Socialist Bertrand Russell as an attempt "to depict the universal convergence of peoples in an upward movement of cooperation." During the late 1950s Russell was the chairman for the CND and present at numerous disarmament demonstrations and protests against English involvement in NATO, at the very time when the symbol was adopted as the CND emblem. It is therefore probable that Russell introduced the basic sign to the organization from which Holton created his final design.

Russell was a former member of the Fabian Society (a fellowship of English Socialists), which prompted a right-wing journal, *American Opinion*, to link the peace symbol, like the antiwar movement in general, to a broad Communist conspiracy of world domination, "It is not at all surprising that the Communists would turn to Russell to design their 'peace sign,'" states a 1970 article in this journal, which continues: "A Marxist from his earliest youth, he greeted the Russian Revolution with the declaration: 'The world is damnable. Lenin and Trotsky are the only bright spots.'" The journal further describes Russell as an active anti-Christian who was well aware that he had chosen an "anti-Christian design long associated with Satanism." In fact, the basic form, which appears both right-side up and upside down as a character in pre-Christian alphabets, was afforded mystical properties and is

in evidence in some pagan rituals. Right-side up, "I" represents "man," while upside down it is the "fallen man." Referred to in Rudolf Koch's *Book of Signs* as "The Crow's foot" or "witch's foot," it was apparently adopted by satanists during the Middle Ages.

The Nazis routinely adopted runic forms for their official iconography, such as the SS runes, the insignia of Hitler's personal bodyguards. Indeed the Nazi iconography calls the "crow's foot" the Todesrune or death rune. Paradoxically, in a right-side up position it was frequently used on death notices, gravestones of SS officers, and badges given to their widows. Not unlike the swastika itself, the direction of this runic symbol has positive and negative implications. The downward version might be interpreted as death and infertility, while the upward version symbolized growth and fertility.

The meaning of signs and symbols are easily transformed into good and evil depending on how they are sanctioned and applied over time—and who accepts said usage. Whatever satanic associations the "Crow's foot" may have had when Bertrand Russell "designed" this symbol, he imbued it with more positive virtues of life and cooperation. Once adopted by the CND, and later by scores of other antiwar, ecology, civil rights, and peace and freedom groups, its meaning was forever changed to that of a sign of protest in the service of humanity. Magic had nothing to do with it.

Steven
Heller

The Magic Symbol of
the Peace Symbol

Cultural
Investigation

**Culture Is Not
Always Popular**

59

Adrian Shaughnessy
Are JPEGs the New Album Covers?

ORIGINALLY PUBLISHED
04.11.07

COMMENTS
66

Over the past few months I've been researching a book about current record cover art. Besides hunting down examples of stimulating music graphics, I've also been looking for digital alternatives to the traditional album cover. As downloading threatens to become the main distribution method for recorded music, it is widely believed that the album cover will be replaced by some new online format—perhaps animated—that will make CD packaging redundant. Well, I might be missing something, but I've found nothing in the digital arena that offers a viable alternative to a well-designed CD or vinyl album cover. Instead, I've discovered a grim-faced resistance movement amongst dozens of tiny record labels determined to hang onto physical packaging and expressive cover art, no matter what.

This resistance movement is found mainly amongst independent labels—micro labels—often run by a single individual, and often existing on budgets that would embarrass a shoestring. And what distinguishes so many of them is a deep-rooted commitment to selling physically packaged music with resonant cover art.

It's not worth discussing what the major labels are up to: they haven't got a clue. There used to be five major record labels; when Sony and BMG merged this became four, and now it is hotly predicted that another merger will reduce the number to three. These lumbering conglomerates are doing what they have always

done: waiting for someone else to show them the way forward. In the meantime, as they dither and prevaricate, their domain is encircled by Apple, Starbucks, Amazon, Wal-Mart, and various corporate entities with the wherewithal to offer digital downloads to an eager public. For anyone who cares about music, this is hardly a heart-warming prospect.

And yet, is the determination of the micro labels to continue producing CD and vinyl packaging anything other than the remnants of a fanboy obsession with recorded music common amongst people who grew up in the predigital era? Most of the label owners I've interviewed for my book have talked about the usual teenage interest in band logos, enduring love affairs with *New Order* album covers, and fixations with the "smell of records." But are we talking about something deeper here? Does music need some sort of physicality to maintain its intrinsic value? If our favorite music merely exists as a sliver of invisible code on a computer, do we lose something?

In a recent *Guardian* article, "It's a Steal," the novelist John Lanchester wrote about literary copyright. He detailed Google's ambitious attempts to digitize the world's literature. Lanchester has some sharp things to say about the way copyright and intellectual property rights are being eroded in the digital age, but he gives a cautious welcome to Google's plans, and does not foresee the end of books. "Personally, I think that books are going to be

marian bantjes
04.12.07 03:33
I think what the music industry needs to figure out is that there is value in good printed material to accompany music. The problem is that they think of it as packaging, and they think of it as packaging for a product that is under transition and they don't know what to do. It's not packaging, it's graphic material for fans. Fans want stuff from the musicians they love: posters, booklets, liner notes, photos … and while some of this can be got online there really is something different about having printed copy, something to hold in your hands. I can easily see myself throwing out all those plastic CD cases with their pathetic 1-fold inserts, but the nicely designed paper ones … no way.

Rob Weychert
04.12.07 09:10
This is purely nostalgia, and a nostalgia that belongs almost exclusively to the visually-inclined. Don't get me wrong; I share this nostalgia with you, but let's get real -- the concept of album art is relatively new, and the concept of music is ancient. Most of what is widely considered to be the best music ever written was created before technology even existed to record audio, and long before there was commercial art to accompany it. These facts make statements like "There is an undeniable sense of completeness when music comes with handsome packaging and engaging graphical material" difficult to defend, no matter how subjective they may be.

60 **Culture Is Not
Always Popular**
Cultural
Investigation
Are JPEGs the New
Album Covers?
Adrian
Shaughnessy

Mark Webster
04.12.07 01:39
Pessimistic as I am, I do feel we have had this debate waving before our eyes for almost ten years yet somehow we have 'wanted' it to happen—Wanted in terms of commercial pressure and economic laws, or at least I'm sure that this is how the major companies would repost. And when I say this, I mean that music has entered a kind of cheap 'easy come easy go' era of mass consumerism where the majority are in need of the latest up to date technology that has been fed so easily to us. It is political, economic and indeed a huge statement on consumer attitudes—and not just simply a 'graphic' issue that you have un-earthed. I wonder at times and in reply to such remarks as, '...it is the music that counts...', how many people do actively listen to their 1000 plus tunes in shuffle mode and are actually engaged, thoughtfully, with the music and their creators. Deleting the file or throwing the dusty 1950s vinyl to the rag-n-bone man poses a huge question that not only man-ifests a problem of materiality but more importantly a problem of behaviour and attitude.

Secondly, and this is perhaps more optimistic, I truly believe that the graphic designer has not yet taken on the challenge in front of what is available in terms of technology nor in light of current consumer trends.

sven
04.12.07 06:16
The computer is becoming the sole agency for all cultural exchange (already people buy and sell paintings based only on a jpeg) so the question is a lifestyle one: do we want to live with and experience objects or digital objects?

This is not a black and white question. The creation and transportation of objects is an immensely wasteful and polluting system, it is also less democratic and reinforces the urban/rural cultural hierarchy.

OK, for one main reason: books are not only, or not primarily, the information they contain. A book is also an object, and a piece of technolo-gy; in fact, a book is an extraordinarily effective piece of technology, portable, durable, expen-sive to pirate but easy to use, not prone to los-ing all its data in crashes, and capable of taking an amazing variety of beautiful forms. Google Book Search is going to be a superb tool for accessing the information in books; but how much of *Middlemarch* or *White Teeth* or *Tintin in Tibet* is information? You can see … just how much of the cultural history of books, and their cultural importance, lies in their bookness. This will, I think, dilute the impact of digitization for writers and publishers: even if you could rip an MP3 of *Moby-Dick*, who on earth would prefer it to a bound copy?"

Lanchester's phrase, "an amazing variety of beautiful forms," applies to the best music packaging as much as it does to books. There is an undeniable sense of completeness when music comes with handsome packaging and engaging graphical material.

I download music, and while I have gripes with the poor audio quality of most downloads, I do it happily enough, relishing its instanta-neousness and convenience. I tell myself that there's no good reason to need music to be packaged since one of its greatest assets is its lack of materiality—if you really want to enjoy music, listen to it with your eyes closed. And yet, when I analyze my feelings toward the digital files that sit on my laptop, or on my iPod, or on neglected backup discs, I find that I care less about them than I care about the CDs and vinyl discs I own.

An audio file with a thumbnail JPEG of the al-bum cover will never have the resonance—not to mention the commercial value—of a well-made piece of packaging. But if the corporate providers of downloadable music have their way, this is the future of recorded music. Who ever had a love affair with a JPEG?

Lorraine Wild
100% Design

ORIGINALLY PUBLISHED
04.07.08

COMMENTS
18

So, it's 1966 and two guys are hanging around their Los Angeles apartment, musing about the sort of things that people mused about in the '60s. "Isn't it strange that folks can look at an image of a really big thing reduced in the pages of a magazine, and take it for granted that it's real? But what if that little reduction of the real thing actually materialized? Like what if a six-inch long bus suddenly appeared at the curb? Wouldn't they be amazed?"

The aesthetic philosophers in question were the artist Ed Ruscha and the artist/comedy writer/composer/performer Mason Williams, perhaps most famous for his hit guitar composition, "Classical Gas." Fellow emigres from Oklahoma, where they had met in fourth grade, Ruscha and Williams occasionally cooked up and produced collaborative projects, most notably *The Royal Road Test* (a spiral-bound book that documents, in forensic fashion, the throwing of a Royal typewriter out the window of a moving automobile, and its aftermath, published in 1967).

Though this conversation seems redolent of a variety of deadpan humor of the period (in the same category as Steve Martin's trademark line, exhaled hoarsely after a deep inhale, "Let's get smaaaaaaaaall"), Mason Williams went to work; and the result was *Bus*, a full-scale (123.5 x 434 in.) reproduction of a 1960s-era Greyhound bus, printed in an edition of two hundred, then folded down and packaged in a box. *Bus* is an inversion of

the question that inspired it, since instead of making a reduction replace, and perform, as the real thing, Williams just confronts us with a big halftone copy of the real thing at real scale. This now extremely rare print was recently on view at the Museum of Contemporary Art in Los Angeles, in an exhibition of works donated to the museum by the artist Michael Asher, and those lucky to see it were quite fascinated by all of the issues dredged up by this strange and humorous work. The joke of *Bus* is in the wacked-out proportion between the (obvious) amount of processing needed to deliver the image, versus the amount of actual information delivered. It's "low-res" taken to an extreme: the mechanical reproduction is unavoidable, and yet there's that big old bus, two out of three dimensions confronting reality, and you know exactly what you are looking at, despite all that is missing.

While *Bus* veers and crashes right into absurdity, it is exactly at the level that Mason Williams could deliver; other ideas that he had, such as a attempting to make a one-to-one reproduction of the Empire State Building, or a (comparatively modest) tugboat just could not be realized. But the bus was doable, though the process to make the print in the days before digital imaging and large-scale inkjet printing was daunting. Williams commissioned the Los Angeles photographer Max Yavno to shoot the bus on a 4 x 5 negative; a 16 x 20 inch print was then sent to a company in Florida where the full-size image was divided into sixteen

segments and printed onto billboard paper. It's clear that Williams didn't fully anticipate what he had gotten himself into: he asked for the two hundred copies to be delivered to his apartment in Hollywood, and ended up with a 5 x 7 foot pallet of paper weighing over a ton sitting in his driveway. Then, he had to face the problem of collating and taping together the sixteen sheets for each print. It was a big challenge just to find a place to tape the sheets together—a tennis court didn't work because the sheets kept blowing around. He finally found the upper floor of a folk club in Glendale that was just about a foot-and-a-half larger than the entire print itself; and four-and-a-half miles of double-stick tape later, he had an edition.

Bus had a peculiar existence: it was immediately exhibited at the Pasadena Art Museum, and a few months later it was included in the Word and Image exhibition of posters curated by Mildred Constantine at the Museum of Modern Art (where there is a picture of people doing graffiti over it at the opening). It was used as a stage backdrop for Williams playing guitar on *The Smothers Brothers Comedy Hour*, where he was a writer for the show; it also appeared on one of Williams's album covers. Greyhound proudly published it in their corporate magazine in 1970 (including pictures of Mason Williams on tour with his band in a bus, of course). In 1967, *Life* magazine staged a photograph of *Bus* in front of Radio City Music Hall (punching holes through it for "passengers" to stick their heads through); the article, called "The Great Poster Wave," featured all the major San Francisco psychedelic poster designers, including Peter Max. That *Bus*, despite its gargantuan size and tiny

print run, was also deemed disposable enough to destroy for a party or a photo shoot might have had to do with the fact that Williams was selling them for only thirty-five dollars apiece. He figured that each copy took nine hours to make, and clearly the Sisyphean production of ordinary commercial graphics at Kmart prices was part of the weirdness of *Bus*.

The eccentric charm of *Bus* is its absolute connection to the time and place of its making. Los Angeles was the location of Warhol's first gallery show, an exhibition of Campbell soup cans at the legendary Ferus Gallery in 1962. The soup cans were (literally) larger than life, as are product names in the photographs and early paintings of Ed Ruscha (one canvas of 1962 featuring a very large Spam logo is even titled *Actual Size*). Sister Corita was making her inspirational silkscreens (and staging Mary's Day parade happenings) out of appropriated shards of advertising typography and copywriting right in the neighborhood where Ruscha and Williams lived. The city was awash in oversized "pop" advertising attached to the movies, scattered amongst the somewhat crappy, first generation commercial buildings that sprawled along the boulevards of Los Angeles: the same gasoline stations, apartments, parking lots, and facades of the Sunset Strip documented so literally by Ed Ruscha in modestly-scaled (yet revolutionary) books that he began to publish around 1963.

When Mason Williams made his edition of *Bus* in 1967, he didn't stop with the production of the image as a poster: he took one more counterintuitive step and had each gigantic poster folded down and packaged in a box. Working

with two friends who found a prototype for a sort of enlarged document storage box, he had the box designed with the title *BUS* on one side, and a deadpan description of the process of producing it printed on the other side. (Including the instruction, "Warning: Do Not Open in the Wind," a tip learned the hard way by Williams.) The funny thing about the packaging of the poster into the box is that it does solve the problem of how to handle and distribute the edition. At the same time, it makes the bus poster even more improbable than it already was: the idea of stuffing full-scale reality into the box is what turns the poster into a crazy hybrid of a book and a spectacle, and the folding and (perhaps) re-folding of it into a communal performance piece. (Though most owners of *Bus* never got that far: Michael Asher confessed to never opening it in all the years he owned it, fearing the consequences of having to get the poster back into the box, and finding it satisfying enough, as he put it, "just knowing that I had a bus in a box.")

Bus was a stunt, a wacky rejoinder to Ruscha's books like *Some Los Angeles Apartments,* or *Every Building on the Sunset Strip*. The ordinary commercial printing standards accepted by Ed Ruscha for his cataloging of the quotidian (scaled down into the pages of a small book) are misunderstood by Mason Williams in a Smothers Brothers-esque, slightly brain-addled way: "Oh, man, you mean you didn't mean billboards?" And instead of the low-key elegance of Ruscha's books (not quite "book" enough for the Library of Congress to accept them for their collection, at first), you get ten pounds and seven ounces of ordinary commercial printing delivering the same everyday world at full-scale: *Bus* is heavy, in more ways than one. It's true that Mason Williams's confrontation with the super-sized print predicts, maybe unintentionally and in a completely sideways manner, the obsession with the reality of the landscape at 100 percent that characterized the work of some American minimalist and conceptualist artists, such as Robert Smithson or Michael Heizer, just a short time later. Reality was a big issue in the '60s, and while some of it is dead serious and driven by philosophical inquiry, *Bus* is the literal poster child for the flip side of that inquiry—the uncanny surrealism of everyday life. Standing in front of *Bus* forty-one years after its making, one can still feel the buzz of ideas swirling around it, enhanced by the humor and energy embodied by the unlikeliness of its production, presentation, and scale. Those of us who design printed things that are meant to reproduce and preserve a moment in time at any size can only hope that our efforts are as 100 percent fine as the *Bus* in the box.

ORIGINALLY PUBLISHED
12.02.09

COMMENTS
13

Martha Scotford
Ulysses: Fast Track to 1934 Best Seller

Imagine you're a big American publisher, and there's a book infamous for its subject and language that you want to publish—but first, you have to go up against the US government to prove it should no longer be banned. And, given the publicity of the court case, you want the book in the bookstores as soon as it's legal.

This describes the situation facing Random House in 1933 as they waited to publish James Joyce's *Ulysses*, which had not been allowed into the United States for twelve years. How they got the ban dropped and delivered the book at just the right moment is a short tale of legal, design, and production choreography.

In 1934, a confluence of US legal, literary and cultural history (not to mention American book design and commercial publishing) produced the first legitimate US edition of Joyce's *Ulysses*. The novel had begun serialization in 1922 in the *Little Review* magazine when US postal authorities seized several issues because they contained obscene material. Once banned but published abroad, copies were covertly brought back into the states by many Americans.

In March 1932, Bennett Cerf, then president of Random House, signed a contract in Paris with James Joyce, responding to Joyce's desire for an authorized and corrected text published in America that could establish his copyright. Random House intended to precipitate a court case to get the ban overturned.

Understandably, Random House wanted books for sale as soon as the ban was lifted. There were two options: the first, being to publish, sell, and wait for the lawsuit sure to come—which would prove enormously expensive if they lost the lawsuit. Alternatively, at the direction of Random House, an existing copy of the book was sent from Paris to Cerf into which copies of positive comments and critical reviews were pasted (to make sure they would be presented as part of the court evidence). The publisher informed the customs officials of the book's arrival in April, to ensure it was opened and seized.

By October 1932, the book was slowly making its way around the New York District Attorney's Office when Cerf reported that a known book pirate was about to release another edition. The court case proceeded, but was postponed several times, with the choice of judge critical. By September 1933, Judge Woolsey (something of a liberal jurist) was chosen and took the book on vacation. Two months later, the case opened and within a month, Woolsey had delivered his decision in favor of *Ulysses*. In his remarks he said he had read the whole book, going over several times the parts believed most objectionable by the US government. He found the book frank, he reported, but not with "the leer of the sensualist" and, therefore, not pornographic. It did not have the effect of an aphrodisiac and should, in his opinion, be admitted to the United States. (As it happened, this was a week after Prohibition was also repealed.)

Martha
Scotford

Ulysses: Fast Track
to 1934 Best Seller

Cultural
Investigation

**Culture Is Not
Always Popular**

65

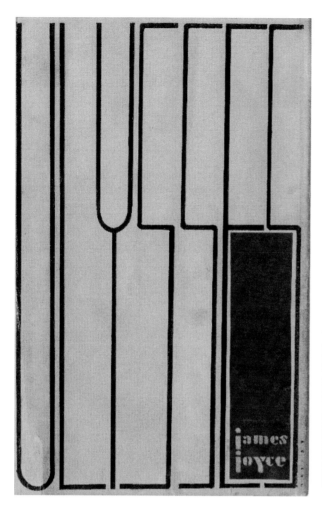

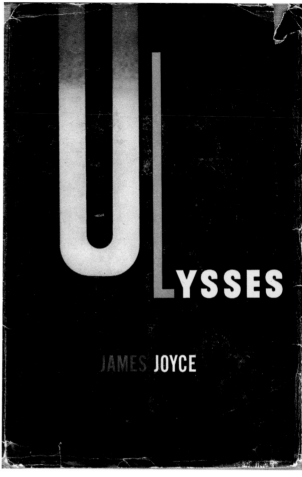

With the announcement of the verdict, Cerf ordered a first print run of 10,300 copies to be ready by January 25, 1934, selling for three dollars and fifty cents apiece. How would they manage that?

During the long wait for legal resolution, Random House had commissioned the interior, binding, and jacket design from Ernst Reichl who worked for H. Wolff Manufacturing (one of the largest book producers at the time). Ernst Reichl came to the United States in 1926 with an art history PhD, and experience in book publishing and design in Germany. He was a "whole book" designer, believing in the harmonious totality of the package and the value of one design vision for all its parts. He would rise to become one of our top book designers, prolific and award-winning, actively promoting the profession and high standards in book design from the 1940s into the 1970s.

The typographic design of *Ulysses* was highly praised at the time of its publication, and the book has gone on to represent a kind of incipient modernity in American book design, particularly in typographic and publication histories. When reproduced, the arresting title spread has stood for the whole. But this isn't the whole story. As Reichl explained in a 1979 interview, "Bennett Cerf wanted it to come out as soon as possible, for the sake of publicity, after the book had been cleared for publication. So he told H. Wolff to start the composition on it, which was not an easy thing to do, because every edition of *Ulysses* at the time had misprints in it."

Reichl later described their still-risky production scheme: "What with repeal (of Prohibition) and a number of wine books going to print in a hurry, what with 6,000 copies of *Anthony Adverse* (that year's best seller) having to be

LEFT Designed by Ernst Reichl for Random House in 1934.

RIGHT designed by Edward McKnight Kauffer for Random House in 1949.

delivered every day, two months had about gone when the dummy of *Ulysses* was finally done. Judge Woolsey's decision was expected shortly, and everything had to be co-ordinated in such a manner that the book could be set, proofread, paged, read again, plated, read for a third time, printed, bound and delivered within five weeks. All materials were selected and work scheduled in such a way that it would proceed in relays: while the last part was still being set preceding chapters were to be made into pages, the middle of the book being plated and the beginning actually on the presses. The initials were drawn, the wrapper marked up for type. To prevent any mistakes it was decided to set from the French edition, published by Shakespeare & Co., in Paris and to read against the German edition of the Odyssey Press in Hamburg. ..."

Five minutes after receiving word of the legal decision, the book went into full production and arrived in bookstores on schedule. The serious effort to produce a correct text was foiled. Rather, as the James Joyce Society website reports, the editors were fooled by a pirated edition printed to look exactly like the Paris edition, even with the Shakespeare and Company name included. This, however, was the careless product of an irresponsible typesetter who committed numerous errors which would not be corrected until the 1940 Random House edition.

Reichl called *Ulysses* "the best known design I ever made" and reported that Merle Armitage showed the title page in slide lectures "to indicate [a] break with tradition." Armitage would go on to use the two-page and large scale concept in several of his own book designs. According to Reichl's notes from 1973, the interior design remained in print until the '70s.

In the end, Ernst Reichl and Random House produced a book celebrated for the content and the style of its writing, presented in a restrained design orchestrated on the jacket, title spread, and part opener pages. Following changes in marketing and production over time, the jacket and cover were repeatedly replaced, but always with an echo of original, until it returned in 2002.

Martha
Scotford

Ulysses: Fast Track
to 1934 Best Seller

Cultural
Investigation

**Culture Is Not
Always Popular**

67

Randy Nakamura
Steampunk'd, or Humbug by Design

ORIGINALLY PUBLISHED
07.07.08

COMMENTS
188

A little reflection will show that humbug is an astonishingly wide-spread phenomenon—in fact almost universal. —P.T. Barnum

Humbug is a term infrequently used in design. It is an archaism straight out of the nineteenth century, meaning "hoax" or "nonsense." The word has strong associations with Dickens's Scrooge and the ultimate showman and hoaxer himself, P.T. Barnum. In this time of cultural recycling, it is a word perhaps best used to describe steampunk, a subculture supposedly born out of a mash-up of DIY (do-it-yourself), Victoriana, punk, science fiction, Japanese anime, and the urge to re-skin one's computer as nineteenth-century bric-a-brac. If the number of recent articles in the mainstream press is any reliable barometer (the *New York Times, Boston Globe, Paper*, and *Print* all have featured the movement in the past year), steampunk is the next big thing. This appears to be the result of a fascination with remixing historical and contemporary aesthetics, as if all eras can be collapsed into the present. What is most interesting and disappointing about steampunk is the odd DIY design culture that it has engendered.

Dissatisfied with their out-of-the-box Dells or Apples, steampunkers have declared war on mass production. Their solution? Nineteenth-century Victorian England. A strange choice to say the least. Recalling an era that is the ground zero of mass production, the cultural inflection point from the artisan to the manufactured is an odd way to escape the evils of silicon chips, instant obsolescence, and homogeneous design devoid of the human hand. I haven't figured out whether cracking open your computer, attaching it to an Underwood typewriter, then inserting it into a combination Victorian mantel clock and desk and calling it "The Nagy Magical-Movable-Type Pixello-Dynamotronic Computational Engine" is some sort of daft wit or evidence of a pedantry bordering on the pathological. Steampunkers may have dubious taste, but one cannot accuse them of lacking a sense of humor. However, the jig is up: as a design aesthetic, steampunk is still nascent, a set of interesting ideas that have been given the spotlight far too soon.

Subculture or not, steampunk appears to have achieved the level of a cottage industry on the Web. From the Steampunk Workshop to the Aether Emporium there seems to be no end of sites showing off these farragoes. Guitars embellished with gears, countless keyboards and LCD monitors embroidered with brass fittings and feet, and objects which merely seem to be fulfilling the formula of: brass + wood grain = Victorian. Conversely, there seems to be a distinct fascination with exposing mechanisms, peering inside the shells of things. This is a popular, almost hackneyed post-modernist trope, an idea about dismantling received structures and conventions that have run rampant through every conceivable medium over the last half century: the turning of buildings

Tom Sepe
07.22.08 08:56
My name is Tom Sepe and I'm the creator of the Whirlygig Emoto—(the "steampunk motorbike" that you failed to credit.)

Firstly, if you are going to make the point that steampunk is non-functional surfactant, then you really shouldn't use a photograph of my bike as an example. The fully-functioning Whirlygig is built on a junked 1967 frame that has been completely re-tooled, gutted and forced to motivate using lead-acid chemical electricity—an 18th century technology that very well could have been society's primary one if not for the oil and rubber industries. (I am of course using modern electronics to control the input and output of electrons, yet the principle is the same one that powered the first electric vehicles.)

And although I agree that "function" is a primary component of Steampunk, I would also submit that it is the job of the artist to decide what function is fulfilled. ... So to critique a laptop-mod as being "all about the look" is really missing the point. ...

If at worst, Steampunk is "bad hobbyists with great publicists" as you say, then perhaps you might also notice that at its best, Steampunk is a vibrant and multi-faceted artistic movement, that includes men and women, geeks, metal-workers, hobbyists, scientists etc..- a movement that is inspiring people to create beautiful, functioning objects in the world around them, and to share that know-how with anyone who is curious.

inside out to expose ductwork and utilitarian structures once hidden; the metafictional narrative where the conventions of the narrative structure are continually exposed and corrupted; clothing that bares every seam, stitch and piece of fabric, and so on, ad nauseam. The steampunkers seem to take all this a bit more literally. Sean Orlando of the Kinetic Steam Works ingenuously observes, "The wonderful thing about a steam engine is that you can follow the path of power generation and function beginning with the fire box and boiler, follow the plumbing, valves, gauges, gears, d-valves, pistons, eccentric shafts and fly-wheels all the way from the source of power to the final outcome of kinetic potential." One could easily argue that following the etched surface of a printed circuit board would provide no less a fascinating visual "map" of the processes of a computer or electronic device.

Yet as Peter Berbergal of the *Boston Globe* notes, "in all of the new Steampunk design there is a strong nostalgia for a time when technology was mysterious and yet had a real mark of the craftsperson burnished into it." Never mind the fact that the Victorian era was a time of demystification: Darwin's theory of natural selection upset centuries of received religious knowledge about human origins, and the mechanization of virtually everything meant you could produce objects, designs, and books ten or twenty times faster and distribute them to the very ends of the Earth. As Philip Meggs, commenting on the beginning of the Industrial Revolution, has succinctly put it: "Handicraft almost completely vanished. The unity of design and production ended." The world had suddenly become smaller. If steampunkers are looking to the past for some sort of inspired return to a prior era, then they are running in slack parallel with their ancestors. The Victorians were cultural raiders without peer. Rococo, Tudor, Gothic revival and the umpteenth generation of *neo-neo-classicism* were not enough. They went abroad to bring back the ill-gotten gains of their imperial aesthetic loot. Moorish ornaments, Ukiyo-e, Chinese porcelain, and hieroglyphics all found their way into Victorian eclecticism. Form *before* concept.

Despite the formal clumsiness of most steampunk objects, there is a certain conceptual zing to them: the immediate thrill of a counterfactual come to life. What if Charles Babbage's steam-powered difference engines (think of a computer with mechanical gears instead of silicon chips) had been completed and mass produced in the 1820s? Voilà! It would look exactly like this "antiqued" PowerBook, the mutant spawn of a nineteenth-century Sears catalog and the Apple Industrial Design Group. Or perhaps not. If one gets past the patina, the quaintly burnished woodwork, the problem is that steampunk is far too enamored of the look, the surface skin of an derivatively small chunk of the Victorian era filtered through Terry Gilliam's *Brazil* and Jules Verne, whose illustrated "scientific romances" seem to have formed the ur-aesthetic for steampunk. But the inspiration gets butchered in the process. There is nothing yet in steampunk that can remotely compare visually to Gilliam's dystopian epic or the ornamental splendor of the Hetzel edition of Verne. In comparison, steampunk is humbug design, scrap-booking masquerading as the avant-garde.

There also is the larger issue of what exactly the Victorian influences are doing on the level of meaning. If Terry Gilliam's *Brazil* is really a touchstone for steampunkers, does that not imply that they are substantively misreading Gilliam's use of the Victorian? In *Brazil*, it is fairly clear that these aesthetic anachronisms are instruments of oppression and surveillance: the omnipresent, naked CRT monitors with magnifying glass attached and typewriter keyboards give a sweatshop aura to every office. Or, the labyrinthine ductwork that emerges from the walls clumsily conceals the infra-structural guts of a society that is cheap, totalitarian, and constantly at war (the lack of finish and recycled nature of most contraptions in the movie seems to indicate war time shortages and rationing). I would even argue that Brazil is less influenced by Victoriana in its aesthetic than say *film noir* and a funhouse version of Blitz-era London. Was not *Brazil* once described by Gilliam as "Walter Mitty meets Franz Kafka?" But these nuances seem to be lost on the steampunkers, who obsessively fixate on a few oddly-styled gadgets from the film.

Steampunking, with its commerce-driven, faddish re-skinning of their own history, is closer to Disney than punk or sci-fi. A laptop styled like an Eastlake sideboard is merely a threat of bad taste, not a threatening reaction to massive social and economic disenfranchisement. In its essence steampunk seems suburban in its attitude: nostalgic for an imagined, *non-*

Randy
Nakamura

Steampunk'd, or
Humbug by Design

Cultural
Investigation

**Culture Is Not
Always Popular**

69

existent past, politically quietist, and culturally insular hidden behind cul-de-sacs of carefully styled anachronisms that let in no chaos or ferment. The larger, more impossible questions are missing. How would the Victorian imagination conceive and execute a functioning computer? The answer must be more interesting than adding wood veneers to your laptop or turning a mouse into a contraption of gears that looks more like a medieval torture device.

We are being taken for rubes. At worst, the steampunkers seem to be mediocre hobbyists with great publicists. It seems fine to me that an obscure niche of DIY hobbyists want to create an imaginary Victorian present, no matter how insular or simpleminded it might be. Reality is what you make of it, even if it is apparent

that some people prefer reality to look like a discarded sci-fi movie prop. It is entirely another thing for the press, in their endless "style" trolling, to claim steampunk as some sort of important movement. If the press behaves as a gaggle of inept tastemakers, then the uncritical pimping of steampunk must serve as a "mission accomplished." What it boils down to is that instead of inventing something new, the Steampunkers have mastered one of the oldest of arts: that of self-promotion. P.T. Barnum, that nineteenth-century master of theater, hoax, and hype, would be proud.

ORIGINALLY PUBLISHED
05.07.09

COMMENTS
57

John Cantwell
Trump, the Logo

The first plans for Trump Tower were drawn in secret, late in the 1970s. Der Scutt, the building's architect, devised a saw-toothed, gleaming dark bronze glass tower that was to be constructed on the site of the old Bonwit Teller department store on Fifth Avenue in New York City. The secrecy, uncharacteristic of Donald Trump, was for good reason. When Trump and Scutt began work on what was then dubbed "Project T," Trump had neither the rights to the Bonwit Teller property, nor the funding for construction, nor the approval for a crucial urban redevelopment tax abatement from New York City, nor the air rights from neighboring Tiffany's, which Trump needed in order to build the Tower to his desired height. In short, Trump Tower began as little more than a mad scheme, the sum of Trump's vast confidence and appetite for success, and the project's fate would ultimately hinge on Donald Trump's ability to will Trump Tower into existence.

Put mildly, Trump's ambitions for the Tower were enormous. With only one major project to his name, the Grand Hyatt on East Forty-Second Street (on which Der Scutt was also the lead design architect), Trump was, at best, a semi-somebody—the big-talking son of Fred Trump, a well-connected outer-boroughs developer who owned thousands of working-class housing units in Brooklyn and Queens. For the younger Trump, who was already flipping properties in Ohio and Arizona before he finished undergrad at UPenn, con-trolling his father's sizable real estate holdings would never be enough. There was little glamour in middle class housing. And besides, whatever money could be made running the family business would never match the billion-dollar deals being brokered across the East River, in Manhattan. From the start, Trump Tower was intended to be Donald Trump's literal and figurative stamp on New York City, a bold, once-in-a-lifetime swipe at the big leagues.

Trump Tower was the first of Donald Trump's buildings on which his name appeared—a significant personal achievement for someone so concerned with personal recognition, but also an important step forward for Trump's businesses. Affixing his name to the building made Trump Tower an instantly recognizable landmark and transformed the Tower into Trump's most literal and significant vehicle for branding both himself and his future projects. The building's logo—thick block letters that spell out TRUMP TOWER in all caps—was particularly significant to the emerging Trump brand identity, marking Trump's territory on Fifth Avenue while also defining his prevailing aesthetic and influencing the ways he would label subsequent buildings.

The logo above the building's main entrance, huge and gleaming in thirty-four-inch brass block letters, bluntly announces Trump's presence on the street. It's crude, perhaps, but undeniably effective. In a neighborhood filled

John
Cantwell

Trump,
the Logo

Cultural
Investigation

**Culture Is Not
Always Popular**

71

with names like Bergdorf, Cartier, and Tiffany, none is more prominent than Trump's. Inside, the same lettering is repeated (in miniature) on nearly every conceivable surface—on windows, directory signs, elevator labels, you name it. At a certain point, the word "overcompensation" springs to mind. Trump uses the logo to ensure that he is never shown up by his high-profile neighbors, or even by the prominent tenants in his building. From the moment you walk under those big brass letters and enter the Trump lobby, with its eighty-foot waterfall and rose-colored Italian marble walls, it is made plain that you are in Trump's world, and no one else's.

Trump Tower was built under an airtight construction schedule. If the building was not completed by the end of 1983, Trump would not qualify for a massive tax abatement from the city, so much of the building's design, including the logo, was done on the fly. Final preconstruction renderings of Trump Tower did not include a visual identity, and early photos of the construction site show that Trump was using a temporary—and very ugly—logo when ground was broken. A later photo, though, taken roughly a year before the building opened, shows that Scutt and Trump had by then chosen the final identity. The picture shows a brass quintet standing atop an awning in front of Trump Tower, the building's steel skeleton still exposed. A lit Christmas tree sits on a riser behind the band, and off to the right, almost out of view, the final Trump Tower logo is visible.

Der Scutt designed the Trump Tower logo. Scutt says he had relative autonomy in terms of the logo's design, at least initially. Scutt chose the lettering for the logo—Stymie Extra Bold—because he thought it fit the look of Trump Tower. His design, he says, was "a purely aesthetic decision." Stymie is in some ways an ironic choice for Trump Tower. Designed in the 1930s by Morris Fuller Benton for the American Type Foundry, Stymie is a typeface more often associated with industry than luxury. IBM used a variant of Stymie for its logo, and the New York Times Magazine has used Stymie for years. In other respects, though, Stymie is perfect Trump Tower. Stymie belongs to a family of typefaces called slab serifs, which are often used for visual identities that call for impact; a lot of college uniforms, for instance, use slab serifs. Scutt, however, says he did not consider the typeface's history when he chose Stymie.

"I couldn't give a rat's ass as to the history of it," he says. "I chose it because I liked it."

Der Scutt's only lasting regret about the logo is something he had no control over. Scutt's initial design for the lettering over the building's main entrance called for the letters to be seventeen inches tall. He was aiming, he says, for elegance; he kept telling Trump to "be Tiffany's"—that is, he wanted the building's entrance to communicate with its elegant neighbor. Trump had other ideas. According to Scutt, Trump went behind his back and had the letters doubled in size, throwing off the proportions of the entrance. "I told him people flying into New York would see the sign before their planes landed," he says.

The rest, though, is history. The Trump Tower logo became the basis for the identities of Trump's highly visible side businesses and glamour projects—Trump's early books, The Art of the Deal and Surviving at the Top, and Trump's board game, Trump: The Game, all used a compressed version of Scutt's design. The logo has also proven remarkably durable—it's remained unchanged for more than twenty-five years, and still exerts a powerful presence both inside and outside Trump Tower. Trump would likely say he predicted that all along.

The overall use of Trump's logos, however, has changed over the years. In the late 1980s, after a decade of rabid expansion fueled by continued leveraging of himself and his properties, Trump nearly went bankrupt. He has referred to this period as a "blip." Whatever you call it, the upshot is that Trump lost much of his empire—management control of the Plaza Hotel; the titles to Trump Shuttle, his airline; his 238-foot yacht, the Trump Princess; and his private Boeing 727 (which he subsequently repurchased). He was forced to agree to a personal spending limit of four hundred and fifty thousand dollars a month. But, worst of all, Trump lost his credit; banks were suddenly reluctant to finance Trump's massive ventures. Trump found, though, that he did not have to look far for a new revenue stream. There was still money to be made by licensing the Trump name.

Trump's first post-blip licensing deal was the Trump International at Columbus Circle. Though the building bore Trump's name— again in gleaming bronze letters—Trump was

high of our most recent gilded age, what better time to look back and consider the excesses from years past?

it's interesting that you would point out the j. lo and britney spears perfumes as another seemingly trivial topic for design criticism. it seems to me more people should be writing about stuff like that from a design perspective. there were probably millions of bottles of those perfumes produced, and they wound up in millions of homes, mostly in the bedrooms of young girls. those bottles explicitly and implicitly communicate so many things—about their namesakes, about feminity, about notions of beauty and desirability—and, believe it or not, they affect how people live. no, a bottle of j. lo perfume is not on the same level design-wise as a gehry building or eames chair. but how many pre-teen girls are being actively influenced by modern furniture design? not many, right? now, maybe the world would be a better place if this situation was reversed. but it's not. and that means (at least in my opinion) that if one is serious about considering design, one must consider the high and low, and deal with the world as it is, instead of only focusing on how it should be. reyner banham made this same point fifty years ago.

more than solely expressing opinions and making value judgements, it seems to me that the role of a design critic would be to help people understand how design affects the world in which they live, or to at least realize that they live in an environment that's actually designed. if people understand that more fully, then they'll perhaps advocate for better design. and that would be good, right?

Damer
06.01.09 10:31
The real story here isn't the logo itself, it's the notion of a man as a brand.

This article touches on the interesting subject of the role of communication design in the creation and perpetuation of the celebrity-as-corporate-entity. So it's odd that the title and general focus of this article is on the actual letterforms of the TRUMP wordmark. Although that backstory is interesting, it's a small part of the overall story (talk about getting stymied).

paid an up-front fee as a consultant, and his ownership stake in the property was limited to a penthouse apartment in the building and a share of the restaurant and parking. Many properties he's developed since have been structured around similar deals. The remarkable thing, though, is that most people still believe Trump owns these buildings; his pseudo attachment to the licensed properties lends them a certain cachet long after he's moved on to the next project. In his 1997 *New Yorker* profile of Trump (written around the time the Trump International was opening and Trump's star was once again on the rise), Mark Singer perfectly summed up Trump's skill for "image ownership": "By appearing to exert control over assets that aren't necessarily his—at least not in ways that his pronouncements suggest— [Trump] exercises his real talent: using his name as a form of leverage."

Today, Trump's licensing empire extends far beyond real estate. A brief sampling of Trump products currently available include Trump Steaks, Trump: The Fragrance, Donald Trump Menswear, Trump Ice (bottled water), and Trump Vodka (with a label designed by Milton Glaser). While he still actively oversees the design of the new buildings that bear his name—he does, after all, need to protect the brand—Trump does not always work side by side with the designers who shape the look of his licensed products. On Trump Vodka, for instance, Milton Glaser's office was hired by Drinks America, the vodka's distributor, and Glaser did not have direct contact with Trump until the Trump Vodka launch party. (Drinks America, coincidentally, specializes in celeb-brand alcohol—they also market Dr. Dre cognac and Willie Nelson whiskey.)

Today, each of Trump's licensed products uses a different visual identity. There is no longer a singular Trump style—the business now hinges on the brand, not the man. Maybe this is what Trump ultimately envisioned thirty years back, when Der Scutt sketched out the first iterations of Trump Tower. Maybe Trump knew the building would propel him into that strange atmosphere, popular culture, where he would forever buzz around our collective consciousness in some gold-plated helicopter. Maybe he understood he was destined to exist as an idea more than a person, to be an adjective and a noun, and maybe this is what he truly desired.

John
Cantwell

Trump,
the Logo

Cultural
Investigation

**Culture Is Not
Always Popular**

73

Steven Heller
Branding Youth in the Totalitarian State

ORIGINALLY PUBLISHED
06.05.08

COMMENTS
11

Youth may be wasted on the young, but under the totalitarian state they were not forgotten. For the state to prosper, youth was turned into a sub-brand that both followed and perpetuated the dominant ideology. Graphics played a huge role in making this happen.

In Nazi Germany, being a member of the Hitlerjugend (Hitler Youth) and Bund Deutscher Mädel (Organization of German Maidens), enabled children to conform to a party that dictated and built a sanctioned social community. As part of a sub-brand they enjoyed the signs and symbols that adhered to National Socialist dictates. Curiously, when Hitler took over the party he wasn't particularly interested in German adolescents because they could not vote. Yet propaganda minister Joseph Goebbels saw Germany's disenfranchised youth as the key to the Nazi's future. So by 1926, when Hitlerjugend was founded, the Führer also believed young people would provide a limitless supply of leaders and followers.

Hitlerjugend accepted all Aryan boys and the Bund Deutscher Mädel all girls, aged fourteen to eighteen. Boys ten to thirteen belonged to Jungevolk and girls to the Jungemädel. For boys HJ was, in effect, the farm team for the SA, SS, and Reich Labor Service. For girls it was a finishing school for being loyal wives and fecund mothers.

Members wore snappy uniforms, went on overnight hikes, played sports, exercised, and earned badges—lots of badges. They were required to spend most of their free time at Hitlerjugend camps, learning the Nazi creed, which included honor, sacrifice, camaraderie, and anti-Semitism. They canvased neighborhoods, distributed leaflets, recruited new members, and often engaged in violent skirmishes with Communist youths. There was even a junior gestapo, the Hitlerjugend-Streifendienst, which monitored other children. During the allied bombardment of Germany, it was the Hitlerjugend members who manned anti-aircraft guns and were killed or wounded. Those who were captured were compelled by their oath to die for the Führer. Much of their fervency came from the barrage of signs and symbols they happily consumed.

The Italians were equally as demanding. Nothing was more integral to Italian Fascist life than its youth. In 1923, Giovanni Gentile, the education minister and Fascist philosopher, conceived of a new educational system. This system was not intended to train youth to think for themselves, but rather, to turn them into instruments of the regime. In fact "the cult of the cradle," as the Fascist strategy was known, was an aggressive official doctrine determined to inculcate in predominantly male youngsters, the mythology of the omnipotent regime in order to transform so-called flowers of faith into soldiers of empire. Relentless propaganda campaigns and the "Fascistization" of schools and youth groups would breed a new cultural order.

that the militant leaders could stand for something evil, yet portray to their followers a sense of pride and security.

The job of the new regime was to weave Fascism through the fabric of Italian society. Teachers were tasked to glorify Mussolini on all occasions. All classes started the day singing the official Fascist hymns, like "Giovinezza" and "Balilla," the anthem of the youth organizations. The mystique of youth was a fascist obsession. This obsession was played out through propaganda and built upon the manufactured youthful image of the Duce (the media was prohibited from discussing his grandchildren but countless photographs of the bare-chested Mussolini were published in newspapers and magazines). The Duce also encouraged the creation of youth groups that emphasized sports and martial training in order that its members be fit enough to carry the baton of the Fascist movement into the future. Indeed the shock troops of Fascism were originally gangs of unbridled youth— a generation of combatants storming through Italy wearing black shirts, jackboots, carrying death's head flags, and wielding batons against an enemy that represented social decay and cultural elitism.

Italian Fascism, like National Socialism, proclaimed a revolution against socialism, liberalism, materialism, and egoism. Just evoking the word revolution implied a generational uprising. The Fascists made the most of their ties to youth, yet paradoxically the propagation of Fascist ideals began with an aging body, the Fascist Grand Council. The orders of the Grand Council were implemented by the Milizia Volontaria per la Sicurezza Nazionale (MVSN), formed in 1923 and was composed of twenty-somethings and older members known collectively as the Blackshirt militia, who personally pledged undeviating obedience to Mussolini. In the spirit of revolution and to infuse fresh blood into the MVSN, the Grand Council instituted youth organizations that included eight to twenty-one-year-olds. The first such group founded in 1920, was the Avanguardia Studentesca dei Fasci Italiani di Combattimento, under the control of the Milan fascio, which published a magazine titled *Giovinezza* (Youth). In 1921 the original group became the Avanguardia Giovanile Fascista (or Vanguardisti) for boys from fifteen to eighteen years old. Within a few years the original journal evolved into a more startlingly designed and expensively produced *Gioventù Fascista* edited by the regime's leading stylist, Achille Starace, which through its modern poster-like covers of young Vanguardisti rendered in a

streamlined manner, defined a Fascist graphic youth style that increased the allure of membership.

The Fascists tightened their hold on the youth, in part through inspiring ideological images. Uniforms were designed with careful attention to detail and style and with each incremental age level the regalia (including various shiny badges and insignia) increased in direct proportion to completed indoctrination. The wearing of uniforms was required during all official gatherings (of which there were many), as well as all rites and celebrations. Although not compulsory for every student during school hours, those not so attired were indeed suspect.

Images portrayed individual young Fascists in sleek poses like statues poured from the same mold. The airbrush became an ideological tool in the making of myths. Fascist artists used the airbrush to streamline human figures into modernistic effigies and this mythic image of the Giovanili symbolized obedience and allegiance. In contrast to the stiff heroic realism of Nazi iconography, portrayals of Fascist youth involved futuristic nuance that reduced the human figure essentially to a sleek logo. The quintessential Opera Nazionale Balilla member wearing short pants, black shirt, fez, and crossed white breast straps looked more like a toy soldier than a hardened fighter; the helmeted Vanguardisti carrying a baton or dagger looked more menacing yet still resided in that netherworld between youth and adulthood.

The Fascists worshipped might and celebrated speed, which was duly represented in modernistic graphics and typography. Antiquated, central-axis page composition was replaced by more dynamic aesthetics that wed futurism to art deco—controlled anarchy to decorative mannerism. Typefaces with sharp edges and contoured right angles expressing velocity, as well as a stencil lettering like *Braggadocio* (Bravado), replaced the classic Roman alphabets (at least in propaganda aimed at the young) considered old fashioned. Language drove the look of type and Mussolinian words like struggle, courage, death, glory, discipline, martyr, and sacrifice were appropriately spelled out in letters that seemed to speak loudly and bombastically.

Mixing Roman (romanità) and Fascist mythology resulted in the mélange of hybrid graphic

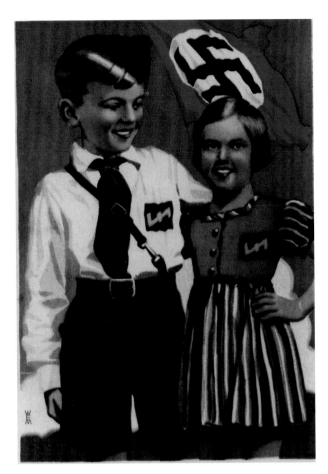

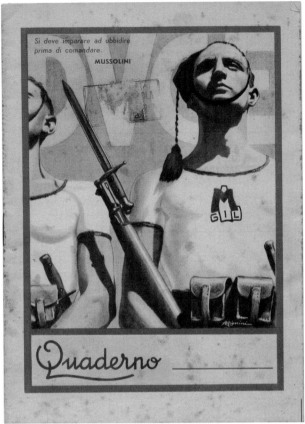

codes. Take for instance covers for quaderni, assignment booklets for school exams and essays, often illustrated with colorful propaganda: the quaderno was such a common accoutrement that it was an ideal place to reinforce Fascist ideas on a daily basis. Some covers showed the Roman fasces rendered in a classical manner while others mixed ancient with modern renderings of Fascist rites. The most popular quaderni covers showed warplanes, weapons, and scenes of fascist conquest (particularly in Abyssinia) sometimes drawn in a light-handed cartoon style, often with the motto "Mussolini is always right" emblazoned on the front or back cover. Graphics were abundant and plentiful when it came to idealizing the Fascist cause.

Children were the great red hope for the Marxist-Leninist "New Soviet Man" and as early as 1918, Pravda, the voice of the Communist Party, affirmed: "the children's book as a major weapon for education must receive the widest possible distribution." By 1924, two years after the Soviet Union was formed, the

Central Committee of the Party announced its mission to develop a new kind of juvenile literature that rejected bourgeois ornamentation and trivial fantasy dominant during the preceding Mir iskusstva (World of Art) era from around 1881 to 1917. In fact, Mir iskusstva books produced during the so-called silver age, as the reign of Czar Nicholas and Alexandra was known, were impressively decorated in the style of the Russian equivalent of art nouveau, a curious fusion of Japonisme, pre-Raphaelite mannerisms, and Russian folk art.

After the 1917 October Revolution, with Russia in the throes of civil war, the Bolshevik state was bankrupt, forcing Lenin to reluctantly embrace capitalistic measures. Under the New Economic Policy, free-enterprise was briefly allowed and as a result almost one hundred separate independent and state-run children's book publishers were founded in Moscow and Petrograd (later Leningrad), each with the goal to enlighten and inspire the next generation through pictorial books. Hence quality book production was attained through high-grade

LEFT Hitler Youth wearing the Hitler Jugend uniform (Austrian version)

RIGHT Quaderno, a school assignment book, featuring images designed to inspire and influence young students

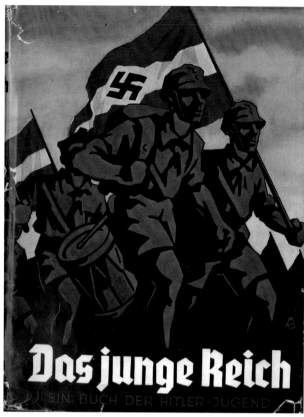

paper stocks and advanced color technology. Which in turn created an art form, that seemed to cry out for experimentation and attracted a slew of progressive revolutionary artists, including Rodchenko, Gustav Klucis, Vladimir Tatlin, Natan Altman, and El Lissitzky.

No one was more determined to end illiteracy and educate the masses than Lenin's wife, Nadezhda Krupskaya, a former school teacher (shades of Laura Bush), who assumed a leadership role, along with commissar Anatoly Lunacharsky, in the Commissariat of Enlightenment. She helped establish free libraries and schools and given her unflagging support for the new literature, picture books were now regularly subsidized by the government as agitprop used for spreading Socialist ideals and Communist programs throughout the land. Literally thousands of titles of various quality and merit were published in hefty amounts ranging from ten thousand to fifty thousand copies, sometimes more.

The holy marriage of word and picture came with an ideological rationale representing the Proletkult movement, which sought to elevate the worker (and proletarian workmanship) to heroic status. But the golden age ended in 1932 when Stalin collectivized the publishing industry (like he did the farms) into a single entity and through functionaries decreed that artists and writers must embrace Socialist realism's turgid "Red Romanticism." Despite a copious number of children's books and pamphlets produced during the initial surge of artistic reform, when Uncle Joe's iron fist fell from above—and many avant-gardists were denounced as counter-revolutionary—books failing to conform to sanctioned parameters were confiscated or destroyed. Formalists, meaning those who experimented with abstract visual languages, were considered "enemies of the people." Anti-intellectualism reigned in large part thanks to Leon Trotsky, who referred to the formalist school as representing "abortive idealism." Parochial thinking ultimately spilled over into children's books.

Michael Bierut
Innovation Is the New Black

ORIGINALLY PUBLISHED
11.20.05

COMMENTS
57

Last month I was invited by Patrick Whitney, director of the Institute of Design at the Illinois Institute of Technology, to participate in a symposium on the "'creative corporation' and the adoption of design by business leaders." Naturally, I said yes, quoting Lance, the drug dealer in *Pulp Fiction*, who, when asked by Vincent Vega what will happen after he gives Marcellus Wallace's wife an adrenaline injection to the heart, answers "I'm curious about that myself."

It turned out that the operant word at the symposium wasn't *design* but *innovation*. Yes, innovation. Everyone wanted to know about it. Everyone wanted to talk about it. One of the panelists was *Business Week*'s legendary design advocate Bruce Nussbaum. "When I talk to my editors about design, I have trouble keeping them interested," he confessed. "But there's a tremendous interest in innovation." The lesson to me seemed clear. If we want the business world to pay attention to us, we need to purge the D-word from our vocabularies. That's right: we are all innovators now.

A recent email provides proof of the timeliness of this approach. "Empower Yourself to Innovate," the DMI urges me, sounding suspiciously like Stuart Smalley. A visit to the DMI's website for their upcoming conference, Empowered Innovation, confirms that the organization has already gotten with the program in a big way. The word "design" is nowhere to be found in the main description of the conference. It finally makes its appearance halfway

through a list of conference topics that include "Innovation within an Organizational Context," "Experimentation Matters: New Opportunities for Innovation," and "Culture-Driven Innovation." It turns out that Magdalena De Gasperi from Braun GmbH will be speaking on "The Impact of Innovation and Design on Brand Equity." Design, it appears, is welcome only when properly escorted ... by Innovation! And it's no surprise that the organization officially known as the Design Management Institute is using its initialism more and more and letting its formal name wither quietly away, just like KFC did as it sought to distance itself from the greasy brand equity of the words "Fried Chicken." I suppose I hardly need to add that the DMI has a blog called—care to guess?—that's right, the *Innovation Blog*.

This mania for innovation, or at least for endlessly repeating the word "innovation," is just the latest in a long line of fads that have swept the business world for years. In the mid-eighties, Motorola developed a seemingly effective quality management program based on a sophisticated statistical model called Six Sigma, which involved attempting to reduce the number of defects in their business processes to less than 3.4 per million. Within a few years, managers everywhere were demanding that their organizations begin "implementing Six Sigma principles." The mystical invocation of the Greek letter; the unnerving specificity of 3.4 per million (as opposed to the presumably unacceptable 3.5 per million); the talismanic

Ryan Nee
11.21.05 01:01
My favorite definition of design is by John Heskett in his book Toothpicks and Logos:

Design, stripped to its essence, can be defined as the human capacity to make our environment in ways without precedent in nature, to serve our needs, and give us meaning in our lives.

Design, by this definition, could include graphic design and architecture, but also business planning, parenting, and just about anything else imaginable. It's about intentionally crafting and shaping something for a reason.

Good design—be it graphic design, parenting, business planning, or whatever—doesn't necessarily need to be innovative. I'd rather have good parents than innovative ones. I'd rather work with a good designer than an innovative one. Innovation should be a result of a good design process, not the other way around. I think that we should start shifting the meaning and scope of design, rather than coming up with catchy—er, innovative—new words to describe it.

bruce nussbaum
11.21.05 06:16
Everyone loves design but no one wants to call it design. Top CEOs and managers want to call design something else—innovation. Innovation, that they are comfortable with. Design, well, it's a little too wild and crazy for them. So they call it innovation.

I've been seeing this phenomenon for some time now—ever since design took off as a strategy and way of thinking

inside big corporations. The same managers who are perfectly comfortable talking about "vision," whatever that is, don't like to talk about "design." Innovation, however, connotes measurement, control and has a kind of engineering tonality to it. So "innovation" is accepted.

As for me, I think that if managers are uncomfortable with the term design, they should call it a "banana." Bananas are beautiful, functional, organic, unique, measureable, portable, pleasurable and provide a delightful, emotional experience to consumers. Bananas embody what CEOs and managers are struggling to achieve in using design to create new products and services.

power of the bell curve diagram that was often used to "illustrate" the theory: all of this arcana was meant to instill awe in employees who would shrug off a homelier directive like "measure twice, cut once."

It's not hard to see why innovation is becoming the design world's favorite euphemism. Design sounds cosmetic and ephemeral; innovation sounds energetic and essential. Design conjures images of androgynous figures in black turtlenecks wielding clove cigarettes; innovators are forthright fellows with their shirtsleeves rolled up, covering whiteboards with vigorous Magic Markered diagrams, arrows pointing to words like "Results!" But best of all, the cult of innovation neatly sidesteps the problem that has befuddled the business case for design from the beginning. Thomas Watson Jr.'s famous dictum "good design is good business" implies that there's good design and there's bad design; what he doesn't reveal is how to reliably tell one from the other. Neither has anyone else. It's taken for granted that innovation, however, is *always* good.

Everyone wins on the innovation bandwagon. A recalcitrant client may cheerfully admit to having no taste, but no one wants to stand accused of opposing innovation. And a growing number of firms stand ready to lead the innovation charge; a much-talked-about article in *Business Week* last August, "Get Creative! How to Build Innovative Companies," singled out Doblin, Design Continuum, Ziba, and IDEO. In fact, if anyone deserves the credit for inventing the don't-think-of-it-as-design-think-of-it-as-innovation meme, it's IDEO. "Innovation at IDEO," visitors are assured on their website, "is grounded in a collaborative methodology that simultaneously examines user desirability, technical feasibility, and business viability." No idle sitting around and waiting for inspiration

to strike at IDEO! Skeptics requiring further persuasion will find it in *The Art of Innovation* and *The Ten Faces of Innovation*, two books that IDEO's general manager Tom Kelley has written on the subject.

I was surprised to learn, however, that although innovation is always good, it isn't always effective. "We all know that reliable methods of innovation are becoming important to business as they realize that 96% of all innovation attempts fail to meet their financial goals," read the invitation to the Institute of Design symposium, a figure derived from research by Doblin. Now, I suppose you could do worse than failing twenty-four out of every twenty-five tries, but this sounds suspiciously like Albert Einstein's famous definition of insanity: doing the same thing over and over again but expecting a different result. But thank goodness, a solution is at hand: "Business leaders are increasingly looking to design to not just help, but lead their innovation processes." So we come full circle. Don't say design, say innovation, and when innovation doesn't work, make sure you saved some of that design stuff, because you're going to need it.

With this new vision of design-as-innovation identified—somewhat chillingly, if you ask me—in *Business Week* as "the Next Big Thing after Six Sigma" (the ironically intended capitalization is theirs), perhaps a new golden age of respect for designers—or innovators, or whatever you want to call us—is upon us at last. Or maybe it simply announces the availability of a turbo-charged version of the kind of frantic rationalizations that we've always deployed in our desperation to put our ideas across. Either way, I'm reminded of something Charles Eames used to say: innovate as a last resort. Have we run out of options at last?

William Drenttel
My Country Is Not a Brand

ORIGINALLY PUBLISHED
11.25.04

COMMENTS
40

Branding was originally an approach for creating reputations for commercial products. Over time, it has come to be applied to almost everything, from high school sports to school meal programs; from universities to research centers; from art museums to ballet companies to cultural institutions; from political campaigns to cities to states. Today, even nations have become brands.

Item: Last month, we flew to Toronto to attend the Ontario Design Thinkers Conference.—a conference in which the weakest presentation came from Jeff Swystun, the global director of Interbrand. Among other objectionable tactics (Swystun showed considerable work produced by other designers, none of whom were credited), his canned PowerPoint presentation displayed, at a certain point, three brand logos simultaneously: Kodak, the Bay (a leading Canadian retail brand), and the American flag. I was outraged, and all I could think was, my country is not a brand.

Item: That same week, Robert George wrote a cover story for the *New Republic* titled "Conscientious Objector: Why I Can't Vote for Bush." This is how he ended his indictment: "At crucial points before and after the Iraq war, Bush's middle managers have failed him, and the 'brand' called America has suffered in the world market." According to his argument, US officials should be summarily dismissed because they have let their shareholders down and the brand has suffered in the marketplace.

Item: In the most recent issue of *Eye* (no. 53), devoted to "Brand Madness", Nick Bell cites the example of Charlotte Beers, former CEO of Ogilvy and Mather, who was hired by the US State Department to "combat rising tides of anti-Americanism." Bell quotes Naomi Klein: "Secretary of State Colin Powell dismissed criticism of the appointment [of Beers]: 'There is nothing wrong with getting somebody who knows how to sell something... We need someone who can re-brand American foreign policy... She got me to buy Uncle Ben's rice.'"

Item: Not long ago, in a *New York Times Magazine* interview, Bruce Mau urged designers to embrace "the richness of the marketplace." By way of example, he described his own approach to this Herculean task: "we are being asked to work on a vision for the future of Guatemala. How can we design Guatemala over the next 10 years?"

What's most troubling here is the deeply inappropriate vocabulary we choose to deploy as we randomly penetrate such allegedly foreign disciplines as politics and international diplomacy. The decision to vote for George Bush based on his handling of the American brand? Defending a State Department foreign policy hire because, "SHE GOT ME TO BUY UNCLE BEN'S RICE?" A designer who believes that, based on his own knowledge of the marketplace, he can re-design the future of a country, albeit just a little one in Central America? While we're at it, let's not forget Rem Koolhaas designing

Ryan Nee
11.26.04 03:57
A logo is a symbol which conjures up a personal point of view about an entity, based on a set of experiences or perceptions of the entity. A flag is a symbol which conjures up a personal point of view about a country, based on a set of experiences or perceptions of the country. There isn't big difference between the two. Is there a need to create one?

I don't see anything wrong with a country trying to figure out how it wants to be perceived, and implementing the steps necessary to get there. Often times, it can be a good thing. We judge countries based on the same gut-reactions that we do corporations -- regardless of whether our judgements are made based upon real experiences or misinformed perceptions. Why not try to control these things?

In branding, language is strictly controlled because it creates experience. In Chinese, the United States of America is translated as "Beautiful Kingdom." That certainly must change China's perception of America. Another example: if we named "Operation Iraqi Freedom" something else, like "Operation Forced Democracy" or "Operation Annihilation," our perception of the same military operation would change, even if the operation itself was identical.

Michael Bierut
11.26.04 06:51
This has been an interesting discussion. It's hard to dismiss the metaphor of America as (poorly-managed?) company when you realize that George W. Bush is our first president to have an MBA, and from Harvard Business School, no

a bar-coded flag for the capitalistic future of the European Union, or Landor setting out to "brand" entire countries, including Jordan and Hong Kong.

Eye addresses some of these issues in its "Brand Madness" issue, as does *Design Observer*'s Michael Bierut in his recent post, "The World in Two Footnotes." (Also relevant are Michael's posts on the marketing of political parties in the Indian elections and the design of the new Iraqi flag.) Jessica Helfand and I also addressed some of these issues a year ago in Vancouver in a talk titled, "Culture Is Not Always Popular."

Nick Bell's article on "The Steamroller of Branding" in *Eye* is a thoughtful critique that examines the process of creating identities for art museums and performing arts centers. Bell notes in particular the way branding has crept into the experience of the art—how it has actually invaded the space of the gallery and performance locale—rather than focusing solely on the commercial activities of these cultural institutions. I agree wholeheartedly with this assessment—yet I find this singular focus on the branding of art and performance institutions somewhat vexing, as it inherently leads back to an impenetrable dichotomy between art and commerce. Weren't the signatories of the First Things First manifesto attacked for privileging high culture above commercial culture? Ultimately, this minimizes the importance of this essential critique of "brand madness" that make the newest suite of Eye essays so imperative.

The problem with "Content," as I believe both Bell and Bierut would attest, is that it risks becoming a fundamentally generic concept: in this way, it's not unlike the way "the brand" has become simply "Brand," sometimes invoked with an almost religious-like tone. (Whenever I hear these terms used in this way, I'm reminded of Goethe writing about the Sublime.) Content should not be an abstraction for designers, but rather something to be evaluated in specific and differentiated terms. It is in its specificity that designers need to begin making distinctions—distinctions which are not merely programmatic or pragmatic, but carry with them implicit moral dimensions.

There is, for instance, a difference between helping an NGO to fundraise and helping an NGO to disseminate information about the state of the world in a crisis zone. Given the requirements of capitalism and communication in a branding-laden culture, such overtly divergent goals are, oddly, being subsumed under the same umbrella of *branding*. And yet they could not be more different.

The CARE identity program—its logo and its branding applications—are not the same as its challenge to the United Nations to take strong action in the Sudan. Its project no. SDN099 funds reproductive and psychosocial health services for abducted children and survivors of sexual violence in South Darfur. Meanwhile, through its corporate partners, Cisco Systems is helping to feed widows in Afghanistan, and Starbucks and CARE "Winning Together" to fight global poverty, especially in major coffee-growing areas of the world. Of course, you cannot find CARE in Iraq because they have withdrawn after "the apparent death of Mrs. Margaret Hassan." But right next to the "Donate Now! Sudan Crisis" button, you can "Click here to voice your sympathy for her family."

This is but one instance in which the muddled notions of branding are communicated, and even here, there are multiple types of content revealed: some tragic, some critical to the future of a geopolitical region, some involving genocide, some abjectly promotional. What is missing, however, are distinctions: distinctions between marketing efforts (CARE fundraising for hunger) and promotional initiatives (Starbucks feeding hungry laborers in Columbia); between communication (CARE reporting on a crisis zone) and advocacy (CARE trying to persuade the UN to intervene in Darfur); and between news feeds (Margaret Hassan's brutal murder) and community (at the push of a button, send her family your heartfelt condolences now). The future of peace in entire regions of the world is the topic, and yet the form for our experience is fundamentally filtered and branded—just as in Nick Bell's example of the filtered and branded experience of art in museums.

Branding, of course, has its value, its place in commerce and its confirmed role in the implementation of certain design initiatives. At its best, it leads to better commercial communication, to understanding the needs of an audience, or building long-term relationships with consumers. And yes: wouldn't the world be a better world if more countries understood

(and by conjecture, respected) the perspectives of other countries? Wouldn't America be more successful in the Arab and Muslim world if it was a little less interested in cheap oil and a little more interested in their culture, their interests and needs? Wouldn't it help if the United States had more people in its State Department who spoke fluent Arabic? (As of last year, there were only fifty-four, according to the Advisory Group on Public Diplomacy's report Changing Minds Winning Peace.)

Meanwhile, we set our sights on branding the war, with sound bytes and promotional bumpers like "Operation Desert Storm" and "Operation Iraqi Freedom." In England, "Britain TM" is created for the Blair administration by Demos, based loosely on the premise of "Cool Britannia." There are also studies giving legitimacy to the "Branding of Britain in relation to the Brand South Africa." In Iraq, even before it had achieved independence as a sovereign nation, branding experts had a plan for a new Iraqi flag, a design that today might be characterized as either a failure of process or of research. At the end of the day, it was neither: it was a failure of intent. The symbol for a country should not be created by branding experts.

When the vocabulary of a nation's foreign policy is the vocabulary of branding, then it is, in fact, selling Uncle Ben's Rice. This transaction, with the vocabulary of the supermarket counter, is not how I envision my country speaking to the rest of the world.

ORIGINALLY PUBLISHED
02.09.10

COMMENTS
40

Mark Lamster
What Am I Doing Here? Tall Buildings and High Anxiety in Las Vegas

John M. Carlin
02.26.10 12:41
Here's my tourist's take on "What's the point of CityCenter if it's just an upscale development in a mid-size American city, six hours from New York?".

In a nutshell, I see no point or value in a continued Disney-fication of Vegas. For most of the places those that adopted a heavy theme, any semblance of seamless experience degrades quickly as soon as you get past the lobby or casino floor. By the time you're in your room, you couldn't differentiate it from any major hotel chain room in any other city. I think the question should be flipped on it's head a bit and ask why would someone go to Vegas to think or believe their experiencing Rome, Paris or New York?

dan stutz
02.26.10 10:36
I loved my one week visit to Las Vegas last January. Entering Citi Center was quite eye-opening, exciting and yes, exhausting. The inside Aria Hotel decor was a brown orgasm of understate-ment. The cold weather helped us walk, walk and walk between all of the glass buildings. The main question is: what will Fat America do in July when the tem-peratures reaches 128 degrees? Clark County had better rent one or two of the empty luxury shop spaces for Mini Emergency Room Clinics. Hope they stay out of Chapter Eleven!

A weakness of much architectural criticism is that it is, by nature and necessity, formalist. A critic looks at a work in its opening week—if not before—forms an opinion on its aesthetics and takes a guess as to how it will function. There is utility to this practice: we all want to hear about the next new thing, and we want to hear about it right now. But it's also deceptive; so many of architecture's qualities reveal them-selves over time and through prolonged expe-rience. Visiting a place is vastly different from living in a place. Our perceptions of something new will gradually change as we learn to live with it, as we see how it operates and as our behavior changes along with it. The departed World Trade Center, if nothing else, serves as an indelible reminder of just how vastly our ideas about buildings evolve over time.

A few weeks ago I spent three days in a new entertainment complex, CityCenter, in Las Vegas. What follows here is not a traditional re-view, but a diary of my experience in that time. While I won't pretend that this offers some kind of corrective to the problem described above, it did at least allow for a certain immersion in the project, and along similar lines to what a typi-cal guest might experience. It should be noted that my stay was financed by CityCenter. This is how a good deal of architectural coverage is paid for in these straitened times. Few publica-tions have the resources to send critics around the globe, and the number is ever diminishing.

Before we begin in earnest, here's the tale of the tape: CityCenter, as its name implies, is a downtown unto itself: sixty-seven acres, three miles in circumference, more than six thou-sand hotel rooms serviced by twelve thousand employees. It cost upward of $8 billion to build. The place has generated its share of controver-sies, about which you can read elsewhere. It is wedged into a plot along the Las Vegas Strip between the Bellagio and the Monte Carlo, to which it is connected by a private monorail—all three properties are owned by MGM Mirage. CityCenter was master-planned by Ehren-krantz, Eckstut, and Kuhn, and has four hotels designed by name-brand architectural prac-tices (Cesar Pelli, Rafael Viñoly, Norman Foster, and KPF), a pair of condo towers (by Murphy/Jahn), and a full-blown work of starchitecture (a shopping mall by Daniel Libeskind). Its con-ceits are several: It is the first and only "green" complex on the Strip. It is a diversified enter-tainment complex in which gambling will not be the primary revenue source. It is relentlessly and unapologetically modern.

Okay. Here we go.

Day 1
3:30 p.m.: Picked up at McCarran Airport by one of CityCenter's stretch limousines. It is sil-ver and powered by natural gas. Can there be such a thing as a "green" fleet of stretch limos? Welcome to Las Vegas.

Mark
Lamster

What Am I Doing Here?
Tall Buildings and High Anxiety
in Las Vegas

Cultural
Investigation

**Culture Is Not
Always Popular**

83

4:15 p.m.: Arrive at CityCenter. First impression: the statistics attesting to its scale hardly do it justice. It makes New York's TimeWarner Center look like a suburban strip mall. It appears cool and efficient and expensive—the same ambiance as TimeWarner. It takes the danger and seaminess out of Las Vegas and replaces it with name-brand corporate opulence. Is this a good thing or a bad thing? I'd like to experience a little of the honky-tonk that makes Vegas Vegas, but I'm glad to have an austere room with impeccable fittings—no cheesy faux design here. The Aria hotel (Cesar Pelli) is pristine, and the view from the thirty-fourth floor extends beyond some pretty unimpressive competition. (I'm looking at you, Planet Hollywood.)

4:30 p.m.: As for honky-tonk: it's right across the street. Tattoo parlors. Discount marts. Off-brand fast-food joints. But it's hard to get to them. CityCenter is an anodized-aluminum Oz sheathed in reflective glass, a place apart from a city as fragmented as Daniel Libeskind's architecture. There is literally no way to cross the street at grade. Forget being a pedestrian here.

4:45 p.m.: One has to walk outdoors to travel between the buildings within CityCenter. This was a strategy imposed on the architects to foster a sense of urbanity and to keep the

place from feeling hermetic, but it's less than ideal on this (rare) rainy day, and I suspect it will be especially unpleasant in August, when it's 125 degrees in the shade.

5:30 p.m.: A note on Las Vegas nomenclature: It's gaming, not gambling. Gambling is a foolish activity that can only end in tears. Gaming is harmless entertainment. Please keep them straight.

9:00 p.m.: Survived *Viva Elvis* by Cirque du Soleil, billed as "a harmonious fusion of dance, acrobatics, and live music." It is not harmonious. It is an assault on the senses. Feel slightly guilty that I had my fingers jammed in my ears for the entire show with one of CityCenter's PR reps sitting next to me.

11:00 p.m.: One suspects that occupancy rates are low, but the casino floor is jumping on a school night. There's a rumor circulating, almost certainly apocryphal, that a Japanese businessman has dropped $89 million in the casino. Meanwhile, a fellow journalist and former professional gambler has taken the place for $250. In a most unlikely turn of events, I actually feel sympathy for a casino.

11:30 p.m.: Hmm. The taps in my sinks (you get two in each room) are coughing like the fish

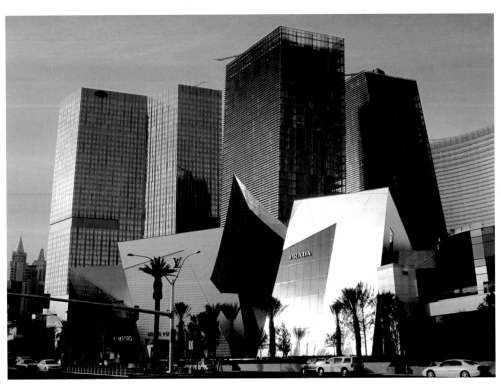

fountain in Tati's Mon Oncle. All electronics in the room are digital interfaces, a system that's a bit too sophisticated for its own good. Did I just set my alarm for 7:30? Not sure.

Day 2

7:30 a.m.: Alarm works.

8:00 a.m.: Alas, breakfast with an old college roommate is off. He's a recent transplant to Vegas from Buffalo, but out of town on business. I'm interested in his experience of these two places on opposite ends of the American urban spectrum, one a frigid industrial city with its best years behind it, the other a rapidly expanding desert metropolis built on an economy of dreams.

9:00 a.m.: Managed to cross the Strip via pedestrian bridge to get the wide view of the complex. CityCenter is what you might call postmetaphor Las Vegas. Cosmetically, its buildings are not simulacra of buildings from other places and times—Rome, Paris, New York, Venice, Medieval England. Nor does it seem like "Sin City." It's not seedy. It's more khaki pants than sharkskin suit. Which invites the question, at least for me: What's the point of CityCenter if it's just an upscale development in a mid-size American city, six hours from New York?

9:15 a.m.: How big is CityCenter? The Harmon, at twenty-five stories, is the "boutique" hotel on the lot. And it was planned to be considerably taller. Differentiating between the hotels—the Aria, the Vdara, the Mandarin Oriental—is difficult. They all look vaguely similar (towers of reflective glass), with vaguely similar amenities.

9:45 a.m.: Building heights on the Strip are determined by the "cone of approach" air corridor to nearby McCarran Airport. This is the opposite of zoning in most cities, where building heights are stepped back from the ground up. In Vegas, it happens from above. A bit of investigation reveals this to be a fairly contentious legal issue. Does the airport's appropriation of aerial space constitute an unconstitutional taking of property rights? Let's leave that to the lawyers, and our friends at BLDGBLOG.

10:00 a.m.: Principal architect Francisco Gonzalez leads a tour of Murphy/Jahn's Veer Towers. They lean at five degrees, hence the name. Actually, it's not a tour: the buildings

are not yet open. A few journalists and the PR team mill around on the access road in front of the buildings, which are easily the best things about CityCenter. They are at once robust and delicate. There's no reflective glass. This is unheard of in Vegas, and was a major concession won by Gonzalez. Staggered panels of clear and fritted yellow glass animate the facades and give the complex a welcome shot of color. Horizontal louvers (Gonzalez calls them "fins") give shade from the desert sun. Most of the condo units are sold. Whether anyone will actually use them or if they're simply investment properties is another question.

11:00 a.m.: After the tour, Gonzalez and I take a walk around Crystals, Libeskind's shopping mall, which is adjacent to the Veer Towers and shares some of their support structure. Gonzalez wears a leather coat and has a disarming Spanish accent that belies a bulldog personality. "I was hated here but I got everything I wanted. I don't think Libeskind pushed hard enough. He got a mall. I think he was happy with that. I came in with my crazy English and I pushed very hard." I have a difficult time believing anyone hated him. He is sincere, free of pretense, sharp. A reflection of his work. Libeskind, clearly, was impressed. The two are collaborating on a major development project in East Asia.

11:45 a.m.: Planet Hollywood Las Vegas: World's ugliest building? Discuss amongst yourselves.

11:55 a.m.: With the exception of a branded Assouline shop in Crystals, there is no bookstore on the Strip. There was a Borders at the Mandalay Bay, but it closed. Also, the fountains at the Bellagio don't start until 3 p.m. Learned that the hard way.

12:30 p.m.: Lunch at American Fish, chef Michael Mina's seafood restaurant at Aria. Fine dining is structured as a major component of CityCenter's appeal, and there are restaurants helmed by star chefs studded throughout the complex. The food at this one is especially good, and I don't even like seafood. The decor? Comfortable. Every restaurant here looks essentially the same, in a contemporary but impersonal way. The servers are uniformly excellent, as if they've somehow internalized Danny Meyer's philosophy of hospitality. Which invites the question. Are the servers outside of New

Mark
Lamster

What Am I Doing Here?
Tall Buildings and High Anxiety
in Las Vegas

Cultural
Investigation

**Culture Is Not
Always Popular**

85

York naturally nice? Does New York so jade its inhabitants that even our servers require a remedial course in professional behavior?

1:30 p.m.: Tour of Crystals, CityCenter's signature work of starchitecture. A Libeskind minion tries his best to retroactively justify Libeskind's idiosyncratic architectural language. "It's a vortex drawing energy off the Strip." "It's a lifelike spiral." "Rocks." "Fractals." Please stop. Does it matter, anyway? From the outside, it's dramatic and shiny. Inside, it's a bit disappointing. The folds and cuts so prominent on the exterior suggest intriguing, Piranesian spaces, but upon entering one finds a fairly straightforward mall with some wonky ceilings and skylights. Shadows are projected on blank walls where you'd think the skylights would throw their own patterns. This seems like a failing. If you need projections to create visual drama, why all the structural gymnastics? Materially rich and visually sumptuous installations by David Rockwell—a teak stairwell, a blobby wooden catwalk—clash uncomfortably with Libeskind's angular white walled avant-gardism. Sculptures by WET, the firm behind the Bellagio fountains, are underwhelming, though still works-in-progress.

2:30 p.m.: Despite its flaws, it's hard not to be won over by Crystals. It does have its dramatic moments, especially from the outside. It makes, at least by Vegas standards, considerable effort to engage its neighbors and the street. I've heard it said that its entire purpose is to occupy the wives of high-stakes gamblers, but this doesn't seem especially fair. With his silly glasses and funny accent, Libeskind has made something of a cartoon of himself, which is a shame. As Lebbeus Woods recently noted, Libeskind's experimental "Machines" of the 1980s are beautiful and complex metaphorical works that still have the power to inspire. I wish he'd look back at that work and quit it with the "spirals" and "vortexes" and "fractals."

3:00 p.m.: Is there public space in Las Vegas without piped-in music?

5:00 p.m.: The absurdity of CityCenter's urban gesture of separating its buildings now becomes apparent. The PR team has arranged for SUVs to take journalists from the Aria to the Mandarin Oriental for a cocktail party. The buildings are maybe 150 feet from each other.

5:30 p.m.: The lobby of the Mandarin Oriental smells like fancy soap, and the Sky Bar has panoramic views. But I start to feel claustrophobic and duck out of the event. For a certain type of person, Vegas is a non-stop party. For me, it induces a kind of persistent, low-grade anxiety. There's something dystopic about the place generally, and CityCenter is starting to feel like the world of Blade Runner come to life. I head back to my room, shut the black-out curtains and lie in bed. More people commit suicide in Las Vegas than in any other city in the United States.

7:30 p.m.: I like Karim Rashid. He has the courage of his convictions, even if I don't share them, and he's unafraid to appear slightly ridiculous in public. That said, Silk Road, his restaurant at the Vdara, is not a success, even on his terms. The blobby sofas in its bar area are uncomfortable and the decorative wave patterns on its walls looks like they were pulled from the lobby of a Marriott.

9:45 p.m.: Dinner at Silk Road has now entered its third hour, despite a paucity of customers. The mind wanders. Is the word "vdara" Spanish for "banal architectural experience"? Alas, no. It is the invention of the CityCenter marketing team, and has no meaning. Lesson learned. With due respect to Robert Venturi, Las Vegas is no longer a good place to look for meaning.

10:00 p.m.: While we're at it, the Silk Road isn't a focused enough theme for a coherent menu. It's too weak a thread to unite the cuisines of China, India, Persia, and the Mediterranean. And because this is Vegas, the restaurant also has to double as a steak house—the Silk Road by way of Nebraska?—which makes no sense but says something about the clientele. The result: generic restaurant food.

10:45 p.m.: After dinner, journalists are invited to Eva Longoria Parker's nightclub, Eve, in Crystals. I pass by on the way to the Bellagio fountains. Eva Longoria Parker is not in attendance. The women pretty much all wear sequined tube dresses hiked to mid-thigh. The men look unkempt. Not really my scene.

11:15 p.m.: Am I the only person not entranced by the Bellagio fountains? They're visually impressive and a technological feat, fine, but

it's hard for me to enjoy anything accompanied by the schlocky music of Elton John.

Day 3

9:00 a.m.: Along the long corridor leading to the convention hall, the entire Aria staff has lined up to cheer attendees of a large luxury travel conference, a much coveted "get" for the fledgling hotel. The media center is on the path, so I get the treatment. It's nice to wake up to a standing ovation, but it feels silly and contrived.

9:15 a.m.: A tour of Aria with a pair of enthusiastic architects from Pelli's New Haven office. Working hundred-hour weeks for several years running, they managed to design Aria, all eight million square feet of it, without opening an office in Las Vegas. Can't blame them.

9:20 a.m.: The enormous semicircular glass canopy that fronts the Aria is a bravura work of structural design, one of the highlights of the complex.

9:30 a.m.: Ditch the tour to head out to the Strip so I can buy a souvenir for my daughter. (A small stuffed animal in the Aria gift shop goes for sixty-eight dollars.) Walk down to the New York-New York complex, which has an air of squalid desperation. How it will survive with CityCenter and other new developments competing for business is beyond me. A friend quips that the only way they could fill the place is "if they reenact 9/11 every morning." No comment.

9:45 a.m.: Worth noting that the fake New York has a dummy Whitney Museum (albeit with a crass theater marquee in place of Breuer's bridge/awning assembly). I love the Whitney, but it's odd that they've chosen it instead of the more famous Guggenheim facade. Did the Guggenheim's aggressive legal team have something to do with this? I'll bet.

12:45 p.m.: My stay is over. Another "sustainable" limo ride to the airport. The environmentally attuned strech limo is the operative metaphor for CityCenter.

10:30 p.m.: Back in New York, on the BQE, the city skyline visible on the horizon through the window of a Town Car. Lights are lights. But somehow these seem anchored, real, solid. The Vegas anomie finally begins to wane.

Day 4

7:00 p.m.: Drinks at Prime Meats, in Brooklyn, with my wife. Realistically, this place is as much an artifice as anything on the Strip, a re-imagining of a nineteenth-century saloon, complete with polished bar, antique typography, Edison bulbs. Why, then, does it feel so much more honest? Because its aesthetic is filtered through a contemporary sensibility? Because it seems a natural part of a vibrant neighborhood? Is this all bullshit I invent to make myself feel more comfortable? Could the real problem with Las Vegas—my real problem with Las Vegas—be that its commercial imperatives are simply too transparent? Are my insecurities the problem? Maybe a bit of artifice is what I need to survive; the make-up that makes the model appealing. Anyway, the punch is good. Time for another round.

Mark
Lamster

What Am I Doing Here?
Tall Buildings and High Anxiety
in Las Vegas

Cultural
Investigation

**Culture Is Not
Always Popular**

87

Adam Harrison Levy
Jump Cut: Thoughts on Editing

ORIGINALLY PUBLISHED
07.07.11

COMMENTS
5

To be a top-notch film editor you need to have the eye of a painter, the ear of a composer, and the story sense of a writer. You also need the ruthlessness of a commodities trader. What can designers, architects, and writers learn from the art of film editing?

A number of years ago, while living in London, I worked for a company that made documentaries for the BBC. It was during the waning days of shooting on 16mm film; video was on the ascent. Digital software such as Avid and Lightworks were emerging and old style film editing was giving way to ones and zeros. This was not necessarily a bad thing—non-linear digital editing enhances speed and flexibility—but it also diminishes craft and what I can only call culture.

The office where I worked occupied the top floor of a converted wharf that overlooked the river Thames—Eames office chairs, angle poise lamps, Le Corbusier sofas. Large windows framed views of river and sky. The office was open and bright.

The editing room was different. It was small and dark and its interior was shrouded with drapes. An immense flatbed Steenbeck editing machine with two hooded monitors took up one wall. Gray metal reels of film were stacked against another. Diagrams were taped wherever extra space was available. Strips of film hung like laundry over bins on casters.

At nine in the morning the editor and his assistant would enter the room ceremoniously carrying mugs of tea. The director would enter about an hour later, stay through lunch (often brought in by the assistant) and depart around four to make phone calls, work on the script or meet with producers.

At eight in the evening, when the office had emptied, the assistant would dart out and return with bottles of beer. Only then would the editor crack open the door. If I was lucky, he would call me in and I would stand in the dark as he ran through the footage of his day's work.

The film hissed as it sped through the Steenbeck's complicated system of reels and relays. The dialogue—without levels, music, or fades—crackled through small speakers. Images flickered. The editor would lean back and watch the rough cut while he jotted down notes, made technical talk with his assistant, and knocked back the beers.

The first thing I learned was that an editor does much more than splice film. They make thousands of decisions throughout the day as they carve out a path through a thicket of material. For every cut there are perhaps twenty other cuts that could be made. For every yes there are at least twenty nos.

If a scene wasn't working, the editor would physically undo a splice, chose a different strip of film, and splice it back together. As a

John Thackara
07.21.11 01:43
Thanks for a terrific piece. Two follow-up questions: is it true [or an urban legend] that, in a documentary, one minute ends up being used for every 60 that are shot? And: is there a contradiction between the minute attention to detail you describe here, and the fact that most people will watch the film in a world filled with distractions? otherwise stated, is there an equivalent in film of the 'dynamic white space' that's so important in newspaper design or the unprogrammed liminal space office designers talk about??

result the story would incrementally change course, subtly influencing everything that had come before as well as the footage that would come later. Miniscule changes could have immense implications.

Editing, like stringing sentences together, or working through a design, is not the rational problem-solving procedure we often pretend it to be. It's more like a process of discovery where skill and chance work together. The skill of an editor is to be confident enough to allow for chance to indicate where the next cut should go, and then to be adept enough to follow that path. In a similar way novelists talk about characters taking over a story or graphic designers describe how ratios between type and form feel right. If the editor is really working in sync with his material he doesn't assemble the film, the film assembles him. Do some buildings build themselves?

One evening the editor was screening a rough cut of a film about the use of unclaimed urban lots in London. An old man was recalling planting a Victory garden during World War II. As he talked he was tenderly tending a row of runner beans. His face filled most of the frame. The sun was setting behind him; it was a lovely scene. The editor abruptly stopped the film.

"Did you see that?" he asked.
I hadn't seen anything.
"See how it jumps there?"
Only then did I notice that there was a visual stutter.
"That's a jump cut. I should have caught that sooner."
"Jump cut?"
"The cameraman changed shot size but not enough. I made a cut there, and shortened the man's sentence. But the second shot is too near in size to the first. It's not large enough of a shift. The eye trips on the cut."
"I don't understand." I said.

The editor undid the spice and chose some different strips of film. In the new sequence the old man was still tending the runner beans but when he reached the part of the sentence that the editor wanted to shorten, he now cut to a wider master shot that took in the surrounding buildings and more sky. The editor then laid the sound track under both shots and "glued" the whole together. Weirdly the eye could handle this more dramatic cut easier than the smaller, more subtle one. The visual brain

seems to respond better to quick and dramatic changes of scale than subtle shifts within the same visual field.

Watching the editor also taught me the value of simplicity. If the editor thought that a scene wasn't working the first thing he did was to eliminate. Fewer cuts, fewer overlapping sounds, fewer camera moves. Or, for a certain kind of documentary film, fewer words spoken by the narrator. Suggestion and simplicity encourage the viewer to engage with the material, to extend outwards into it, while didactic exposition shuts the viewer out. Doors and windows draw you in, color seduces, and a whisper is often more effective than a shout.

The editor didn't always cut on verbal sense— that is, when a person finished a sentence or drew in a breath. Sometimes he would line up one frame with the following frame and match a visual pattern, or an angle of light, or a line of color. Sometimes he would run a scratch music track back and forth and cut the images to synchronize with the rhythm and speed of the music rather than to story or speech. If the underlying emotional current remained the same during those scenes, or the plot was strong enough, these cuts worked as effectively, if not more so, than a merely practical one. The film felt fluid. Abstraction worked powerfully to evoke emotion and to further story. Is this true in the graphic arts as well?

The final lesson was this: I was standing there. The editor spent his day making decisions and micromanipulating image and sound. The director would sit with him and make suggestions and together they would continually shape and re-shape the film; they were wrestling form out of controlled chaos.

But that also meant they were extremely close to the material. This was a danger and the editor knew it. Experience had taught him to open the process up. As a result he welcomed my comments. But he seemed to value the inane ("Is that the same lot where the old man grew his Victory garden?" or "Does he eat those beans raw?" or "What did he say?") over what I felt were more astute comments ("beautiful light" or "I love the way you cut on the move."). In other words, he appreciated me most when I was fresh and stupid. When I began to learn too much ("Shouldn't you hold that shot for one more beat?") the door to the editing room didn't open quite as often.

Jessica Helfand
Can Graphic Design Make You Cry?

ORIGINALLY PUBLISHED
07.29.09

COMMENTS
56

I grew up surrounded by pictures of drama and terror and death. Our house was filled with oversized, captivating posters in which fear and frolic were provocatively conjoined through pictures and words. That they were propaganda was meaningless to me: after all, I was a child, with no money or independence or power of my own, so exercising any suggested behavior prompted by a poster's message was out of the question. (Though surely the implied cautionary tale—become sexually promiscuous and you will contract syphilis and die—could not have been lost on my well-intentioned parents.) Still, these great big confabs of massive typography and layered image were the visual hallmarks of my immediate orbit, literally flanking my passage from the reliable safety of home to the untold mysteries of the outside world, and providing what I would later come to realize was my introduction to graphic design.

Much later, as a graduate student of graphic design in the late 1980s, I was exposed to the parameters of what design was and could be, and here, my struggle to reconcile form with emotion was hopelessly stalled. While I begrudgingly acknowledged the value of my formal education, such aesthetic orthodoxy was, frankly, anathema to me. How, after all, could you make design that communicated to human beings and deliberately drain it of all human content? I have spent a good part of my adult life trying to answer precisely this question.

When I was a student, the prevailing wisdom maintained that the true power of design lay in chiseling it down to its purest form: it was only when it was unencumbered by sentiment that design could truly deliver on its modernist promise. To inject personal voice was to deviate from this no-nonsense objective, and one was best advised to resist such subjective impulses. Better to hone your craft and minimize your imprint, remove yourself from the work and focus on the most salient, most germane form your message could and must take. The designer's mission was simple: to create the simplest, most harmonious, most neutral form, thereby enabling communication to the widest possible audience.

Oddly, none of us dared challenge this hypothesis because it was widely assumed that our design ancestors had struggled nobly against years of oppression to drag themselves out of the murky propaganda brought about by war and commerce and decoration and, God help us, commercial art. We were the lucky survivors. Now: go fill your three-haired paintbrush with Plaka, and shut up.

It bears saying that most, if not all of my teachers had come of age in Europe, during that post-war period when the profession privileged clarity above all else. As the chosen disciples of this noble tradition (descendants of the Bauhaus, the Kunstgewerbeschule, and Black Mountain College, those pioneers

Jen Renninger
08.04.09 03:20
Such a lovely and relevant piece.

This very thing has been on my mind lately and I admit that I wish to be lumped into the group of "so many designers ... engaged in addressing design for the public good—design that is sustainable, meaningful, socially relevant". Regardless, one experience in particular has me wondering about what that means exactly:

I received a rather personal email from a woman who'd purchased one of my posters. She told me about a recent, life changing event and how the poster touched her on such a deeply personal level that she felt the need to see it every day. By the end of the email I felt as if I couldn't breathe. It left me wondering about the difference between design and art. More pointedly, the difference between design affecting the surrounding world in a general way or affecting one person in an immediate personal way. Maybe it's the work that can accomplish both that really holds the key?

Mark Kaufman
08.04.09 04:58
A beautifully written and heartfelt sentiment.

This touches on a subject that most designers, even those of us that strive to create works for the public good need to keep reminding ourselves of, that we are human and the consumers of our work are ultimately human. Our clients are also human, but their desires are sometimes in conflict with their humanity; profit, sales, and marketshare do not often inspire sentimentality or a good cry. The benefits and features of a contemporary campaign for a telecom provider, call coverage, rollover minutes and price points lets say, are at odds with the classic campaign for Ma Bell that urged customers to reach out and touch someone. Even though both campaigns objective was to spur greater sales.

Objectivity vs. humanity is an age old conflict in the design profession. Thanks for reminding me where I stand.

who brought graphic design to America), they dutifully adhered to a don't-rock-the-boat view of design education—indeed, of design itself. And here, the general perspective was one that privileged rigor over voice, seeking the most reductivist solutions to life's most complex problems.

This never sat well with me. It occurred to me then, as it does now, that life's most complex problems are the same: war is war, death is death, the world evolves but the basic problems do not essentially change. That styles come and go is a given (Victor Moscoso's 1960s civil rights protest posters were as visually representative of the generation in which they were published as is the one I'm about to reveal from 1915), but how is it that sometime between the Summer of Love and Hurricane Gilbert, an entire generation of designers virtually abdicated responsibility where the true representation of human experience is concerned? And that we were encouraged to do so in the name of design?

The book I published late last year *[Scrapbooks: An American History]* could most certainly never have been produced twenty years ago, when there was little if any support, let alone tolerance, for the value of human narrative in the context of graphic design. Yet to look at this poster—published in 1915 by the Boston Committee on Public Safety, following the sinking of the *Lusitania*—is to wonder how it was ever possible to imagine design in the absence of such fundamentally personal stories. The image was based on a widely circulated news account from Ireland about the tragedy, which claimed the lives of more than one hundred Americans. "On the Cunard Wharf lies a mother with a three-month-old child clasped tightly in her arms. Her face wears a half smile. Her baby's head rests against her breast. No one has tried to separate them."

No one has tried to separate them, indeed: nor did the artist, Fred Spear, attempt to separate image from sentiment, news from art, form from content. It remains even now a chilling and unforgettable picture—a mother and her child, swept into sudden death— which, in conjunction with the single word, creates a message of ferociously simple impact. Some years ago, I asked my students if graphic design ever made them cry. Particularly with regard to graphic design that lived

online—where the cacophony of competing messages makes a single, immersive experience unlikely—was such a thing even remotely possible? And why, they countered, was this a goal?

The goal, I explained, was to join the manufactured thing—graphic design as an external representation of something else—to the world of the living. The goal was to connect, to enlighten, to more deeply understand, and how can you act if you can't remember? You remember when you feel something, like I felt terror as a child in a world of public health posters. But as much as I was haunted by them, I was mesmerized by their beauty, their theatricality, their humanity—and that memory has never left me. Who among us does not hope to create work with such indelible, lasting power?

This all bears repeating now, at a time in which so many designers are engaged in addressing design for the public good—design that is sustainable, meaningful, socially relevant—because how can you achieve any of this if you don't engage at some fundamentally human level, a level where memory and feeling are as valued as form and execution?

I write this now at the risk of exposing myself to personal attack: nostalgia is now as it has always been, a bad thing in design. At its best, it's redundant. (At its worst, it's kitsch.) But the opposite is equally vexing, because design that caters to designers, or design that privileges novelty over reality, or design that ignores its basic constituents—design for social change is, after all, design that must be socially relevant, and that means design for and about real people—is just as problematic as design that celebrates modernist ideals in the name of neutrality. Design that strives for neutrality, that seeks to extinguish its relationship to the human condition, risks removing itself from the very nucleus of its purpose, which is, yes, to inform and educate—but also, to enchant. And at the end of the day, we succeed in this effort by being honest: we're not graphic designers but people who make graphic design. Which means that first, we're people: people who pay taxes and raise children and read newspapers and vote. People who eat and sleep and argue and question. People who laugh. People who remember. People who even, occasionally, cry.

Jessica
Helfand

Can Graphic Design
Make You Cry?

Cultural
Investigation

**Culture Is Not
Always Popular**

91

Eric Baker
Today

quatſch

Cichorienbilder

für alTe gebiſſe

I. t o m u s

dada - e n z y -

klopädie

QUaTSCH MaſTEnball

Mhoürrbne
Mohrrüben

QUaTSCH

des

Osiris

1919

verlaG grotesye kunst
Berlín W 8 Kanonierſtraſze 2

PLAYER'S CIGARETTES.

9TH DIVISION.

Each morning, for about three years, Eric Baker would trawl the Internet, spending thirty minutes in search of images that were beautiful, funny, absurd, and inspiring. Today was a weekly round-up of the best of his haul, a pop-up exhibition that celebrated the accidental, the improbable, and the quintessentially ephemeral. With no text or captions, no provenance or promoted links, Today was framed by a simple conceit: text free, picture driven, at turns comic, cryptic, and hilariously arcane, it was a whimsical tour of visual culture.

Like many designers, Baker was—and is—an inveterate collector, a self-proclaimed design obsessive who delighted in excavating whatever lost treasures he could locate online. Vintage letterheads. Vernacular photos. Political propaganda. Theatrical broadsides. Graffiti one week, Giacometti the next, Baker shared the kooky and the magical with equal delight. As a counter-narrative to the intensity of our daily design discourse, Today was a tonic: part eye candy, part history lesson, part mystical trip down memory lane. Our readers adored it, and we hope you do, too.

Cultural
Investigation

Today

Eric
Baker

Eric
Baker

Today

Cultural
Investigation

**Culture is Not
Always Popular**

95

Eric
Baker

Today

Cultural
Investigation

**Culture is Not
Always Popular**

97

03.

Will and Whimsy

Design Observer's early years corresponded with the heyday of blogging. With the advent of publishing platforms like Blogger, WordPress, and Movable Type (our site began on the last of these), suddenly anyone could choose to make their private diary entries in public. The default voice of the blogger was personal, casual, and confiding: my cat did something cute today; here's a movie or book or TV show I like; or, do you know what really makes me mad? Some of the day's most popular design blogs trafficked in quick hits and opinionated (if often unsupported) commentary.

Design Observer's tone was different from the start. Yes, it was personal, and yes, it was opinionated. But even its earliest pieces were most assuredly essays, not journal entries: they were carefully researched, had a beginning, middle, and end, and were written for a broader audience even before that audience had discovered the site. As a result, *Design Observer* acquired a reputation as a serious place, perhaps even intimidatingly so.

Yet throughout its history, the site has made room for the lightweight as well as the heavy, finding lessons in trivial subjects and ephemeral phenomena that blossomed, rather than evaporated, under prolonged scrutiny. From Dmitri Siegel on the not-so-nameless girl whose portrait has appeared on millions of hours of television test patterns, to Mimi Lipson on the life and death of the worst diner in Philadelphia, to Karrie Jacobs on what presidential dogs can tell us about presidential politics, these pieces all bear the mark of what Steve Heller calls the "proclivity for obsession" familiar to anyone who cares—perhaps too much—about design.

Michael Bierut
Warning: May Contain Non-Design Content

ORIGINALLY PUBLISHED
03.18.06

COMMENTS
62

A few weeks ago, my colleague Jessica Helfand posted an article ["Give Me Privacy or Give Me an ID Card"] on this site about the possible introduction of a national identification card here in the United States. Within an hour came the first comment: "What does this have to do with design? If you have a political agenda please keep it to other pages. I am not sure of your leaning but I come here for design."

I come here for design. Lawrence Weschler's recent article got some similar responses. ("Obscure references...trying to impress each other...please, can we start talking some sense?") In these cases, our visitors react like diners who just got served penne alla vodka in a Mexican restaurant: it's not the kind of dish they came for, and they doubt the proprietors have the expertise required to serve it up.

Guys, I know how you feel. I used to feel the same way.

More than twenty years ago, I served on a committee that had been formed to explore the possibilities of setting up a New York chapter of the AIGA. Almost all of the other committee members were older, well-known—and in some cases, legendary—designers. I was there to be a worker bee.

I had only been in New York for a year or so. Back in design school in 1970s Cincinnati, I had been starved for design. It would be

hard for a student today to imagine a world so isolated. No email, no blogs. Only one (fairly inaccessible) design conference that no one I knew had ever attended. Because there were no AIGA chapters, there were no AIGA student groups. Few of us could afford subscriptions to the only design magazines I knew about, *CA*, *Print*, and *Graphis*. Those few copies we got our hands on were passed around with the fervor of adult magazines after lights out at a Boy Scout jamboree. No *How*, no *Step*, and of course no *Emigre* or *dot dot dot*. We studied the theory of graphic design day in and day out, but the real practice of graphic design was something mysterious that happened somewhere else. It wasn't even a subject for the history books: Phil Meggs wouldn't publish his monumental *History of Graphic Design* until 1983.

In New York, I was suddenly in—what seemed to me then, at least—the center of the design universe. There was already so much to see and do, but I wanted more. I was ravenous. Establishing a New York chapter for the AIGA would mean more lectures, more events, more graphic design. For the committee's first meeting, I had made a list of all the designers I would love to see speak, and I volunteered to share it with the group.

A few names in, one of the well-known designers in the group cut me off with a bored wave: "Oh God, not more show and tell portfolio crap." To my surprise, the others

Kieran Lynn
03.18.06 10:23
The problem is that the design world is completely diametrically opposed—we are living in two schools of thought. One of which who desires the discussion for understanding the design world, learning technique, and theory, and the other trying to dissect the philosophical underpinnings of design and how it operates in our culture. I understand Aj's concern over the lifeline of sites like Design Observer into the community as a practical and receptive ground for the many people who hope to learn for themselves and love design the way that everyone here cherishes and treasures it, but I must play devil's advocate to your comment.

Design plays an amazing roll in the world in which we live. Inspiration can be culled from anywhere; « Ethiopian grave markers, Passover tales, Ethiopian grave markers, Passover tales, fifty-year-old experimental novels, Cold War diplomacy » Even when we talk about politics, and business, design plays an integral part in facilitating globalization (McDonald's and Coke) and can influences policy and incite change (Russian Constructivists and the 1917 Russian Revolution).

The Design Observer writers are not «dismissing the concerns of loyal readers—who wouldn't comment if they didn't feel attached to this site, part of a community» but I believe are trying to push beyond the boundaries of magazines like How, Print, CMYK. This has more to do with investigating design beyond many of the other outlets available. They specializing in

began nodding in agreement. "Yeah, instead of wallowing in graphic design stuff, we should have something like...a Betty Boop film festival." A Betty Boop film festival? I wanted to hear a lecture from Josef Müller-Brockmann, not watch cartoons. I assumed my senior committee members were pretentious and jaded, considering themselves—bizarrely—too sophisticated to admit they cared about the one thing I cared about most: design. I was confused and crestfallen. Please, I wanted to say, can we start talking some sense?

I thought I was a pretty darned good designer back then. A few years before, in my senior year, I had designed something I was still quite proud of: a catalog for Cincinnati's Contemporary Arts Center on the work of visionary theater designer Robert Wilson. The CAC didn't hire me because I knew anything about Robert Wilson. I had never heard of him. More likely they liked my price: $1,000, all in, for a 112-page book, cheap even by 1980 standards.

The CAC's director, Robert Stearns, invited me to his house one evening to see the material that needed to be included in the catalog: about seventy-five photographs, captions, and a major essay by *New York Times* critic John Rockwell. I had never heard of John Rockwell. To get us in the mood, Stearns put on some music that he said had been composed by Wilson's latest collaborator. It was called *Einstein on the Beach* and it was weird and repetitive. The composer was Philip Glass. I had never heard of *Einstein on the Beach* or Philip Glass. Stearns gave me the album cover to look at. I noticed with almost tearful relief that it had been designed by Milton Glaser. I had heard of Milton Glaser.

I was completely unfazed by the fact I knew nothing about Robert Wilson, John Rockwell, *Einstein on the Beach*, or Philip Glass. In my mind, they were all tangential to the real work ahead, which would simply be to lay out seventy-five photographs and eight thousand words of text over 112 pages in a way that would impress the likes of Milton Glaser.

With single-minded obliviousness, I plunged ahead, got the job done, and was quite pleased with the results.

About a year after my disappointing meeting with the planners of the AIGA New York chapter, I finally saw my first Robert Wilson production. It was the Brooklyn Academy of Music's 1984 revival of *Einstein on the Beach*. And sitting there in the audience, utterly transported, it came crashing down on me: I had completely screwed up that catalog. Seen live, Wilson's work was epic, miraculous, hypnotic, transcendent. My stupid layouts were none of those things. They weren't even pale, dim echoes of any of those things. They were simply no more and no less than a whole lot of empty-headed graphic design. And graphic design wasn't enough. It never is.

Over the years, I came to realize that my best work has always involved subjects that interested me, or—even better—subjects about which I've become interested, and even passionate about, through the very process of doing design work. I believe I'm still passionate about graphic design. But the great thing about graphic design is that it is almost always about something else. Corporate law. Professional football. Art. Politics. Robert Wilson. And if I can't get excited about whatever that something else is, I really have trouble doing good work as a designer. To me, the conclusion is inescapable: the more things you're interested in, the better your work will be.

In that spirit, I like to think that *Design Observer* is a place for people to read and talk about graphic design. But I also like to think that it's a place where someone might accidentally discover some other things, things that seem to have nothing to do with design: Ethiopian grave markers, Passover tales, fifty-year-old experimental novels, Cold War diplomacy. Hell, I wouldn't even mind a post on Betty Boop.

Not everything is design. But design is about everything. So do yourself a favor: be ready for anything.

Michael
Bierut

Warning: May Contain
Non-Design Content

Will and
Whimsy

**Culture Is Not
Always Popular**

101

ORIGINALLY PUBLISHED
01.03.05

COMMENTS
16

Dmitri Siegel
Mysterious Disappearance of Carole Hersee

Have you seen this girl? Her name is Carole Hersee. This portrait of her is perhaps the most widely broadcast image in the history of television. Since it first appeared in 1967 on BBC2, Carole's face has been on-air for over seventy thousand hours and is still in use today in over thirty countries. She used to appear regularly at the end of the daily broadcast schedule and accompany the sleepless (and the very patient) until programming resumed in the morning. With the advent of twenty-four-hour programming, however, her schedule has been drastically reduced. As Carole joins the composing stick and the California type-case in the dustbin of design history, the public loses yet another tangible connection to the process of design and an oddly comforting reminder that culture is essentially a mechanical process.

This image of Carole is called Test Card F and was designed by her father George Hersee, an engineer for the BBC. As the name implies, this was not the first test card ever designed, nor was it the last. Test cards (or test patterns as they are called in the United States) are the descendants of tune-in cards, which were first broadcast in 1937. The tune-in card was used to identify the station, and to aid the viewer in fine-tuning their sets. Originally test cards were actual cards, usually hand drawn and measuring two by three feet. Broadcasting a card required little besides holding it in front of a camera. The first test signal consisted simply of a large black cross on a white background.

But as video technology evolved, circles, grids, diagonals, and converging lines were added and redrawn. These black-and-white graphics were essentially an optical obstacle course. Negotiating them was a quick way to test and adjust vertical and horizontal linearity (proportions), scanning linearity (even spacing of the scan lines), video frequencies (shadings), picture resolution (focus), interlacing (reducing flicker), and, finally, oscillation (especially at the corners, where picture quality is most likely to degrade).

These early graphic cards did not, however, address the most significant technical challenge that arose with the advent of color television. Suddenly, it became critical that cameras and televisions properly display flesh-tones. This was what led George Hersee to take some snapshots of his daughters, Carole and Gillian, for a mock-up of Test Card F. He did not think either of the girls would ever be on the air. He used Carole's picture simply to demonstrate to the management of BBC2 that a test card featuring a picture of a person would be the most useful graphic for adjusting the color performance of the channel's cameras and monitors. The management agreed, but they also decided that replacing the little girl in the mock-up with an adult model meant risking that the card would need costly updating to conform to the whims of grown-up fashion. So Carole was brought in for a proper photo shoot and the now famous photograph was taken.

Gunnar Swanson
01.03.05 06:32
The most common test pattern of my youth was the old "Indian Head." Black and white; I must be old.

If I remember correctly, the Amiga computer tee shirt that Garth wore in Wayne's World was loosely based on it. Wayne's World. Amiga. I still must be old.

Andrew Montgomery
01.04.05 06:14
Following the evolution of the BBC tuning signal provides an interesting bit of design and typographic history. Test Card F was designed by an engineer; one might assume that the earlier versions were as well, although there is definitely some thought put into form as well as function.

As an aside on the topic of out-dated design tools, I didn't have a chance to meet printer and designer Bill Poole, although I had the pleasure of visiting his studio before it was sold and disassembled, and was charmed to meet his wife Margaret. Bill had passed away a year earlier in a tragic accident on his property and therefore the police had been called. The investigators briefly suspected foul play when they discovered—and couldn't identify—a strange object in Bill's hand... it was a folding bone.

Each of the props that surrounded Carole that day served a technical purpose. The chalk cross was positioned on the chalkboard to help engineers locate the center of the picture. Mr. Hersee once admitted that the BBC considered using a South Asian model with a bindi forehead marking for this purpose; apparently, the white cross on its black background proved more versatile. Because white images on television are made up of overlapping red, green, and blue, poor convergence of these colors shows up as "color fringing" on the cross. Even the somewhat unsettling clown has a purpose. Color televisions filter red, green, and blue signals from the black and white ones and decode them separately. This process causes the color signals to be delayed. If the black and white signals are not properly held back as well, a television suffers what is called a chrominance/luminance delay error. This causes the yellow of the clown's buttons to jump to the right, leaving the buttons themselves plain white.

Despite its functionality, Test Card F is seen less and less as the twenty-four-hour programming day becomes the norm. Broadcast designers and editors still use test patterns to adjust color temperatures, but it is more and more rare for the average person to encounter this rough edge of the designed world. There are still little reminders: the "Not found" message that appears in a Web browser, the occasional "Searching for Satellite" screen on cable. But this default vocabulary has already been co-opted and reused by designers. Printers' marks and error messages have become commonplace design elements. Carole faces oblivion at best, and stylistic regurgitation at worst. In either case, a chapter of design history will be lost—the story of how a somewhat arbitrary, thoroughly constraint-driven process made a picture of a girl playing tic-tac-toe with a clown the most widely viewed show in the history of television.

Kathleen Meaney
Comparakeet

ORIGINALLY PUBLISHED
12.08.14

COMMENTS
16

Doubtless, the reader will say, while looking at the seven figures of Parakeets represented in the plate, that I spared not my labor. I never do, so anxious am I to promote his pleasure.
—John James Audubon

Comparing two versions of the now extinct Carolina parakeet—Mark Catesby's 1771 engraving with John James Audubon's 1825 plate—is to witness the inanimate come to life. Catesby follows a traditional eighteenth-century drawing style: a single bird, set in profile, against a blank background.[1] Audubon documents a visual breakthrough in ornithological illustration: his parakeets are drawn in context, in motion, and (seemingly) in collaboration. This is no flock fluke, as these parakeets could be found "climbing or hanging in every imaginable posture ... [and] usually alight extremely close together,"[2] thus giving a more accurate behavioral representation.

From the singular to the singular sensation, this example parallels the impact that the digital humanities is having on academic study. It encourages collaborative projects over single authored ones; it broadens contexts through print and digital connectivity; and (like Audubon's foreshortened parrot, staring straight at us) it engages with vast audiences, through digital networks and accessibility. This dynamic field breathes life into our interpretation of history, and the result is de-extinction. Through the emergence of the digital humanities, the humanities come alive with new research possibilities that enhance traditional methods of learning. Let's see how Audubon's work, in particular, can be reframed through this digital lens.

Audubon's Birds of America comprises 435 engravings that represent 1,065 birds. His aviary offerings seem boundless, yet viewing this rare folio is limiting if only one plate at a time is displayed. What is lacking from this typical viewing experience is comparison. Pictures alone are merely pictures, "however when part of a sequence, a sequence of only two, the art of the image is transformed into something more"[3]—animation, illusion, interpretation. Finding correlations between plates, between plates and preparatory sketches, as well as texts, is instructive. However, if the material is too precious to display physically, then what are the digital assets that could supplement and enhance this type of display? Perhaps a dynamic table of contents; non-linear sorting (viewing pages based on similarity in composition, backgrounds, behaviors, bird size, etc.); annotations or audio; 3-D rendering or stacking; zoom and search functions; or juxtaposition for cross-referencing. These are methods for learning—there are surprises that transpire through these digital affordances; they are revealing and they ask us to reevaluate our expectations. Conceiving Audubon's work comprehensively as a digital database would allow viewers, researchers, and teachers to "visually interpret, remap or reframe."[4]

Did you know that Audubon published a companion text whose title is as long as a flamingo's neck: *Ornithological Biography, Or an Account of the Habits of the Birds of the United States of America: Accompanied by Descriptions of the Objects Represented in the Work Entitled The Birds of America, and Interspersed with Delineations of American Scenery and Manners*. As the above suggests, this field guide is in direct dialogue with each plate, yet rarely are these documents displayed together.

What a design opportunity! How can digital technology integrate text and image? How can design unite two disparate manuscripts that were intended to be utilized together?

As revealed in an Audubon exhibit at the New-York Historical Society, the artist made preparatory "watercolors" for each plate. Not mere sketches, but elaborate compositions that served as guides for replication. How do these drawings compare to their corresponding plate? What do their discrepancies reveal about the artistic contribution of Robert Havell, Jr. (or should we say, Robert Havell, Genius?), the esteemed printer of *Birds of America*? And more importantly, how do these supplemental image and text collections cross-chronicle history?

The pièce de résistance comes at the moment the peacock displays his plumage: never before has there been a comprehensive display of watercolors with their corresponding plates.[5] Never before could we digitally layer the two for comparison. We have a "neural network for the concept of comparison." [6] Juxtaposition produces immediate cognitive effects. From this unique digital perspective, collaborative efforts unfold and questions arise.

Indeed, this is a "galvanizing moment to be a humanist involved in devising, designing, and deploying new tools; in opening expanded modes of inquiry unthinkable under pre-digital conditions...through the as-yet-unrealized possibilities of digital platforms."[7] History touts Audubon as the single auteur—a solitary bird. Comparisons reveal otherwise. His work was part of a flock. So if history gives you the bird, redefine it, digitally, as a mother flocker.

This is an exacting comparison of the flamingo's shape and size. Such fidelity to form is common throughout most of Audubon's watercolor-to-plate comparisons, suggesting that tracing methods were employed. The background has been added as well, which was the artistic contribution of the engraver (the aforementioned Havell), but how was it art directed, if at all?

LEFT John James Audubon, American Flamingo (Phoenicopterus ruber), Havell plate no. 431, 1938. Watercolor, graphite, gouache, black ink, and pastel with glazes on paper, laid on card.

RIGHT This is an exacting comparison of the flamingo's shape and size. Such fidelity to form is common throughout most of Audubon's watercolor to plate comparisons, suggesting that tracing methods were employed. The background has been added as well, which was the artistic contribution of the engraver (the aforementioned Havell), but how was it art directed, if at all?

LEFT John James Audubon, Golden Eagle (Aquila chrysaetos), Havell plate no. 181, 1833. Watercolor, pastel, graphite, black ink, and black chalk with touches of gouache and selective glazing on paper, laid on card.

RIGHT Three-dimensionality is achieved by extending the eagle's beak and feathers outside the composition. The suggestion of flight is further enhanced by shifting the bird vertically (and conversely, lowering the mountainous background). There is a noticeable omission of the background figure, Audubon himself supposedly, who had been drawn crossing a fallen tree. What was the reason for this omission?

Notes

1. Lee A. Vedder, *John James Audubon and The Birds of America: A Visionary Achievement in Ornithological Illustration* (San Marino, CA: Huntington Library, 2006).

2. John James Audubon and William MacGillivray, *Ornithological biography or an account of the habits of the birds of the United States of America; accompanied by descriptions of the objects represented in the work entitled The Birds of America, and interspersed with delineations of American scenery and manners* (Edinburgh: A. Black, 1831–1849).

3. Scott McCloud, *Understanding Comics* (New York: HarperPerennial, 1994).

4. Anne Burdick, Johanna Drucker, Peter Lunenfeld, Todd Samuel Presner, and Jeffrey T. Schnapp, *Digital_Humanities* (Cambridge, MA: MIT Press, 2012).

5. Initiated in the spring of 2014, the New-York Historical Society is showcasing a comprehensive exhibit of Audubon's watercolors—in three parts—entitled *Audubon's Aviary: The Complete Flock*, which offers various watercolor to plate comparisons. The next and final installment of this three-part exhibit opens next year.

6. James E. Zull, *The Art of Changing the Brain: Enriching Teaching by Exploring the Biology of Learning* (Sterling, VA: Stylus Pub., 2002).

7. Burdick et al., *Digital_Humanities*.

8. John James Audubon, *Ornithological Biography*, accessed online at the Darlington Digital Library, University of Pittsburgh.

How do you create a three-dimensional space on a two-dimensional surface? Margins that tightly crop the composition force the heron's bill to extend the frame. This strategy reveals Havell's genius, as it causes the heron to jump off the page. Furthermore, visual perception tells us that if the bill extends the margin, then the fish must invade the viewer's space. We're witnessing a magical three-dimensional moment. Can we attribute these decisions solely to Havell?

Again, three-dimensionality is achieved by extending the eagle's beak and feathers outside the composition. The suggestion of flight is further enhanced by shifting the bird vertically (and conversely, lowering the mountainous background). There is a noticeable omission of the background figure, Audubon himself supposedly, who had been drawn crossing a fallen tree. What was the reason for this omission?

The America goldfinch comparison quickly reveals an additional thistle branch. Can we presume that this change is meant to simply fill space?

Unlike the rest, this plate was originally engraved by W. H. Lizars and then retouched by Havell. Significant changes are evident between the two *Wild Turkey (female and young)* compositions. The context shifts from being hidden in foliage (watercolor) to full exposure (plate). This happens through the elimination of the upper background. Where once the environment is full-bleed, now it becomes vignetted. Was this a decision to help delineate the form of the mother turkey, so she is contrasted and not camouflaged?

Dramatic changes to the background are evident: a shift from mid-tones to dark creates a brooding night scene. Is this merely the result of a deeply bitten copper plate or was it intentional to alter the mood?

"The Chuck-will's-widow manifests a strong antipathy towards all snakes, however harmless they may be."[8] Comparison reveals that this frightened and hissing female bird along with her support branch is lowered on the plate. The addition of a vine (*Bignonia capreolata*?) separates her from the "harmless Harlequin" snake (in actuality it may be a copperhead). Audubon doesn't mention this vine in the *Ornithological Biography*. Was this addition merely formal, made to lighten up the overall brown composition with green and red? Perhaps not. Seeing that the red flowers on the vine perfectly match the red segments on the snake, camouflaging the snake from the viewer, this change probably had motive: The snake now emerges last, surprisingly, and the viewer shares the same emotion as this bird.

ORIGINALLY PUBLISHED
01.07.10

COMMENTS
9

Karrie Jacobs
A President and His Dog, Part Two

If you go to whitehouse.gov in search of photos and information about Bo, the Portuguese water dog who became the First Pet back in April, you will have to do a search. Unlike the previous administration's Scottish terrier, Barney, who for a time had his own dedicated section of the White House homepage and even his own URL, Bo is a quieter presence. A little light probing yields his official portrait and the occasional candid of the dog frolicking with the First Family, but, unlike Barney, whose role was to "humanize" the Bush White House, Bo's isn't the face this administration is most eager to put forward.

The White House website is a young institution, only in its third administration. The first, in the Clinton years, was primitive by today's standards, and its role was to provide access to policy documents. During the Bush years, the White House website became an object of fascination for me because, like the blogs and websites of so many more ordinary households, it seemed to shine a light on the inner life of the place, not necessarily what was actually going on, but what the administration sincerely wanted us to believe was going on. The Bush White House understood that the Web is a powerful conduit, a way to reach the public without the nasty meddling of the Washington press corps, so the site became a pageant of the administration's fantasy life: photos of the president looking like he's in charge on 9/11, photos of the president as a benevolent and decent man, bestowing largesse, photos of him speaking on, say, AIDS policy with one of his trademark Orwellian slogans behind him such as, "Compassion in Action."

As Dan Froomkin, who wrote the *Washington Post*'s White House blog during the Bush years told me, "Well, it's propaganda." Yes it was. Obvious propaganda, clumsily executed, as weirdly off-kilter as Soviet social realism.

The Bush website had a stars-and-stripes motif early on, and it gave way in the waning years of his administration to a simpler design based on a powder blue background. (At some point, Barney was banished to the White House Kids page.) The current graphics, while descended from the Bush website's blue period, are infinitely more sophisticated. Boxes and shading are thoughtfully deployed and Bush's slapdash sans serif has given way to a careful menu of typographic approaches, with a serif font used for headlines and more formal text blocks and a sans serif used for the ostensibly less formal blog copy. The overall look suggests that you are invited to a very prestigious function, like a royal wedding.

But Froomkin's words are as true now as they were five years ago. It's still propaganda. It's just better propaganda. The website is now clearly calibrated toward advancing the administration's legislative goals. The top of the page is dominated by four rotating lead stories, framed in a blue box, each illustrated with a powerful photo. Two days after the president's

Karrie
Jacobs

A President and His
Dog, Part Two

Will and
Whimsy

**Culture Is Not
Always Popular**

107

speech outlining his strategy for Afghanistan, story number one was "The New Way Forward," illustrated with a photo by veteran White House photographer Pete Souza. Obama stands at a lectern before an audience of West Point cadets. It's the gray uniforms and young attentive faces, not the president, that dominate the picture. Story number two is "Who Do You Trust?" accompanied by a portrait of an unsmiling Joe Biden. It links to a video of the vice president discussing health care reform with a group of doctors and nurses. Number three is "Educate to Innovate," a campaign to get students excited about math, science, and technology. Obama, in the photo, is watching a student demonstrate a Rube Goldbergian contraption. Fourth is "Health Insurance Reform and Women," accompanied by a portrait of Michelle Obama looking earnestly at the camera, a simple black outfit offset by a string of pearls, which links to a video of her discussing health care "as a woman and as a mom."

The message you get immediately from the website is one of a White House that is superhumanly focused on its priorities: Afghanistan, health care, education, and healthcare. A few weeks later, the four top stories are healthcare, jobs, accountability on Wall Street, and jobs. If you have any doubt what the administration is hoping to accomplish at any given moment, you can just flip through those top-of-the-webpage stories.

Just below the main story box is a smaller box that also leads to a presidential discussion of health care. Then there are two columns of text, at the left a stream of the latest stories from the White House blog and, on the right, a stream of "featured legislation." This is the website of a very serious White House. What this means is that unlike the website of the Bush years, it's not such good entertainment. Perhaps if you're a Republican or a teabagger, this site is as hilarious for you as the Bush site was for me, but what I see when I look at it is an attempt at unrelenting diligence.

There are also a number of blogs. The main White House blog is a policy wonk's dream. Secretary of Labor Hilda Solis hosts a live chat on her "regulatory agenda." The president meets with Al Gore ahead of his trip to Copenhagen. You can vote for the winners of the president's SAVE award, an ideas competition for government employees to save taxpayer

dollars. Other blogs include the Office of Public Engagement blog:

The Office of Public Engagement is the embodiment of the President's goal of making government inclusive, transparent, accountable and responsible.

We create and coordinate opportunities for direct dialogue between the Obama Administration and the American public, while bringing new voices to the table and ensuring that everyone can participate and inform the work of the President.

Here's a sample post: "On Friday we hosted a reception commemorating the 540th anniversary of the birth of Guru Nanak Dev Ji, the first guru in Sikhism. It was the first time that this holiday has ever been celebrated at the White House."

Clearly these are not blogs in the loose-cannon, invective-spewing, Wonkette sense of the word. These are disciplined promotions, not of image, but of policy. It's as if NPR were in the White House.

The only spot where the policy-driven program loosens up a bit is in the Photo of the Day feature, which debuted in October. Many of them are the work of Souza, who was the White House photographer during the Reagan administration and came back after documenting Obama's political career in a book called *The Rise of Barack Obama*. He is also director of the White House Photo Office, and it's his photos that give the site its most compelling moments. Remember that shot of the president and Michelle Obama nuzzling in the service elevator between inaugural balls? That was his. "It tells a complete story," Souza said to the Washington Post. "You know exactly what's going on." The story that's being told in the photos of the day is of a White House that's doing its best to avoid demagoguery. It is as if the collective weight of these images is being used to undercut the Obama-is-the-world's-biggest-celebrity meme. The president is not even in many of the photos, and when he is depicted, he's not always the focal point.

The caption on the December 1 photo says: "President Barack Obama reads as Marine One lifts off from the South Lawn of the White House," but the photo is dominated by the

Will and Whimsy

A President and His Dog, Part Two

Karrie Jacobs

helicopter itself and the Washington Monument. The president is a tiny figure framed by a square window like a character in an Advent calendar. On December 2: Three Marines in dress uniforms, two male and one female, look on as Michelle Obama "debuts the White House Christmas decorations" and "promotes the Marine Corps Toys for Tots" program. The interesting thing about this photo is that neither the First Lady nor the Christmas decorations are visible in the picture. The two male Marines appear to be white, and stand at attention, their close-cropped heads, white belts, and hands folded behind their backs. The only person looking at the camera is an African American female officer with a feminine bob and what looks to be a chest full of medals. Arguably, it is propaganda, but very carefully calibrated. On December 15, the photo du jour is of the presidential limo at a Home Depot in Alexandria, Virginia, where Obama has come to speak about energy-efficient retrofits. He is not in the photo. It is a picture that is less about the administration's political agenda and more about the surreal nature of the presidency: the distinctive limo and the Secret Service agents look very strange parked in a big box store's lumber aisle.

The photos of the day read to me like an attempt, largely successful, to depict the culture of the administration as one that is pointedly egalitarian. Some of the images are inevitably not that different from Bush-era photos: the Obama family dispenses food to the needy on Thanksgiving, Obama strides across the White House lawn after his helicopter lands. We've seen those kinds of images before. But my favorite pictures on the site show the backstage life of the White House, a rehearsal for the state dinner with the Indian prime minister, for example, in which the president is nowhere to be seen. It's a bit like watching a snippet from an episode of *The West Wing*. The overall message is that real people are living real lives and doing real jobs in this distinctively unreal place.

And, of course, Bo shows up as the subject of the photo of the day from time to time. On December 3, Bo poses all by himself near a Christmas tree in the Diplomatic Reception Room of the White House. And on December 16, he's shown after he's hopped into the driver's seat of a DC police car. The website demonstrates that the Obama White House is not immune to Bo's allure, but unlike the previous administration, the cute doggy is not the single most appealing thing they have to offer.

Karrie
Jacobs

A President and His
Dog, Part Two

Will and
Whimsy

**Culture Is Not
Always Popular**

109

Mimi Lipson
A Place for Ribs

ORIGINALLY PUBLISHED
03.16.09

COMMENTS
20

I love/hate the Broad Street Diner.
It may be the worst diner in Philadelphia, but I live practically across the street. When I first moved here, I was excited about having a twenty-four-hour diner on my block. I imagined Saturday morning pancakes, a convenient bowl of soup, late night snacks on my way home from louche outings. I imagined showing the place off to envious houseguests who didn't have twenty-four-hour diners on their blocks. Boy, did I ever have a lot to learn.

It looks pretty inviting from the outside. It has an attractive white brick-face facade with stainless steel trim. Midcentury. I come from a place where diners are tiny things, sometimes in old train cars. Stools and a counter, maybe a booth or two, somewhere to hang up your jacket. But around here the diners are grand, with picture windows and acres of terrazzo and "Bakery on Premises," sometimes even cocktails. The Broad Street Diner is—or rather, once was—that type of place.

Out front, a towering sign:

BROAD STREET DINER
Banquet Rooms
A Place For Ribs

Look at what's going on in the parking lot and you start to get a feel for the place. There's always an attendant on duty...either the fat, ruddy halfwit or the skinny, bug-eyed freak. Most of the time I really don't know what they're doing. The skinny guy will sometimes open up the fire hydrant on the curb and flood my street, sending a river of trash down the block where it eventually comes to rest in damp, stinking piles.

Step inside. The dining room is big enough to accommodate two horseshoe-shaped counters, side by side (ostensibly Smoking and Nonsmoking, though the whole place is usually enveloped in a fog bank of smoke). There are two rows of booths to your right, one row to your left. There's an IN door and an OUT door, and to leave you have to pass through a turnstile and past the cashier, who sits reading the paper in a bulletproof enclosure.

Forget about *American Graffiti* or even *Alice*, because any charm the place may have once had has been stamped out by various desultory attempts at redecoration. The booths are covered in '80s vintage Burger King vinyl. There are plastic philodendrons in hanging baskets, and the ceiling is covered with white Formica. Two neon signs flicker and buzz on the far wall, one red and the other blue, spelling out—identically, redundantly—"Broad Street Diner" in airport-bar cursive. Someone thought that was a good idea.

It smells like...like something septic beneath something antiseptic. And of course like cigarette smoke.

Mackenzie
03.27.09 10:56
Wow I loved this, was transported. It felt like a dreamscape. It is a reminder of the root of why we love design in the first place, the way it resides as a part of the whole. Part of the texture of the larger weaving of life.

Mimi—hearty thanks for a sweet trip back to Philly before I have the chance to take a real trip back there this summer :^)

p.berkbigler
03.27.09 01:12
Mimi—hearty thanks for a sweet trip back to Philly before I have the chance to take a real trip back there this summer :^)

I relished two years of the city while in grad school and absolutely came to rely on a handful of diners for all sorts of respite: a great late-night snack after a project was finished, a good Saturday morning kickstart to get cranking on projects before the next week...

I never made it to the Broad Street, but spent a lot of quality time at the Oak Lane further along Broad and also loved the Trolley Car in Mt. Airy.

Hearty seconds to the thoughts of Mackenzie above—great to see the joys of diner food and the diner served up with a helping of design to boot. Order up!

110 **Culture Is Not
Always Popular**
 Will and
Whimsy
 A Place
for Ribs
 Mimi
Lipson

Above the counters, where you might see daily specials in some other diner, are photographs of food. Like in a ghetto Chinese takeout joint, but instead of pork lo mein and kung pao shrimp and fried rice with lobster sauce it's meatloaf, spaghetti, chicken croquettes. I love pictures of food. One day I noticed that someone had taken down the pictures over the Smoking counter, so I asked the manager about it. I said I wanted them if they were getting thrown out anyway. He grudgingly took my phone number and shoved it behind the cash register. That was over a year ago. Nothing has been put up in their place, and the photos over the Nonsmoking counter are still there.

What I really covet, though, is the illuminated dessert menu in the vestibule. It's a grid of photos on a florescent light box: various colorful parfaits and cakes and such, and then... momentarily unrecognizable beneath a ghostly nimbus of scuff-marks...sitting upright on a plate, its red flesh faded to orange...a half slice of watermelon!

The food at the diner is an abomination, unless you stick to the Hamburger Alley section of the menu. Otherwise, beware: anything called a platter or a meal will arrive bobbing in a pool of sweet, glutinous gravy. No amount of cajoling, no specious claims of allergies will prevent them from putting mayonnaise on your grilled cheese sandwich. The fries have some sort of acrid flavor dust on them. You would think they couldn't fuck up breakfast—after all, it is a diner—but the eggs taste like rancid margarine and the potatoes are almost raw. Even the oatmeal is sticky, cold, congealed, and the less said about the coffee the better.

I wonder if anyone ever orders ribs there.

The first time I came in, a guy in head-to-toe military camouflage was handing out menus. I moved into my house in a snowstorm, in the middle of the night, after a three thousand-mile drive. How wonderful to pull on my boots and my coat (I didn't even bother buttoning it up) and run across the street, and how unexpected to be greeted by a lantern-jawed guardsman or reservist or whatever he was. But I never saw him again.

The waitresses wear old-fashioned uniforms and opaque support hose. To say the service is bad would sell them short, because actually it

approaches Zen-like detachment. They never make eye contact, but they are more languorous than crusty. Ask for a glass of water and see what happens. In a while—maybe five minutes, maybe fifteen—your waitress will casually deposit a half-filled plastic tumbler of warm water at the edge of your table as she drifts past on her way to the counter. For that is her real place: sitting at the counter smoking, or tending to her side work, or dreaming of a footbath...or five o'clock...or a soft Panamanian moon.

Our waitress hands R. his check and says, "I think I added that up wrong. It's got a one... seven, eight...four...I don't know." Slaps it face-down in front of him.

One peculiarity of the place is that everyone always gets his or her own individual check. No exceptions.

She puts another check in front of R.'s four-year-old daughter.

So now you have your check. Maybe you're paying with a twenty and you need to get change for a tip. That means you will have to go through the turnstile, pay the cashier inside the bulletproof booth, and exit the diner. Then, and it is impossible to make this seem intentional, you go back into the diner and leave your tip and go through the turnstile again.

* * *

I'm sitting at the Nonsmoking counter absorbed in my newspaper when I become aware of someone standing next to me. I look up. It's the skinny bug-eyed freak from the parking lot.

"You're at 1337." (My street address.) (Momentary panic, followed by acknowledgement.)

"I used to live there. In the brown room."

"There's no brown room in my house."

"There's a brown room, and I lived in the brown room."

A Lebanese family named Thomas owned the house before me. As far as I know, they'd lived there since the forties. I'd met the surviving members: a ninety-five-year-old woman in a

housecoat and her son, of indeterminate age, who occupied the living room on a hospital bed. I try, fruitlessly, to insert the skinny bug-eyed freak into this domestic arrangement. Later, back at home I notice for the first time that some of the bedroom doors have deadbolts.

* * *

In the basement of the diner is the Crystal Room, a function room with a separate entrance. Some of my older neighbors remember when they used to have "gypsy weddings" there. You would hear gunshots, they say. Now it's mostly graduation parties and such: white stretch limos, Mylar balloons, party clothes. The teenagers like to bring the party up to the sidewalk, where they shriek and fight and sing and call to each other from opposite ends of the block. Sometimes they're at it until 4 a.m. when the trash truck comes to empty the dumpsters. Between the Crystal Room and the trash truck, it's hard to sleep with the windows open; but Philadelphia is hot in the summer, and sometimes you can't avoid it.

Recently, I was awakened in the middle of the night by a bunch of people yelling right outside my house. Then I heard a police car, and then more yelling. But I'm used to the shenanigans by now, and I drifted back to sleep.

In the morning, there was blood splattered all over the sidewalk, and some soiled bandages. My neighbor told me someone had put his fist through the window at the diner. They bandaged him up and tossed him out, and then he had another freak-out in front of my door. Sure enough, there it was—and there it remains: a fist-sized hole in the vestibule with a piece of cardboard taped over it.

I could sympathize. Who hasn't had the urge to put their fist through the window at the Broad Street Diner?

The strange thing is, the Broad Street Diner is always busy! Here's what I'd like to be able to say: that through the doors pass a vibrant and many-hued pageant of humanity. I wish I could tell you about sassy grandmothers and moony-eyed lovers and wise characters in tattered overcoats and fingerless gloves with stuffed parrots on their shoulders. It's not like that at all. But it does anchor the neighborhood—a neighborhood of working stiffs and church ladies, with a few art students and adventur-

ous yuppies and miscellaneous other outliers mixed in. So I guess it comes down to what your expectations are in terms of local color. I humbly offer the following:

You enter the diner and turn left past the bulletproof cashier's cage, past a booth where three old black ladies in church hats are saying grace over their eggs. You sit on a stool by the picture window and order a cup of coffee. The door swings open and in comes a bona fide South Philly alpha female: leather trench coat, stiletto-heeled boots, Tammy Faye makeup. Her perfume overwhelms the room's ambient septic/antiseptic smell. Her hair, of course, is big big big. She throws herself onto the next stool with a sigh and pulls a cell phone from her comically oversized handbag. A pause. Then she erupts in a maelstrom of activity, holding four simultaneous conversations.

To a waitress walking toward the kitchen with a tray of dirty plates: "Is Jimmy working today? Tell him it's Sandy…Billy's cousin. He knows, he knows."

Into her cell phone: "Hi, honey. Yeah, it's me. Listen, hon, DO YOU HAVE A TUX? Because it's BLACK TIE, that's why. Because it's the MAYOR. Hang on a sec."

To a waitress behind the counter: "Can you ask Jimmy to make me an egg white omelet? You're a doll."

To an old guy who's wandered in selling Eagles swag—he's holding up a jersey for her to inspect: "Let me see the back, hon." (Makes a twirling motion with the crimson-taloned index finger of her nonphone hand.) "Do you have that in a small in a pink? I need three pink smalls."

To the counter waitress again: "You know what, sweetie? Never mind. Just bring me half a grapefruit and some hot water with lemon."

She goes on like this for maybe ten minutes, the star of the show, seizing the attention of everyone in the diner either actively or passively. Suddenly, she jumps up and rushes through the turnstile and out the vestibule, past the fat, ruddy halfwit to Broad Street, where she flags down a taxi with a wave of her enormous handbag. A ten-dollar bill sits next to her untouched grapefruit.

It's not *Fried Green Tomatoes*, but believe me, we'll look back on it in a few years and wonder what happened to the real America, the place we loved.

Epilogue

I probably jinxed the diner. Certainly, I didn't put my money where my mouth was. I'd be out of coffee, and I'd think of popping in, and then the thought would cause my stomach to make a funny noise. Or I'd have someone over and we'd want to grab a bite, but I couldn't be bothered with explaining about Hamburger Alley or listening to them complain about the wait-resses, so I'd suggest going around the corner for a bowl of pho instead. At some point, I noticed the diner wasn't open all night anymore. Then it started closing at 9, then 8, and then it became a "breakfast and lunch only" place. Sometimes, though, it was still closed when I walked past at 8:30 or 9 a.m. I mentioned it to a neighbor. "Oh, they sold it to some Chinese," she said, as though this explained everything. One day it didn't open at all. It's been closed for over a year now. A handwritten sign, taped to the vestibule window near the fist hole, says, "We Will Grand Opening Soon."

Mimi
Lipson

A Place
for Ribs

Will and
Whimsy

**Culture Is Not
Always Popular**

113

Tom Vanderbilt
Small Worlds

ORIGINALLY PUBLISHED
09.13.06

COMMENTS
24

One of the first things I like to do upon visiting a new city is to visit the scale-model version of itself.

From Havana to Copenhagen, I've hunted down these miniature metropolises in dusty historical museums and under-visited exhibition halls. I've pressed the buttons that light up landmarks and crouched down to peer into tiny streets. Since these models have typically been built decades earlier, they sit as three-dimensional monuments of a city interrupted, captured in time and modeling foam. This can lead to unexpectedly poignant moments, such as the extant World Trade Center towers at the Panorama of New York City at the often-overlooked Queens Museum.

At other times, they are used to assemble a vision of a city not yet here, as I recently discovered on a trip to Beijing. There, at the gleaming new Beijing Planning Exhibition Hall, just off Tiananmen Square, exists what is, in its size and replicating rigor, one of the most impressive urban miniatures I have ever seen.

Occupying an entire room, the miniature Beijing is a staggering testament to the city's sprawling density, with its broad boulevards, endless housing blocks and imperial sweep. If the model itself seems massive, the sheer size of the expanding city is further evident in the fact that beyond the red ropes encircling the model, the rest of Beijing, that creeping progression marked in the ever outwardly

radiating ring roads. This great sprawl, which undoubtedly would have even taxed the effort of a cadre of Chinese modelers, is not rendered as model but as glass plates (upon which one can walk) featuring aerial survey photographs. To top it all off, the second floor has a series of mounted binoculars through one which one can peer down, like some Jules Vernean aeronaut exploring the city from a novel perspective.

As I scanned for one of my few Beijing landmarks, my hotel in Chaoyang district, I suddenly became aware of my own unmediated sense of mirth and wonder, and thought: "What accounts for the peculiar appeal of the scale-model miniature?"

Surely one reason for their ineluctable allure is that simple Olympian sense of being able to consume as large as entity as Beijing or New York in a single eyeful.

This is a fiction, of course, albeit a powerful one. But the Beijing I was looking at was only as real as one's imagination would allow it to be. For its painstaking physical verisimilitude, it is an empty, mute, frozen city, vacant of life and urban reality. Nowhere is there Beijing's cacophonous traffic, nowhere the legendary smog (by some accounts currently the world's worst). This model does not capture the convulsive destruction of the city's historic hutong neighborhoods, or the slow eradication of the "Kingdom of Bicycles," or the droves of immi-

John Kaliski
09.14.06 03:41
Perhaps the most terrifying model I have ever studied is that of Albert Speer's Germania. Adolf and Albert used to spend many hours alone (some have wondered about this), admiring this horrific vision of classical splendor—the future capital of the 1000-year reich that was not to be. Hitler admired Speer's organizational and miniaturization skills to such a degree that for a time Speer deluded himself not only into imagining that he was an architectural god, but also the heir to the final solution. More often than one might imagine they have gone together. In this sense at least I am not completely on-board to Tom's comment that models ... "are an ideal of perfection yet to be encumbered by realism, by political demands and the other contingencies of full-scale life." My own sense, even as I remain fascinated by City models and visit them when I get the chance, is that they are now an archaic, if not always barbaric, means of urban representation that seeks to represent the life and political power of the chosen at the expense of most of the rest of us. Hence it does not surprise me that a regime such as the one in China would spend time and money to build a model of their future capital. Better to have a God-like view in a conference hall where all contingencies can be controlled than experience the reality of the streets (conveniently framed and frozen under glass to be stomped upon). Interestingly, one wonders if the tepid response to the first models of the Ground Zero site did not raise some of the same concerns in our more democratic situation. And this gets me to the last point.

Dan Hill
09.14.06 05:40
*From a slightly different angle,
video games offer a similar
sensation, though it reverses
the polarity and miniaturises
you, placing you within the city
model, at the size of your TV
screen. Here, the city is perhaps
best conjured through modeling
behaviour and detail rather than
urban form at scale. This is
where software based models
have the edge over physical
miniatures, as they could react
to real-time data. Although, it can
be profoundly disorientating to
visit a city after discovering it first
in a video game, as I discovered
when I hit the beach at Santa
Monica, only to realise I'd been
there before. Kinda. Kevin
Lynch's notion of imageability
may be key here.*

*Finally, what impact do these
models have on the urban f
orm itself? Is there any kind
of feedback loop? I've specu-
lated that this may happen with
architecture, as video game
rendering engines conjure
increasingly accurate models
of things like Fallingwater or
cities themselves.*

*But as you note: it's still not
the real thing :)*

grants living in temporary work camps who have come to build this next city. There are no construction cranes in this model—this is not real time, unlike the model in Paul Auster's novel *The Music of Chance*, a "City of the World," marked by "extravagant smallness," in which past and present commingled (its creator depicted himself as a young man and an adult, in different locations). This model was to be so precise, in fact, it would feature a telescoping model within the model—if its creator had time to build it.

What it does show, strikingly, is the Beijing that will soon become the backdrop for the 2008 Olympics broadcast. And so there was a small representation of Rem Koolhaas's serpentine headquarters for China Central Television (with the eerily apt initials CCTV), Herzog and De Meuron's "bird's nest" Olympic stadium, and the Water Cube, the Arup et al., National Swimming Center. These are all striking, aspirational architecture, and I could not help but remember back to a cluttered shop in Shanghai that was selling old propaganda posters—the drive for maximum harvests and industrial output and the like—and think that I was not looking at some version of the same, with important buildings by "name" architects standing in for factory quotas and wheat production numbers.

This too seems to be a factor in the appeal of models, that is, the sense that once you build something, even if it is at one to one hundred scale, it is essentially completed. Call it antici-patory urbanism. One thinks of the many iconic historical photographs of architects and civic leaders hovering over some new project—the latest being Mssrs. Libeskind, Pataki, and so on, pointing down into the new skyline of Low-er Manhattan—dominating the city through their Brobdignagian mass, almost willing it into being. Of course, these buildings can now be rendered in a much more thoroughgoing and complex way digitally—pixilated walkthroughs and the like—but those, no matter how well done, still seem a bit otherworldly, like ex-pensive fantasy real estate in some precinct of Second Life. All those gigabytes cannot seem to ultimately hold a candle to some good old-fashioned Lucite and three-dimensions.

There is a pristine, uncorrupted sense to mod-els. They are an ideal of perfection yet to be encumbered by realism, by political demands and the other contingencies of full-scale life. The architectural photographer Balthazar

Korab once told me that he had taken pictures of a client's model and the actual completed building, and that the client preferred his pho-tographs of the model.

And one should of course not dismiss the sheer sense of childlike wonder that models possess. As children, we are enchanted by miniature toys not only because we can relate to them in size, but because of the sense they give of being in control of one's environment—entire armies or dollhouses under one's domain. As adults, miniatures seem almost nostalgic, for they reconnect us with that small world, and I think something in this feeling ex-plains the strangely powerful appeal of tilt-shift photography, which distorts images selectively so that they fool us into thinking we are in fact looking at a miniature. This is, tactically, the op-posite of what Korab had achieved—to make the fake look real—but in spirit they are part of the same project.

Raymond Lester, who designed and built the New York City diorama for the 1964 World's Fair, was an enthusiastic model-railroader as a child before going on to a career that began with making miniature, scientifically precise replicas of battleships during World War II—then eventually progressing to being the chief model maker for Robert Moses's outsized ambitions (including the doomed Lower Manhattan Expressway). But one suspects that somewhere always lurking within this adult in a world of power and ambition was a child with an HO-scale view of the world.

There is the question of whether something is simply too large, too complex to be modeled. Several years ago, I spent an afternoon ex-ploring the incredible ruins of the Mississippi River Basin Model, near Jackson, Mississippi. Built by German POW labor during the war, it is a scale-model replica, spanning some two hundred acres, of the river's entire reach, from northern Mississippi to New Orleans, untold thousands of acres faithfully carved in model-ing clay. The corps used it for several decades to predict the effects of its various engineering projects and, on several occasions, to esti-mate in real time the downriver effects during various floods. When the corps began shift-ing to computer modeling in the 1980s, the model was vacated, left to slowly decay in the Mississippi humidity and sun. At the corps' Wa-terways Experimentation Station in Vicksburg, Mississippi, however, there are still physical

models being built, sprawling lakes and minia-
ture rivers contained in metal hangers.

Some of the engineers still swore by physical
models for being able to predict dynamics
that even the most powerful computer might
miss. But any model is ultimately haunted
by a simple, powerful fact: It is not reality.
The truth may be that reality is impossible to
capture. Something like the Mississippi River is
changing every minute, and it was this difficulty
in rendering some version of truth that one en-
gineer told me kept him "awake at night." A few
years later, Hurricane Katrina proved his fears
correct, even if not as predicted. Nature cannot
be adequately replicated in a bathtub, or even
a swimming pool.

What had recently reminded me of the Mis-
sissippi River Basin Model was a session of
Google Earth. As with a model, Google Earth
gives one a God's eye view of some landscape
otherwise unknown in its totality; it also re-
awakens one's perspective of the familiar. As it
happened, I came upon a stretch of the Missis-
sippi River, and the view I had via my browser
reminded me of striding tall atop the topo-
graphical model. On an impulse, I punched
up Clinton, Mississippi, and watched as the
browser "flew" south. After a few minutes,
navigating along what I could remember of the
place, I was able to find the Basin Model, look-
ing a bit like, well, a drained river. I now had a
view, taken from outer space, of a miniaturized
landscape, upon which another, even more
miniature, landscape was superimposed. To
complete the picture, I remembered that at the
corps headquarters was a smaller, table-sized
model of the model. As the narrator in *Music of
Chance* had marveled, "a model of the model
of the model. It could go on forever."

ORIGINALLY PUBLISHED
05.14.06

COMMENTS
31

Alissa Walker
Why Scientology Is Good for Hollywood

Last week may have marked the end of a year-long promotional campaign of impossible proportions. But it was only the beginning of the age of enlightenment for the Church of Scientology.

An astounding twenty-three million visitors visited Scientology websites in 2005, where the FAQ page now seems to tap the mind of an *US Weekly* reader. In the same year, Scientology logged a record 289,000 minutes of radio and TV coverage—coverage that upgraded Scientology from an obscure insider reference to national late night talk show fodder. When Isaac Hayes left *South Park* because of an episode that depicted Scientologist beliefs, Comedy Central issued a stunningly cheeky response from the show's creators: "Scientology, you may have won THIS battle, but the million-year war for Earth has just begun!" They said exactly what had been on our minds for months: Scientology is really screwing up Hollywood.

But if you live where I do, in the actual city of Hollywood, just a few blocks away from where the Oscars are held, you see the Church of Scientology as somewhat of a savior. Within a two-mile corridor along Hollywood Boulevard, the church owns eight historic buildings, four of which are on the National Register of Historic Places. In a neighborhood where architectural triumphs evaporate with little remorse, Scientology is the most ardent preservationist force in town.

Los Angeles is infamous for its design amnesia, but Hollywood seems to have been whacked over the head particularly hard. By 1960, all but one of the film studios that financed the building boom in the '20s had relocated to different parts of the city, leaving a gilded shell to rot. Over the next forty years, the city adopted some rather extreme planning methods.

The earthquake-damaged Egyptian Theatre was cemented shut, sealing its ornate 1922 details inside like the King Tut tomb it was inspired by. Sardi's, the glamorous Schindler-designed sister to the New York power lunch spot was thrust out by current tenant, Le Sex Shoppe. Even after it was declared a cultural monument, the once-lush Garden Court apartment building, known later as "Hotel Hell," was soon leveled by an even more frightening, white cage of a complex named The Galaxy. No such measures were needed when the famous Brown Derby restaurant fell into disrepair; transients simply burned it to the ground.

When I moved here five years ago, the legendary heart of Hollywood—the intersection of Hollywood and Highland—was a vacant lot. I walked my new neighborhood expecting a shimmering celluloid siren—or at least a seductive, dark-hearted lounge lizard. But Hollywood today is more of a jaundiced has-been with her teeth punched out. Shingle-weary 1926 craftsman, weedy parking lot, strip mall with stucco frosting, chain-link fence. Repeat.

Alissa
Walker

Why Scientology Is
Good for Hollywood

Will and
Whimsy

**Culture Is Not
Always Popular**

117

Slowly, Hollywood is making a comeback. But discovering an original structure that's not impregnated by souvenir shops is like seeing a celebrity on Hollywood Boulevard before 11 p.m.

One such structure holds court in the center of Hollywood: it's the prestigious Guaranty Building, a true Beaux-Arts beauty. Charlie Chaplin and Cecil B. DeMille invested in this building. Social columnist Hedda Hopper kept an office here. It still looks much like a 1923 banking center, which, at 150 feet, was once one of the tallest buildings in LA. Today, it is the mother church of the worldwide Scientology religion.

Next door, the church owns the Regal Shoes building, a streamline moderne curved-corner property built in 1939. A few blocks down is a two-story Normandy-style building, home of the Scientology Test Center. Across the street from that is the Hotel Christie, the bricked-and-columned colonial revival built in 1923 by Arthur Kelly, considered the first luxury hotel in Hollywood due to its private baths. A neon sign runs its length like a theater marquee: S-C-I-E-N-T-O-L-O-G-Y lit up green and yellow at night. A lovely complex on the western end of Hollywood includes a Spanish colonial church. The fluorescent pink bougainvillea of that courtyard compared to the graffiti etched in the empty storefronts of The Galaxy, right next door, makes me wish L. Ron Hubbard had started his writing career sooner.

With seemingly little self-awareness, Scientology has become the unofficial pioneer of Hollywood's gentrification movement. But why? In the '60s and '70s, when Scientology was staking its claim, land was cheap. What spurred them to scout and restore aging facades instead? In addition to his talents for spinning a religion out of a mediocre science fiction career, was Hubbard an urban planning visionary?

Maybe, I thought, in Scientology speak, architectural renovation serves as a stirring metaphor for spiritual rebirth. Like a suppressive robbing an engram bank, I needed answers.

The crown jewel of Scientology's heirlooms is the Château Élysée, a 1929 replica of a seventeenth-century French château now known as the Celebrity Centre International. It was built by Eleanor Ince, widow of Thomas Ince, the original movie mogul to house

luminaries like Clark Gable, Humphrey Bogart, Katharine Hepburn, Errol Flynn, and Ginger Rogers. It's also where Katie Holmes came, reportedly almost every day during the past year, to study. I chose this as my architectural gateway into Scientology.

I call ahead, saying I'm an architecture enthusiast and I'd like to set up an appointment to tour the building with someone who knows about the restoration process. They assure me they have someone on hand for just that request, and urge me to come any day, from 9 a.m. until 10 p.m. Their doors are always open.

The doors are, in fact, closed, when I arrive, so I tell the guard smiling outside why I'm here. This request puzzles him greatly, and he guides me in, looking for backup.

In 1992, the church devoted over one million hours to restoring the Château Élysée to its 1929 state. The lobby is rococo-perfect. Hand-painted frescoes cover the ceilings and most of the walls. Original crystal fixtures sprout from every surface, throwing their glittery patina over the room. Thick, large-footed furniture is upholstered in sumptuous Victorian florals. I sit in a burgundy armchair and stare up at the blue plaster sky, rimmed with clouds and columns.

A woman named Trish scurries to my side, asking if I'm indeed the person who wanted to know about the building's architecture. I ask her if she's the restoration expert. "Well, I know a little bit about the building," she says. "But I know a lot about Scientology, and that's who owns the building!"

But—the restoration expert? "I'm not sure who you spoke to," she says. "But I could show you around. And you could learn a little about Scientology on the way?"

I'd only gotten a peek at the famous pink-and-green-checkerboard marble floors. And the French gardens—I could barely see them from the street since they stretched canvas around the property's perimeter. "I'd love to learn about Scientology," I say.

Perfectly centered in the salmon pink recesses of the lobby's wide cream paneling are huge flat-screen monitors. The tour begins by walking from screen to screen, where wide-eyed people demonstrate Scientology's ability to

depriving Scientology of their property rights. Actually that was not true, I just refused to sign their permits for months until they agreed to minimally meet preservation standards. ...

Suffice it to say that when the history of Hollywood redevelopment is written the Scientologists will be noted as major Hollywood property owners who initially had to be brow beaten by public and private interests into becoming preservationists. The real heroes of Hollywood revitalization and preservation are hardly unknown or blasé. They certainly have never been dispassionate about saving this community's legacy and fostering better development. Unfortunately they and their efforts, both the good, the bad and the ugly, were not the subject of this post—a post, however well intentioned, nevertheless written from the point of view of a fictional (perhaps Thetan?) design universe that I do not live in.

overcome life's trauma—in this case, attacks by German shepherds. I pretend to watch but secretly memorize the carved gold woodwork along the wall.

My E-Meter readings are taken in the corner of a sitting room with an ivory grand piano. When I'm forced to grip metal cylinders and recall a traumatic moment myself—I conjure visions of vicious German shepherds—I observe how well the scarlet curtain swags match the red in the carpet. The auditing classrooms are upstairs, on a level painted entirely in pastoral motif, with glossy-eyed rabbits prancing along the chair rail. The world-famous purification program, a regimen which releases toxins so violently that students have been known to have drug flashbacks, takes place in a pristine black-and-white tiled spa.

When we step into the garden, I audibly gasp. This is the view I've strained to see over the jasmine-entwined fence for five years—the Château Élysée, unobscured. Towering above neighboring cinderblock apartments, it's quite literally a castle. Turrets rise from fluffy Engelmann oaks to spike the sky. The hum of the Hollywood Freeway is drown out by a splashy fountain. The afternoon sun filters through ninety-foot palms onto feather-thin ferns that surround an orangery. I'm in the Loire, not Los Angeles. I feel dangerously close to being brainwashed with period detail.

In my reverie I point at a leafy balcony on the sixth floor. The top four floors are home to the hotel suites heaped with history. I have a list of which celebrity lived in which room—each with original furnishings—and I'd like to see Bogart's or Hepburn's, maybe. Trish shakes her head without dimming her smile. It's a functioning hotel for visiting Scientologists, she says. They're off-limits. The tour is over.

Trish guides me back into a tiny office where I politely decline several classes that will lead to enhanced professional growth. She looks troubled when I don't write my phone number down on her evaluation sheet. I get it: the door to Scientology will reopen if I pay thirty-five dollars for the Personal Efficiency Course. I stare out the window, where Eleanor Ince designed a moat to encircle her sculpted boxwoods, and seriously consider it.

Hubbard didn't live to see the completion of the Celebrity Centre's restoration, but he did

author a 1955 initiative called Project Celebrity, in which he acknowledged his desire to recruit those who "entertain, fashion and take care of the world." The century of star power threaded through these buildings draws a direct line to the headline-snagging Scientologists of today. Even the consecrations concentrated in Hollywood's historic entertainment district milk every bit of their Walk of Fame locations: the L. Ron Hubbard Life Exhibition in the Guaranty Building packs as much bang into its guided tour as the Hollywood Wax Museum down the street.

The Château Élysée has the same theme-park appeal; as a castle it rivals the one inhabited by Sleeping Beauty, a mere thirty-nine miles away. But the fairy-tale perfection is also a physical representation of the hyper-idyllic world in which Scientologists so firmly believe. Scientology preaches "a civilization without insanity, without criminals and without war, where the able can prosper and honest beings can have rights, and where man is free to rise to greater heights." A building frozen in the prime of its bygone era becomes a more believable refuge from the complications of modern life.

Perhaps then, the distinctive landmarks serve as a motivational tool? As students of Scientology ascend the bridge toward total self-determinism, maybe they also climb the architectural ranks. They start as cashiers at the Hubbard bookstore on the ground floor of the Hotel Christie; the penthouse of the Château Élysée tantalizing them along with their dreams of becoming level-seven Operating Thetans. Brochures for Flag, the spiritual retreat center and Mecca of Scientology, promise "maximum case gain" at the palatial 1927 Mediterranean-revival Fort Harrison Hotel, in Clearwater, Florida.

Hubbard's legacy has ensured that Hollywood's golden age is safe—albeit only for the enjoyment of those who have been saved themselves. Yet even our local government has failed to protect historic buildings from demise, and he's managed to elevate our secular spaces—hotels, banks, theaters—into untouchable sacred grounds. Given our track record, maybe it's for our own good.

And, like most of their tenets, Scientology has decided that what's good for Hollywood is good for everyone. They already have their eye on a lovely art deco masterpiece in a town near you.

Alissa
Walker

Why Scientology Is
Good for Hollywood

Will and
Whimsy

**Culture Is Not
Always Popular**

119

Steven Heller
Japanese Face Masks

In Ridley Scott's *Blade Runner*, you may recall seeing scores of surgical face-mask-wearing passersby navigating their ways through the dense futuristic metropolis that is a cross between Tokyo and LA. It always struck me as odd—yet somewhat comforting—that in the future regular people would protect themselves and others in such a way from the ravages of germs and the inevitability of disease. But living in New York City, where people have a tendency to sneeze without even covering their mouths, I figured the mass employ of surgical face masks in the streets and on public transportation was simply a utopian fantasy. So I was totally surprised to find on my first trip to Tokyo that not only is it the custom to wear such masks everywhere, it's big business too, with a nod to graphic design.

I have a proclivity for obsession and I quickly became obsessed with finding where and how the Tokyo natives obtained their masks and why, in fact, they wore them at the expense, I thought, of looking quite eerie. I soon learned that what's eerie to some is decidedly natural for many. According to my calculations one out of every five people from all social strata, age groups, and genders wore them in virtually every public circumstance. I found a logical preponderance on the streets, especially in the crowded Shibuya and Ginza districts, and on the over-stuffed mass transit trains and buses, but also in fine hotels and restaurants (while eating they were placed awkwardly under the

chin and looked like drool cups). I even saw one gentleman comically, albeit seriously, smoking a cigarette through one.

Although some people wore the masks because they had colds or were afraid of catching them (and contagion from bird flu was a real fear), the majority of wearers are actually allergic to the cedar pollen that has become so annoyingly common since the end of World War II. Massive deforestation during and after the war was compensated for by thousands of cedar plantings, which unbeknownst to the agrarians at the time, gave off potent pollen on a par with ragweed in the United States. Apparently, the surgical masks, which cover nose and mouth, considerably reduce the intake of the allergens. What's more, since blowing one's nose in public is considered bad form (I learned from experience), any reduction of sneezing is as much a question of manners as hygiene. (Interesting though, tissue packages with advertising, for everything from strip shows to currency exchange, is one of the most common advertising give aways on the street.)

But back to obsessions: For the few days I was working in Tokyo I made it my mission to buy as many face mask packages as I could find. I found them in the numerous 7-Eleven and Lawson convenience stores on virtually every street corner, hanging next to the "white business shirts" and near the white umbrellas (everything being so uniform). The masks

Jeneko
04.19.11 09:35
I live in Japan currently and your blog popped up while I was looking to purchase a designer facemask....

*Anyways, in Japan there are many reasons why they wear masks the top four being
1. they are sick and are being courteous to others by trying to keep it to themselves
2. paranoia of getting sick
3. pollen
4. Fashion!*

Many younger people here in Japan purchase designer face masks or wear the simple ones because it is now considered a fashionable. It is not uncommon to see people wearing masks with their favorite characters on them, or done up to make it look they have an animal face. It is considered quite cool here.

Also, there are more than just the boring medical ones back in the US, back last year when H1N1 was scaring everyone, my doctor's office started giving out masks to anyone who was coughing, and even there you could find Disney, cute patterns and different colors.

Lastly: "Interesting though, tissue packages with advertising, for everything from strip shows to currency exchange, is one of the most common advertising give-aways on the street." That is because while it is rude to blow your nose in public, it is incredibly acceptable to excuse yourself to blow your nose, in fact, it is considered very polite to leave the room to stop your sniffles or have your coughing fit (and trust me, it sucks to hold in your coughs till you can leave a room)

routinely came in silvery Mylar packages, usually with a sky blue overall tinge, but also in pink. One was labeled "High Tech Breath Moistener" and was recommended for flying (not a bad idea); another one was promoted as being usable for seven days (though that would give me pause). A few were designed especially for sleeping children, and some, with various layers and baffles, were more technically complex than others. On the back of each package were detailed diagrams on how to use the masks, and also how germs— usually presented as little balls of florescent color—were blocked from entering the breathing passages. The typography is rather clunky in the commercial Japanese style, but entirely appropriate for the mass nature of the product. What I liked most, however, was how soft and comforting the packages felt. Despite or because of the smooth foil/Mylar wrapping you could sense the soothing essence of the product inside. What was also intriguing is the number of different brands. In my brief shopping spree I found ten, each with different hygienic attributes, but I'm sure there are more.

When I returned to New York, I visited my local surgical supply store to see whether anything comparable was sold here. The counter person did show me the surgical masks, but they were in drab medicinal packages (near the rubber gloves) designed not for the general public but for health care professionals. I doubt, of course, that face masks will ever be as big here as that other Japanese import, transistor radios. Americans may like protective gear, but covering one's face with a mask has gloomy and sinister connotations (what's more, Homeland Security would probably ban it). But if there were ever an opportunity, I'd be interested to see how differently we'd design the packages and the masks too. And I wonder what we'd call them—"Face Off," "Germ-Masque," "CoffProof?"

Jessica Helfand
The Designibles

ORIGINALLY PUBLISHED
11.15.04

COMMENTS
34

In the new Robert Zemeckis film, *The Polar Express*, Chris Van Allsburg's dreamy illustrations are animated by way of a new three-dimensional CGI technology called "performance capture." In this process, real actors (Tom Hanks plays most of them) are wired with small sensors attached to a network of digital cameras that simultaneously record three-dimensional facial and body movements in 360-degree views. (In production shots, the sensors themselves are attached to the actors' faces, making them look as though they've been overcome by a rather advanced case of digital acne.)

Meanwhile, Pixar's latest foray into cinematic invention captures more than just perfor-mance, and is, therefore, incredible for a number of reasons—not least of which is the fact that it's not even remotely time-pegged to Christmas.

So what's so incredible about *The Incredi-bles*? It's not the brilliantly detailed portrayal of modern superhero culture writ large. It's not the witty, demented parody of celebrity hero-worship positioned against the rampant passivity of civilian laissez-faire. It's not their agility, their bravery or their will, their strength or their stamina, or even their ability to produce force fields at the dinner table.

No: what's incredible isn't performance capture but another phenomenon altogether. What's incredible about *The Incredibles* is

the art of design capture. Because when it comes to nailing design, the "Is" have it.

The Incredibles dwell in a kind of extraordinary dystopia, at once a celebration and an exagger-ation of Eames-era modernism. Flanking either side of their suburban abode are split-level houses whose bland facades are punctuated by rows of tailored boxwoods: they're robotic stand-ins, a kind of horticultural mutation of Stepford-wife stupor. Inside the house, chairs and tables sport blonde, Danish wood finishes, a midcentury palette further amplified by hints of color: chartreuse upholstery and avocado appliances form the perfect backdrop for a duo of wizened heroes who've been retired from active duty.

Yet as the pace quickens and the action builds, the design does too. Slick designer vehicles (think Philippe Starck on steroids) transport us to new architectural destinations: here are sites dotted by grand concrete allées, framed by volcanic window treatments and walls of perfectly gridded weaponry. Even Syndrome, the villain's sensurround computer screen is well-designed, boasting well-kerned Bank Gothic letterforms within an icy blue-grey in-terface. It's design run amok, at once exquisite and terrifying: Fritz Lang's *Metropolis* meets Frank Lloyd Wright's Imperial Hotel in Japan.

Yet beyond the fear factor, design is also featured as deliriously comical. Arriving at the estate of Edna Mode, visitors are led up a man-

Kurt Andersen
11.16.04 09:35
Yes, yes, yes: among the very best movies of the year, in no small part because it so wildly and hearteningly overdelivers. In this -- and in its deep design savvy -- it also reminded me of Men In Black.

Armin
11.30.04 09:18
I have a hard time with "design" being attributed to The Incredi-bles' success as a good movie. Storytelling, (virtual) set design, character development, talented actors and amazing—and powerful—3-D renderings are what make this movie great. Let's not get giddy and lump all of these together into this precious word of ours as everybody does with product, industrial, fashion and even hair design... unless we want to start calling janitors designers as well: designing cleanliness.

Certainly, this is a lighthearted post by Jessica and, like others, I absolutely enjoyed the movie. Thumbs up!

icured hillside to an International Style house of uncertain provenance. Edna's diminutive size (she admits to three-foot-eight) makes the scale of her minimally furnished home seem even more preposterous: from the Miesian lobby to the Bulthaup-inspired industrial kitchen (and let's not forget the George Nelson benches) it's an aesthetic travesty: design beyond reach. Edna herself is a kind of cross between the diminutive actress Linda Hunt and the design impresario Murray Moss—with dashes of Anna Wintour and Edith Head thrown in for good measure. In Edna's domain, design manifests as a kind of Napoleonic obsession. A devout minimalist permanently clad in monochromatic shades of black and gray, she's the ultimate cartoon embodiment of design. True to form, a glance at her profile reveals that while Mr. Incredible's special power is "strength" and Elastigirl's is "flexibility," Edna's is simply listed as "designer."

The Zemeckis film has, of course, its own artistic merit: one scene at the North Pole features an elf-run command center, with an enormous obelisk made up of hundreds of round-edged black and white television screens, allowing the elves to monitor a world of sleeping children. (More echoes of Fritz Lang here.) But performance capture leaves you feeling like someone introduced an auto-pilot feature in Photoshop: in the end, it's all too mechanically perfect, and no amount of dreamy illustration—or, for that matter, piped-in Bing Crosby holiday favorites—can fill the void.

Pixar's technical contribution to computer animation is the art of texture mapping which, like performance capture, raises the bar for what's visually achievable from storyboard to silver screen. But special effects are only half the battle and, at Pixar, they're the second half. One has only to acknowledge the attention to morality (*The Guardian*'s Oliver Burkeman and Peter Conrad have both called it "Nietzschean") and consider the characters—funny, flawed and yes, flabby—to understand that at Pixar, the play's the thing. But that's not all: take one look at their signature character— the deliciously anthropomorphized Luxo lamp—and you'll agree that design looms large in this new world vision. And thanks to Edna Mode, we now we have our very own superhero to prove it.

Liz Brown
Phil Spector vs. the Wall of Sound

ORIGINALLY PUBLISHED
08.06.07

COMMENTS
12

It's hard to pinpoint exactly when it all went off the rails for producer Phil Spector, when the capes and wigs weren't eccentric quirks anymore, when the First Tycoon of Teen, now standing trial for murder, turned so dark. But if there's one song that captures Spector spinning out of control, over-reaching, it's "River Deep, Mountain High," and if there's one singer that couldn't be encased in a wall of sound, it's Tina Turner.

For Phil Spector, this is the song that got away.

"River Deep" doesn't waste time building to a crescendo. It begins on a crest. It's just a question of getting to the next peak and then next, which is most likely why it found a spot on Celine Dion's set list and launched the hundreds of summer camp performances available on YouTube. One of my favorite renditions comes from "The Most Loved Singing Duo in Malta," Julie and Ludwig, who spin out into a fascinating Eurovisionesque disco frenzy. But more compelling than all that is the way Tina Turner ultimately turned girl group-style and the wall of sound inside out.

Until 1966, Phil Spector possessed perfect command of his material; he was an unstoppable machine, churning out "little symphonies for the kids." The early hits with the Crystals, Darlene Love, and the Ronettes were designed through fanatical attention to detail—angling microphones, stuffing drums with bricks—then filling Gold Star Studios with musicians and instruments—pianos, guitars, brass, strings. Spector started the recording sessions late and worked his singers and musicians overtime, ordering members of the Wrecking Crew, many of them virtuoso jazz guitarists, to play eighth notes again and again, wearing them down until you couldn't tell any one sound from another. (Jerry Wexler of Atlantic Records called this "gargantuan leakage." He hated the molten sound. "But," he tells Mick Brown in a new biography *Tearing Down the Wall of Sound*, "I recognized its incredible, incredible value. Phil was making hits.")

The Ronettes singing "Be My Baby" exemplifies this lush, expansive style. The drums announce themselves, then come the handclaps, next Ronnie Spector's plaintive croon. Soon it all bleeds into one dense, overpowering swell of yearning. Ronnie Spector, Estelle Bennett, and Nedra Talley may have been tough women from Spanish Harlem, but but they smiled and swiveled with their matching hairdos, outfits, and moves, perfectly in sync, perfectly contained.

Spector had topped the charts for five years when he sought out the Ike and Tina Turner Revue for his most ambitious production, "River Deep, Mountain High," written with newly divorced Ellie Greenwich and Jeff Barry. "And I love you, baby, like a schoolboy loves his pie." It's a sweet, laughable line, but it's also the signal that this is no ordinary declaration of love. And it marks the song as Phil Spector's,

because in Spector's world, love is an act of fierce childlike possession. In Spector's world, the beloved is a thing—a pie, a rag doll, a puppy. Just as sound, too, is thing—a pillow, a wave, and, of course, a wall.

The studio sessions in Los Angeles were a spectacle—twenty-one musicians, twenty-one backup vocalists, and an audience that included Mick Jagger, Dennis Hopper, Brian Wilson, and Rodney Bingenheimer, "Mayor of the Sunset Strip"—but not Ike Turner. It's a testament to Phil Spector's force of personality that he out-Svengalied Ike, allowing him a producer credit but barring Tina's manager from the actual production. Tina, so over-whelmed by the scene, left after the first day and didn't return for a week.

The resulting combination of Tina Turner's raw, unbridled passion and Spector's orches-tral swoon was a total disaster. Considered grandiose and incoherent, the song tanked at number eighty-eight on the US charts (though it did peak at number three in the UK). In the aftermath, Spector essentially went into seclusion for the rest of the '60s, sinking into temporary obsolescence. He would re-emerge in 1970 for a massive comeback, the Beatles' *Let It Be*, followed by John Lennon's *Imagine*, Leonard Cohen's *Death of A Ladies' Man*, and the Ramones' *End of the Century*.

Before then, in 1969, Ike and Tina rereleased the song with a new arrangement, stripping away the overdone orchestration, leaving Tina's sound and feeling unfettered, allowing what Spector could not: a voice to build upon itself. In a taped performance, Tina even renames it, announcing, "It's now our version of—a new version of 'Rivers Deep—Moun-tains High.'" The backup singers may wear matching outfits, but there are no mincing girl group steps here, nothing contained about the way the women stalk the stage in long-limbed strides. Spector was bent on creating emotion in his listeners, but Tina is a performer who insists on transmitting emotion herself, with her own voice, reaching her hand out to the audience. "'Cause it goes on and on," she tells them.

Ike knew Tina's style better than Spector and it is this version that is now so widely revered. It's surprising then that when the camera pans to the audience at the end, everyone is seated, clapping politely. What is wrong with those people? Is that a reverse shot from the wrong performance? (See Sandra Bernhard in *Without You I'm Nothing* emoting for a bored African American audience for another reversal.)

Then reverse shot yet again: Watch Tina Turner watch her own song performed for her. At the 2005 Kennedy Center awards, Melissa Etheridge took the stage for a well-meaning, but wincingly over-charged rendition. At first, the high-octane quality of "River Deep" might seem well suited to Etheridge's style of belting, but she just simply doesn't have the range. It becomes an exercise in awkward-ness, especially when the camera cuts to Tina, sandwiched between Robert Redford and Laura Bush. (For a fascinating sidebar, contrast President Bush's impassivity to Etheridge with his involuntary rocking in place when Beyoncé takes the stage for "Proud Mary.")

What might it have felt like to knock that wall down? On YouTube, an enthusiast from Venezuela has posted a promo of radiant Tina backed by the effusive Ikettes. Shot in black and white, shadows stark against the wall, the video feels like surveillance footage of covert abandon. Plus, the white pants suit is dynamite.

Liz
Brown

Phil Spector vs.
the Wall of Sound

Will and
Whimsy

**Culture Is Not
Always Popular**

125

Mark Lamster
The Baseball Card as Design Inspiration

ORIGINALLY PUBLISHED
03.08.11

COMMENTS
5

Like so many American kids, when I was a boy I collected baseball cards. Until my teens I think I liked baseball cards better than professional baseball itself, which I sometimes found boring. Baseball cards I never found boring. There was a sense of excitement you had when you opened a pack—would I get any of my beloved Yankees? A Reggie?—and then the various pleasures of examining each one, categorizing it by team, perhaps trading it to a friend for something better. Looking back, I now see baseball cards as my gateway drug into the world of graphic design. In a sense, the baseball card is a pure design object, its singular purpose being to deliver a sense of aesthetic satisfaction.

If you're looking for aesthetic satisfaction in a baseball card, I would start with the Turkey Red series of 1911, a set of beautiful color lithographs that could be redeemed with a coupon in a cigarette package. I'm also partial to a certain Roberto Clemente, from 1972. In Steve Heller's new book, *I Heart Design*, I have a short piece about the 1887 Allen & Ginter John Ward, who was the Derek Jeter of his day as well as a Columbia-trained lawyer and union advocate.

Though I no longer collect baseball cards—and was really never that obsessive about it, even in my youth—buying a pack of the latest Topps set (always Topps for me; I'm a traditionalist) has always been an annual spring ritual, and one that over the last few years I've made sure to transact at the local card shop here in Carroll Gardens. Sadly, the Baseball Card Dugout, run by inimitable Brooklyn institution Joe Rock, closed last fall, which means I'll have to satisfy my card fix elsewhere.

Haydn Sweterlitsch
03.08.11 12:35
apart from the design of cards over the years and eras, the content they offer can be as rich a source. Take the rare instances where a pitcher's image on his card portrays him while at-bat (I've only ever seen this on a Greg Maddux and David Cone)—subtle form and style shifts and anomalies provide a fascinating landscape.

Hex
03.10.11 12:51
Cards were a gateway drug for sure. In my case, it was Hockey cards (hey, I'm Canadian). Like you, I found the cards much more interesting than the game itself (although Peter Puck helped). However, card packs soon gave way to Comic books... from from there it was a slippery slope into the design industry. The graphic storytelling moulded my impressionable young mind in ways that made a career dealing with visuals on a daily basis virtually inescapable.

Playing cards are taken for granted. They have been ubiquitous objects in households for centuries, but they are hardly ever given the credit they deserve for what they can tell us about culture, history, and design. In my role as a curator, I work with a rich and wide-ranging collection of playing cards—everything from hand-painted medieval decks to cheap souvenir packs from the twentieth century. Forward-thinking collectors and donors made sure that these artifacts of printing were including in a library that could provide appropriate historical context.

I try to put them in historical context whenever possible through exhibitions and classroom teaching, including a recent survey about the history of printing. Several years ago, I published a blog post that showed the backs of various playing cards. It was a straightforward post that showed patterns of dots, dimples, diapers...

To my surprise (and delight), that post generated responses from a new group of readers to my blog—graphic designers. Though I was raised in a household that went through deck after deck for pinochle, cribbage, canasta, bridge...it wasn't until years later that I started to see playing cards from many new perspectives: their design; their role in social life; what they can tell us about printing history.

A newfound fascination focuses on the secondary lives of playing cards. By looking through library catalogs and collections of ephemera, I found cards have that been repurposed for many different uses. Think about it—you're living in the eighteenth century, of a class that can afford a set of playing cards (and of a religious bent that did not forbid them). If one card from your lovely deck ends up getting lost or smudged or burnt, or otherwise becomes unplayable, you can fudge with a handmade replacement.

Timothy
Young

Following
Suit

Will and
Whimsy

**Culture is Not
Always Popular**

129

But if you lose two, your luck is starting to run out; you're...ahem...not playing with a full deck.

What to do with the remaining cards? Keep in mind that up through the beginning of the twentieth century, paper was not inexpensive. Often, those leftover cards were kept and recycled. They were employed as note cards, business cards, and calling cards. (This, of course, applies only to cards with plain backs, which was the case with many decks through the eighteenth century.)

Here is a selection of playing cards that found new lives through the ingenuity of the pen, the printing press, and, in one case, a pair of scissors.

In a way, all of these cards have become archival: holding a secondary value beyond the reason they were created. They still convey their original graphic intent, but carry specific details that can tell us about they how they lived multiple lives.

Will and Whimsy

Following Suit

Timothy Young

Bible 7957

les Paralipomenes et
Esdras (trad. par le maistre
de Sacy) lat. fr. Paris, Desprez
1711. in 8. p.... Brun.

jac. A. Hon

Perfection 7587

principes de la
perfection chrétienne
et religieuse. 2.e ed.
paris. V.e Roudet
et la Dottière 1749
12. V.

jac. St how.

61

Tourneux (le)
De la meilleure ma-
niere d'entendre la
Sainte Messe, Paris
1741, in-18, bafanea.

Bibl. de la Chartreux, fils.

217. Malvin de montazet.
instruction pastorale sur
les sources de l'incrédulité.
in-12. Paris. 1776.

Bib. Griquet

2390 2982

Puffendorf (Samuel. de)
histoire du Regne de
charles Gustave Roy de
Suede. Nuremberg
Knorz 1697. 2 vol in fol
v. fig. Cartes.

Belgique

3213 2969

Rofs. (Alexander.)
Mystagogus Poeticus
or the muses interpreter.
London Kirton. 1653.
in-8°. v.

Paris Belgique
Condet. 1.re Serie N° 113

Timothy
Young

Following
Suit

Will and
Whimsy

Culture is Not
Always Popular

131

Mr Selwyn
in
Bond Street

Le Citoyen Bouverot Vent Icorun
au C.e Moroup Seize frans, qui lui ont
été accordés pour lui aidi à payer
son loyer Nyon le 14.e Janv.er 1799
Payé netté ℈ CM Bonnard

Timothy
Young

Following
Suit

Will and
Whimsy

Culture is Not
Always Popular

133

04.

Reason and Responsibility

In 2009, a generous grant from the Rockefeller Foundation supported what would become two years of collective action and collaboration for social impact across the design industry that included, among other things, a dedicated channel on our site: we called it Change Observer.

Led by Julie Lasky, and fueled by participation by a range of writers from all over the world, Change Observer looked at the intersection of architecture and sustainability; at cultural production and the stewardship of our planet; at private education, public health, and the profoundly overlooked human needs which lay at the epicenter of everything.

We published white papers, challenging systems, stereotypes, and the convenient, if false security of outdated cultural canons. We looked at governance. We examined infrastructure. We questioned leadership practices, publishing protocols, and bureaucratic hierarchies: the Polling Place Photo Project—an experimental partnership with the *New York Times*—allowed us to publish hundreds of civilian photographs taken during the 2006 mid-term and 2008 presidential elections. Later, our writers would look at tote bags as political statements, at politics as reductive vocabularies, and at language itself as a slippery cultural apparatus. And lest any of us feel too good about our status as newly-minted social activists, our writers kept us firmly in line: from Maria Popova writing about the hubris of design imperialism, to Bryan Finoki considering the questionable claims of urban resilience, our essays often raised more questions than they answered. Which was good for all of us.

ORIGINALLY PUBLISHED
12.21.11

COMMENTS
3

John Thackara
From Milk to Superfoods: Supping with the Devil?

I'd be surprised if many readers of this blog work for the fracking industry. Those charming people spend a lot on lobbying and public relations, sure—but their main aim in life is to remain obscure.

But food and drink? The branding, the packaging, the communications, the stores, the promotions, the trade shows, the hotels, the restaurants? Would I be wrong to guess that 75 percent of us have worked for a global food enterprise, directly or indirectly, at some point? I know I have: an industry talk here, a futures workshop there, a couple of health care events...

But two new publications this week have left me sick to the stomach. I just don't think it's defensible any more to turn a blind eye to the social and ecological crimes Big Food is committing, in other parts of the world, so that you and I can eat what we damn well feel like.

When it comes to the food business, I've been having my cake, and eating it, since 1995. That was when Vandana Shiva spoke at Doors of Perception 3 about the hidden but devastating ecological and social costs of global industrial agriculture. That was a wake-up call.

Food figured prominently in 2000, too, when we did Doors East in Ahmadabad. We learned, then, that for eighty million women in India, who own or look after one or two cows, milk is their only livelihood.

It should not have been a surprise last week, then, to read a grim report entitled *The Great Milk Robbery: How Corporations Are Stealing Livelihoods and a Vital Source of Nutrition from the Poor.*

In a long and scrupulously documented report, an NGO called Grain confirms the importance of so-called "people's milk" to the livelihoods and health of hundreds of millions of poor people in the Global South—from small-scale farmers and pastoralists, to local cheesemakers and fresh milk vendors. They nearly all supply safe, nutritious, and affordable milk at a mainly local scale.

The report chronicles in distressing detail the global push by Big Dairy corporations such as Nestlé, PepsiCo, and Cargill to colonize this entire milk flow. Instead of fresh, high-quality milk produced and supplied in the most sustainable ways by small-scale farmers, Big Dairy's strategy is to replace their local milk with powdered and processed milk, produce it on highly polluting mega farms, sell it in excessive packaging, display it in wildly over-chilled stores and, after all that, charge at least double the cost of "peoples milk."

A continued shift to large-scale farms would be an environmental and public health catastrophe. Big Dairy's farms guzzle enormous quantities of water, often at the expense of local communities that depend on the same sources. Their mega farms also require a lot

DMM
12.21.11 12:32
While concentrated, large-scale farming operations are rightly pilloried here, it bears mentioning that on a single front--efficiency--they come out ahead of small farms. Large, efficient food production operations will without doubt continue to be important in the future, as populations worldwide continue to grow and concentrate in cities. What all farmers desperately need is new regulations and policy support, whether large or small, in India or upstate New York. Agribusiness could be made to operate according to entirely different rules, with respect to their dismal records on the handling of excrement, antibiotic and hormone use, and animal quality of life, but only if our governments turned away from their lobbyists.

david stairs
12.23.11 10:17
If there's one thing the organic movement proves, it's that people will pay more for quality. Cooperatives, here I think of Organic Valley in the U.S. and AMUL in India, do exist to help small farmers compete with Big Dairy. Outrage over corporate manipulation of seed stock will, ultimately, result in the failure of Monsanto's efforts to take over the world. This doesn't mean we can afford to lose vigilance. The specter of Food, Inc. is always just over the horizon, and an ugly view it is.

of land—not just for their cows to live on, but to produce their feed. They also produce massive amounts of waste. An industrial farm with two-thousand cows produces as much waste as a small city.

We know the Big Dairy push is an existential threat to the South because it already happened in the North. The United States lost 88 percent of its dairy farms between 1970 and 2006, while the original nine countries of the EU lost 70 percent between 1975 and 1995. Since then, land-grabs and market manipulation have accelerated—accompanied, along the way, by profoundly misguided programs to impose a high-cost, high-tech "green revolution" on Africa's farmers.

Instead of new hybrid seeds, chemical fertilizers and pesticides, family farmers in West Africa said they want to use local seeds, avoid spending precious cash on chemicals, and most importantly to direct public agricultural research to meet their needs.

Where agriculture was born—and is now dying

My sense of queasiness was further exacerbated last week by reading *Food, Farming, and Freedom: Sowing the Arab Spring* by Rami Zurayk. Zurayk, a senior Lebanese agronomist, was not surprised by the Arab Spring. He's been charting the collapse of traditional agricultural livelihoods in the Middle East since the late 1980s—latterly in his blog *Land and People*. That project grew out of a mobile agricultural clinic designed to help small producers rebuild the livelihoods that their enemy's assaults had shattered. Zurayk explains that although the Arab Spring may well have been enabled in part by social media, its roots go much deeper.

The Middle East is where agriculture first emerged, ten-thousand years ago. The most important crops and animal species originated there. Yet today, Middle Eastern countries are the world's largest importers of food. More than 50 percent of the calories eaten in Lebanon are imported. In Iraq it's worse. In the 1950s, Iraq was self-sufficient in agricultural production, by 2002 she relied on imports for 80 to 100 percent of many staples.

What went wrong? Can things be fixed?

At one level, when Zurayk explains that between food and farming and the geopolitics of the region, prospects there look grim. Local food production is perceived by enemies of the small farmers to be a form of opposition to their military-territorial objectives. This explains the systematic bulldozing of olive trees, some of them hundreds of years old, in the West Bank and Gaza.

Neoliberal economic policies have also had catastrophic impacts. Large-scale, export-oriented agriculture—promoted by global corporations, banks, and many development agencies as the "road to growth"—has been a boon to local elites. In Lebanon today 50 percent of the farmland is owned by just 3.5 percent of the farmers—usually absentee landlords.

This export-scale agriculture involves the systematic abuse of agrochemicals. Industrial-scale monocultures have caused tremendous damage to biodiversity and to the fertility of the soil itself.

Industrial agriculture is also a major cause of social dislocation. Poor rural people are first displaced from their land; they then do marginalized work in contract farming; when that becomes unsustainable, they are driven out of farming altogether into the "misery belts" that surround most cities. There, as patterns of production and consumption have changed, obesity and malnutrition have become widespread among the poorer social classes—the majority of the Arab people.

The pattern is repeated in other former colonies across Africa, such as Egypt and Kenya—wherever, in fact, a country is "opened up" to "modernization and development."

India steps back

As in the Middle East, so too in India, farming and food retail are about more than trade. They are the very stuff of culture and ecology, of food security, of identity, and of livelihood.

In 2007, we focused the whole of Doors 9, in Delhi, on food systems. We were told, then, that 29 percent of school-age children in Delhi are classified as obese, that the sugar content of their diet has risen 40 percent during the last fifty years, that its fat content had risen by 20 percent.

Powerful forces were already pushing India to speed up this industrialization of food and

the corporatization of retail. The informal sector did not sell branded products—so big business did not like them, we were told. The construction lobby and landowners could not tolerate vendors' occupation of commercially viable urban space, for which they pay no rent. Delhi's municipal authorities wanted food sales off the streets as part of a "clean up" ahead of the Commonwealth Games.

Large multinational retailers like Walmart, TESCO, Carrefour, and Metro have been trying to expand into India for years—sometimes in partnership, always as teachers, with local business houses such as the Tatas, Reliance Industries, and Aditya Birla. The grand strategy is to offer cheaper food to price-conscious, middle-class Indians.

Last week, India suspended plans to "open" its $450 billion supermarket sector to foreign firms such as Walmart. The *Financial Times* complained that this retail "liberalization... would have improved the functioning of its supply chain". Prior to its suspension, the *Economist* had praised law for "opening up its underdeveloped and fragmented retail market". A Tesco spokesman said the move was a "missed opportunity for customers".

The language used by the the business press and the management consultants is soporific and reassuring: "Liberalization," "Opening up," "Opportunity." The realities that these words hide are evil, pure and simple.

State-of-the-art sustainability
These words are also profoundly old-fashioned.

With twelve million outlets, India has the largest density of small shops in the world. Her so-called "unorganized" retail sector, with its infrastructure of bazaars, mandis, and haats, has evolved over centuries into an ecology of forty million traders, shopkeepers, hawkers, and vendors, together with 650 million farmers.

This amazing ecology is labor-intensive, low entropy, low cost, decentralized, self-organizing, highly efficient—in a word: resilient.

In sustainability terms, India's legacy farming, food and retail systems are state-of-the-art. And it's this ecology that "organized retail" wants to sweep away.

The corporate take-over of retail is often justified in terms of efficiency. Corporate boosters argue that 40 percent of horticulture produce in India is wasted. In the informal sector, the opposite is the case: fruit and vegetables that go bad are eaten by cows, or are composted. This recycling of organic matter is only possible in a highly decentralized system. The global giants are the real wasters. Globalized retail is responsible for the waste of 50 percent of food—not the small farmers and retailers.

Another argument is that farmers will get better prices in a more "efficient" system. Yeah, sure. Nowhere in the world is there evidence that corporations like Walmart and Tesco have increased returns to indigenous subsistence farmers. Their entire business model is based on industrializing production, buying at extremely low prices, and undercutting small retailers and street vendors.

Says Vandana Shiva: "the Walmart model is a model for genocide. A retail monopoly, by buying below the cost of production, and by robbing them of other markets through destroying other alternatives, will destroy farmers". In the past decade, two hundred thousand farmers have committed suicide in India. For Shiva, this is a direct result of agricultural modernization, including the introduction of genetically modified crops.

Superfoods
A couple of months back I heard a woman from PepsiCo talk about her company's big push into "superfoods". PepsiCo will work every angle hard to persuade people to pay premiums of at least 25 percent on their "super" eats. This has got to mean a heap of new work for designers.

But, after reading this week's reports, I've got to say something: for me, given what I know now, working for these guys would be like supping with the devil. During the past years of step-by-step incremental change, of being reasonable, of being grown-up, the situation on the ground—for millions of vulnerable people, and untold vulnerable ecosystems—has gotten steadily worse.

What, you will fairly ask, are you supposed to do with this statement? I don't know. It's a dilemma, not a problem to be solved.

ORIGINALLY PUBLISHED
01.20.09

COMMENTS
40

Dmitri Siegel
Paper, Plastic, or Canvas?

Amidst all the despair in the last few years about the slow extinction of various design-friendly formats (the vinyl LP, the newspaper, the book, etc.), one vehicle for graphic design has vaulted to almost instant ubiquity: the canvas tote. The medium is not new, of course. Public television stations have been giving them away during fund-raisers for decades and L.L. Bean's Boat and Tote has been a New England staple even longer. But the timely environmental appeal of these reusable bags and the easy application of graphics catapulted the canvas tote from the health food store to the runway in a few short years. Graphic designers have embraced the form as a venue for their imagery and messages on par with the T-shirt. The ensuing glut of these bags however raises questions about the sustainability of any product regardless of the intention behind it, and the role that design plays in consumption.

It's difficult to pinpoint when the recent canvas tote craze really started, but there was a pivotal moment two years ago when Anya Hindmarch released the I am Not a Plastic Bag tote in collaboration with the global social change movement, We Are What We Do. The bag was originally sold in limited numbers at Hindmarch boutiques, Colette and Dover Street Market in London, but when it went into wide release at Sainsbury's, eighty thousand people lined up to get one. When the bag hit stores in Taiwan, there was so much demand that the riot police had to be called in to control a stampede, which sent thirty people to the hospital.

Suddenly the formerly crunchy canvas tote had cachet.

Marc Jacobs skewered his own eponymous empire with his Marc by Marc for Marc tote. This fascination with cheap bags seemed like part reaction to, and part extension of the high-end handbag frenzy that gripped the fashion industry for much of the '00s. It had all the same qualities of exclusivity and brand envy, but also seemed, at least in part, to be an acknowledgement that things had gone too far. Was Jacobs's self-mocking tote a mea culpa for the astronomical handbag prices he had helped engineer at Louis Vuitton or was it a sly attempt to mainstream the phenomenon?

Simultaneous with the fashion world's affair with the tote, the graphic design community seemed to rediscover this humble sack. The canvas tote is a great medium for graphic design because it is flat and easy to print on. The canvas provides a beautiful off-white ground and the material is as wonderfully suited to silkscreen printing as primed canvas is to oil paint. The recent show at Open Space in Beacon, New York demonstrated the material appeal of the bags and the adaptability of their flat surface. Short-run printing and the quick transfer of graphic files make it remarkably easy to produce a relatively high-quality bag. Design blogs have become enthralled by the never-ending stream of canvas totes—each one made unique by a clever, beautiful, and sometimes both, graphic.

Dmitri
Siegel

Paper, Plastic,
or Canvas?

Reason and
Responsibility

**Culture Is Not
Always Popular**

139

But the primary reason that designers in both fields have embraced canvas totes so quickly and nearly universally is their compelling social benefits. Not only is canvas a renewable resource, but the bags are biodegradable and sturdy enough to stand up to years of use. Re-using canvas bags could reduce the number of plastic bags that are used and discarded every year. According to Vincent Cobb, founder of reusablebags.com, somewhere between five hundred billion and a trillion plastic bags are consumed worldwide each year. The impact of the super-thin plastic bags given away free with purchase at super-markets and shops is so severe that governments from Ireland to San Francisco to China have banned their distribution altogether. With the devastating effects of global warming and pollution becoming a feature of everyday life, designers and consumers alike latched onto reusable canvas totes as a tangible step they could take to help the environment. Canvas totes are often cited as an example of how good design can help the environment because of the promise that they will replace plastic bags.

Ironically, however the plastic bag problem can in large part be traced back to the quality of its design as well. Before the introduction of the ultra thin plastic bags in the 1980s, groceries were packed almost exclusively in paper bags. Plastic bags were touted as a way to save trees. Within a few years plastic was dominant and now commands 80 percent of grocery and supermarket traffic. Comparing a plastic bag to a paper bag it is easy to see why: the ultra thin plastic bag is a vastly superior design. It consumes 40 percent less energy, generates 80 percent less solid waste, produces 70 percent fewer atmospheric emissions, and releases up to 94 percent fewer waterborne waste. A plastic bag costs roughly a quarter as much to produce as a paper bag and is substantially lighter so it takes far less fossil fuel to transport. Plastic bags are among the most highly reused items in the home and are just as recyclable as paper.

The problem is that what is marvelous about an individual plastic bag becomes menacing when multiplied out to accommodate a rapidly growing global economy. The low cost of the bags allowed merchants to give them away and despite the strength of an individual bag, they are routinely packed with a single item or double bagged unnecessarily. The bag was so cleverly designed that there is simply no barrier to their indiscriminate distribution. Their incredible durability means it can take up to hundreds of years for them to decompose (a process that releases hazardous toxins). Although plastic bags are recyclable, the evidence suggests that even after ten years, in-store recycling programs have barely managed to achieve a 1 percent recycle rate. It is simply too easy and efficient to keep making and distributing more plastic bags. Meanwhile consumers mistakenly try to recycle the bags through their curbside recycling programs (perhaps because of the recycle symbols printed on the bags) creating a sorting nightmare at recycling facilities across the country.

Are we headed for the same kind of catch-22 with the adoption of the cleverly designed canvas tote with its renewable materials and infinite potential for customization? I am certainly an outlier in this case but I recently found twenty-three canvas totes in my house. Most of them were given to me as promotional materials for design studios, start-ups, boutique shops; more than one came from an environmental event or organization; one even commemorates a friend's wedding. A local community group recently delivered a reusable shopping bag to every house in my neighborhood to promote local holiday shopping. On the one hand all this interest in reusable bags is inspiring, but just like the story of Anya Hindmarch's I'm Not a Plastic Bag tote, it also reveals the fundamental contradiction of the canvas tote phenomenon. Best intentions are almost immediately buried under an avalanche of conspicuous consumption and proliferation of choice. The environmental promise of reusable bags becomes pretty dubious when there are closets and drawers full of them in every home.

This contradiction can largely be traced back to the influence of graphic design. Once this gorgeous flat surface presented itself, it quickly became simply a substrate for messaging, branding, promotion, and so on. Judging by the cost, producing one tote is roughly equivalent to producing four hundred plastic bags. That's fine if you actually use the tote four hundred times, but what if you just end up with forty totes in your closet? Once the emphasis shifts from reusing a bag to having a bag that reflects your status or personality, the environmental goal starts drifting out of sight.

like Mohawks, but rather punk by ideology ... despite appearance) who seized the tote long before Anya Hindmarch created a mainstream re-introduction of the tote (capitalizing on its use by the "cool kids.") In any case, recently I've encountered many situations in which the canvas tote is being rejected by the same crowd that helped make them popular. One could speculate that this is because their propulsion into mainstream culture directly correlates with the loss of their appeal to underground culture, but I speculate that it's because what the canvas tote has come to represent, many of the points you have outlined above and the painful truth evident to only a few, that our world is over "designed" and commercialized. Promotional totes are sooo lame!

I could not find any data on the subject of how much the use of canvas totes has decreased the number of plastic bags, but at best the totes can only be a catalyst for the act of reusing. Designers are correct in thinking that making a more appealing bag increases the likelihood that it will be reused, but the environmental benefit does not come from people acquiring bags. It comes from people reusing them. Successful attempts to reduce the number of plastic bags have all focused on (not surprisingly) depressing the consumption of plastic bags. For example, in 2001, Ireland consumed 1.2 billion plastic bags, or 316 per person. In 2002 they introduced what they called a PlasTax—fifteen cents for every plastic bag consumed. The program reduced consumption of plastic bags in that country by 90 percent! This seems to undercut the whole strategy of selling canvas totes as a way to help the environment. Based on the Irish example, even a fifteen cent price tag might actually inhibit the use of canvas totes by 90 percent. In terms of actually reducing the number of plastic bags, programs like the one at IKEA, which charges customers five cents per plastic bag and donates the proceeds to a conservation group, are probably more likely to have an impact than selling a canvas alternative. The best thing for the environment is reuse and that can be accomplished just as easily by reusing plastic bags.

The canvas tote is a great example of the power and the paradox of design in a consumer society. On the one hand design has allowed for personal expression, and fantastic variation in an otherwise mundane object. Every well-designed tote has the potential to replace some of the estimated one thousand plastic bags that each family brings home every year. The aesthetic power of a single design raised more awareness about the impact of plastic bags on our environment than any government or nongovernmental organization. On the other hand, it is unclear that a consumable can counteract the effects of consumption. The designs that make each bag unique contribute to an overabundance of things that are essentially identical and the constant stream of newness discourages reuse. Just as the remarkable efficiency of the plastic bag ended up making it a menace to the environment, graphic design's ability to generate options and choices may turn a sustainable idea into an environmental calamity.

ORIGINALLY PUBLISHED
07.29.10

COMMENTS
13

Maria Popova
The Language of Design Imperialism

I go to a lot of conferences. Design conferences, tech conferences, media conferences, cross-disciplinary conferences. And the worst of them are always the ones brimming with panels, on which a handful of industry heavy hitters sit around for an hour, throwing at each other opinions that oscillate between congratulatory and contrarian but inevitably dance around a hermetic subject of collectively predetermined importance. The problem with such panels is that they regurgitate existing viewpoints held within the industry bubble about issues framed by the industry paradigm, often in buzzword-encrusted language that offers little substance beyond the collective fluff slinging.

Over the past few weeks, the design community has witnessed the virtual version of an industry panel. Ignited by Bruce Nussbaum's controversial, and some may say solely for the sake thereof, contention that humanitarian designers are the new imperialists and followed by a flurry of responses ranging from insightful, fact-grounded retorts to righteous indignation to argumentative defensiveness, the debate has brought up some necessary conversations, but it has also become a platform for near-academic discussion of an issue tragically removed from the actual cultural landscapes where humanitarian design projects live.

What's most worrisome and ironic about the debate is the almost complete lack—with the exception of a few blog comments here and there—of voices of designers who work in the very regions and communities in question, those loosely defined as the "developing world" and the "Western poor." Worse yet, entirely missing are the much-needed multidisciplinary voices whose work is the cultural glue between design and its social implementation—anthropologists, scientists, educators, writers.

Yes, writers.

Because if designers are the new imperialists, the delusional white-caped superheroes Nussbaum calls them out to be, design writers are their giddy, overeager sidekicks, complicit in disengaging from the very communities in which humanitarian design is meant to be manifest.

The way we talk and write about these issues is incredibly important. As argued in "Lost in Translation," Lera Boroditsky's excellent *Wall Street Journal* article, language shapes culture and cognition in a powerful way. The very vocabulary we use in this debate is incredibly flawed. We can't even come up with a fair way of describing the communities in question. We slide across a spectrum of political quasi-correctness and tragic generalization, from the near-obsolete for reasons of clear condescension "third world" to the hardly better "developing world" to Alex Steffen's alarmingly geo-generalized "Global South" to the depressingly hierarchical "bottom billion." These lump

terms not only dehumanize entire classes of people, but they also fail to account for the vast cultural differences between the various micro-communities within these brackets. Political, anthropological, ethnic, religious, and socio-logical differences that would explain why, for instance, the XO-1 laptop from One Laptop Per Child, once hailed as a pinnacle of human-itarian design, was embraced in Paraguay and reviled in India.

We talk about working "in the field" as the ultimate litmus test for true "humanitarian design." But the notion of "the field" flattens out an incredibly rich, layered, multiplane social system in which these design projects and products live. No wonder we consistently fail to design what Emily Pilloton aptly terms "systems, not stuff."

I'd be curious to know how these communities and cultures verbalize their own sense of self and identity. How do you say "bottom billion" in Swahili? How does "the field" describe itself in Aymara?

Even the term "humanitarian design" bespeaks a fundamental limitation—incredibly anthro-pocentric, it fails to recognize the importance of design that lives in a complex ecosystem of humanity and nature, society and environment, which are always symbiotically linked to one another's well-being. When even our language exudes the kind of cultural conceit that got us in our climate crisis pickle, there's some-thing fundamentally wrong with how we think about our role in the world—as designers and as people.

In a brilliant *SEED* magazine article from 2008, authors Maywa Montenegro and Terry Glavin make a convincing argument for the link between biodiversity and cultural diversity. "Pull back from the jargon," they caution, "and the essence is simple: Homogeneous land-scapes—whether linguistic, cultural, biological, or genetic—are brittle and prone to failure." But a key point of failure in today's global design landscape lies precisely in the jargon—we need to invent new ways of writing, talking,

and thinking about concepts of "humanitarian design"; we need new language that doesn't homogenize entire cultures, new vocabulary that better reflects the intricate lace of the world's biocultural and psychosocial diversity as a drawing board for design.

To borrow from science and resilience theory, the work of Italian anthropologist and linguist Luisa Maffi, founder of biocultural diversity conservancy Terralingua, offers ample evi-dence that the loss of indigenous languages is followed closely by a loss of biodiversity. Without trying to oversimplify what's clearly a complex issue, this raises an obvious question: Could it be that as soon as we lose our linguis-tic grasp of a species, we stop talking about it, then thinking about it, then caring about it? When it comes to humanitarian design, we never invented this language in the first place, a language that allows us to properly talk, think, and care about indigenous communities and their biocultural landscape. Our jargon has set us up for failure from the get-go.

So what can the design community do? I don't have the answer. And I am certain no one person does. But cross-disciplinary teams of designers, scientists, anthropologists, lin-guists, and writers might. Teams that include what GlobalVoices founder Ethan Zuckerman recently called "bridge figures"—people who have one foot in an expert community, be that technology or design or another discipline, and one in a local community benefiting from this expertise.

For now, let's embrace our responsibility as designers and design writers to honor cultural diversity. Let's stop hiding behind industry jar-gon. Let's invent a new language that allows us to better think, talk, and care about indigenous cultures and microcommunities before we try to retrofit them to our projects and our precon-ceptions. Language that is just, because this is not just semantics. Above all, let's welcome voices and viewpoints from other disciplines, other parts of the world and other paradigms. Enough with the industry panels already.

Maria
Popova

The Language of
Design Imperialism

Reason and
Responsibility

**Culture Is Not
Always Popular**

143

Meena Kadri
Yoza

ORIGINALLY PUBLISHED
02.22.11

COMMENTS
2

I must admit that I wake up extra early to read the chapters (blushing) I never use to go to the library but... i feel like i have a library on my phone and its great, YAY! — Yoza reader

Designed to encourage reading, writing, and responding, Yoza engages African youths with stories and social issues. The project, which was spearheaded by Steve Vosloo, a technology researcher in Cape Town, and financed by South Africa's Shuttleworth Foundation, is dedicated to a participatory culture hungry for micro doses of literature that are accessible as pixels not paper.

Officially launched last September, Yoza is based on Vosloo's observations that African youths are book poor, yet mobile rich. An estimated 90 percent of urban South African youths have access to cell phones, and 70 percent of those phones are Web enabled. In stark contrast, more than half of South African households own no leisure books and only 7 percent of public schools have functional libraries.

Yoza's first story, *Kontax*, was released experimentally in 2009. Written by Sam Wilson, an author and scriptwriter, Kontax followed the adventures of a local graffiti crew around Cape Town. Its twenty pages were initially published over a month of daily dispatches via a mobisite and later on the popular Mxit social network. Each episode, released in both English and isiXhosa, was around four hundred words long. Prizes were offered for the best readers' comments and sequel ideas.

Via Yoza, seventeen thousand users accessed the full premiere Kontax series—well eclipsing the South African "best seller" standard of five thousand book sales. Each chapter costs the reader around one US cent to download. Explains Vosloo, "Mobile data is cheap relative to voice and SMS—and of course, books. It's also about access." According to Vosloo, readership exploded when Yoza was made available to Mxit's fifteen million local subscribers—a share currently far greater than Facebook's.

The comments allow Vosloo to stay in touch with what readers want. "It's become clear that youth are keen to be both educated and entertained," he notes. "We get many requests for stories which are relevant to their lives. We've had requests for story lines which cover drugs and teen pregnancy, careers, money and more." Feedback has helped to shape several narratives in the works, including *Streetskillz*, which is set during the South African–hosted World Cup soccer matches; *Sisterz*, which explores dark family secrets and teenage life; and *Confessions of a Virgin Loser*, which follows a boy steering his way through the complications of peer pressure, teenage sex, and HIV/AIDS. Social issues provide a further avenue for interaction. A story that touched on domestic violence elicited a slew of comments in support of the affected character as well as personal accounts.

Alongside content derived from popular culture, Yoza has published versions of classics from Shakespeare to Wordsworth. Feedback from teachers in low-income schools tells of class assignments given in conjunction with Yoza content and applauds the access to literature the platform has provided. Comments across the site (often in text-speak) reveal an engaged audience ready to amend mistakes that have eluded Yoza's editors.

Looking to the future, Vosloo has been speaking with potential sponsors; he approached one bank about a series that would weave financial literacy into its storyline. Sponsors are attracted to a medium that stimulates appetite by releasing stories in installments before making the entire series available on a website, where it continues to attract commentary. "It's a bit like the transition from a box office to DVD release," Vosloo says. "There's the initial rush to devour a fresh feature yet the legacy contributes to a growing library of accessible content."

Bryan Finoki
Architecture vs. the People

ORIGINALLY PUBLISHED
04.27.15

COMMENTS
5

So often we hear, with regard to cities, terms like "livable," "sustainable," "green," "resilient," and more recently, "smart," spreading promise of a city as the ideal model for humanity's urban dwellers. We are fed dreams of a self-aware, self-sustaining, self-mending, ecological, and egalitarian urban paradise. But livable, green, sustainable, and smart for whom, exactly? And, at what cost? And whose? If the city of the future can't better the lives of those most in need—those without homes— then how do we measure its success? Despite many well-intended "quality of life" advancements made through urban design, separate infrastructures are put into place to explicitly degrade the lives of the city's already poorest. And the architectural surface often has to deliver the message.

Architecture is a prism for pondering more than design. It is the dominant means by which humanity's landscapes are formatted for social life. We are a social species, but perhaps more than that, we are a spatial species; andultimately, because of these relations, a political one, too. While architecture is our interface with the earth, it is also the dimension through which we interact with each other and organize (and are organized by) larger systems of political, legal, and economic class structuring. Since so very few have a hand in actually shaping the city, most people are captives of the spaces they inhabit and subjects of their categorical powers and biases. Many more are even fiercely excluded from participating at all in the city's making.

Architecture alone has never produced a truly egalitarian society, and perhaps there can never be true equality without an absolute recalibration of the spatial. In fact, from the urban poor's perspective, you could say architecture is a kind of warfare through other means; at times a bureaucratic leviathan of segregation and incarceration, and at others blunt force trauma to the head. It only makes sense that many scholars and activists today are working together to further social movements already afoot within the evolving framework of "spatial justice."

* * *

At the very least, the issue of antihomeless design does occasionally turn up in the news. In London last year, locals found spikes placed in the ground near an upscale real estate development to ward off rough sleepers. Days later, activists dumped concrete over them and they were never replaced. More recently, in Manchester, barbs were installed alongside the sidewalks of a high-end shopping mall to discourage loitering. Photos taken by activists went viral and led to their removal. Last year in France, right wing officials in Angoulême installed cages over city-center benches on Christmas Eve to expel the homeless. From Wales to Vienna, cages are erected near heat

exhausts where the homeless seek warmth. Tokyo has long been known to deploy similar tactics. But now cities all over the world are practicing their own brand of "defensive," or "disciplinary" design. These sorts of cruel strategies are hardly anything new to cities in the United States. They date back to at least the 1980s, when these architectural irritants started to crop up in places like New York, San Francisco, and Los Angeles, when the deflation in federal affordable housing budgets led to an increase in homelessness, but they probably originate with the entrenchment of urban poverty after the Vietnam War.

I've lived in San Francisco—a city that loves to portray itself as exceptionally homeless-friendly—for close to twenty years and can attest to not only the existence of these crude measures dating to the mid-1990s, but have seen them become more insidiously interwoven into the legal fabric through other city practices and criminalization policies. Just weeks ago, city officials forced St. Mary's Cathedral to remove a sprinkler system it had set up to deter overnight campers. Homeless activists speculated that the city pressured the church only to spare itself the negative image of wasting water (California is experiencing its worst recorded drought), not because it has an issue with using sprinklers to deter homeless encampments (in fact, the city has used strategically timed park sprinklers and street cleaners with hoses to deter homeless persons). Nevertheless, the increase in limiting the use of public space by the homeless is what continues to drive them to places like the church. But these policies are not merely acts of enforcement through the treatment of landscape, they are a malicious inscribing of institutional violence onto the very sanctuary of the notion of "public" itself at the immediate cost to society's most vulnerable.

The trajectory of these urban campaigns to ban the homeless from the city is part of the larger transformation into not only "smart" or "resilient" cities (cities that could potentially, through technology, automate the policing of the homeless and limit their movements), but toward what geographer David Harvey calls the "revanchist city," and what other scholars like Stephen Graham refer to as the "new military urbanism"—the city that aggressively takes back public space and its commons in order to incorporate it into the globalized, commerce-driven terrain, and the practice of which is both extremely lucrative and part of a long legacy of racism and urban paranoia. For those impoverished communities deemed an offense to globalization's image of urban life (members of the Occupy movement, poor black communities, immigrants, and the homeless), they are quietly (or not) targeted and removed, or suspended in a cycle of jail and release. So, while city police agencies gorge on inflated budgets, the poor's credibility is ruined by frivolous citations and criminal records.

Because of the homeless' permanent existence in the outer public domain, they are particularly prone to architecture as something that has been designed to be specifically hostile to them, yet camouflaged into the normal fabric as permanent barriers. The post-9/11 makeover of the urban environment only served to justify the intensification of this process under a new name. For the homeless populations struggling to survive in the neoliberal city, urban design translates into an infinitely inhospitable surface; a brutal runaway edge that they can neither penetrate nor separate themselves from.

While the conditions of homelessness are the result of many complex and largely misunderstood—and misrepresented—sociocultural underpinnings, they partially thrive within the inhumane trappings of the built environment's architectural surfaces themselves. For those who are pushed toward the outside, the city is a colossal mega-structure that sustains only their permanent exteriorization. It is a city designed to ensure the near impossibility of their inhabitation. Between the vitriol of those who wish to see the homeless simply disappear and the militancy of advocates devoted to homeless rights and resistance, the policing of homelessness pushes them ever toward the city's edge. The homeless are essentially being made into antimonumental ghosts— ghosts of an architectural surface that makes them disappear.

Bryan Finoki
Spaciocide

ORIGINALLY PUBLISHED
07.13.15

Last year, a former police chief from Pennsylvania who founded a non-profit that feeds the homeless in Fort Lauderdale, Florida, said that the strategies the city is using to expel the homeless are "very close to ethnic cleansing." While ethnic cleansing is inarguably a strong statement, recent strategies there and elsewhere might mimic something close.

Sari Hanafi, a professor of sociology at the American University of Beirut, calls the Israeli colonization of Palestine "spacio-cide" in that, as he explained, "it targets land for the purpose of rendering inevitable the voluntary transfer of the Palestinian population primarily by targeting the space upon which the Palestinian people live." American "anti-homeless urbanism" is aimed at achieving a similar totalizing effect that politically and spatially dismantles the entire agency of "public" upon which the homeless landscape operates. The strategy is to force homeless persons to evict themselves; to voluntary abandon the city. Not only is the very tenet and universal right to "public" exceptionally criminalized for the homeless, it challenges the role of infrastructure more universally, and, calls into question the integrity of the Eighth Amendment, which prohibits the government from imposing cruel and unusual punishment onto its people. We must ask, does the idea of "public" even exist anymore?

Using Hanafi's concept, the nature of this spaciocide could be characterized by: (1) it being part of an ideology that targets the urban poor as capitalism's antagonizers; (2) antihomeless laws that are justified not only on political and security—but even humanitarian—grounds; (3) "homeless" as a category that represents the state's rendering of the poor into near-rightless bodies; (4) deploying spatial devices that are not demarcated outright as segregationist, but with the objective of exiling the homeless from public space; and (5) the fact that it is multi-dimensional.

The spaciocide against homeless occupation is a landscape designed to strip bare the homeless right where they stand. It amounts to a complete negation of homeless rights, infrastructure, and ability to acquire jobs and services that exist outside of designated shelters and providers where the homeless can be tracked. It also threatens to supplant a public infrastructure with a newly amplified policed one.

City surfaces are armored with a taxonomy of miniature barricades. Street furniture is designed to make long-term rest impossible, particularly for the most needy—discomfort as design principle. Barbed bushes and cactuses act as green barriers to crawl spaces, while streets popular for gatherings are bleached to discourage overnight assemblies. Gates seal alleyways and construction sites that offer respite. Parks are watered by sprinklers at night to make grounds too wet for camping. Freeway overpasses and empty lots are fenced off, while floodlights expose the homeless to other

violent elements. A barrage of noise irritants have been used with loudspeakers in downtown parks and lots overnight. Some devices function at specific frequencies only audible to teenagers to make loitering undesirable. Colored lights are placed inside bathrooms to make seeing veins under the skin difficult, dissuading illicit drug use; outdoor restrooms charge money the homeless can't afford; water faucets in park toilets have either been shut off or redesigned to prevent sinks from being used for hair washing, and so on. Roadway medians have been deemed places of trespass. Bundled belongings are routinely confiscated, trashed, or discarded. Camps are destroyed and banned from the city. Homeless people are constantly intimidated by security guards, profiled, rounded up by police, and relocated away from popular city events under the pretexts of preventing tourist harassment. Entire downtowns are turned into "beggar free" zones.

This only scratches the surface of the physical architecture of displacement. Yet, it couldn't succeed without the buttress of an equally draconian legal architecture to sanction the mechanisms that make it virtually impossible to (lawfully!) live below the poverty line. A recent study found that California alone has five hundred laws on its books across fifty-eight cities, an average of nine in each. Even the ACLU is pleading with Berkeley lawmakers to reconsider its homeless policy framework. The London borough of Hackney just passed a Public Space Protection Orders law giving authorities powers to remove a broad spectrum of people almost at will from downtown.

While camping in the American city is generally illegal, sleeping in vehicles overnight is becoming increasingly illegal too, and more dangerous. Sacramento, California has an ordinance that outlaws camping on private property for more than one night, prompting claims that such laws have caused a 2,400 percent leap in Sacramento's city camping citations. The homeless have long since been priced out of public transportation. And the library, a homeless sanctuary for decades, has begun preventing people from napping and using restrooms based on various new policies,

including an "anti-odor" law. Many lack access to clean water, and are often ticketed for simply being homeless.

Over the past twenty years a litany of ordinances has stacked up to curb homeless-specific behavior, by also purposefully confusing it with various forms of general anti-social behavior. With bans on panhandling, loitering, littering, smoking, public urination and defecation, and sitting and lying on the pavement, poor people are also subject to harsh jaywalking fines and twenty-four-hour "stay away" ordinances from recreation spaces. Shockingly, the public's right to hand out food is becoming illegal. Some cities, like San Francisco, have privatized the recycling industry and removed the public facilities and monetary capabilities that sustained recyclers for generations. The California Highway Patrol apparently has a program that relieves homeless people from arrest by coercing them into participating in officer training programs that help identify specific drug-use behaviors. Fines levied for vagrancy can be so high that it's impossible for any homeless person to pay them, prompting arrest and often thirty-day jail sentences that only build a criminal record.

City planners zone out and ghettoize non-profits assisting the homeless along urban peripheries, and use shelters to keep biometric identity records of the poor that feed into police databases. Cities have even been known to offer one-way bus tickets to homeless people during holidays to "visit their families" in other states. Worse, some, like Las Vegas, have literally rounded up their homeless communities and bussed them across state lines to be dumped in other locations.

How telling is it that some State Assemblies have finally been pressured to pass a Homeless Bill of Rights? Sadly, we're complying with an "out of sight, out of mind" culture of extreme negligence that institutionalizes the removal of an entire population for which the ideologies of neoliberal capitalism and urban paranoia only further perpetuates. In the process, we're ruining the remains of any "public" that invariably pertains to us all.

Bryan
Finoki

Spaciocide

Reason and
Responsibility

**Culture Is Not
Always Popular**

149

Stephen Eskilson
Heteronormative Design Discourse

ORIGINALLY PUBLISHED
09.25.13

COMMENTS
2

The question of sexual identity, a central focus of a great deal of thought in recent decades, has received scant attention in the design world. The subject seems largely invisible in both the practice of design and of design writing where a blanket state of heteronormative assumptions still prevail. The term "heteronormative" itself, a key theme of queer theory that was coined by Michael Warner over twenty years ago, while a mainstream standard bearer in art and literary studies,[1] rarely appears in a design context. Of course, this invisibility in the design world—a circumstance in which heterosexual mores appear natural and normal to the exclusion of all others—furthers a power dynamic through which heteronormative power is exercised throughout culture. As Warner wrote incisively in *Social Text*, "so much of heterosexual privilege lies in heterosexual culture's exclusive ability to interpret itself *as society* [my italics]."[2] I think a brief consideration of heteronormativity in design discourse can provide a fresh view of design's transformative powers of communication.

Historically, one of the only attempts at the recognition of an alternative to heteronormative design discourse came in the form of Susan Sontag's famous 1964 essay, "Notes on 'Camp.'"[3] In this essay, Sontag used the predigital equivalent of a PowerPoint format, elucidating fifty-three numbered thoughts on what she identifies as a new sensibility. "Camp" is taste that celebrates artifice, wit, and ironic decorative overkill. In statement number eight,

Sontag asserted that the art nouveau style, which in the early 1960s was in the midst of a flourishing revival, was exemplary of the camp sensibility. Sontag particularly admired the art nouveau tendency to transform, what she called "things-being-what-they-are-not," such as the Metro entrances by Hector Guimard.

While Sontag, writing in a pre-Stonewall era, was oblique in explicating her thesis's relationship to homosexuality (she broaches the subject directly in number fifty-one). Fifty-one: "The peculiar relation between Camp taste and homosexuality has to be explained. While it's not true that Camp taste is homosexual taste, there is no doubt a peculiar affinity and overlap." Sontag's equation of camp's ironic attitude and homosexuality proved to have legs as conservative, homophobic critics latched on to her assertion in attempts to condemn it. For example, Hilton Kramer wrote some years later, "the origin of camp is to be found in the subculture of homosexuality. Camp humor derives, in its essence, from the homosexual's recognition that his condition represents a kind of joke on nature, a denial of its imperatives, and thus a mode of psychological artifice."[4] While clearly disagreeing on many matters of substance, both Sontag and Kramer recognized the transformative cultural power of persons operating outside of a heteronormative framework.

At this point I would like to shift gears and argue that Chip Kidd is a designer whose work has had a transformative impact on visual

Brian Donnelly
10.09.13 10:58
Nice analysis of Kidd's designs and their use of photography. While I certainly welcome the use of important critical terms such as heteronormative in design discourse, I don't see a solid link here to that concept. The disruption here has more to do with the idea of 'visual language,' which is a very lazy and unexamined phrase in visual culture and design studies. Kidd is able to simply step outside the norms and supposed grammar or syntax of design (illustrations for fiction; photos for non) simply because they don't exist. His work, like all challenging, fresh or creative design, shows us that the rules aren't rules at all -- not a language, in other words -- but habits, coincidental and contingent bits of mimesis, iteration, repetition; an entirely idiomatic bag full of bits of temporary code, easily and rapidly replaced.

It is unsettling but necessary for designers to think through how open-ended and unsystematic design is; and how hard the visual aspect of design is to 'read,' precisely because it is not linguistic in nature.

communication in a manner that contested the culture of heteronormativity. Born in 1964, Kidd rose to graphic design prominence through the book covers he has designed for the publisher Alfred A. Knopf. These covers have been widely celebrated for over twenty years, while Kidd's many laurels include a memorable drop quote from a *New York Times* piece, he "helped transform the American book jacket from a decorative bit of packaging into a striking evocation of the writing it contained."[5] One note: Kidd's stature was elevated in the 1990s at the same time that Warner and others were eloquently building the foundations of queer theory and calling attention to heteronormativity in society. In examining Kidd's book covers and considering their role in contesting the dominant discourse, I make no claims for his intent as an artist, nor do I seek some sort of hidden gay iconography in his work, but rather hope to view them with an eye toward understanding their powerful impact on contemporary visual culture.

Chip Kidd's book covers are notable for their use of photography. As detailed by Véronique Vienne in her 2003 monograph, Kidd was led in this direction by his supervisor at Knopf, art director and book designer Carol Devine Carson. It was Carson's love of photography that opened the door for Knopf designers to pursue a new course: the use of photographs on the covers of works of fiction.[6] Conventionally, illustration had been the medium of choice for fiction, while photography was reserved for non-fiction works of history and the like.

Kidd's pioneering work in photographic-based fiction covers is grounded in a unique, conceptual use of the medium. Visually, one of his key strategies is the employment of synecdoche in images of people, whereby a fragment of the body stands in for the whole. For example, in his 1989 cover for Mark Richard's *The Ice at the Bottom of the World* (a collection of stories based on life in the American South), the partial view of a worn male figurine grabs viewers while ultimately locking them out of any holistic sense of visual closure. The figure is also dislocated from the space by the combination of an upside-down reflection and a similarly reversed background.

Another collection of short stories, this one by Walter Kirn, served as the inspiration for Kidd's 1990 cover for *My Hard Bargain*. This collection, which delves into powerful themes

of sexuality and religious alienation, was published with a two-part cover, half photo and half text, a composition that has become one of Kidd's trademark strategies. The front of the cover shows four fingers cropped at the knuckles, a suggestive synecdoche through which the fingers can serve to recall an individual or a group. A similar yet blurred image on the back of the jacket further engages the reader with the conceptual slippage initiated on the front cover. (An aside: these photos show Kidd's own hands, an example perhaps of synecdoche as selfie?) I would argue that the conceptual dislocations caused by these fragmented synecdoches are representative of a sensibility that rejects the heteronormative stability of most images.

A second strategy employed by Kidd involves the serendipitous discovery of evocative photographs, many featuring damage of either the subject or the photo itself. These worn, appealingly second-hand photos play into the broken significations and discontinuities that mark his studio practice. Kidd's 2001 cover for *Depraved Indifference*, the third volume in a fictionalized trilogy loosely based on the life of Sante and Kenneth Kimes, features a sepia-tinted image of a figure standing alone, her face obliterated by damage to the photograph. The slightly askew photo, which had been given to Kidd by a fan, drives home a sense of emptiness and danger. In the case of another photo that Kidd received—rather than sought out—the medium is undamaged, but the subject is a stuffed animal that is clearly past its prime. This photo, which is from the portfolio of photographer Lars Klove, was utilized to create the 2000 cover of Paul Golding's *The Abomination*, a novel that relates the struggles of a gay childhood. While perhaps some viewers bring a distant recollection of the haunting story of the *Velveteen Rabbit* (a 1922 magical realist story of a bunny seeking acceptance), for most others the image works in the gaps of meaning, the distressed state of the upside down stuffed animal offering a glimpse but not a doorway into the narrative therein.

Kidd's covers discussed here are by no means aligned with the decorative irony of camp. However, their transformative impact is derived from the slippages in meaning that Sontag called "things-being-what-they-are-not." In doing so, they destabilize the heteronormative, rearranging the manner in which a potential reader approaches a book.

Notes

1. See, for example, Tom Folland, "Robert Rauschenberg's Queer Modernism: The Early Combines and Decoration," *Art Bulletin* 92, no. 4 (2010): 348–365. doi: 10.1080/00043079. 2010.10786118.

2. Michael Warner, "Introduction: Fear of a Queer Planet," *Social Text*, no. 29 (1991): 3–17.

3. Susan Sontag, "Notes on 'Camp,'" *Partisan Review* 31, no. 4 (1964): 515–530.

4. Hilton Kramer, *The Revenge of the Philistines: Art and Culture 1972–1984* (New York: Free Press, 1985), 6n2.

5. Penelope Green, "The Book on a Graphics Superhero," *New York Times*, November 3, 2005, https://nyti.ms/2tY-DlqJ.

6. Véronique Vienne, *Chip Kidd* (New Haven, CT: Yale University Press, 2003) 13.

Andrew Shea
Flies in Urinals: The Value of Design Disruptions

ORIGINALLY PUBLISHED
05.01.12

COMMENTS
4

I stream the news on my phone most mornings as I wake up, taking it from bedroom to bathroom, from kitchen to wherever. In January I heard a report about behavior change that stopped me in my tracks somewhere along the way. I think a lot about how designers can tweak their process to produce positive behavior change. That report on NPR's *Morning Edition*, "What Vietnam Taught Us About Breaking Bad Habits," helped me think about the topic in a new way. In it, reporter Alix Spiegel investigated why people break their New Years resolutions.

Spiegel started her report by reviewing how the US government helped heroin-addicted soldiers who served in the Vietnam War. I was shocked to learn that 15 percent of them got hooked on the drug. President Nixon created the Special Action Office for Drug Abuse Prevention to deal with the problem and appointed Dr. Jerome Jaffe to head up the effort. As part of their agenda of rehabilitation and prevention, the soldiers were required to dry up before leaving the country. To me this sounded like too simplistic of an approach to tackle such a big problem. However, Dr. Jaffe charged psychiatric researcher Lee Robins with the task of surveying the soldiers to learn how many relapsed after returning home. According to Robins's finding, that number was only 5 percent. In contrast, nearly 90 percent of heroin addicts who live in the United States and try to quit end up relapsing. Could a design initiative produce similarly successful results?

I have had many conversations with designers and educators who are dubious of the recent surge of what some call "social design." They claim that these projects rarely lead to real behavior change and provide arguments to back up their claim: the limitations of the sixteen-week semester during which many of these projects take place, the strategic flaw of designing for, not with the people they are trying to help, and the fact that many of the outcomes are inherently difficult to track and measure. Some of the results may not be measurable at all, especially in instances where the design is not being used commercially. While these are good arguments, Spiegel's report provides more clues that might help designers craft solutions that influence behavior.

Spiegel interviewed psychologists Wendy Wood and David Neal, both of whom research behavior change. Neal pointed out that public awareness campaigns generally work for actions that people perform infrequently, like giving to a charity or donating blood. However, these campaigns do not work well when it comes to habitual actions, like smoking or eating. The reason for this is because our environment comes to shape much of our behavior. According to Wood, 45 percent of our behavior throughout the day is repeated. She describes us as being "integrated" with our environment; we spend most of our time in just a few locations where it becomes easy to form complex routines and myriad habits. Neal highlighted a familiar scenario that demonstrates how

environments can shape our behaviors: "For a smoker the view of the entrance to their office building—which is a place that they go to smoke all the time—becomes a powerful mental cue to go and perform that behavior." He suggests that the best way to create behavior change is to "disrupt the environment" in a way that might help to "alter the action sequence and disrupt the learned body sequence that's driving the behavior," which allows us to snap out of our learned behavior and "reassert control" of our actions. So smokers who want to kick their habit might use a different entrance into their workplace in order to eliminate that cue. Vietnam veterans beat their heroin addiction by leaving the place where heroin was easy to get, by changing their social circle, and by adjusting to a new daily routine. All of these changes in environment helped to modify their behavior.

So how can we designers work to disrupt environments that may trigger behavior change? At least a few designers regularly work this way, one of whom is Candy Chang. Chang creates urban interventions in derelict public spaces. One of her inspiring projects, *Before I Die*, prompted passersby to "share their hopes and dreams in public space" by filling in a graphic template that she spray painted on the side of an abandoned house in New Orleans. People were quick to stop, fill in the blanks, and become part of larger conversation. Chang's passion to create these conversations is contagious. In fact, she set up a set of instructions on the project website so that others can create their own "Before I die..." installations. According the website, *Before I Die* is projected to spread to over thirty cities worldwide. The kind of temporary behavior change that results from this disruptive design is more qualitative than quantitative, but there are hard

numbers to back up the importance role that environment plays in shaping our behavior.

I discovered my favorite example of disruptive design about ten years ago, between flights at Amsterdam's Schiphol Airport. This was not a slick new airline logo that attracted new customers or an innovative wayfinding system that helped people find their flights. It was the realistic image of a small black fly inside the white urinals in the men's bathroom. When I first saw the fly, I wondered why it stayed put. Then I looked to the empty urinal next to me and spotted the same fly. They all had them. In response to dirty bathrooms caused by men urinating on the floor, an airport maintenance worker suggested that they etch the image onto the urinals to give men something to aim at as they hurry to and from flights. According to NPR science correspondent Robert Krulwich, who gave a fuller account of the story, the man thought back to his time serving in the Dutch Army during the 1960s, when red dots had been painted on the latrines in the barracks to improve cleanliness. Sure enough, spillage rates in the airport men's room dropped an estimated 80 percent after the fly was introduced, leading to a much cleaner bathroom. The story not only highlights our instinct to aim at targets, but also shows how a routine action can be disrupted by a simple, strategically-placed graphic.

Every design project poses a unique set of challenges and there is no foolproof formula that can always lead to behavior change. However, designers can benefit from Wood and Neal's insights about the role that environment plays in our actions. Consider their advice by asking how your design can disrupt an environment where frequent behavior occurs.

Andrew
Shea

Flies in Urinals: The Value
of Design Disruption

Reason and
Responsibility

**Culture Is Not
Always Popular**

153

Mark Dery
Dawn of the Dead Mall

ORIGINALLY PUBLISHED
11.09.09

COMMENTS
15

Dead malls, according to Deadmalls.com, are malls whose vacancy rate has reached the tipping point; whose consumer traffic is alarmingly low; are "dated or deteriorating"; or all of the above. A May 2009 article in the *Wall Street Journal*, "Recession Turns Malls into Ghost Towns," predicts that the dead mall bodycount "will swell to more than 100 by the end of this year." Dead malls are a sign of the times, victims of the economic plague years.

The multi-tiered, fully enclosed mall (as opposed to the strip mall) has been the Vatican of shiny, happy consumerism since it staked its claim on the crabgrass frontier—and the public mind—in postwar America. The nation's first enclosed shopping mall, the Southdale Center, opened its doors in Edina, outside Minneapolis, in 1956. Southdale was the brainchild of the Los Angeles–based architect (and Viennese refugee from the Anschluss) Victor Gruen. A socialist and former student of the modernist designer Peter Behrens, Gruen saw in the covered mall a vision of things to come.

In his dreams, Southdale would be the nucleus of a utopian experiment in master-planned, mixed-use community, complete with housing, schools, a medical center, even a park and lake. It was all very Gropius-goes-Epcot. None of those Bauhausian fantasies came to pass, of course. (Do they ever?) On the bright side, Southdale did have a garden court with a café. And a fishpond. And brightly colored birds twittering in a twenty-one foot cage. Reporting on the opening, *Architectural Record* made it sound like the Platonic ideal of downtown— what downtown would be "if downtown weren't so noisy and dirty and chaotic." A town square in a bell jar: modern, orderly, spanking clean.

But it wasn't Gruen's Mad Men take on the Viennese plazas he remembered so fondly that made his ur-mall go viral. Developers liked the way Gruen used architecture to socially engineer our patterns of consumption. His goal, he said, was to design an environment in which "shoppers will be so bedazzled by a store's surroundings that they will be drawn— unconsciously, continually—to shop." (Remember, Gruen was from Freud's Vienna, where psychoanalysis was a growth industry.)

Until Southdale, shopping centers had been "extroverted," in architectural parlance: store windows faced outward, toward the parking lot, as well as inward, toward the main concourse. Southdale's display windows were visible to the mall crawler only; from the outside, it was a blank box, blind to its suburban surroundings—the proverbial "world in miniature, in which customers will find everything they need," as Walter Benjamin put it in his *Arcades Project* description of the proto-malls of nineteenth-century Paris. In Gruen's galleria, shopping becomes a stage-managed experience in an unreal, hermetically sealed environment, where consumer behavior can (in theory, at least) be scientifically managed.

This innovation, together with Gruen's decision to squeeze more stores into a smaller, more walkable space by building a multistoried structure connected by escalators, and his decision to bookend the mall with big name "anchor" stores—magnets to attract shoppers who, with luck, would browse the smaller shops as well (a strategy James Farrell, author of *One Nation Under Goods: Malls and the Seductions of American Shopping*, calls "coopetition")—cut the die for nearly every mall in America today, which means Gruen "may well have been the most influential architect of the twentieth century" in Malcolm Gladwell's hedging estimation.

Unfortunately, Gruen made the fatal mistake—fatal for an arm-waving futurist visionary, anyway—of living long enough to see American consumer culture embrace his idea with a vengeance. In a 1978 speech, he recalled visiting one of his old malls, where he swooned in horror at "the ugliness...of the land-wasting seas of parking" around it, and the soul-killing sprawl beyond.

Good thing he didn't survive to see the undeath of the American mall. Most economic commentators attribute its dire state to the epic fail of the American economy. In April of this year, one of the country's biggest mall operators—General Growth Properties, owner, manager, or both, of over two hundred properties in forty-four states—filed for bankruptcy, mortally wounded by the exodus of retail tenants.

Good riddance to bad rubbish, some say. In the comment thread to the November 12, 2008, *Newsweek* article, "Is the Mall Dead?," a reader writes, "The end of temples of consumerism and irresponsibility? Sweet. The demise of a culture of greed? No problem."

But wait, my inner Marxist wonders: isn't that the voice of bobo privilege talking? Teens marooned in decentered developments didn't ask to live there; for many of them, the local mall is the closest thing to a commons, be it ever so ersatz. And malls are employment engines. Sure, in many cases the jobs they generate are low-skill and low-wage, but from each according to his ability, etc.

"I'm fine if some malls die," says Farrell, "but it's important to remember that malls had good points too. In a world in which no-new-taxes

has made most new public buildings look like pole barns, malls have provided an architecture of elegance and pleasure—they are some of the best public spaces in America. In a country of cars, malls have provided a place for the pleasures of pedestrianism, and for the see-and-be-seen people-watching that's one of the delights of the mall experience."

Still, Woodstockian dreams of getting ourselves back to the garden—demolishing every last mall and letting the amber waves of grain roll back—are popular these days: "tear them down, recycle what can be recycled...and turn them back into carbon-absorbing, tree-filled natural landscape, habitat for wild animals," a reader writes, on the *New York Times* site. For many, malls have come to symbolize the culture rot brought on by market capitalism: amok consumption, Real Housewives of New Jersey vulgarity.

Visions of taking a wrecking ball to malls everywhere are satisfyingly apocalyptic. But sending all that rebar, concrete, and Tyvek to a landfill is politically incorrect in the extreme. Already, architects, urbanists, designers, and critics are thinking toward a near future in which dead malls are repurposed, redesigned, and reincarnated as greener, smarter, and more often than not more aesthetically inspiring places—seedbeds for locavore-oriented agriculture, vibrant social beehives, or [fill in the huge footprint where the mall used to stand].

Brimming with evangelical zeal, New Urbanists are exhorting communities with dead malls to reverse the historical logic of Gruenization, turning malls inside-out so storefronts face the wider world and transforming them into mixed-use agglomerations of residences and retail; repurposing parking lots into civic plazas; infilling the dead zones that surround most malls with transit-accessible neighborhoods checkerboarded with public spaces (a rare commodity in sprawl developments), and weaving the streets of said neighborhoods into those of the surrounding suburbs.

The more visionary ideas sound a lot like what the cyberpunk Bruce Sterling calls "architecture fiction," somewhere between Greg Lynn and *Silent Running*, Teddy Cruz and *Ecotopia*. The San Francisco-based Stoner Meek Architecture and Urban Design, finalists in the 2003 Dead Malls competition launched by the Los Angeles Forum for Architecture and Urban

Mark
Dery

Dawn of the
Dead Mall

Reason and
Responsibility

**Culture Is Not
Always Popular**

155

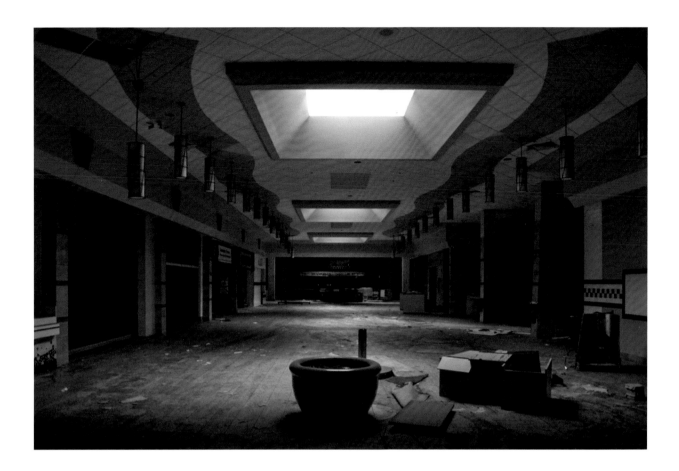

ABOVE Randall Park Mall in Cleveland Ohio, once the world's largest shopping mall.

Design, propose a postsprawl take on the Vallejo Plaza in California: deconstruct the moribund mall, they advised, and reconstruct it as a shopping center-cum-ecotourist attraction, its stores squatting, half-submerged, in the nearby wetlands remediation project. For his third-place-winning entry in the Reburbia competition, Forrest Fulton wonders, in "Big Box Agriculture: A Productive Suburb," why a ghost box grocery store can't morph "from retailer of food—food detached from processes from which it came to be—to producer of food"? The store as look-alike outlet for the trucked-in, taste-alike products of factory farming is reborn as a grocery store Alice Waters could love. The box transforms into a restaurant; a greenhouse pops out of its roof. Where the desolate parking lot once stood, a pocket farm springs up. Light poles turn into solar trees studded with photovoltaic cells. Fulton imagines "pushing a shopping cart through this suburban farm and picking your produce right from the vine, with the option to bring your harvest to the restaurant chef for preparation and eating your harvest on the spot."

Two other entrants, Evan Collins ("LivaBlox: Converting Big Box Stores to Container Homes") and Micah Winkelstein of B3 Architects ("Transforming the Big Box into a Livable Environment"), envision the radical re-use of ghost boxes as termite mounds of domestic, retail, and agricultural activity. Collins conjures Legoland stacks of brightly colored modular homes, fabricated from a recycled store and its discarded shipping containers. Where his "vacated megastore" now stands, Winkelstein sees a "behemoth structure" that is home to a mini city of lofts, its ginormous common roof crowned with solar panels and carpeted with gardens and landscaped greens, wind turbines sprouting everywhere.

Radiant City, here we come. But Farrell spots some potholes in the road to Erewhon. Projects that resurrect dead malls "are visionary and wonderful," he says, but many of them "involve a sense of public purpose that seems absent in America just now. I would love to see malls function as a commons, with public-private purposes, addressing the environment

we really live in instead of the consumer fantasyland that has been the mainstay of mall design so far."

As we cling by our hangnails to the historical precipice, with ecotastrophe on one side and econopocalypse on the other, that consumer fantasyland is an economic indulgence and an environmental obscenity we can't afford—the dead end of an economic philosophy tied to manic overdevelopment (code word: "housing starts"), maxed-out credit cards (code word: "consumer confidence"), and arcane financial plays that generate humongous profits for Wall Street's elite but little of real worth, in human terms. It's the last gasp of the consumer culture founded on the economic logic articulated early in the twentieth century by Earnest Elmo Calkins, who admonished his fellow advertising executives in 1932 that "consumer engineering must see to it that we use up the kind of goods we now merely use," and by the domestic theorist Christine Frederick, who observed in 1929 that "the way to break the vicious deadlock of a low standard of living is to spend freely, and even waste creatively."

The extreme turbulence that hit the American economy in 2008 offers a rare window of opportunity to hit the re-set button on consumer culture as we know it—to re-tool market capitalism along greener, more socially conscious and, crucially, more profoundly satisfying lines. Because an age of repurposing, recycling, and retrofitting needn't be a Beige New World of Soviet-style austerity measures. On the contrary, while we'll likely have far fewer status totems in the near future, the quality of our experiential lives could be far richer in diversity, if we muster the political will to make them so. "The most important fact about our shopping malls," the social scientist Henry Fairlie told the *Week* magazine, "is that we do not need most of what they sell." Animated by the requisite "sense of public purpose," the postmall, postsprawl suburbs could be exuberantly heterogeneous Places That Do Not Suck, where food is grown closer to home, cottage industries are the norm, and the Nowheresville of chain restaurants and big box retailers and megamalls has given way to local cuisines, one-of-a-kind shops, and walkable communities with a sense of place and social cohesion.

Or we could persist in the fundamentalist faith in overproduction and hyperconsumption that has brought us to this pass. In *Dawn of the Dead*, George Romero's black comedy about mindless consumption, he offers a glimpse of that future, one of many possible tomorrows. Two SWAT team officers have just escaped from a ravening horde of cannibalistic zombies, into the safety of an abandoned mall. "Well, we're in, but how the hell are we gonna get back?" Suddenly, they realize no one's minding the store.

Peter: Who the hell cares?! Let's go shopping!
Roger: Watches! Watches!
Peter: Wait a minute man, let's just get the stuff we need. I'll get a television and a radio.
Roger: And chocolate, chocolate. Hey, how about a mink coat?

Mark
Dery

Dawn of the
Dead Mall

Reason and
Responsibility

**Culture Is Not
Always Popular**

157

Elizabeth (Dori) Tunstall
What If Uncle Sam Wanted You?

ORIGINALLY PUBLISHED
11.01.07

COMMENTS
26

What if Uncle Sam wanted you to design not posters, but services in the war zones of Afghanistan or Iraq? As a design anthropologist, I am always interested in how the processes and artifacts of design help define what it means to be a citizen. Over the past seven years, my focus has been on design and human governance. I've applied anthropologically informed design thinking to support US elections and voting experiences (through Design for Democracy), emergency and evacuation strategies, the IRS's design management of taxation, and, most recently, public health for Chicago's Bureau of Health Services. But what if I decided to apply design thinking to the US military? What roles could design thinking play in war? A recent *New York Times* article, "Army Enlists Anthropologists in War Zone," makes these questions especially relevant.

War is one of the constants of human activity as far back as the pre-historical record. Designed artifacts have certainly played a significant role in war from propaganda posters to the design of weapons. But what about design thinking as it applies to designing social solutions? What if the US Army asked designers to join teams to do "service design" projects in Afghanistan?

The context for my questions is the current debate within the professional anthropology community about the embedding of anthropologists with soldiers in Afghanistan. The Pentagon has started a relatively new program

called Human Terrain Teams, in which social scientists are paired with combat soldiers to help translate the cultural environment to inform noncombat decision making. The participation of anthropologists in this program has generated controversy because anthropology has always branded itself as a "neutral observer"—or if partisan, as an advocate for the powerless. Historically, anthropology's role in the "Colonial Imperial" project makes the discipline wary of aligning itself with powerful military institutions. Pragmatically, the field's code of ethics requires that research participants give informed consent to projects and that knowledge be non-proprietary. Only twenty-five years ago you could get barred from the American Anthropological Association for working in a for-profit corporation, indicating the seriousness with which anthropologists have protected their neutral observer brand.

As a field less complicatedly aligned with powerful institutions, design's history and pragmatics differ from that of anthropology. The emerging emphasis on design thinking for business, government, and social institutions makes this anthropological debate relevant to design—at least hypothetically. Following the recent *New York Times* article, I posted my thoughts about the controversy and solicited other anthrodesigners' response on the Anthrodesign Yahoo Group LISTSERV. Some anthropologists and social scientists eagerly entered the fray with the pros and cons of participation in this military project. They

Samantha
11.01.07 08:54
For a little under 3 years I designed websites posters and other collateral for the U.S. Army as a member of their Army.mil Web team. My experience facilitated growth and insight into the worlds of design, military culture, the government and ethics that I would have never encountered designing in another environment. As a designer wrapping my head around the topics and challenges you mentioned in your article became more persistent and apparent over my time on the team. I appreciate your post and particularly am interested in your question: "So how prepared is the design field to engage with their ethical expectations?" This is something I struggled with for a long time.

Clarissa
11.30.07 10:13
I believe that we as designers, hold special power over information. Information nowadays might be the most powerful weapon a society has. I live in South America, in a country where manipulation of information reigns. I believe it is our duty—as well as it has been for journalists for decades—to transmit correct, truthful, educational, relevant and ethical information to the public, no matter what our "product" is. I completely agree with the article, and think that designers should star seeing themselves in the same position of holders of a precious good as journalists and historians do.

asked if future anthropologists would be put in danger or if the field would compromise its credibility. With some coaxing, a few designers contributed to the discussion. They mentioned design's role in creating wartime propaganda and weapons. Designers framed the issue as one of personal ethical choice, which contrasted with the anthropologists' interest in larger issues of professional ethics and standards.

Are we, as designers, so individualistic? I say "we" to emphasize that I consider this an insider perspective, not just that of an outside anthropologist. Are there collective ideas for which the profession stands? AIGA did adopt the Universal Declaration of Human Rights in 2006. As design seeks to expand its progressive impact on business, government, and society, I wonder if we, designers as thinkers, can continue to afford to see ourselves in such individualistic ways. At the recent AIGA conference in Denver, Richard Grefé presented how designing now includes *form + content + context + time*. As the effect of one's designing scales beyond form and content to context and time, the ethical issues scale as well.

I genuinely wonder how the design community would respond if called upon by the US Army to create service designs in Afghanistan. At the University of Illinois at Chicago, I educate "anthro-design" students in research methods and critical theory. For the past two years, over half of the students have selected topics related to ethics and designing. Both undergraduate and graduate students want to understand the role of design in, for example, promoting cultures of fear, commercialism, ecological and social sustainability, and altruistic projects in Africa. They express dissatisfaction when they interview designers who talk about ethics as personal choice. They want designing itself to be ethical. So how prepared is the design field to engage with their ethical expectations? I provide them with the perspective of ethical codes from anthropology. But, what are the ethical codes for design thinking?

So I open up the question, How should the design community respond if the US Army asked us to join teams to do service design projects in Afghanistan? What if Uncle Sam wants our design thinking?

John Thackara
Trust Is Not an Algorithm

ORIGINALLY PUBLISHED
06.07.13

COMMENTS
3

By some accounts the world's information is doubling every two years. This impressive if unprovable fact has got many people wondering: what to do with it?

Many big brands hope that the analysis of big data will give them a 360-degree view of customers: Who they're interacting with, where they shop, how they think about a bank, hotel, or store.

Banks and insurance companies are especially fired up by the prospect that big data will yield more accurate and profitable pricing models. They're also keeping a nervous eye on start-up land where a queue of newbies perceive an opportunity to re-design financial services from scratch. Some of the latter are launching peer-to-peer insurance platforms that allow individuals to develop their risk pools without the participation of major insurers. Others have built platforms to sell risk coverage on demand, as microtransactions: "You want to ski off-piste? Click here and you're covered."

In Malaysia, you can already buy lifestyle insurance, as it's called, from a Facebook page. In the UK, special insurance cover for Chihuahua owners is available right now.

In the so-called health care 'space', open data advocates are confident they can help citizens better understand different kinds of treatment. Improved citizen awareness, they argue, will spark action to improve performance. There is evidence that health outcomes improve when patients have access to shared health care information in ways that allow them to compare treatments with others like them.

Nearby, in the personal data economy space, the promise of "self-knowledge through numbers" has spawned dozens of new ventures. One such, Quantified Self, has become a movement; QS groups meet the world over to devise new forms of "self-tracking."

In the world's city halls, a not-so-small army of consultants is pitching the concept of smart cities to beleaguered officials. The promise: collect data from the five billion people now using mobile phones; combine these with data from fifty billion interconnected sensing and monitoring devices—and lo! the resource efficiency of a city's transport, energy, industry, and buildings can be transformed.

National governments are not immune from the big data buzz. Many believe that vast amounts of data generated by governmental activities can be used to launch new ventures, analyze trends, make data-driven decisions, and solve complex problems. For its more radical advocates, big data (and its in-your-face cousin, open data) are about more than transparency: They can be the basis of a full read/write society in which all citizens participate actively continuously in governance.

Kerwin
06.17.13 10:57
Maybe we have a watershed moment in the making. As you note, the quantified self-movement is likely to produce large streams of personal data. This data is particularly significant because it's of immediate and relevant use— it tracks hard-to-capture micropatterns, like sleep, activity level, and other fundamentals of what makes humans healthy and functional. However, there are more interested parties in this data, such as employers and insurance companies, and more incentives to profile users in problematic ways. Can this new data engine bring to a head what other scenarios have not? That is, the need for data sharing standards (in the technical sense, like MIDI is the digital standard for interfacing with instruments) that give end users meaningful controls about who gets to see this most private of data sets. Trust can't form or last without a balance of control and power between members of a community, along with a heavy dose of transparency and shared value that feels fair to all involved.

Big data, it seems, have become a product category in their own right—and this means new work for design. Many of the smartest designers I know are working on better ways to capture, curate, store, search for, share, transfer, analyze, and visualize, big data.

What numbers miss

These opportunities afforded by big data are real enough—but they also contain a danger: that we become be so focused on numbers that we lose sight of other opportunities. Consider, for a start, all the things that matter, but which cannot be counted.

In health care, for example medical treatments enhanced by data-driven platforms are but one part of a much bigger picture. Ninety-five percent of person-to-person care happens informally outside the bio-medical system—in the home, and in the community. For insurers and cash-strapped governments alike, this vast upstream world is where innovation is most needed.

We are beginning to understand communities as social-ecological systems in which the health of the system, more than individual interventions, is the priority. Seen through this lens, one of the most important determinants of a community's health is the time spent by human connectors: the family doctor, the midwife, the teacher, the priest. Communications and data are helpful, even essential, in their work—but their interactions are for the most part *relational*, *embodied,* and *context dependent*. Trust, in communities, is not an algorithm.

The same goes for cities. Embedded systems and analytical tools will clearly be helpful—but what makes cities truly smart are its citizens as they innovate tools and business models to meet daily necessities in new ways.

Another limitation of big data: they capture information about transactions in the formal economy where they are most easily monitored. This focus obscures most of the world's economic activity, which is informal. Seventy-five percent of adults in Africa, for example, work in microenterprises whose activities barely register in official data. Many of these traders use custom-made means of exchange. The same goes for India: for all the attention paid to India Inc., 90 percent of that huge country's workers are informal.

A lack of data does not mean a lack of value and potential. Billions of people with low-cash incomes meet their daily life needs outside the money economy—for example, through traditional networks of reciprocity and gifts. They survive, and often prosper, within indigenous social systems based on kinship, sharing, and myriad ways to share resources. These activities are socially embedded, so they are hard to count—but they are no less important for that.

This solidarity economy is not confined to the Global South. Across the industrialized North, informal solutions have emerged in response to an implosion of the formal economy. More than fifty thousand social enterprises are now operating in Britain, for example. And in the United States, *40 percent of the workforce will be freelance by 2020*.

My biggest concern with big data is the prospect that they will give managers and policy makers a sense of being in control when such confidence is not justified. We have incomplete or contradictory knowledge about large-scale, system-wide challenges such as climate change, or resource depletion. Such "wicked" challenges do not lend themselves to data-driven solutions: These interconnected systems influence each other in unknowable ways.

What most worries climate change scientists, for example, is the possibility of an "ecological surprise." These are unexpected, catastrophic, system-scale transformations that brew for ages below the measurable surface of events. Being nonlinear, such collapse dynamics are impossible to predict.

All is not number

In his book *Sacred Economics*, Charles Eisenstein charts the long history of our unhealthy preoccupation with data. In Eisenstein's account, the problem dates back to the early Greeks. Their emphasis on the primacy of the abstract, he writes, became "an unseen principle that ordered the world". The ideology of abstraction permeated the DNA of our civilization to the point where, today, the size of the financial sector dwarfs the living economy. For the trader at his or her computer, as for Pythagoras, "all is number."

Number-fetishism is associated with an adjacent handicap: binary thinking. The problem with big data is not that numbers are bad—it's

John
Thackara

Trust Is Not
an Algorithm

Reason and
Responsibility

**Culture Is Not
Always Popular**

161

that we've made them an end-in-themselves in ways that lead us to misallocate time, attention, and resources. big data can work well in support for online resource-sharing— Airbnb, Uber, eBay and their like—but they're of modest efficacy to the informal economy where, to repeat, a big majority of the world's citizens subsist.

As Niti Bhan, an informal economy expert, points out, what informal workers most need, but usually lack, is the capacity to plan ahead rather than be perpetually at the mercy of seasonality. This means liquidity (money)—and insurance, too. These needs are being met in an ad hoc way by the mutualization of risk among trusted networks—but incompletely.

The opportunity today reminds me of the ways access to telephony was revolutionized in India. Sam Pitroda's Public Call Office (PCO) concept, based on the clever sharing of devices and infrastructure, enabled hundreds of millions of people to gain access to telephony for the first time. Pitroda's innovation was first, to aggregate demand; and second, to scale the service rapidly by involving existing local entrepreneurs. His vision of "an entrepreneur in every street" was realized in vast areas of the country.

Large financial firms, although one doubts that they realize it, are well placed to play a similar role in the regenerative economy that's now emerging. Unlike an online start-up, they have physical proximity to hundreds of millions of citizens. One global firm I know has one hundred thousand branch offices around the globe. In its mind, these branches are a regrettable overhead necessary for the "distribution" of financial products to its one hundren million customers.

Treated thus, the result is an army of de-motivated sales agents who meet customers once

a year to fill in application forms. But they could do so much more. Social trust—unlike the algorithmic kind—is based on embodiment, context, and colocation. These proximity assets could support all manner of socially-useful services.

Inter-generational contracts
Large institutions have a temporal as well as geographic advantage over online start-ups: the capability, should they and their shareholders choose, to act over the long-term.

Most start-ups attract investment on the basis of a profitable "turn" a few years down the line. Big firms, having completed that journey, could provide the slow money, the 'nurture capital', that connects directly to the land and to places where investors live.

Big firms have the potential, too, to introduce the inter-generational contracts that social-ecological systems also need, but lack.

Large institutions have a third and vital role to play in devising new ways to take care of eco-systems. Ecological and political researchers have argued for an approach called *adaptive co-management* (ACM). ACM emphasizes the sharing of rights, responsibilities, and power between different levels and sectors of government and civil society. It means the creation of what climate scientists call *social-ecological constellations*—fluid collections of people and organizations that learn, continuously, how to share rights, responsibilities, and power between different levels and sectors of government.

This messy, open-ended and demanding work task is easier for a large organization to support, than a small one. It relies not on data but on a different kind of certainty—a different kind of trust.

ORIGINALLY PUBLISHED
08.10.17

COMMENTS
2

Ashleigh Axios
To Be a Design-Led Company

What got us here won't get us there...
I want to have design leading the way...
A lot more user research. A lot more mockups.
—Matt Mullenweg, 2016 State of the Word

In 2016, Automattic CEO Matt Mullenweg announced that the company was to be design-led for the first time. Automattic's new era would be recognized by designers leading the way in product and marketing improvements—heading up more projects, conducting user research, and creating more mockups than ever before.

It wasn't how Automattic had come to be successful, but it marked a promising entry into a new chapter of future success. After all, over the last ten years, design-led companies have maintained significant stock market advantage, outperforming the S&P by an extraordinary 211 percent. That is, publicly-traded companies have shown year-after-year for the last decade that design-led businesses maintain significant market advantage over their competitors. That's a big endorsement for being design-led or as the Design Management Institute calls it, "design-centric."

Automattic secured John Maeda as the new head of design in the early fall of 2016 and I joined soon after, drawn in by the promise of the ability to help a successful company take its achievements to new areas, heights, and communities through design.

Automattic ended 2016 and started 2017 hiring more design talent as well as connecting and empowering designers to do their best user-focused work in deeper collaboration with one another. New, strategic audiences were identified and introduced. Separated designers were brought together for short sprints over common product challenges at meetups. And "non-designers" were introduced to design concepts and brought into collaboration.

Designing better products, services, communications, and working to better understand our customers has been a necessary part of the process of Automattic becoming design-led, but there's still much more work to be done. I believe that now is the time to fully embrace the other areas in order to complete the journey of becoming a design-driven company. Perhaps you're wondering, "what are the other areas?"

Maximizing design impact across areas
There are different models for this, but I'll share my simple model that strategically uses design in three main ways:

- *Design as tactical driver:* where design alters a discrete product, service, or communication effort;
- *Design for system innovation:* where design alters an existing system or creates a new one to deliver a better solution; and

Ashleigh
Axios

To Be a Design-Led
Company

Reason and
Responsibility

**Culture Is Not
Always Popular**

163

- *Design as a catalyst for transformation:* where design changes attitudes and behaviors of a community or organization.

In some ways, it may be easier to understand these areas by looking at how they relate to one another. By applying my model to a modified version of the Winterhouse Symposium for Design Education and Social Change 4 matrix, I hope to help us see the relationships.

Let's get familiar with the modified matrix first. On one axis, they show the *scale of engagement*, which I've renamed to the *scale of impact*. This ranges from a smaller, project- or customer-based impact to a larger, cultural- or community-based impact.

On the other axis, they show the range of expertise, which I've renamed to who's needed. This represents those needed to complete the task at hand and ranges from an individual person to a larger, cross-sector group.

Together, they create the matrix you see below.

Design as a tactical driver fits in the bottom, left corner of the matrix. It only requires an individual designer or a small, interdisciplinary group in order to alter a discrete product, service, or communication. Similarly, the impact will likely be limited to the audience of the discrete project.

Design for system innovation fits right in the middle of the matrix. It requires an interdisciplinary group or cross-team collaboration

in order to achieve the goal. Because the impact is system-based, it can scale beyond an individual project and help across multiple projects and teams at once.

Design as a catalyst for transformation fits in the top, right corner of the matrix. Because the aim is to change the attitudes and behaviors of a community, this area often takes cross-sector or cross-industry collaboration and buy in. Likewise, the impact of this work is beyond a project or series of projects, and is instead at the cultural or community scale.

Design as a tactical driver can be seen as zoomed in with a shorter timeline, and design as a catalyst for transformation can be seen as zoomed out with a longer timeline.

Similarly, the risk and the reward for each area scales along the same line. *Design as a tactical driver* is the least risky, but also has the least reward, whereas *design as a catalyst for transformation* is the most risky – often because of the timeline and the unknowns of working with a wider array of folks, but can offer the highest reward due to the larger audience and scope.

Now, if you're like me, having some examples in each of these will help this go from interesting and theoretical to applicable and practical. I'll share some examples specific to Automattic.

- For *design as a tactical driver*, a solo designer can redesign part or all of the WordPress.com sign-up flow to aid others in signing up.
- For *design for system innovation*, a group with representatives from multiple teams within Automattic can collaborate on design patterns to generate a company style guide.
- And for *design as a catalyst for transformation*, folks across tech with one or a few representatives from Automattic can come together to build a culture of inclusion through dialogue and common goals.

Now, notably, each of these things is important just like each area is important.

A company should have designers assessing and improving discrete products, like a sign-up flow, to ensure that it works for customers and for business goals. A company should also have collaboration across teams to lead to systemic design solutions like a shared style guide or design patterns. Without that, just imagine how each team would have to do more tactical work—often duplicating efforts and wasting resources. And lastly, a company should invest in designing their culture, which includes both the internal culture and those the company exists within. Changing culture is extremely helpful in ensuring the company and the market grows. No amount of discrete design work or collaboration toward system-based solutions will adjust a culture on its own. Effective changes to culture require collaborating with stakeholders and major influencers.

Each of these areas requires a type of focus, a range of time, and a specific number and type of participant. They each have different levels of risk and reward, and produce different scales of outcomes. These differences are why it's helpful to keep each category in mind; they

help ensure each part of the business and each customer touchpoint is benefiting from design leadership.

Automattic started on its path to being design-led where many companies and individuals start, with design as a tactical driver. It's a natural way to get started because it only requires an individual designer and anywhere from one week to a couple of months to complete a project. It also aligns with how most design programs teach, making it the area designers are most practiced in when they enter the professional world. The relatively short timeline necessary for this area means design tasks are less risky, while still audience-focused. Again, it's a natural and smart place to start.

While there's always much more work to be done, Automattic is now pretty strong at design as a tactical driver. We've started to build solid examples of *design for system innovation* and need to be doing more of it. And just this year we initiated an extracurricular design as a catalyst for transformation project, collaborating with companies on culture-building improvements to broader tech, but these efforts need to be given space within our core efforts in order to not further elongate the already long timeline needed to see results.

I will continue working to share the importance of working at scale, across areas of impact, at Automattic. I'll be looking for successes that can be shared across teams to lead to systemic solutions. I'll be looking for weak areas of culture and finding partners internally and externally to collaborate on designing solutions. I'll also be looking for designers in Automattic who are interested in taking their product or marketing experience and scaling it and will help patch them into opportunities for personal and professional growth. I hope you'll consider doing the same where you work so that our industries are filled with design-led companies and people who know how to harness that power.

Ashleigh
Axios

To Be a Design-Led
Company

Reason and
Responsibility

**Culture Is Not
Always Popular**

165

ORIGINALLY PUBLISHED
11.09.16

COMMENTS
23

Michael Bierut
Jessica Helfand
Let's Get to Work

Many (most?) of us woke this morning to the shocking news of a Trump presidency. We feel misled by the press, unsettled by the electorate, abandoned by the audacity of our sustained, if arguably futile hope. There is much to say the morning after, and our sleeplessness and shock likely blind us to any logical predictions. (Are predictions ever logical?)

But there is a case to be made that design is inherently an optimistic enterprise, a way of expressing confidence in the face of challenges, no matter how bleak. Designers understand this implicitly: we may not be in a position to control change, but we are its most ardent and expressive ambassadors. We may oppose an unthinkable political victory, but we remain deeply committed to seeking, and serving, real social progress. We may be down—but we're not out.

Today, as a new administration beckons, let's remember who we are, what we do, and how we can remain resolute in the face of what feels to so many of us like such a bruising defeat. How we can restore dignity to communication. How we can exchange hubris for humility. How we can, indeed, how we must bear in mind that democracy is about who we are, not who's temporarily in office.

Our participation in the American political process isn't something that happens every four years. It happens every day, at every level, through partnerships, across disciplines, beyond expectations. We may be divided as a nation, but we remain united as a community: a community of like-minded peers, passionate thinkers, and enthusiastic makers. We remain, now as ever, citizens of a world where inclusiveness will always trump ignorance. Designers often think of themselves as problem solvers: so let's start solving some problems. The voting may be over, but the work is just beginning.

Véronique Vienne
Cafés and Cigarettes

ORIGINALLY PUBLISHED
12.08.15

COMMENTS
4

168 **Culture Is Not
Always Popular** Reason and
Responsibility Cafés and
Cigarettes Véronique
Vienne

ogies, but in Paris they've recently become synonymous. Local café culture, as we knew it, might be a thing of the past. Weeks after the attacks of November 13, patches of pavement, once littered with cigarette butts, are still strewn with tiny commemorative candles.

Smoking can kill you.

Lighting up a cigarette at a terrace café, a relaxing ritual so many Parisians took for granted, is today an act of defiance. Anti-smoking bans—and now terrorists—have eroded the appeal of the sidewalk nicotine buzz. Adding insult to injury, less than a week after the senseless murders, the French National Assembly voted to outlaw distinctive cigarette packaging, making neutral, featureless packs mandatory.

In France, one beloved brand did the most damage: Gauloises. Its electric blue pack, emblazoned with a drawing of a winged helmet, was plain yet elegant, understated yet handsome. In the 1950s, French men and women allegedly consumed more than one billion packs of Gauloises a month—most on them while sitting at terrace cafés.

Hemingway, Sartre, and Picasso chain-smoked unfiltered Gauloises at the terrace of the Deux Magots brasserie. This was a time when you couldn't imagine being a real artist unless there was smoke in your eyes—your itchy, squinty, burning eyes—eyes stung by the painful memories of two world wars.

Originally, Gauloises did wonders for the morale of men in uniform. Tobacco is a mood

Véronique
Vienne

Cafés and
Cigarettes

Reason and
Responsibility

**Culture Is Not
Always Popular**

169

aged in the 1930s for French civilians. But in the mind of smokers, the Gauloises never lost their trooper persona. During the Second World War, Gauloises hung from the lips of members of the underground resistance movement.

The designer of the famous Gauloises pack was Marcel Jacno (born Jachnovitch). In 1936, he had updated the old army pack and turned it into a successful brand. A prolific theater poster designer, he is best known for his work for the Avignon Festival. He had been a member of the resistance, arrested and deported to Buchenwald in 1940. Back from the camps, he got to work, and over the next decades updated the design of the Gauloises packs to reflect the peacetime personality of the brand's many line extensions.

leaning forward to light the cigarette of a woman to stubbing in ashtrays or removing bits of tobacco from the tip of your tongue. The Gauloises' brand imagery and strong tobacco aroma were as iconic as Brigitte Bardot, the baguette, and the beret.

Patriotic symbols come and go. The brand with the flying helmet is among the recent casualties. After the Paris attacks, the French flag is making a comeback as a symbol of unity. However, before French tobacconists remove the last blue packs from their shelves, one can still light up one of those robust, unfiltered, dark tobacco cigarettes. Pensively blowing smoke in the air, one can experience what it's like to look at the world through eyes stung by the memory of painful events.

SOPHOCLE

ANTIGONE

Collection du Répertoire

L'ARCHE
ÉDITEUR
À PARIS

ALFRED
DE MUSSET

ON NE
BADINE PAS
AVEC L'AMOUR

Collection du Répertoire

L'ARCHE
ÉDITEUR
À PARIS

Véronique
Vienne

Cafés and
Cigarettes

Reason and
Responsibility

**Culture Is Not
Always Popular** 171

JACNO

DIRECTION JEAN VILAR

TNP
THÉÂTRE NATIONAL POPULAIRE

THÉÂTRE NATIONAL DU PALAIS DE **CHAILLOT**
PLACE DU TROCADÉRO. PARIS XVI

Antigone

DE **SOPHOCLE**

TRADUCTION :
André BONNARD
avec l'accord de la Comédie Française

DISPOSITIF SCÉNIQUE ET COSTUMES :
Gustave SINGIER

MUSIQUE :
André JOLIVET

RÉGIE :
Jean VILAR

René ALONE
Philippe AVRON
Laurent BRANCAZ
Willy BRUNO
Jacques CHAMPREUX
René CHAUVAUT
Philippe DERESDIN
Jacques DELROISSE
Charles DENNER
Jean-Pierre DUCLOS
Claude EVRARD

Jacques FAMERY
Jean MAUVAIS
Christiane MINAZZOLI
Jean MONDAIN
Pierre ORY
Mario PILAR
Marcelle RANSON
Georges RIQUIER
Catherine SELLERS
José VARELA
Jean VILAR
Georges WILSON

PRIX DES PLACES **2, 4, 6**ᴺᶠ
timbre compris

LOCATION

A LA CAISSE du Palais de Chaillot, 12 jours à l'avance, jour de la représentation compris. Tous les jours de 11 à 18 H (le dimanche de 11 à 17 H seulement).
PAR TÉLÉPHONE : PASsy 56-31 (au moins 2 jours à l'avance). Tous les jours de 15 à 20 H sauf le dimanche.

POUR LOUER PAR CORRESPONDANCE : réclamer d'abord les formulaires au Palais de Chaillot : au service de l'administration pendant les heures ouvrables normales, ou au guichet spécial du Grand Foyer pendant les "Accueils en Musique" et les entr'actes.

RENSEIGNEMENTS PAR TÉLÉPHONE : POINCARÉ 39-50

COMEDIE-FRANÇAISE
auteurs nouveaux à la Comédie Française

TROISIÈME SPECTACLE
Trois pièces en un acte au même programme

Gabriel Cousin
LA DESCENTE SUR RÉCIFE
Mise en scène de M. Jacques Destoop

Jean-Claude Grumberg
RIXE
Mise en scène de M. Jean-Paul Roussillon

René de Obaldia
LE GÉNÉRAL INCONNU
Mise en scène de M. Jacques Rosner

Scénographie et costumes de Mᵐᵉ Claude Lemaire
Présentation de M. Michel Etcheverry

Six représentations à 20 h 45
Lundi 8, Mardi 9, Lundi 15, Mardi 16, Jeudi 18 et Jeudi 25 Mars 1971

3, 5, 7, 10, 15, 20ᶠ

COMÉDIE-FRA **1680**

Location ouverte une semaine à l'avance, jour pour jour, de 11 à 18 h.
Location par téléphone : 742-22-70 et 742-86-23

JACNO

IMP. L. HARDY — PARIS 17969

Véronique
Vienne

Cafés and
Cigarettes

Reason and
Responsibility

**Culture Is Not
Always Popular**

173

05.

New Vernaculars

No matter how broad its founders conceived their purview, *Design Observer* has returned, over and over again to the same fundamental questions: what do designers do, how do they do it, and—perhaps most crucially—why do they do it?

By its nature, design is an activity that demands to be judged by its results. Yet, any design outcome is necessarily the result of a long cascade of decisions, some conscious, some the product of forces so complex they nearly defy analysis. Consider the contrasting technological contexts invoked by Rick Poynor as he describes the creation of a 1920 collage by Raoul Hausmann, and its viral dissemination on the Internet nearly one hundred years later. Or the history-changing implications of what Phil Patton calls "the mascot of asymmetrical warfare," the shoulder-borne RPG-7, a $10 weapon capable of taking down a guided missile. Or the return of the commune as noted by Allison Arieff, an artifact of the hippie '70s repurposed for today's sharing economy. In each case, design form is answering to human desire, but the path from conception to consummation is neither straight nor uncluttered.

Leading that complicated journey is the designer, each with his or her own ambition, doubt, ambivalence, and certainty. Designers were not the sole audience for these essays, but they were the first, the ones who found here some kind of balance between personal gratification and social engagement. Jessica Helfand quotes Konstantin Stanislavsky: "Love the art in yourself, not yourself in the art." *Design Observer* was never better than when it looked both within the designer's world and beyond its slippery borders.

ORIGINALLY PUBLISHED
05.23.05

COMMENTS
54

Jessica Helfand
Method Designing: The Paradox of Modern Design Education

Over a century ago, Konstantin Stanislavsky revolutionized the modern theater by introducing a new system of training, in which the actor would draw on his or her own emotions to achieve a true understanding of a character. "We protested against the old manner of acting and against theatricality, against artificial pathos and declamation," Stanislavsky wrote, and indeed, in an era framed by considerable social and civil unrest, the very notion that characters could be shown to have an interior life was itself remarkably revolutionary. Through the practice of what we have come to know, today, as "method" acting, an actor could explore, identify, and ultimately reveal the degree to which a character could be a hugely complex human being with feelings, emotions, and often conflicting desires.

To this day, method acting remains a highly regarded pedagogical model for training actors. But when did it become an appropriate system for educating designers?

Schools of thought are always hotbeds of ideological controversy: there are always exceptions to the rule, deviations from the principal learning curve. In creative education this a particularly thorny issue: How to teach discipline *and* promote invention? Arguably, designers who were trained to understand two-dimensional composition by crafting eight-by-eight inch Plaka boards were more conscious of the former than the latter, while

today's design students firmly occupy the opposite camp.

And while each approach might be said to be imperfect, it is the contemporary conditions within which today's design students are expected to "make work" that gives me cause for concern.

In the interest of full disclosure, I was an actress before I became a graphic designer. I struggled with just how difficult it was to understand a role, to be another person—and while the skeptic in me had my doubts about method acting as a kind of religion, I recognized then (still do) that at its core, it was all about a kind of stripped-down emotional honesty. If you could achieve this honesty, your performance would resonate with a kind of pitch-perfect humanity and you had a far better chance of truly engaging your audience as a result.

Engaging the audience, of course, might be said to characterize the designer's goal as well. Perhaps this is why, having spent the better part of the last two weeks participating in year-end reviews at several design schools, I am at once hopeful and discouraged by what I am seeing—in particular, by a kind of self-aware, idiosyncratic abstraction that seems to lie at the core of the theoretical process. And while a good deal of the work I've seen is original, imaginative, and in more than a few cases, magnificently daring, I find it oddly vexing that

Peter Buchanan-Smith
05.25.05 03:02
It's obviously a problem if students are making work that's impenetrable (personal or not). To me the real question has always been how to make the work even more engaging and the answer has usually been found in "the personal" (to a greater or lesser degree as Jessica describes it.) Like others in this thread have stated, I'm also not sure that "method acting" is really a fair comparison in the context of design. That said I would like to make a defense for "personal work."

For starters, it would be safe to assume that personal work (usually) demonstrates that a designer has some personal stake in their work. This is not to say that a re-design of a Citibank logo can't demonstrate a level of personal commitment: you would hope that it would. But by exploring their own ideas, the hope is that they will eventually understand how they can inject themselves into the job at hand—no matter what the job might be. After all, a smart person can quickly acquire the tools to fulfill more specific professional design requirements on the job. And although a student's body of work might not be fully functional upon graduation, it sometimes is the seed that can continue to grow after and perhaps even sustain them in years to come. I would encourage anyone (young or old) to be exercising their passions, even if this means having to do personal work "on the side"; this spirit has kept me sane throughout the darkest days of my career. And last but not least, you hope that at the very least, that the student has got something out of their system. This notion of

176 **Culture Is Not
Always Popular**

New
Vernaculars

Method Designing:
The Paradox of Modern
Design Education

Jessica
Helfand

somewhere along the line, we have allowed our students to appropriate some part of method acting—the part that glorifies feeling and celebrates vanity; the part that amplifies personal memory and replays it as objective truth. It's extremely subjective and it's extremely seductive and more often than not, it's extremely misplaced as graphic design.

The good news is that in an effort to produce designers who can think for themselves, we ask our students to identify a method which becomes evident through the work that they produce. Such an emphasis on authorship is, by and large, a way to train young designers as thinkers—and not merely as service providers. (So far, so good.) At the same time, we encourage them to seek references beyond the obvious: the richness of their sources testifies to an ability to engage a larger universe, and their work benefits from locating itself along a trajectory they've chosen and defined for themselves.

The bad news is that as a consequence of seeking validation elsewhere, there is an unusual bias toward false identity: so the design student, after looking at so much art, believes that she or he is making art. The design student, after considering so deeply the intangible forces framing the interpretation of visual form, comes to believe that the very act of interpretation is itself the form. This is where the method backfires so paradoxically: in being true to ourselves, we distance ourselves from a more universal truth, the kind that designers, in making messages clear, are so naturally predisposed to understand.

In an age of staged, declarative theater, Stanislavsky's came as a radical response to what was then a stilted performative norm.

Yet the reason it has survived since its inception more than a century ago may have more to do with the rigors of form than the emotions of the performer: at the end of the day, there's still a tangible barometer of authenticity—and that's the script. (Hamlet can be many things, but in the end, he's still got to deliver his lines.) Perhaps this lies at the core of the problem: where's *our script*? When did we begin to allow, let alone forgive, let alone encourage work that is so rhetorical, so impervious to public engagement? The persistent evidence of impenetrable personal work in design schools across America is a serious epidemic, resulting in a kind of method designing that erroneously treats sentiment as substance, and why? It was, after all, Stanislavsky himself who cautioned: "Love the art in yourself, not yourself in the art." Where did we go wrong?

The problem with method designing is not our students' problem: it is *our* problem. Let's teach our students to keep asking difficult questions, to keep solving harder problems, to keep inventing better worlds and yes, to be true to themselves. As emissaries of visual communication, our audiences deserve nothing less. To better understand ourselves as authors requires a certain amount of self-reflection, but when did the mirror of autobiography become our canvas, our public lens to the world? If such self-love leads to more honest communication, to more novel form making, to more meaningful solutions, then so much the better. But for designers, such self-knowledge can not be a method. It is simply a motive.

Jessica
Helfand

Method Designing:
The Paradox of Modern
Design Education

New
Vernaculars

**Culture Is Not
Always Popular**

177

ORIGINALLY PUBLISHED
05.19.17

Sean Adams
Return of the Standards Manuals; or, Revenge of the Rigid

In 2015, Jesse Reed and Hamish Smyth started a Kickstarter campaign to reprint the NASA Graphics Standards Manual, designed by Danne and Blackburn in 1975. Recently, Reed and Smyth, as Standards Manual, with AIGA, have launched another Kickstarter campaign to reprint the EPA *Graphic Standards System*. Chermayeff and Geismar designed the identity and system in 1977. To date the suite of manuals also includes the manuals for the Official Symbol of the American Revolution Bicentennial, and the New York City Transit Authority.

The commonality with all of these manuals, beside their overwhelming popularity now, is the rigidity of the graphic systems. The manuals clearly mandate how to use the logo, how not to use the logo, what color is acceptable, and the only typeface option. Examples of applications show the grid structure and type of imagery. As many possible examples are identified from a satellite to a telephone directory cover. These are not systems to be messed with.

What is contrary here is the current fascination with these hard-line identity systems in a design culture that proselytizes the virtues of flexible logos and customizable systems. Let's identify the differences. The classical post-war identity program followed the strict guidelines. Designers working with the program followed the rules in the manual and produced work that maintained a consistent visual system.

By the 1980s, the idea of a flexible identity— that is, a logo that can change—came to the surface in the graphic design industry. The MTV logo (Manhattan Design, 1980) is a prominent example of the flexible identity system. Designers working with a flexible system were encouraged to bring their own creativity to the project and create dynamic and surprising results.

Over the past twenty-five years, the majority of identity systems I designed have a flexible component. It proved to be necessary to maintain the system with a large group of other designers and creative partners. A hard-line simple logo was doomed to fail. A reed that will not bend, breaks. The changeable identity also spoke to the contemporary audience, now with shorter attention spans and a constant need for the different. But was that true? Or simply another narrative?

It is reasonable that the classic identity program was a post-World War II invention. For a generation that had suffered through the unstable ground of the Great Depression and then fought the largest conflict in history, a simple and clean logo that never changes makes sense. Designers working with these rigid visual systems came from a wartime mentality of following orders, whether in the service or as a civilian. If the logo was black, it was always black. There are stories of an in-house design department that had clear rules in addition to the identity: the uniform was

a white shirt and black tie for men and gray tailored dress for women. No personal effects, such as photographs or plants, could be set on a desk. And to add to the warm environment, each designer had a triangle template to verify that all desk lamps were set at the same angle.

In contrast, after the counter-culture movement of the 1960s and the hedonistic 1970s everyone was told he or she was creative. Authority should be questioned and the establishment could not be trusted. If you conformed and were not an individual who expressed yourself, you were taken to a therapist. In this setting then, a rigid logo system was anathema. Free to be... you and me.

By the 2000s flexible logos and loose visual systems were to be expected. In the right hands, typically the originator's, the system could be dynamic and lively. But too often, the license for creative freedom led to a disintegration of the brand's message and visual

presence. New colors appeared and soon the corporate blue was missing. Someone's friend was an illustrator, so that person was hired to make images for the advertising that had nothing to do with the brand's communication. The designer or creative director managing this system was faced with the choice of allowing the visuals to evolve and mutate, or to lay down the law and demand consistency. The choice would seem clear—a brand message is competing with millions of other messages daily. A cohesive communication is critical. I do recall, however, an angry designer feeling abused and quitting his job because he had to use a corporate color he didn't like.

Perhaps the fascination of these hard-line standards manuals comes not just from the incredible design, but the longing for a simpler time when our roles as designers was clear. How wonderful it would be to design one logo, with a simple color palette, one typeface, and consistent image style and then stick to it.

Rick Poynor
Why Tatlin Can Never Go Home Again

ORIGINALLY PUBLISHED
02.04.14

COMMENTS
1

At Pinterest, which I joined recently, I have started a couple of boards related to collage, one devoted to contemporary work and the other to the history of collage from the 1920s to the 1990s. I subscribe to the view expressed by David Shields in his book *Reality Hunger* that collage was "the most important innovation in the art of the twentieth century" (although collage actually predates the century). It's early days for the boards, but both will be collections of collages that I already know about but want to store in a handy place and of discoveries that are new to me. The historical board will accumulate in a broadly chronological manner until it reaches the present era, and then I suppose it will be more or less finished.

This structured style of pinning might not be the usual, more random way of filling Pinterest boards, but one thing that appeals to me about the site is the chance to contrive deliberate visual relationships between the pins, though "proximities" might be a better word since a board's layout is shifting all the time under the pressure of new pins loaded on at the top. Still, pins stay close enough to their neighbors for visual and conceptual connections to remain. One future improvement I hope Pinterest will make is a facility allowing pins to be grouped within a board with more precision, which one could do as a matter of course on a traditional corkboard.

An early pin for the History of Collage board was the Dadaist Raoul Hausmann's famous *Tatlin at Home* created in 1920. Perhaps I should try to get with the program more, but the decision to include this icon of Dada nose thumbing raised many questions. An activity that promises to be quick (and with the "Pin it" button installed the process could scarcely be quicker) can turn out to be unexpectedly labor intensive. Since there are already many images of *Tatlin at Home* on Pinterest, the most social thing to do would be simply to re-pin someone else's—the most popular *Tatlin at Home* pin has been re-pinned twenty-three times. The entire site is built on the idea that sharing pins without too much mulling it over is what pinners will routinely choose to do.

But *Tatlin at Home* is a historical artifact, not a throwaway image, so which pin was the most accurate as a representation? There were large differences in color and small but nagging variations at the edges of the image. The right-hand edge seemed particularly unlikely in all the pins I looked at. Having cut out the dressmakers' dummy containing body organs and the fire extinguisher underneath, why would Hausmann then choose to slice and crop them so awkwardly? On the other side of the collage, the man's hand and foot comes and goes and the crop on the ship's propeller at the top also varies. Not for the first time it seemed I would have to leave Pinterest to find the most reliable online source and with art, as a rule, this tends to be the museum that owns the piece. Before doing that, I consulted some books, seven in all, that reproduce *Tatlin at Home*. From

William S. Rubin's *Dada & Surrealist Art* to Dawn Ades's *Photomontage*, it became clear that in the original the complete edge of the dressmakers' dummy could be seen, as well as most of the fire extinguisher (though both of these older reproductions are in black and white).

However, even these earlier images published long before the Internet are unreliable. In a photograph of Hausmann and fellow Dadaist Hannah Höch taken in 1920 at the International Dada Fair in Berlin, *Tatlin at Home* can be seen on the wall—Ades shows the picture on the page opposite the collage. The collage's edge is visible and the space between the dummy and the picture's edge is larger than in any reproduction I have seen. More of the machine-headed man's shirt collar is showing and there is slightly more space above the propeller.

According to the illustration credits, the photograph in Ades's book came from the Moderna Museet (Museum of Modern Art) in Stockholm. Online, the Bridgeman Art Library appears to confirm the Moderna Museet as the work's location and the picture (with library watermark) shows a wider right-hand edge, though there is a curious line along the edge that cannot be part of the piece. Surely, then, a visit to the Moderna Museet website would provide the most reliable image of *Tatlin at Home*, perhaps at a size suitable for pinning, the object of my quest. A search on the site produced no evidence that the work is part of the museum's collection any more. How could it be that such a celebrated masterpiece of photomontage—with full apologies to the anti-art spirit of Dada—has simply disappeared, seemingly while hiding in plain sight?

Eventually, in a bulletin on the Moderna Museet site, with text in Swedish, I found the answer. *Tatlin* is no longer at home. The original copy of the photomontage has vanished without trace. In 1971, this unforgettable satire on the new mechanical man was stolen while being transported, four years after the museum acquired it, and it has never been recovered. Any reproduction seen anywhere today can only be a copy of a copy derived from photographs taken before that date. The color photography in the countless images online looks dated because it is dated; I have a book, *Dada and Surrealism* by Robert Short, with a similarly toned reproduction. The full-page image is a likely source for some of the homemade scans online.

In the end, I pinned an image I found on Flickr. It isn't large and the color is probably a little too bright, but it's sharper than most and, crucially, it shows as much of the stolen work as we are likely to get unless, by some miraculous stroke, *Tatlin* returns home one day none the worse for his travels, and can be photographed anew. Yet it's so effortless now to pluck digital images without really thinking about them. As with all the other images in our public galleries of plunder, we like to imagine that we have personally captured *Tatlin*, that we are on familiar everyday terms with him, that we own and know this uprooted and casually disseminated "pin." But I've never seen the missing original and it's unlikely, unless there's information you ought to share with the Swedish authorities, that you've had the chance to study the original in the flesh. I'll only add that for this early apparition of a cybernaut Hausmann used a photograph of a man he found in an American magazine, who happened to remind him of the Russian avant-garde architect famous for his visionary tower. It isn't even Tatlin in the picture.

Rick
Poynor

Why Tatlin Can Never
Go Home Again

New
Vernaculars

**Culture Is Not
Always Popular**

181

ORIGINALLY PUBLISHED
05.30.05

COMMENTS
12

William Drenttel
Maps of Cyberspace

When I saw the poster for the upcoming American Institute of Graphic Arts conference in Boston, I immediately thought, "Oh, another map of cyberspace." It has that pseudo-Internet-in-space look, after all. Designed by Corey McPherson Nash, this typographic cacophony allows selected tidbits of language to emerge from the ether: "listen," "experiment," "inspire," "change," "discuss," "create." As a poster for AIGA, it's promoting buzzwords with DESIGN as the organizing conceit.

But it's an image that suggests much more: fluidity of language, mutation and transformation, media saturation, random noise, virtual chaos, layered clutter. If you went further, layering even more words on top of words, the colors would ultimately dissolve into blackness. If every word were a sound, you'd just hear a hazy, constant din. Mostly, it's an allusion to chaos, to our perception that cyberspace is cluttered with bits, to an anxiety that there is so much "out there" that it's incomprehensible.

This is in stark contrast to the modernist fantasy of designer Muriel Cooper from her days at the Visual Language Workshop at the MIT Media Lab, where language was information that could be dynamically organized within a rational three-dimensional space. (An example of her influence is the Intel commercial by Imaginary Forces and Mark Zurolo.) This tradition is also evident in some of the more recent work of David Small and Lisa Strausfeld.

Of course, it is the Internet that has changed our perception of space, precisely because the sheer volume of interconnectivity is beyond our imagination, whether it be language-based, data-based, or community-based. Yet, if we cannot map it, how can we understand it?

Imagine mapping the endless and repetitive paths of your computer's mouse for a single week—every click, every fetch, every drag. It'd be a map of one activity over a set period of time—a mouse that traveled 5.47893 miles in one week. Every line signifies the gathering of some bit of information, a connection to a friend, the highlighting of a textual phrase to erase—plus the implied risk, after this distance traveled, of repetitive strain injury. This drawing happened at a desk somewhere, but the context being mapped is elsewhere. It's a map that captures a piece of the puzzle, but only a sliver.

Of course, there are more literal maps of the Internet. CAIDA, the Cooperative Association for Internet Data Analysis, pictures "a robust, scalable global Internet infrastructure," visualizing Internet topology at a macroscopic scale. When the Internet was in its infancy, monitoring traffic was relatively simple. However, after experiencing phenomenal growth in the 1990s, tracking connectivity has become a daunting task. CAIDA researchers attempted to strip away less-connected autonomous systems in order to explore Internet connectivity among ISPs. The May 2003 CAIDA map

nectady, Pittsfield, Pasadena, Salt Lake City, Washington DC, France, India, China, Mexico, the Caribbean, Japan, Europe, United States, Boston, New York, Miami, La Jolla, Sydney, Australia, Istanbul, Turkey, London, Tokyo, Japan, South Korea, Singapore, Italy, Palo Alto, Silicon Valley, Wisconsin, Canada, Thailand, the Philippines, La Guardia, O'Hare, Philadelphia, Hollywood, Florida, Germany, Britain, Hong Kong, Taiwan, Brisbane

Company and Brand Names: General Electric, Iomega, Handspring, Kyocera, Disney, IBM, Compaq, Starbucks, Larousse, Chanel, Apple, Target, Volkswagen, Nordstrom, Visa, American Express, Kmart, Wal-Mart, Armani, Kinko's, Logitech, Microsoft, Pizza Hut, California Pizza Kitchen, TGI Friday's, Black Eyed Pea, McDonald's, Ford, 7-Eleven, Dunkin' Donuts, Pottery Barn, Crate and Barrel, CNN, The Learning Channel, BBC, Discovery Channel, MTV, Eyestorm, Starwood Hotels & Resorts, Sheraton, Westin, Wolfgang Puck Cafes, Figs, Beverly Centre, StyleWorks, Gallup, Japan Airlines, Clairol, L'Oreal, Perry Ellis, Zip drive, Visor, Lexan, Cycolac, iMac, iVillage, Vamp, Beetle, Oxo, PayPal, PowerPoint, Formica, Muzak, Home and Garden Television, W, Weetabix, Herbal Essences True Intense Color, Féria

Periodical, Television, and Movie Titles: Seven, The Washington Post, Elle, Lucky, Clueless, Maison Française, Dwell, Business Week, Time, Sydney Sun-Herald, The New York Times Magazine, Vogue, Trading Spaces, Changing Rooms, Ground Force, House Invaders, While You Were Out, Surprise by Design, Crib Crashers, Lion King, White Teeth, The Adonis Complex, Looking Good, The Journal of the American Dental Association, Fashion Theory, Journal of Design History, Enterprise & Society

Institutional Names: Art Centre College of Design, Harvard, Bauhaus, Industrial Designers Society of America, San Francisco Museum of Modern Art, Guggenheim Museum, Domus Academy, American Institute of Graphic Arts, American Society of Interior Designers, American Association of Retired Persons, Fashion Institute of Technology

Did you catch all of that? What are the hyperlinks our minds conjure for all of these words? And what do the mind's equivalent visual maps look like? If design is to continue to be meaningful, as opposed to just good at randomly sparking nerve endings, perhaps our task is to reduce and discipline it, not stimulate more variety?

graphs "1,134,634 IP addresses and 2,434,073 IP links, probing approximately 865,000 destinations spread across 76,000 (62 percent of the total) globally routable network prefixes." Trackable over time, the CAIDA map treats the Internet as a worldview, much like astronomers have historically forced celestial events into worldly circular forms. (See Johann Elert Bode's 1802 *Projection on the Plane of the Ecliptic of the Parabolic Orbits of 72 Comets*.)

More recently there have been numerous online attempts at mapping content in real time. The *SmartMoney* Map of the Market is a quantitatively-generated representation of the market's sectors, along with individual stocks within each sector presented in Mondrian-like patterns. Marcos Weskamp's Newsmap shows stories in the news, derived from the Google News news aggregator, by presenting a tree-map visualization of "the underlying patterns in news reporting across cultures and within news segments in constant change around the globe." Buzztracker, created by Craig Mod and Chin Music Press, is a dynamic map of where news is occurring—software that "visualizes frequencies and relationships between locations in the Google world news directory."

The interconnectivity of the Internet is moving at a speed that defies our imagination. Blogs, a term unheard of even two years ago, are now ubiquitous. Technorati, as of today, tracks 10,552,890 weblogs and 1,164,251,940 links. A month ago this number was only in the nine millions. But this growth leads to efforts to summarize "the real-time web, organized by you," with subject tags turning into a typographic map of blog content. That almost half the tags are mapped in non-Roman alphabets says a lot about how international the Internet is. (That "music" is not a primary tag, but that "música" is, of course, says it all.)

Of course, Technorati did not invent the mapping of tags. Flickr came first, only months ago, and has changed everything, both by archiving the photography of the world (over sixteen million images to date), and by opening up a shared community through "tags." Cyberspace suddenly becomes one giant photo gallery, a make-your-own-archive of imagery. The Flickr map of "all time most popular tags" is not a history of photography: it is a map of this week's most popular subject matter as articulated by user-defined tags. In the same way, *del.icio.*

us is a universe of shared bookmarks, "a social bookmarks manager."

Of the 145 Flickr tags mapped in typographic scale, half are cities and places—Africa, Amsterdam, Austin; beach, bridge, building. Meanwhile, typographic scale suggests that the most popular tags are: art, beach, birthday, California, cameraphone, cat, family, flowers, friends, Japan, London, me, NYC, party, travel, vacation, and wedding. (Designers can take some solace in their ongoing obsession with street signs: graffiti, sign and streetart are three popular tags.) These maps not only summarize the ways millions of photographs are categorized; they also provide access to broad communities of topical interest and narrow cliques of shared experience.

The Flickr map is, of course, a macro view of the world. The micro perspective of Internet connectivity is harder to get at—and why the map of Enron email, and its reporting by the *New York Times*, is so remarkable. While privacy concerns typically keep researchers from analyzing deep patterns in email correspondence, the failure of Enron allowed the US Federal Regulatory Agency to make public 1.5 million internal corporate emails. Researchers at many institutions, including Carnegie Mellon and Johns Hopkins, are having a field day analyzing these notes from 150 accounts, including those of the company's top executives. It's a corporate Peyton Place made public for all to see and relish. What happens to the pattern of communications when one new email address is added to the universe? What happens when broadly distributed emails suddenly generate statistical anomalies in private messages? Can one track when certain people are suddenly left out of the loop? Can one tell where decisions are really made from email traffic patterns? Plus, there are social dynamics: increased traffic during the Texas football season; and increased traffic about fantasy football when Enron began to fade.

The mapping of cyberspace is the mapping of our time, just as much as mapping DNA sequences is the mapping of the human genome. We should hope that there would be hundreds of maps, statisticians and social scientists and designers working to explain—and to visualize this evolving new world. It's an exploration worthy of Ferdinand de Magellan's voyage around the world in 1519–1521.

William
Drenttel

Maps of
Cyberspace

New
Vernaculars

**Culture Is Not
Always Popular** 183

ORIGINALLY PUBLISHED
12.13.12

Rob Walker
Tracking War Drones

Anybody who is vaguely in touch with current events has some idea that weaponized drones have become a staple tool of twenty-first-century warcraft. But given that the details of drone programs are shrouded in secrecy, it's been difficult to make this turn of events comprehensible. Some recent online projects have attempted to do so.

James Bridle's Dronestagram has been greeted with a remarkable flurry of attention, particularly considering that so far it consists of just nine images. Probably this is because it's a compelling concept—and indeed most of the coverage has consisted of summarizing the concept. So here it is: Bridle tracks reports of drone strikes; does his best to determine where they occurred; grabs a satellite image of the area from Google Maps; and posts that image on Instagram and Tumblr, with a short summary of whatever information about the strike is available. The idea, Bridle writes, is "making these locations just a little bit more visible, a little closer. A little more real."

Since Google Maps offer a muddier and less appealing visual experience than most of what's on Dronestagram so far, I was curious if Bridle was using Instagram's famous filters on the images he posts. (Nothing I read addressed that question.) I asked, and he does, although not in any systematic way. "I usually pick whichever one enhances the selected image best," he explained via email, "gives it some contrast/depth."

At first this sounds fishy. How do the corny aesthetic gimmicks of the photo-sharing network (gimmicks that of course I use routinely to tart up my own distinctly unimpressive Instagram pictures) work in the service of making these locations "more real?" But upon reflection, I think the decision not only makes sense but is necessary: Part of what's interesting about Dronestagram is that it's interrupting a platform associated with prettified images of breakfast, pets, sunsets, old signs, babies, and parties to bring the latest news of drone-inflicted fatalities. So using the platform's visual vernacular makes the images stand out by almost blending in—just one more quotidian snapshot, except not at all.

Using filters also indirectly acknowledges the gap between these images and the real places they represent: Actual public information about precise drone-strike locations tends to be sketchy, and Bridle relies on the Bureau of Investigative Journalism and press accounts. So the images on Dronestagram aren't so much documents as signifiers. And this limitation is of course a reflection of one of the most troubling aspects of drone warfare: its determinedly murky nature.

As I was putting this post together, I happened upon a *Salon* story about another drone-tracking effort: Dronestream. Josh Begley (evidently as part of a Douglas Rushkoff class at NYU) has set out to tweet basic data about every reported US drone strike since 2002. His first twelve

New Vernaculars Tracking War Drones Rob Walker

dronestagram

121 posts **23.4k** followers **5** following

Dronestagram An artwork, 2012-2015, by James Bridle. Also on Tumblr and Twitter.
See website for details.
booktwo.org/notebook/dronestagram-drones-eye-view

Followed by **hansulrichobrist**

ABOVE Dronestagram was a three-year project, posting images of the landscapes of drone strikes to social media, on Instagram, Twitter, and Tumblr by James Bridle.

hours of tweeting brought him up through March 2010. If Bridle is trying to infiltrate your information flow, what Begley is really offering is the overwhelming litany as a form of polemic—a strategy that reminds me of "Break the Record," by Anne-James Chaton and Andy Moor, a music piece consisting largely of statistics regarding the scope and cost of security at the Olympics, and "All You Need Is a (Separation Barrier)," a short and highly effective radio piece by Niall Farrell in the form of an audio list of walls and structures built to supposedly solve problems around the planet.

Interestingly, Dronestream creator Begley has apparently also devised an app that alerts users to drone strike news, but has not been able to get Apple to approve it for inclusion in its App Store. The app is described as drawing

on information from the Bureau of Investigative Journalism, which has its own data-presentation solution: an "interactive map."

Somehow interactive maps seem almost retro at this point. But I started poking around, trying to cross-reference the material there with a particular Dronestagram image, and was somewhat taken aback when I realized how many strikes had occurred in the same vicinity. I also realized that while I think each of these distinct approaches to making drone warfare more comprehensible has merit, what's even more effective is considering them together. The more such projects can integrate with and reinforce each other, the better, I suspect, for all of them.

Alice Twemlow
Dodging, Dazzling, and Divulging

We live in an era of algorithmic monitoring in which our purchases, preferences, politics, and perversions are increasingly tagged, tracked, predicted, and sold. The ways in which new media technologies are used by the state and corporations to compile our personal data has emerged as the issue du jour of the global design community. Student assignments, thesis projects, conferences, workshops, and exhibitions are busy excavating the substantive implications of living in the post-Snowden age.

While many designers are complicit, even instrumental, in this mass monetization and regulation of our digital identities, others resist, and as a result draw attention to its insidiousness. Some of these instances of resistance are simply informational—meant to help people understand how and why our private and anonymous existence is being eroded, or to incite us to take measures to protect it, and to support the work of digital rights activists such as the Tor network, a global network of thousands of volunteer-run servers, relays, and services designed to help anonymize data. Another strategy is to provide tools and tactics to enable more active ways for us to dodge, expose, or fight back against the unwanted attentions of governments and corporations.

The US Federal Aviation Administration has recently predicted that by 2020, the skies above America could well be abuzz with up to seven million commercial, hobbyist and government drones, that's almost three times as many as we have now. Some of them will be equipped with high definition digital cameras, infrared cameras, and Gorgon Stare sensors. Facial recognition technologies are still in development and are dependent on the compilation of databases of peoples' faces, but they are already widely being used. High-definition video surveillance, one of the world's fastest growing industries, accumulates an astonishing 413 petabytes of data a day. In the UK, for example, the British Security Industry Authority has estimated that there are up to 5.9 million CCTV cameras, which equates to one for every eleven citizens, viewing us as many as three hundred times a day.

The projects featured here draw attention to the larger topic of surveillance in the physical and digital spaces we inhabit, and aim to enhance understanding of the issue. Most respond to specific technologies—drones, facial recognition software, CCTV, or text scanning software, for example—and provide ways to avoid, jam, or otherwise confuse them. In addition to the informational projects in circulation, are many others that can be considered, according to the primary response that they seek to encourage in their users. There are those that offer us measures through which to retreat and hide ourselves and our data; and those that urge us to confront our surveillants through activist techniques such as "sousveillance" or the pre-emptive exposure of our data, as a challenge to those in power.

Dodging and dazzling

Many of the designed responses to surveillance currently being generated are focused on enabling people to disguise their identities through time-tested camouflage and distraction techniques, such as the creation of extra informational "noise," updated to evade today's technologies. This camouflage can be visual, genetic, or digital.

Japanese designer Aya Tsukioka has developed a series of Rube Goldberg-like outfits that enable a very literal form of urban camouflage: a skirt that unfolds into a tent structure printed with the image of a street vending machine, a purse that looks like a manhole cover which you can leave on the street, and a child's backpack that allows the wearer to disguise themselves as a fire hydrant. Inspired by the ancient ninja, who cloaked themselves in black blankets at night, the items are intended to provide urban dwellers with momentary refuge from attackers or surveillants.

More recently the Brooklyn-based architecture practice, Snarkitecture issued a series of architectural camouflage garments, intended to create what they call, "moments of architectural confusion, where you become visually lost within different material surfaces." The initial line uses urban patterns from New York City such as subway station tiles and marble flooring, but since you can upload your own images to the website Print All Over Me, you can create your own urban camouflage customized to your own locale.

Similarly, German designers Sabina Keric and Yvonne Bayer made three-dimensional sculptures out of materials including bags of frozen peas or plastic soda bottles in which the wearer merges with retail displays in superstores, as a way to momentarily avoid what they call the "noise of commerce."

Numerous deployments of the principles of the Faraday Cage can also be seen, derived from the invention of an English Victorian scientist, in which a metal foil-coated room was proved to exclude electrostatic and electromagnetic influences. During a residency with Hughes Condon Marler Architects in 2014, the social artist Julien Thomas created a pop-up Faraday Café in Vancouver's Chinatown. The café contained a 2.5-by-4.9-meter box formed out of aluminum mesh, a conductive material, which cancels electromagnetic signals, and thus repels Wi-Fi and cell phone reception. In this cage, café customers could seek refuge from constant connectivity, as well as temporary protection from surveillance.

Seen is a font by Slovenian designer Emil Kozole that contains a preloaded set of sensitive "spook words" that the NSA and other agencies are searching for in our communications. The typeface can be used in any popular software such as Illustrator, InDesign, Word, or in a browser. It can be used normally to write text, but once one of these trigger words is written the font automatically strikes it through. This font highlights where you are potentially prone to being surveilled whilst also preventing you from potentially being tracked.

During his service in the Korean military, the designer Sang Mun worked for the NSA, learning first-hand how to extract information from defense targets. When he moved to the United States to study graphic design at the Rhode Island School of Design and found out that such techniques of nation state algorithmic monitoring were also applied to US citizens, he decided to devote his work to exposing, protesting, and preventing this digital surveillance. His zxx disruptive typeface, a free Open Type Font, is recognizable by people, but confuses the Optical Character Recognition text scanning software. The name zxx comes from the Library of Congress' Alpha-3 ISO 639-2—codes for the representation of names of languages. zxx is used to signify "No linguistic content; Not applicable."

Divulging

Numerous projects engage with the tactics associated with sousveillance, a term coined by Steve Mann, which refers to the use of small wearable or portable personal technologies to record the activity of a street protest, say, from the perspective of a participant. It inverts the hierarchy of observation, bringing the camera down from its all-seeing vantage point on buildings, to human level by mounting cameras or other means of observation onto people themselves.

A typical example is Korean design studio Shinseungback Kimyonghun's all-seeing jacket, appliqued with camera lenses that can record assailants and broadcast the images on the Internet. More dramatic is Julian Oliver's Transparency Grenade, a handheld device for leaking information from closed meetings.

Alice
Twemlow

Dodging, Dazzling,
and Divulging

New
Vernaculars

**Culture Is Not
Always Popular**

187

Equipped with a tiny computer, microphone and powerful wireless antenna, the Transparency Grenade captures network traffic and audio at the site and securely and anonymously streams it to a dedicated server where it is mined for information, which is then presented on an online, public map.

Dutch designer Ruben Pater believes that we need to arm ourselves with information rather than weapons in order to resist the pervasiveness of civilian drone surveillance. He has designed a field guide that assembles the silhouettes of drones to help us identify them in flight, and suggested countermeasures to help us hide from them. The field guide is printed on a large sheet of mirrored aluminum paper which can be used either as a shield to dodge the heat-sensitive drone sensors or to reflect the sunlight and to confuse their cameras. Much of the information in Pater's drone guide derives from an instruction manual for avoiding drone attacks found by the Associated Press in Timbuktu, and reportedly written by a senior commander of al-Qaeda in North Africa. In an effort to spread the information, Pater has

translated the guide into multiple languages and provides it as a downloadable PDF. Another way to fight back against digital surveillance is to pre-emptively expose and display your data, which—as Superflux founder Anab Jain explains—"can send a very strong message to those in power—that citizens are aware and keen to do something about it."

The NSA and other government security services secretly collect and scan our personal information and correspondence for trigger words; from the overtly malevolent: "anthrax," and "bomb" to the seemingly benign: "pork," and "storm." Benjamin Grosser's Scaremail is a web browser extension that aims to disrupt this surveillance by adding an algorithmically generated narrative containing a collection of probable NSA search terms to the signature of every new email. This "story" acts as a trap for NSA programs like PRISM and XKeyscore, overwhelming them with too many results and forcing them to look at nonsense. Each email's story is unique, in an attempt to avoid automated filtering by NSA search systems.

ORIGINALLY PUBLISHED
04.04.11

COMMENTS
10

Phil Patton
On the Shoulders of Rebels

It is one of the most successful designs on the planet, a rugged, adaptable device that has been in service for fifty years and outperforms far more expensive models.

It is the product of continuous refinement, simplification, and customer feedback. It rebuts the myth that military developers never turn out anything but expensive over-engineered design—or that communist countries never produced designs that worked.

Unfortunately, what it does is spread murder and mayhem.

The rocket-propelled grenade, or RPG, is used by armies and insurgents all over the world. Created in the Soviet Union, the RPG-7 has been employed in Yemen and Uganda, Chechnya and Vietnam. Most recently, it has shown up in the hands of Libyan rebels, its metal warhead silhouetted against the sky like a missile or minaret. According to a senior military official speaking to NPR correspondent Tom Gjelten, the weapons are coveted by Libyan rebels "because with those they could stop Gadhafi's tanks."

Ironically, after attempting to duck them for decades, the US has begun making its own RPG-7s—built by the firm AirTronic—and may distribute them to rebel movements. Despite its grim function, the RPG-7 stands as one of the supreme examples of design for global success, built on ideals of simplicity, functionalism, durability, and ease of use and maintenance.

"RPG-7s are in the militaries of over 40 countries," notes Col. Leslie Grau, a recognized expert on the weapon. "They are simple and cheap and everywhere. They don't take much training."

Such ease is a function of the RPG-7's rudimentary design, says Richard Jones, editor of the military journal *Jane's Infantry Weapons*. "There are no electronics to break, no mechanism to jam."

And yet this $10 weapon can destroy a $50 million helicopter or $5 million tank, making the RPG the mascot of asymmetrical warfare. The launcher weighs just sixteen pounds, but the warhead can penetrate four feet of reinforced concrete, six feet of bricks and two feet of metal.

A crude mix of wood and metal, with a blast end trumpet resembling a diabolical musical instrument, the RPG is terrifying: No one forgets the sight and sound of it—the whoosh, the blue-gray smoke and the slightly wobbly rotation of the projectile's flight. Fear lies on both sides: The RPG's shooter has to have the courage to get within two or three hundren meters of the target, according to Russian journalist Artyom Borovik in *The Hidden War*, his classic account of the Soviet war in Afghanistan.

Phil
Patton

On the Shoulders
of Rebels

New
Vernaculars

**Culture Is Not
Always Popular**

189

RPGs brought down the helicopter in *Black Hawk Down*. "Basically, the RPG singlehandedly lost the Russians their first Chechen War," writes Gary Brecher, author of a newspaper column on military strategy. Half of all U.S. deaths in the first months of the current Iraq War were caused by RPGs, according to a study by the Center for Army Lessons Learned. Osama Bin Laden posed with RPGs, and John Kerry is seen holding a captured Viet Cong RPG in his war snapshots. In 2000 the Real Irish Republican Army launched RPGs at the headquarters of MI6, the British Secret Intelligence Service. War rugs woven by refugees in Pakistan and Iran show RPGs in their patterns, along with helicopters and jets.

Today's models are descendants of the US bazooka and of Hitler's Panzerfaust, which was used in the last days of World War II. Beginning in the 1940s, the Russians improved the Panzerfaust by stages. The weapon took its present form in 1961. The initials composing its name translate to both English (Rocket-Propelled Grenade) and Russian (Raketniy Protivotankoviy Granatomet—literally, "rocket antitank grenade launcher"). The Soviet Union licensed the weapon for manufacture in factories in such hot spots as China, Libya, and Iran, and at the state arsenal of Iraq. By the end of the Cold War, the world was full of cheap

RPGs, and their utility was well established. The RPG-7 carries cultural and social overtones, like another sturdy Russian weapon: the AK-47, whose biography is the subject of C. J. Chivers's recent book, *The Gun*. It figures in photos and films as an icon of rebellion. Just as one man's insurgent is another's freedom fighter, the RPG can be seen as either the sling of David against totalitarian Goliaths or the terrorist's Saturday night special. The RPG threatened the Stryker vehicles that were the centerpiece of former Defense Secretary Donald Rumsfeld's new military strategy. "The RPG-7 will be around for a good while yet," says Col. Grau. "It is a proven, cheap killer of technology which will continue to play a significant role—particularly when conventional forces are pitted against irregular forces."

The Pentagon seems to agree in ordering up a somewhat easier-to-use version for its arsenal that is made in the USA.

What if someone invented a device that did good as efficiently as the RPG does harm? Imagine a benign twin of the RPG that gave life and healed wounds? That would be a design worth celebrating.

BELOW Russian RPG-7 rocket launcher

ORIGINALLY PUBLISHED
05.02.14

Véronique Vienne
Tell, Don't Show: Algorithmic Thinking for Beginners

Frieder Nake is a pioneer of generative design. Fifty years ago he was tinkering with electronic devices to produce digital patterns in rapid sequencing. He had studied mathematics at the University of Stuttgart and was investigating the computable aspects of aesthetics and their relationship to semiotics. Today, Friday April 18, 2014, half a century later, Nake, now 75, a spry figure in sneakers, is standing in a classroom in the small town of Amiens, France. The local design school, ESAD, has invited him to give a workshop on algorithmic thinking. I have no programming experience but I have managed to get my name on the list. The director of the school, Barbara Dennys, is my next-door neighbor.

I don't want to die stupid.

"We never understand anything, which is great," says Nake, as an introduction to his class. However, for this German computer scientist, the fact that we never understand anything is not an excuse for being intellectually slothful. He quotes Wittgenstein. "What we cannot talk about, we must consign to silence, but what can be said must be said clearly."

Algorithmic thinking: the ability to state precisely what you only know intuitively.

The entire class is conducted in English even though no one in the room (myself included) is a native English speaker. But today English is to Europe what Latin was to the Mediterranean basin in the Middle Ages—a *lingua franca*. In the majority of the cases, though, fluency is limited to reading and listening. In France, at the end of a conference delivered in English, no questions are ever asked. The auditorium will most likely be packed, but the silence following the presentation is deafening. Any questions? The only noise in the room is the suddenly audible tinnitus in your ears.

Like strings of codes, English words do not conjure images in the minds of French listeners. Making sense of what is being said doesn't involve visualization, yet far from being a handicap, this is an asset. In fact, English gives my compatriots access to a part of their brain that's practically picture-free. The graphics window is not activated, so to speak. Frieder Nake will take advantage of this loophole: he will demonstrate how, in algorithmic thinking, the visible world is not the ultimate reference, but merely the by-product of a step-by-step construction generated in the brain.

In other words, we are here to learn to turn codes into images—not the other way round.

I sit on a high stool, my laptop at the ready. The trick is to hold back expectations, to curb the desire to visualize what's about to come. "We are semiotics animals," says Nake. "We have many contexts, whereas machines have only one context." He wants us to "think the way our

Véronique
Vienne

Tell, Don't Show:
Algorithmic Thinking for
Beginners

New
Vernaculars

**Culture Is Not
Always Popular**

191

computers would think if they could think." All around me people wear blank expressions on their faces. I envy them.

The majority of the French students, I soon discover, have yet another advantage over me: their stream of consciousness is not crowded with contextual references. They've never heard of John Maeda, or April Greiman, or Ludwig Josef Johann Wittgenstein, for that matter. They are not elated, as I am, when Nake mentions some familiar names. They keep their eyes on the prize—the programming—while I cling to each cultural reference, hoping against hope that this master class will be about philosophical ideas rather than about the systematic computation of innumerable infinites.

I left my comfort zone when I walked into the classroom. As a writer, I thrive on ambiguity. I have learned to "show, don't tell"—to let readers interpret significant details within the text. But unlike readers, machines have no imagination. You have to tell them exactly what to do. Computers never interpret code on their own—in fact, Nake assures us, machines would prefer to idle in the sleep mode rather than carry out instructions. To nudge their lazy pixels into action, we have to whet their appetite with tantalizing algorithms.

For this workshop, Nake has decided to use the programming language of the software Processing to teach our laptops to draw like Piet Mondrian. It's ironic, since Mondrian's famous non-representational style is the result of a long pictorial journey from figuration to abstraction—trees to grids—whereas in this case, we are going to try to understand his art backward, from abstraction to figuration.

To prepare for the class, Nake has worked from 5 p.m. the day before until 3 a.m. the next morning. His brain is still on fire. He hasn't slept much. Mondrian has proven to be more of a challenge than he had expected. On his digital canvas, the well-tempered matrices of the Dutch master are still defying Nake's algorithmic sequences.

Algorithmic thinking is the closest thing to pure reasoning. The various patterns generated by the Processing software only serve to test whether or not the proposed parameters are correct. Under Nake's supervision, we spend hours figuring out possible equations before "running" the visual interface. When we do, it's only to track our mistakes: diagonal strokes that show up uninvited, vertical bars that have a tendency to bunch up in the margins, or horizontal ones that stubbornly ignore instructions to stay apart.

Is the world of forms simply a verification procedure devised by some mathematical entity to make sure that his (or her) assumptions are correct? Nake seems to think so.

As the day progresses, the computational challenges are piling up. Nake would love to keep on working, but we have to stop for lunch. (We are, after all, in France.) By midafternoon, we are still bogged down in procedural programming, a quagmire of trial-and-errors. It's pretty obvious that we will never get to object-oriented programming—the quantum leap into specifying the step which the program must take to control the behavior of forms. Impatient, a student sitting next to me has already programmed colors to randomly fill some of the rectangular fields, even though Nake is still exploring the finer points of Mondrian's crisscrossed compositions.

We are in an art school, in the graphic design department, where visual literacy is the dominant culture. I glance around the classroom, wondering if the next generation of designers will be willing to postpone the instant gratification provided by the brilliant LCD images on their screens in favor of the more elusive cerebral emotions of algorithmic thinking?

Meanwhile, the German mathematician is giving us a lesson in intellectual endurance. Far from being embarrassing, the difficulties he encounters are a source of amusement for him. In fact, his entire being seems to be made of glowing liquid crystals, so intense is his concentration. "Geometry is like Heaven," he declares. "Graphics is like Hell." With the sleeve of his black linen shirt, he erases the previous layer of equations from the whiteboard. He turns to look at us. He is beaming. Wistfully, as if writing a programming statement between two semicolons, he says: "As soon as the real world enters, everything becomes special—and nothing works anymore."

ORIGINALLY PUBLISHED

11.30.15

COMMENTS

7

Rachel Berger
Designing in the Now

Part 1

It is difficult to have any perspective on our own historical moment. That would require looking into the distant future and predicting what will have mattered. The upside is that if we're all still around in fifty years and any of what I have to say here turns out to be right, I can feel very smug about it. And if I'm wrong, no one will remember anyway.

Of course, pundits are racing to lay claim to this era: it's meta-modernism, hyper-modernism, the digital age, the information age. It's the metrosexual, mass indie, new Victorian, normcore, hipster, yipster, post-ironic, boomerang, millennial, generation Y. To be safe, let's just call it: the NOW.

In the NOW—as in prior eras—the oscillation between simplicity and complexity has been a major theme in graphic design. Design historians follow the pendulum's swing from the highly decorative style of art nouveau, to the rise of modernism and its criminalization of ornament, to the postmodernist backlash, with design fracturing into countless subcultures and the disorder of early digital experimentation.

Apple has taken us all on its own ride between these extremes. In the 1980s, its visual language was driven by the radical simplicity of Susan Kare's low resolution screen graphics for the original Macintosh computer. Twenty years later, company leaders like Steve Jobs

and Scott Forstall championed the adoption of a highly ornamented aesthetic known as skeuomorphism. Skeuomorphic design models the look of digital products after their real world counterparts, even if there is no direct relationship to functionality. And the growth of the iOS mobile operating system brought skeuomorphism to billions of screens. More recently, under Jony Ive's creative direction, Apple has adopted a resolutely modernist, flat design aesthetic.

Contemporary designers are the inheritors of these competing legacies. And when I think about complexity and simplicity in the visual culture of the NOW, the NOW appears to be suffering from bipolar disorder. As far as the digital product space goes, we are drowning in a sea of sameness. A quick survey of tech start-up homepages reveals an absurdly narrow and reductive visual language. Site after site employs a pithy slogan in white san serif type, centered top to bottom and left to right, overlaying a responsive, edge-to-edge photograph that includes at least part of a white person. Even Google has finally succumbed to the gravitational pull of the anodyne sans.

Airbnb was a pioneer of this visual style. In the summer of 2012, the company's homepage started featuring a large white headline over a pretty, full bleed photo. But the company's 2014 identity redesign—and the subsequent attention it garnered—secured Airbnb's place on the shortlist of start-ups that are genu-

Rachel
Berger

Designing in
the Now

New
Vernaculars

**Culture Is Not
Always Popular**

193

inely invested in visual design. Airbnb hired London-based creative agency DesignStudio to lead the redesign, which took over a year to realize. Members of the DesignStudio team embedded themselves at Airbnb's company headquarters and stayed in Airbnbs on four continents. They also had plenty of access to Airbnb founders Brian Chesky and Joe Gebbia, who are RISD grads and designers in their own right.

When the new identity was finally unveiled, the press focused almost exclusively on the new logo: an abstract icon Airbnb called "Bélo." Compared to the coverage of the Bélo (It looks like someone else's logo! It looks like genitalia!), there was scant mention of the site redesign, except to tout its functionality and consistency across devices. At the time, the attention paid to the Bélo made sense—the mark represented Airbnb's aspiration to become a true global brand with a universally recognizable symbol. Meanwhile, the website redesign was solid, and a logical evolution from the previous design, but it wasn't revolutionary. Unfortunately, Airbnb's reputation as a design-led company that mints money and the bland, all-pleasing nature of its web design has made the site a tempting object of replication.

Book cover designer Peter Mendelsund recently took to Twitter to complain about copy cat art direction:

Whenever I hear that someone in my field has been asked (told) to design a book jacket that looks like some other, pre-existing jacket ... told to ape a previously successful title, or a 'genre look' (and this is increasingly how we are directed), I think to myself ... there's a word which describes when a thing is designed to look like those things which surround it, and that word is 'camouflage.'

While camouflage means blending in, it can also mean fitting in. When product managers in companies that lack a strong creative vision of their own direct their designers to "do that thing that Airbnb did," they probably view it as a fast and easy way to signal to the public that their product is in the same class as Airbnb. Sites like these aren't clones of each other because this is the best or only way to design a user interface. It is a good enough way. It is also a fearful way. It sells both the product and the user short.

If we assume a product is unique, why should it be delivered in the same way as every other product? If we assume a user is a human, wouldn't she appreciate variety, specificity, and design choices that support the unique experience she is about to have with the product? The simplistic, unconsidered visual language of so many digital products and the time we spend engaging with it in the NOW has made us ravenous for ink, paint, ornament, humanity, beauty, and evidence of the hand (and not one that's a prop for a device).

Part 2

While the Bay Area is the epicenter of mainstream digital design's mindless minimalism, it is also at the heart of a decorative zeitgeist. Hipster coffee and barber shops that cater to tech workers and the creative class have embraced a steampunk aesthetic of leather aprons, elaborate mustaches, and gleaming espresso makers that resemble monotype machines. In print design, the NOW's decorative zeitgeist is inspired by a pre-digital—even pre-modern—age of letterpress, screen printing, hand lettering, sign painting, and mural making. The period influence is so strong that it can be hard to tell the difference between true vintage lettering and examples of it from the NOW.

The decorative zeitgeist is also deeply connected to the digital zeitgeist.

Many leading tech start-ups are infatuated with hand craftsmanship and "low technology." A couple years ago, Twitter relocated two nineteenth-century cabins from rural Montana to its San Francisco headquarters. Facebook's Analog Research Lab, where designers and artists create printed ephemera using predigital means, is an oft-cited example of a tech company's regard for vintage tools. At its best, the lab feeds the creative culture of the company. However, it sometimes feels like a well funded vanity project—unrelated to the core business, a relatively inexpensive way to keep designers happy, a petting zoo for retrograde technologies (and technologists).

Tech companies guilty of following the herd on digital design hire lettering artists to decorate their workspaces—and feed their souls. Erik Marinovich recently partnered with New Bohemia Signs to create a mural at the headquarters of Tripit, the travel organizing app.

In the NOW, young lettering artists like Jessica Hische and Marinovich are rock stars in the creative community, with tens of thousands of followers on Twitter and Instagram, international speaking gigs, and seemingly endless commissions from the business, culture, and publishing sectors. At California College of the Arts, where I chair the graphic design program, students adore Hische and Marinovich and are more eager to learn hand lettering and calligraphy than coding and scripting. Who can blame them? They are already sick of their computers, and they aren't even in professional practice yet.

San Francisco-based architect Olle Lundberg has worked with many tech companies, including Twitter. In a 2014 *New Yorker* article, Lundberg commented on the tech world's hunger for the real:

"'We have lost the visual connection to the maker in our lives, and our tech clients are the ones who feel most impoverished by it, because they're surrounded by the digital world,' he says. 'They're looking for a way to reestablish their individual identity, and we've found that introducing real crafts is one way to do that.'"

In the Bay Area of the NOW, we are all part of the tech world. And so we all hunger for the real.

Pinterest, a digital tool that enables users to save, sort, and browse images, is the megaphone of the decorative zeitgeist. Pinterest users pin and re-pin endless images of elaborate dropcaps and ampersands, hand-inked inspirational quotes, and letterpress-printed wedding invitations. Often, markers, sketchpads, and other analogue tools are artfully arranged in the frame, providing irrefutable evidence of the making process. On Pinterest, the "hand lettering" category has more than six million followers. Meanwhile, poor "cooking" has fewer than one hundred thousand. In September, the mostly virtual connection between the digital and decorative zeitgeists spilled back into the real world: Pinterest hosted Jessica Hische's book launch party.

Unfortunately, the decorative zeitgeist is not the path to redemption from minimalist digital monotony. After a while, ornamentalism becomes its own sea of sameness. The hundreds (if not thousands) of young designers who are

jumping into the hand-lettering game are too reliant on a particular maximalist aesthetic, with elaborate swashes, display capitals, conjoined letterforms, and decorative flourishes, and even the increasingly rigid rituals of documenting and sharing the work (*tools-en-scène*, Instagram Valencia filter).

For a designer of the NOW, it can be hard to know how to make great work without falling victim to all these minimalist or maximalist clichés.

Part 3
Young designer, are you looking to stand out without getting tossed out? Are you feeling discouraged by the brainlessly simple digital design and brainlessly complex analog design that's getting so much play these days?

Don't panic! There is a great place to find innovative and inspiring visual communication today: digital game design.

Truly great games are a world unto themselves, with their own rules, their own norms, and their own visual language. They break out from the crowd by being different, but to be playable, they must be coherent. In great games, the degree of visual simplicity or complexity is deliberate, informed by and informing the play experience. Here are two recent cases.

The puzzle game Threes! is a great example of so-called simple design. In Threes!, the user slides numbered tiles on a grid to combine multiples of three. That's it. *Wired* called it "so utterly simple and exquisitely satisfying it seems like the type of thing that doesn't get invented so much as discovered." If only that were true. The Threes! design process was long and difficult.

Development began in late 2012, when Asher Vollmer, a game developer, sent Greg Wohlwend, a graphic designer, a sketch for a sliding numbers game. A day later, Greg sent back some mock-ups. A game that was prototyped in a night would take more than a year to perfect.

As they worked on the game, Vollmer and Wohlwend made dozens of prototypes. At points in its development, Threes! included holes, monsters, flags, extra walls, planets, atoms, arrows, sushi, and argyle patterns. But basic gameplay kept getting buried under

tricksy features and whimsical design touches. The designers were continuously building the game up, stripping it down, building it up, and stripping it down again.

After months of development, the idea for having tiles merge to make new numbers surfaced. Wohlwend worried that it was too simplistic, but Vollmer argued on behalf of simplicity, telling *Wired*: "I actually like that it's so clean and pure. It's incredibly gratifying to have a system with such simple rules that you can play over and over again and constantly get better at." So far, Vollmer's been proven right. Threes! is very easy to play and very difficult to beat, giving it the elusive quality he calls "foreverplay."

If Threes! is the minimalist version of foreverplay, the yet-to-be-released but feverishly anticipated game *No Man's Sky* is the maximalist version.

No Man's Sky is being developed by Hello Games, a tiny studio in the UK led by a programmer named Sean Murray. The game is an homage to the pulp science fiction novels that Murray loved as a child, and to the vivid cover art that often accompanied the stories.

No Man's Sky will let virtual travelers explore eighteen quintillion planets in an infinite, procedurally generated galaxy. Every player will begin on a randomly chosen planet at the outer perimeter of that galaxy. The goal is to explore, survive, and head toward the center. "Procedurally generated" means that the game has an algorithmic structure. Just fourteen lines of code make the rules that determine the age and placement of stars, the presence of asteroid belts and moons and planets, the physics of gravity, the arc of orbits, the composition of atmospheres, and the appearance of life on a small fraction of those planets.

A recent *New Yorker* article about the game described a game artists' process for developing visual archetypes that the coders' algorithms would mutate. She spent a day making insects: looking up images online, designing features for an insect archetype, studying how the algorithms deformed the archetype in hundreds of permutations, then making corrections.

In the NOW, designers can draw inspiration from so much amazing work, both simple and complex, and choose which stylistic levers to pull for maximum impact. In the NOW, designers have to resist the overwhelming pressure to follow the crowd to a safe, unoriginal spot that Squarespace has already made a supremely adequate template for.

Allison Arieff
WeCommune

First, there was the deluge of Woodstock nostalgia over the past few months. Then, three separate emails mentioning Ernest Callenbach's 1975 green counterculture classic, *Ecotopia*. And a sign on the bulletin board at my local grocer reading, "Will paint your house in exchange for a vehicle that runs." All signs pointing to...the return of the commune.

But not of the sort you're thinking of. "Hippies didn't invent communes, and I'm not going to let them co-opt a great idea," says Stephanie Smith, founder and CEO of WeCommune. "Things went wrong and now I want to single-handedly rebrand that great idea."

Smith's enthusiasm lay not in the sexualized, pot-smoking haze of the intentional communities of the '60s but in the social and economic benefits of what she refers to as "communing" can offer. While technically a commune is defined simply as a community that shares resources, for Smith, a Harvard-trained entrepreneur and designer (she founded the Ecoshack Design Studio and Lab in Joshua Tree, California, in 2003), it "seems like the answer to everything."

WeCommune's evolution is rooted in Smith's artistic and architectural experimentation. She began marketing a green shelter known as the Nomad Yurt. In a design competition entry, she imagined the transformation from "cubicle to commune" and accordingly morphed a Steelcase cubicle into "a growing-corn-on-the-roof kinda thing." A provocative T-shirt she designed, emblazoned with the slogan, "Wanna Start a Commune?" attracted enough attention that Levi's asked to sell it in their stores. She is well aware that "commune" is a loaded term, and that's the point. "It's a visionary idea. Crazy but smart because it can offer an alternative to cash and credit economies that clearly aren't working. It's a third economic infrastructure."

This year, Smith developed a technology platform that launched in beta form just a few weeks ago. It's designed to give users a fast, flexible, and entertaining way to share resources and build community with the people in their world. That world can be a neighborhood, an apartment building, a cul-de-sac, or even a rock band. The point is that a group gets together for a common purpose that is rewarding both financially and emotionally. "You don't share resources with people you're not in close community with," says Smith. "You can't have one without the other."

In describing her vision, Smith cites not just Callenbach but also Bucky Fuller, Colorado's semi-anarchistic Drop City, Peter Coyote and the Diggers, and the '70s economic treatise *Small Is Beautiful* as influences. Rattling off commune stats that chart the failure of the storied sixties attempts (there were over fifty thousand communes in 1967–1969, but less than one hundred remained by 1972), she

Allison
Arieff

WeCommune

New
Vernaculars

**Culture Is Not
Always Popular**

197

explains now that technology is the differentiator. That, and clear economic benefits. As she tells potential funders, "If we do this right, everyone will save $500 to $1,000 a month."

Smith received seed funding for the launch of the platform and sees future earnings through an affiliate model of the sort seen at personal finance site mint.com. Costco, she reasons, already has a group buying club, so why not make it easier for WeCommune members (there are already three hundred active communes registered on the site) to join? The site will also help facilitate leverage buying of things like solar panels and urban agriculture services. "You can be in a commune where you are now," says Smith. "You can share and come together. It doesn't have to be a radical act. This is not Facebook by any means, but it is meant to wake people up and bring them together."

ORIGINALLY PUBLISHED
08.12.09

COMMENTS
46

Michael Erard
A Short Manifesto on the Future of Attention

In 1971, the oft-quoted political scientist Herbert Simon predicted that in an information age, cultural producers (that's designers, but also filmmakers, theater types, musicians, artists) would quickly face a shortage of attention. "What information consumes is rather obvious: it consumes the attention of its recipients," he wrote. The more information, the less attention, and "the need to allocate that attention efficiently among the overabundance of information sources that might consume it."

Now we have a wide-ranging discussion about what is and what can't be free (Malcolm Gladwell on Chris Anderson, Virginia Postrel on Chris Anderson), which is basically about *the future of profit*. Maybe we should be considering a dilemma of a human nature: the *future of attention*.

Because there's a connection between the two.

Making something "free" is obviously an allocation strategy. "Free" attracts attention. Making things brief is an allocation strategy as well. The problem is that free isn't sustainable, and that brief is underpriced.

We need a Ronald Reagan of attention, someone to inspire us away from the fight over smaller and smaller pieces of the attention pie. Someone who will inspire us to make the attention pie bigger.

I imagine attention festivals: week-long multimedia, cross-industry carnivals of readings, installations, and performances, where you go from a tent with thirty-second films, guitar solos, ten-minute video games, and haiku to the tent with only Andy Warhol movies, to myriad venues with other media forms and activities requiring other attention lengths. In the Nano Tent, you can hear ringtones and read tweets. A festival organized not by the forms of the commodities themselves but of the experience of interacting with them. Not organized by time elapsed, but by cognitive investment: a pop song, which goes by quickly, can resonate for days; a poem, which can go by more quickly, sticks through a season. A festival in which you can see images of your brain on knitting and on Twitter.

I imagine a retail sector for cultural products that's organized around the attention span: not around "books" or "music" but around short stories and pop songs in one aisle, poems and arias in the other. In the long store: five-thousand-piece jigsaw puzzles, big novels, beer brewing equipment, DVDs of *The Wire*. Clerks could suggest and build attentional menus. We would develop attentional connoisseurship: the right pairings of the short and long. We would understand, and promote, attentional health.

I imagine attention-based pricing, in which prices of information commodities are inversely adjusted to the cognitive investment of

Michael
Erard

A Short Manifesto
on the Future of Attention

New
Vernaculars

**Culture Is Not
Always Popular**

199

consuming them. All the candy for the human brain—haiku, ringtones, bumper stickers—would be priced like the luxuries that they are. Things requiring longer attention spans would be cheaper—they might even be free, and the higher fixed costs of producing them would be covered by the higher sales of the short attention span products. Single TV episodes would be more expensive to purchase than whole seasons, in the same way that a six-pack of Oreos at the gas station is more expensive, per cookie, than a whole tray at the grocery store.

I imagine an attention tax that aspiring cultural producers must pay. A barrier to entry. If you want people to read your book, then you have to read books; if you want people to buy your book, then you buy books. Give your attention to the industry of your choice. Like indie musicians have done for decades, conceive of the scene as an attention economy, in which those who pay in (e.g., I go to your shows) get to take out (e.g., you come to my shows). It would also mitigate one oft-claimed peril of the rise of the amateur, which is that they don't know quantity from quality: consuming many other examples from a variety of sources, even amateur producers would generate a sense of what's good and what's bad: in other words, in their community they'd evolve a set of standards. This might frustrate the elitists, who want to impose their standards. But standards would, given enough time, emerge. (In this I have faith.)

I imagine software, a smartphone app, perhaps, you can use to audit your attentional expenditures. So that before you embark on trying to write a book, you will be able to see how much time you spent reading books over the last month or year. So that before you design a marketing campaign that assumes that people aren't doing much else with their time until you show up, you will be able to see what you yourself were doing with your time, which was something perfectly good. This will show you that you're a savvy allocator of your attentional resources—and so is everybody else.

And yet I can't shake fantasizing about attention that has no price, that can't be bought or sold, but is given freely: a gift. I buy and read books because I want to give the gift of my attention to the attention economy I'm (as a writer) a part of. I'm inspired by Lewis Hyde in *The Gift*, who says that what distinguishes commodities is that they're used up, but what distinguishes gifts is that they circulate—the gift is never trapped, consumed, used up, contained, or confined. That seems like the best basis for cultural production to thrive.

So this is what it's come to: when an attention gift economy seems more practical and sustainable than an exchange economy for information commodities, which is being rotted by the gift's ugly negation: the free.

Nielsen have been butchering something as simple as measuring how much attention people pay to TV, consistently equating engaging in an activity with attending to it. Which is preposterous proposition. So, how do we measure the real stuff, this cognitive gold, and cash it in?

One thing's for sure, it won't be just the journalists or just the cognitive scientists or just the technologists who figure it out – it will be the cross-pollination of ideas, which should be the foundation of whatever business model for attention we end up with.

New
Vernaculars

A Short Manifesto
on the Future of Attention

Michael
Erard

ORIGINALLY PUBLISHED
03.16.09

COMMENTS
53

Kenneth FitzGerald
I Believe in Design

In each of the communities I've lived, I've encountered one of these trucks. It's always a white van, hand-inscribed by paint or perma- nent marker with a variety of biblical verses and religious admonitions. From this base model, the individual owners accessorize. The van I knew in Massachusetts had a set of small crosses rising from the roof (the owner was a carpenter by trade). Here in Virginia, some of the texts are lettered on florescent colored paper.

Of course, the intention of the owners is for me to take notice, and I do. However, the next step should be for me to contemplate religious faith. And once again, I do—but in a context of de- sign. For me, these vehicles are one manifes- tation of an ongoing concern—the relationship of graphic design and faith.

It's because of my devotion to graphic design that I've always enjoyed encountering these vehicles. They've also been a constant of sorts as I've bounced around the country. Each is a refreshing, individualized visual delight roam- ing the streets. Just a bit of typographic whimsy amongst a flat-hued and airbrush-detailed monotony of cars. They're folk art on wheels!

Actually reading the texts can sometimes put a bit of a damper on the gratification. Damnation declarations can weigh on the mind, no matter the state of one's conscience or current karmic burden. As genre artifacts, these vans are

rather muted. None display the special eccentricity or wild invention of a Howard Finster. However, such appraisal seems silly under the circumstances—even though there exists a considerable financial market that makes such distinctions.

But this isn't another claim that designers should appreciate naive graphic design. For those who'd regard these vans—or any application of such "design"—as an eyesore, I'm not here to argue otherwise. Unless you're stuck behind or beside one in a traffic jam, you can let it roll out of sight and mind.

In the classroom, the expression of religious belief in design is something I've always encountered. As a teacher, I'm regularly presented student work with explicit religious content. In addition, many students cite their faith as inspiration and motivation for their designing.

I know that my evangelical students are repre- sentative of a significant demographic in the professional graphic design community. The statistics on belief in the population overall tells us it's not a minority position. However, I can't recall ever running across anything but a furtive mention of faith within some other design discussion. Admittedly, I'm no longer the most diligent reader of the design press. Perhaps the discussions are happening out of my sight, as I'm worldly-minded.

Just as there seems a more vocal left-leaning population of designers, is it that the secularists hold sway here too? Is there an underground of "devout" designers? Or are there no discussions because there's really nothing much to say? Does calling it out do the subject—and the affected designers—a disservice?

The same might be said of investigating the influence of sexual orientation upon and within design. Certainly bringing plain ol' sex into the debate (i.e., is there a feminine design?) will reliably roil the design community. If there isn't a distinctive formality to faith-based design, what's to talk about?

Historically, graphic design has found plenty of room for the ineffable in its theories. Not to demean either religious belief or modernist principles but many of the historic (and contemporary) rationales for graphic design activity have been based more in faith than

evidence. Gestalt principles are still unencumbered by objective verification, to name just one. Graphic design's traditional emphasis on rationality and neutrality immediately seems to portend a conflict with a sensibility that highlights transcendence. Of course, rationalism has resided in cooperation with faith for centuries, despite events in the recent past.

I count it as no surprise that my experience critiquing religious content in student work has gone without contention or awkwardness. Students do question my ability to evaluate their work at times but never due to my personal spirituality or lack thereof (that I simply possess a contrary taste is far and away the leading complaint). If anything, I've been regarded as a fellow congregant as I've addressed the content with the same verve I do all material.

With eight years of nun-directed Catholic grammar school in my past, I'm quite conversant with the themes of Christianity, so I have a

BELOW The Chesapeake Van, March 2009, photo by Kenneth FitzGerald.

leg up there. However, I'm just as ready to take on—and welcome for my own education—design work based in other faiths. If I've articulated a common critique it's that a student's work isn't passionate enough. That appraisal pretty much goes across the board for student (and professional) work. Most graphic design suffers from an impersonality and detachment that resists audience interaction. For religious work, such an approach is distressingly mortal (bring back the Latin Mass!).

Overall, I'm not expecting any special insight about graphic design and faith. In practical terms as a teacher, I seem to have it covered.

But I wonder sometimes about the absence of public discussion about the topic, no more or less than any other intangible but heartfelt influence upon creativity. And never mind about touching someone's heart with graphic design—what about their soul? Is anyone making the attempt?

Meanwhile, when my local Bible van pulled in a few houses down, I walked over and asked if I might document it. As I photographed its hood, I suggested to the owner he write his message backwards so as to read right in rear view mirrors. At first, he was mystified by my advice, until I referred to ambulances. He allowed that was a good idea. And so design is revealed.

Kenneth
FitzGerald

I Believe
in Design

New
Vernaculars

**Culture Is Not
Always Popular** 203

ORIGINALLY PUBLISHED
09.03.14

COMMENTS
4

Jessica Helfand
Deathiquette: A Design Problem

What does it mean to mourn in the modern world? I raised this very topic when I was invited to speak to the designers at Facebook several months ago. And I have not been able to forget it.

When a death is announced on Facebook, the only way to express sympathy is with a "Like" button. The visual and emotional limitations of this practice are staggering, not only because our technological sophistication sits so far from our human (yes, communicative) capacity to express complex emotions, but because we lack the visual vocabulary for doing so. Even, and perhaps especially, online.

And what does the thumbs-up emoticon actually mean, here? *I like that you shared this? I feel your pain?*

True, the custom of sending black-bordered condolence notes through the post may seem ridiculous to the time-pressed denizens of social media communities. Yet as antediluvian as it may seem, this classic social ritual succeeded because it was governed by a simple, and rather brilliant, design conceit. Instantly readable—a simple black border connoting death—it immediately telegraphed the purpose and poignancy of the information it contained: someone has died, and now you know it. You might, upon receiving this news, experience any of the following feelings:

sympathy, empathy, sadness, grief. You "liked" none of them.

These are sentiments that benefit from a patient heart, begging the question: can grief be processed, compacted, made into an icon? Put another way: how is it that we have progressed this far without a common visual vocabulary capable of expressing sadness?

Perhaps this shows us the limitations of icons. (Designers: take note.)

There's something morally absurd about this topic, particularly when you consider that a quick online search for mourning stationery turns up some quick results on Etsy, where it's being marketed as fodder for Halloween party invitations. Am I being sentimental? Perhaps. But none of us are exempt. Death, eventually, awaits us all.

Go ahead, if you wish, and "like" this post. But next time you learn of the finality of someone else's life, think, for just a moment, before you minimize the enormity of that passage by clicking on a link—let alone one with a thumb in the air. Make no mistake: death is a part of life and condolence is not only a necessary act, it is a social one. It does indeed take a village, and I, for one, am grateful for mine. (I speak from personal experience here.) There simply must be a better way to visualize it on screen.

Timeline
Fifteen Years: 2003–2018

Back in 2003, writing on design tended to fall into one of three categories. There was writing for the trade—profiles of famous designers, tales of studio visits, shop talk for industry insiders—all of which were seldom seen by the general public. There was academic writing—analytical, dense, and frequently theoretical—often swathed in prose so impenetrable it succeeded, if nothing else, in repelling the casual reader. Finally, there were examples of design writing in the popular press—architecture critics reviewing new buildings, for example, or business-oriented reviews for new products—which delivered perfunctory, if not terribly provocative commentary on design's occasional appearance in our lives.

Design Observer was launched on October 24 of that year to ask a relatively simple question: could design be discussed in a thoughtful yet informal way, for designers and non-designers alike, treated as a part of everyday life that it surely was?

The fifteen years that followed revealed a changing cultural, political, and interpersonal landscape: conflicts on every continent, three fateful U.S. presidencies, technologies that changed lives (or disappeared without a trace), a global economy that went from boom to bust and back again. Designers reacted to that world (and sometimes shaped it) and the changing conversation about how, why, where, and for whom design mattered was, to the extent of our ability, recorded here. For over a decade and a half, *Design Observer*'s writers and readers have approached design as the moving target that it is, in an effort to try to capture that most elusive of subjects—so difficult to see, perhaps, because it's been right before our eyes. And still is.

03

October 24
Design Observer
launches

04

January 05
The U.S. begins
fingerprinting
foreign visitors

January 22
Rob Roy Kelly,
design educator,
dies

February
Skype introduces
audio conference
calling

April 27
The World War II
Memorial opens in
Washington, D.C.

September 05
CBS begins
interviews on the
Killian documents
controversy

September 09
Ellen Lupton
publishes *Thinking
with Type*

October 01
Bruce Mau
publishes *Massive
Change*

December 16
The Millau Viaduct
opens to the public
as the world's
tallest bridge

December 31
Taipei 101 opens as
the world's tallest
skyscraper

05

January
Nicholas
Negroponte
introduces One
Laptop Per Child

January 25
Philip Johnson,
architect, dies

February 04
Debbie Millman
launches
Design Matters

February 23
The first YouTube
video is uploaded

September 08
Adrian
Shaughnessy
publishes *How
to Be a Graphic
Designer Without
Losing Your Soul*

November
Emigré publishes
its last print edition

06

March
Michael Bierut is
awarded the AIGA
medal

April 16
Richard Eckersley,
graphic designer,
dies

May 15
Sir Anish Kapoor's
Cloud Gate in
Chicago is unveiled

July 01
Edward Tufte
publishes *Beautiful
Evidence*

July 15
Twitter launches

September 26
Facebook opens to
anyone at least 16
years old

October 23
Maria Popova
launches *Brain
Pickings*

07

January
Michael Bierut
redesigns the
Doomsday Clock

January 09
Steve Jobs
introduces the
iPhone

February 10
Barack Obama
announces his
U.S. presidential
candidacy

May 31
Michael Bierut
publishes *Seventy-
nine Short Essays
on Design*

June
Dropbox is founded

June
The Designer's
Accord is founded

June 07
Criticism ensues
over Wolff Olins'
design of the

London 2012
Olympics logo

June 27
Silas H. Rhodes,
design educator
and AIGA medalist,
dies

September 12
Gary Hustwit's
Helvetica, the
documentary, is
released

December 21
John Maeda
is appointed
president of the
Rhode Island
School of Design

08

January 22
Stocks begin to
plunge worldwide
as concerns of
a U.S. recession
spread

October 06
Tina Brown
and Barry Diller
launch *The Daily
Beast*

October 27
Wendy Keys
releases *Milton
Glaser: To Inform
and to Delight*

November 03
Jessica Helfand
publishes
*Scrapbooks: An
American History*

October 22
Lou Dorfsman,
graphic designer
and AIGA
medalist, dies

December
Hearst Corporation
publishes last print

issue of *Cosmogirl* magazine

09

January 17
Jonathan Hoefler and Tobias Frere-Jones of Hoefler & Frere-Jones Type Foundry split

January 17
Shepard Fairey's Barack Obama "Hope" portrait goes on display in the National Portrait Gallery in Washington, D.C.

January 20
Barack Obama is sworn in as the 44th President of the United States

March 14
Gary Hustwit's *Objectified* is released

April 13
Armin Vit and Byrony Gomez-Palacio announce the closing of *Speak Up*

June 25
Michael Jackson, performer and singer, dies

August 17
Design Observer begins hosting Debbie Millman's podcast, *Design Matters*

August 21
IKEA replaces Futura with Verdana as its company font

August 21
Doug Pray's *Art & Copy: Inside Advertising's*

Creative Revolution is released

September 29
Tim Brown publishes *Change by Design*

10

January
The last print issue of *I.D.* magazine is published

July 26
Reto Caduff's *The Visual Language of Herbert Matter* is released

March
Pinterest launches as a closed beta

May 03
The World Expo begins in Shanghai, featuring Thomas Heatherwick's "Seed Cathedral" for the UK Pavilion

July 16
The first photo is posted on Instagram (then-called Codename)

August 03
Core77's flagship store, Hand-Eye, opens in Portland, Oregon

September 03
Roman Mars' *99% Invisible* podcast is released

October 06
Instagram officially launches

November 07
Queen Elizabeth II creates a Facebook page but others are not allowed

to "poke" or
"friend" her

December 15
Mark Zuckerberg,
founder of
Facebook, is Time
Magazine's 2010
Person of the Year

January 15
Wikipedia
celebrates its tenth
anniversary since
its founding

February 13
Jamie Beck
and Kevin Burg
publish the first
cinemagraph

June 10
Adweek
announces that
Rob Walker leaves
Murketing to join
"the warm and
friendly confines
of the *Design
Observer* empire."

July 08
Snapchat is
launched as
"Picaboo"

August 10
Time magazine
names Pinterest
one of the "50 Best
Websites of 2011"

October 05
Steve Jobs,
entrepreneur, dies

October 20
Debbie Millman
receives the
"People's Choice"
and Steven Heller
receives the
"Design Mind" as
part of the Cooper
Hewitt National
Design Award

October 22
Walker Art Center
Debuts "Graphic
Design: Now in
Production"

12

Transition Design
is conceptualized
at the School of
Design at Carnegie
Mellon University

February 17
Design Observer
begins hosting
the 50 Books | 50
Covers competition

February 27
Thomas
Heatherwick's New
Routemaster bus
begins operating in
the U.K.

March 13
The *Encyclopædia
Britannica*
discontinues its
print edition

April 18
Hillman Curtis,
designer,
filmmaker, and
AIGA medalist, dies

April 18
Steven Heller and
Veronique Vienne
publish *100 Ideas
that Changed
Graphic Design*

May 08
Maurice Sendak,
author and
illustrator, dies

May 22
Tokyo Skytree,
the tallest self-
supporting tower in
the world, opens to
the public

June 05
Twitter unveils the
bird logo

December 20
The *New York Times* publishes "Snow Fall: The Avalanche at Tunnel Creek," widely celebrated as a groundbreaking form of digital journalism

December 31
Newsweek magazine stops print publication

13

January 01
Michael Patrick Cronan, graphic designer and AIGA medalist, dies

March
Jessica Helfand and William Drenttel are awarded the AIGA medal

April 18
Storm Thorgerson, graphic designer, dies

June 06
Edward Snowden discloses operations by a U.S. government mass surveillance program

June 08
Niels Diffrient, industrial designer, dies

September 03
Alvin Eisenman, graphic designer, educator, and AIGA medalist, dies

October 04
Kathy Brew and Roberto Guerra's

Design Is One: The Vignellis is released

December 21
William Drenttel, co-founder of *Design Observer*, AIGA medalist, and president emeritus of AIGA, dies

14

April
Netflix nears 50 million subscribers

May 21
The National September 11 Museum opens to the public

May 27
Massimo Vignelli, graphic designer

and AIGA medalist, dies

June 25
Google announces Material Design, a design language

August 20
Deborah Sussman, designer and AIGA medalist, dies

September 03
Mildred Friedman, design curator and editor, dies

September 13
Howard Paine, graphic designer, dies

October 15
Michael Bierut and Jessica Helfand's *The Observatory* podcast launches

October 31
MSN Messenger shuts down

15

January 07
Charlie Hebdo shooting incident occurs, leading to the Republican marches of January 10–11

February 25
Wolff Olins publishes their Leadership Report, describing the CEO of the future as a Designer-In-Chief

April 12
Hillary Clinton's presidential campaign logo, designed by Michael Bierut, is unveiled

June 04
Hermann Zapf, typeface designer, dies

September
Google's logo redesign includes dots and the G logo

September 10
Adrian Frutiger, typeface designer, dies

November 03
Michael Bierut publishes *How to...*

December
Design Matters is named one of iTunes Best Podcasts of 2015

December 22
SpaceX lands the first reusable rocket to enter orbital space and return

December 27
Ellsworth Kelly, artist, dies

16

March 07
Dropbox has over 500 million users

March 31
Zaha Hadid, architect, dies

May 24
Jessica Helfand publishes *Design: The Invention of Design*

June 16
Mark Lamster becomes the architecture critic at the *Dallas Morning News*

July 15
Donald Trump's presidential campaign reveals logo, replaced the next day

July 22
The last videocassette recorder is manufactured

September 24
The National Museum of African American History and Culture opens in Washington, D.C.

October 04
Elaine Lustig Cohen, graphic designer and AIGA medalist, dies

October 19
Jessica Helfand and Michael Bierut's *The Design of Business | The Business of Design* podcast launches

October 19
Jarrett Fuller's *Scratching the Surface* podcast launches

December 22
Lella Vignelli, designer and AIGA medalist, dies

17

January 20
Donald Trump is sworn in as the 45th President of the United States

January 21
Millions of people worldwide participate in the Women's March to protest the inauguration of U.S. President Donald Trump

February 10
Abstract: The Art of Design, featuring

Paula Scher, is aired

February 16
Dick Bruna, writer, graphic designer, and illustration known for creating *Miffy*, dies

July 22
Margo Chase, graphic designer, dies

August 20
Clive Piercy, graphic designer, dies

October
More than 80 women accuse Harvey Weinstein of sexual harassment, triggering the #MeToo movement

November 07
Michael Bierut publishes *Now You See It and Other Essays on Design*

November 16
Jack Stauffacher, typographer and AIGA medalist, dies

December 02
Ivan Chermayeff, logo designer and AIGA medalist, dies

December 14
The Walt Disney Company announces that it will acquire most of 21st Century Fox

December 22
The last print issue of *Print* magazine is mailed

18

March 04
Updated envelope design is used at the Oscars after 2017 mix-up

March 17
Facebook data breach affecting 50 million users is uncovered

November
Michael Bierut and Jessica Helfand publish *Culture Is Not Always Popular*

November 04
Design Observer hosts the Design, Business, Media, Humanism conference at the Yale School of Management

Biographies

Sean Adams is acting chair of the Graphic Design graduate and undergraduate program at ArtCenter and author of several books on design. Previously a founding partner at AdamsMorioka, he was awarded the AIGA medal in 2014.

Allison Arieff writes about architecture, design and cities for the *New York Times* and numerous other publications. A former editor-in-chief of *Dwell*, she is currently editorial director for urban think tank, SPUR.

Ashleigh Axios was the creative director and a digital strategist for the Obama White House. Currently design exponent at Automattic, she serves on AIGA's National Board of Directors.

Eric Baker is design historian, writer, and graphic designer who teaches at the School of Visual Arts. His work has appeared in *Print*, *Communication Arts*, the *New York Times*, and *Vanity Fair*, among other publications.

Rachel Berger is chair of the Graphic Design department at the California College of the Arts. Previously, she was a designer at SYPartners and Pentagram.

Michael Bierut, a co-founder of *Design Observer*, is a graphic designer, educator, writer, and partner in the New York office of Pentagram. A 2006 recipient of the AIGA Medal, he teaches at Yale University.

Andrew Blauvelt is a designer, curator, educator, and critic. Previously design director of the Walker Art Center, he currently serves as director of the Cranbrook Art Museum.

Liz Brown has written for *Bookforum*, *Elle Decor*, *frieze*, *London Review of Books*, *Los Angeles Times*, *New York Times Book Review*, among other publications.

John Cantwell is a design writer whose articles have appeared in the *Atlantic*, *Core77*, and other publications. He has taught at the School of Visual Arts and at Rutgers University.

Mark Dery is a cultural critic and scholar, best known for his essays on Afro-futurism and culture jamming. The author of numerous books, his biography of Edward Gorey will be published by Little, Brown in 2018.

Thomas de Monchaux, an architectural critic, designer, and author, teaches at Columbia University's Graduate School of Architecture, Planning, and Preservation. He was the inaugural winner of the Winterhouse Award for Design Writing and Criticism.

William Drenttel, (1953–2013), a cofounder of *Design Observer*, Winterhouse, and the Winterhouse Institute, was a laureate of the Art Directors Hall of Fame and member of the Alliance Graphic Internationale. He received the AIGA medal in 2013.

Michael Erard is an author, journalist, and linguist. His work has appeared in the *New York Times*, *Science*, *Wired*, *Slate*, and many other publications.

Stephen Eskilson is an author and professor of art history at Eastern Illinois University.

Bryan Finoki is a writer and artist. He has written for *Archinect*, GOOD, *Domus*, *Harvard Design Magazine*, and *Volume*, among other publications.

Kenneth FitzGerald is the author of *Volume: Writings on Graphic Design, Music, Art, and Culture*. His work has appeared in publications such as *Emigre*, *Print*, *Eye*, *Étapes*, and *Idea*.

John Foster is a graphic designer whose vernacular photography collection has been featured in numerous publications, including *Harper's* and *Newsweek Online*.

Jarrett Fuller is a graphic designer, writer, and educator who teaches at Parsons, Pratt, and the University of the Arts. He hosts the podcast *Scratching the Surface*.

Jessica Helfand, a cofounder of *Design Observer*, is a designe and writer whose latest book is *Design: The Invention of Desire*. A 2006 recipient of the AIGA Medal, she has taught at Yale University since 1996.

Steven Heller Steven Heller, who has authored more than 180 books on design, is co-founder/co-chair of the Designer as Author and Entrepreneur MFA program at the School of Visual Arts. He is the recipient of the 1999 AIGA Medal for lifetime achievement.

Karrie Jacobs is a journalist and editor. She has been a contributing editor for *Metropolis*, *House and Garden*, *Metropolitan Home*, *Architect Magazine*, and *Travel + Leisure*, and was the founding editor-in-chief at *Dwell*.

Meena Kadri, founder of the New Zealand-based studio Random Specific, writes about innovation, collaboration, and social change. She was OpenIDEO's first community lead, and has lectured internationally.

Mark Lamster is the architecture critic of the *Dallas Morning News* and a professor at the University of Texas at Arlington. He is the au-thor of several books, including *The Man in the Glass House: Philip Johnson, Architect of the Modern Century*.

Alexandra Lange is the architecture critic for *Curbed*. Her work has appeared in *Dezeen*, *Metropolis*, *Print*, *New York Magazine*, the *New York Times*, and the *New Yorker*. Her latest book is *The Design of Childhood: How the Material World Shapes Independent Kids*.

Francisco Laranjo is a graphic designer based in Portugal. He is the editor of the design criticism journal *Modes of Criticism* and codirector of the design research center Shared Institute.

Adam Harrison Levy is a writer and a documentary filmmaker. Before joining the faculty at the School of Visual Arts, he taught at Wesleyan University.

Mimi Lipson writes fiction and nonfiction. Her stories have appeared in *BOMB*, *Harvard Review*, *Joyland*, *Witness*, and *Brooklyn Rail*, among other publications.

Kathleen Meaney is a graphic designer and writer. A former designer ar Pentagram, she has taught at the School of Visual Arts, North Carolina State University, and the University of Cincinnati.

Randy Nakamura is a writer, designer, and researcher as well as a PhD candidate in the Critical Studies program at UCLA Architecture and Urban Design. He teaches in the MFA program at California College of the Arts.

Phil Patton (1952–2015) was a design writer whose work appeared in *I.D.*, *Esquire*, the *New York Times*, and *Wired*. He taught at the School of Visual Arts in New York.

Maria Popova is a reader and a writer who has written for the *New York Times*, *Wired UK*, and the *Atlantic*, among others. She is the founder and publisher of Brain Pickings.

Rick Poynor, a cofounder of *Design Observer* and founder of Eye magazine, is Professor of Design and Visual Culture at the University of Reading. His latest book is *National Theatre Posters: A Design History*.

Louise Sandhaus is on the faculty at California Institute of the Arts and the author of *Earthquakes, Mudslides, Fires and Riots: California and Graphic Design 1936–1986*.

Martha Scotford, a design historian, is professor emerita of graphic design at the College of Design, North Carolina State University. She is the author of *Cipe Pineles: A Life of Design*.

Adrian Shaughnessy is a graphic designer, writer, and a founding partner of Unit Editions, a publishing company in London. He is the author of *How to Be a Graphic Designer Without Losing Your Soul*.

Andrew Shea is principal of the design studio many, and Assistant Professor at Parsons School of Design. His writing has been featured by *Fast Company*, *Slate*, *99% Invisible*, *Core77*, and *Print*, among others.

Dmitri Siegel, a branding and strategy executive, has worked for Sundance Channel, Urban Outfitters, Patagonia, and Sonos, among other companies.

John Thackara, a philosopher and writer, is a Senior Fellow at the Royal College of Art in London. His latest book is *How to Thrive In the Next Economy: Designing Tomorrow's World Today*.

Elizabeth (Dori) Tunstall is Dean of the faculty of Design at Ontario College of Art and Design University. Previously, she was associate professor at the School of Art and Design and associate director of the City Design Center at University of Illinois, Chicago.

Alice Twemlow leads the Design and the Deep Future readership at the Royal Academy of Art, and heads the Design Curating and Writing Masters program at Design Academy, Eindhoven. Her book, *Sifting the Trash: A History of Design Criticism*, was published by MIT Press in 2017.

Tom Vanderbilt is a writer whose work has appeared in the *New York Times Magazine*, *Popular Science*, *Rolling Stone*, the *Wall Street Journal*, and the *Financial Times*, among others. His latest book is *You May Also Like: Taste in an Age of Endless Choice*.

Véronique Vienne is an educator, art director, and journalist who has written for numerous publications, including *House and Garden*, *Emigré*, *Communication Arts*, *Eye*, *Graphis*, *Aperture*, *Metropolis*, *Étapes*, and *Print*.

Rob Walker writes The Workologist column for the *New York Times* and formerly wrote the Consumed column for the *New York Times Magazine*. He is the co-editor of *Significant Objects: 100 Extraordinary Stories about Ordinary Things*.

Alissa Walker, formerly an editor at *Gizmodo* and *UnBeige*, is *Curbed*'s first urbanism editor. Her writing has regularly appeared in *Dwell*, *Fast Company*, the *New York Times*, and the *Los Angeles Times*.

Lorraine Wild is principal of Green Dragon Office, and consulting creative director for the Los Angeles County Museum of Art. She is an AIGA Medalist, and is on the faculty of the California Institute of the Arts.

Timothy Young is curator of modern books and manuscripts at Beinecke Rare Book and Manuscript Library at Yale University.

Contributors

52-Blue
Hala Abdul Malak
Carrie Olivia Adams
Sean Adams
Fernando Aguiar
Manuela Aguirre
AIGA
Taslima Akhter
Renna Al-Yassini
Antonio Alcalá
Alexia
Enrique Allen
Jan Almquist
Marc Alt
Gregorio Amaro
Mariana Amatullo
Gideon Amichay
Kurt Andersen
Gail Anderson
Kate Andrews
Julie Anixter
David Antin
Paola Antonelli
Alec Appelbaum
Allison Arieff
Helen Armstrong
Zara Arshad
Ars Libri Ltd.
James Arthur
Aspen Editors
Ashleigh Axios
Lawrence Azerrad
Chika Azuma
Mary Badon
Eric Baker
Marian Bantjes
Jonathan Barnbrook
John Barr
David Barringer
Lawrence Barth
Adam Bartos
Ernest Beck
Roy Behrens
Eugenia Bell
Rachel Berger
Becky Bermont
Andrew Bernheimer
Fred A. Bernstein
Josh Berta
John Bertram
James Biber
Lisa Bielawa
Magda Biernat
Michael Bierut
Eva D. Blake
Johanna Blakley
Teddy Blanks
Andrew Blauvelt
Christian Bök
Jim Bolek
Maddie Bone
Nadine Botha

Ken Botnick
John Bowers
Scott Boylston
Constantin Boym
Alan G. Brake
Brooke Brewer
Gaby Brink
Gabriel Brodbar
Azby Brown
Brigette Brown
Liz Brown
Dominique Browning
Gavin Browning
BUCK
George W. Bush
David Cabianca
Christopher Calderhead
Chris Calori
Sheena Calvert
Michael Cannell
John Cantwell
Ralph Caplan
Alexandra Cardia
Hannah Carlson
Sebastian Carter
James Cartwright
John Cary
John Caserta
Valerie Casey
Robin Cembalest
Center for an Urban Future
Deirdre Cerminaro
Juliette Cezzar
Nadine Chahine
Helen Chang
Patrick Chappatte
Andy Chen
Joanne Chew
Allan Chochinov
Nicholas Christakis
Hal Clifford
Andrea Codrington
Jennifer Cole Phillips
Billy Collins
Jan Conradi
Greg Constantine
Julia Cooke
John Corbett
Sarah Couto
Patrick Cramsie
Jon Crispin
Wim Crouwel
Kate Cullinane
Glen Cummings
Beth Daniels
Meredith Davis
Kwame Dawes
Thomas de Monchaux
Melissa Del Bosque
Mark Dery
Nathalie Destandau
Carolyn Deuschle

Richard Devereaux
Krista Donaldson
Jade Doskow
Stephen Doyle
Courtney Drake
William Drenttel
Jade Dressler
Andy Drewitt
Perrin Drumm
Frederico Duarte
Hugh Dubberly
Sara Duell
Lena Dunham
Stephen Dunn
Charles and Ray Eames
Elliott Earls
Owen Edwards
Adam Eeuwens
Jennifer Ehrenberg
Chappell Ellison
John Emerson
Mitch Epstein
Michael Erard
Stephen Eskilson
Blake Eskin
Gabrielle Esperdy
Katie Evans
Elizabeth Evitts Dickinson
Robert Fabricant
Louise Fili
Bryan Finoki
Thomas Fisher
Kenneth FitzGerald
Ryan Fitzgibbon
Andrew Flamm
Barbara Flanagan
Annette Florid
Laura Flusche
Rob Forbes
Ramsey Ford
John Foster
Natalie Foster
Thomas Frank
Felice C. Frankel
David Freund
Daisy Fried
Robert Frost
Robert Fulford
Cathy Gale
Julia Galef
John Gall
Paul Gansky
Samantha García
Steff Geissbühler
Anthony Gerace
Liz Gerber
Rob Giampietro
Jack Gilbert
Maria Giudice
Jessica Gladstone
Milton Glaser
Joshua Glenn

Kaomi Goetz
Denise Gonzales Crisp
Justin Good
Peter Good
Ken Gordon
Francesca Granata
Jason Grant
Karen Green
Richard Grefé
Robert Grudin
Frank Guan
Elizabeth Guffey
Arvind Gupta
Rachel Hadas
Stanley Hainsworth
Donald Hall
Phil Hamlett
Melissa Harris
Adam Harrison Levy
Mara Haseltine
Michelle Hauser
Carol Hayes
Alexander Heffner
Marvin Heiferman
Eric Heiman
Molly Heintz
Jessica Helfand
William Helfand
Cheryl Heller
Steven Heller
Elizabeth Helman Minchilli
Scott Henderson
Eric J. Herboth
Robert Hetherington
Bob Hicok
Kit Hinrichs
Delphine Hirasuna
Tarpley Hitt
Kirsten Hively
John Hockenberry
Eric Holzenberg
Jason Houston
Andrew Howard
Kate Howe
Cathy Huang
Pieter Hugo
Amanda Hurley
Eddy Ibrahim
Mirko Ilić
Julie Iovine
Christopher Ireland
Alexander Isley
Sara Ivry
Sam Jacob
Karrie Jacobs
Matthew Jacobson
Sara Jamshidi
Ricky Jay
Tracy Jenkins
Wendy Ju
Jennifer Kabat
Meena Kadri

Eve M. Kahn
John Kaliski
William Kamkwamba
Soren Kaplan
Eric Karnes
Jac sm Kee
John Keen
Jerry Kelly
Justin Kemerling
Karen Keung
Roshanak Keyghobadi
Chip Kidd
Rob Kimmel
Emily King
William Davies King
Mark Kingsley
Pat Kirkham
Liza Kirwin
Greg Klee
Alex Knowlton
Ava Kofman
Leonard Koren
Steven Kroeter
Kenneth Krushel
Josh Kun
Amelia Lacy
Juliette LaMontagne
Mark Lamster
Rick Landesberg
Alexandra Lange
James Lapides
Francisco Laranjo
Brian LaRossa
Katherine Larson
Julie Lasky
Jiwon Lee
Warren Lehrer
Ben Lerner
Nancy Levinson
Maya P. Lim
Ping Lim
Manuel Lima
Tod Lippy
Mimi Lipson
John Lucas
Emily Ludolph
Claire Lui
Paul Lukas
Elle Luna
Ellen Lupton
Elaine Lustig Cohen
Wendy MacLeod
John Madere
John Maeda
Giorgio Maffei
Culture Magazine
Irene Malatesta
Paul Maliszewski
Tom Manning
Ezio Manzini
Jane Margolies
Roger Martin

Gabriela Matuszyk
Chaz Maviyane-Davies
Dona Ann McAdams
J.D. McClatchy
Ivana McConnell
Niall McCormack
Michael McGriff
Bradford McKee
Iain McKell
Bryan Mealer
KT Meaney
Rebéca Mendez
James Merrill
W.S. Merwin
Anne Mikoleit
Jeff Miller
Debbie Millman
Momus
Aoife Mooney
Bill Moran
Abelardo Morell
David Morris
Edward Morris
Murray Moss
Michael Mossoba
Christopher Mount
Paul Muldoon
Jason Murdock
Michael Murphy
Dan Nadel
Andrea Nagy Smith
Randy Nakamura
Ashish Nangia
Nichelle Narcisi
Anna Nazo
Becky Neiman
Eric Nevin
Brett Newman
Sue Nguyen
De Andrea Nichols
Jake Nickell
Jesse Nivens
Philip Nobel
Julia Novitch
Franc Nunoo-Quarcoo
Bruce Nussbaum
Sandra Nuut
Dennis O'Driscoll
Diana O'Hehir
Meghan O'Rourke
Observed
Sharon Olds
Wanda Orlikowski
Jason Orton
Jez Owen
Lyle Owerko
Jay Parkinson
Justin Partyka
Phil Patton
Tiffany Peng
Rick Perlstein
Matthew Peterson

Robert Petrick
Jon Piasecki
Robert Pinsky
Massimo Pitis
Kolean Pitner
Vanessa Place
Adam Plunkett
Paul Polak
Maria Popova
Doug Powell
Rick Poynor
Project
Chris Pullman
Rosamond W. Purcell
Moritz Purckhauer
Anne Quito
Joanna Radin
Ira Raja
Avinash Rajagopal
Mark Randall
Claudia Rankine
Alan Rapp
Jen Reel
Willis Regier
Jen Renninger
Angela Riechers
Lana Rigsby
Fred Ritchin
Lucienne Roberts
Alexis Rockman
Milton Rogovin
Jen Roos
Jean W. Rosenthal
Richard Ross
Susan Roy
Hans Rudolf Bosshard
Ed Ruscha
Douglas Rushkoff
Michael Russem
Vera Sacchetti
Gordon Salchow
Louise Sandhaus
Jason Santa Maria
Luc Sante
Kerry Saretsky
Susannah Sayler
Michael Scharf
Jeff Scher
Paula Scher
Annie Schlechter
Carl Schoonover
Jonathan Schultz
Kevin Schultz
Philip Schultz
Martha Scotford
Bill Shaffer
Gerry Shamray
Komal Sharma
Manisha Sharma
Adrian Shaughnessy
Paul Shaw
Andrew Shea

Dick Sheaff
Virginia Shou
Dmitri Siegel
Bonnie Siegler
Rachel Signer
Micah Silver
Christopher Simmons
Taryn Simon
Mike Sinclair
Nancy Skolos
Andrew Sloat
Anna Marie Smith
Bryn Smith
Lilly Smith
Virginia Smith
Matt Soar
Victoria Solan
Michael Sorkin
Ettore Sottsass
Nick Sowers
Jeff Speck
Juliette Spertus
Erik Spiekermann
Matthew Stadler
David Stairs
Lindsay Stark
Karen Stein
Daniel Stephens
Jude Stewart
DJ Stout
Heather Strelecki
Thomas Struth
Gong Szeto
Laura Tarrish
José Teunissen
John Thackara
The AIGA Design Educators
Community
Alan Thomas
Dana Thomas
ThoughtMatter
Ashley Toliver
Cheryl Towler Weese
James Traub
Teal Triggs
Elizabeth Tunstall
Richard Turley
Alice Twemlow
Chase Twichell
Nicola Twilley
David L. Ulin
William Underhill
Petr van Blokland
Jan van Toorn
Tom Vanderbilt
Chelsea Vandiver
Betsy Vardell
Tucker Viemeister
Véronique Vienne
Stephen Vincent Benét
Teun Voeten
Dirk Wachowiak

Alissa Walker
Kevin Walker
Rob Walker
Paula Wallace
Josh Wallaert
Helen Walters
Timothy Jack Ward
Chris Ware
Mal Warwick
John Waters
Jeshurun Webb
James Wegener
Mike Weikert
Joshua Weiner
Laura Weiss
Margaret Wertheim
Lawrence Weschler
George M. Whitesides
Tony Whitfield
Megan Whitmarsh
Lorraine Wild
Kerry William Purcell
Sarah Williams Goldhagen
Christian Wiman
Jane Withers
Peter Wolf
David Womack
Willy Wong
Ken Worpole
Franz Wright
Rebecca Wright
An Xiao Mina
Cheryl Yau
William Butler Yeats
Edvin Yegir
Susan Yelavich
Mark Yoes
Tokujin Yoshioka
Timothy Young
Lin Yee Yuan
Adam Zagajewski
Daniella Zalcman
Mimi Zeiger
Justin Zhuang
Michael Zinman
Erin Zwaska

Acknowledgments

Since 2003, we have published nine hundred authors from all across the globe, representing a spectacular assortment of people and perspectives. We have many people to thank, beginning with the original partners.

The idea of a public design conversation was nothing short of intoxicating to William Drenttel, a voracious reader and book collector who viewed design as a kind of connective tissue between all disciplines. He saw, easily before any of us did, the rich possibilities for conversation and engagement, and he was thrilled by the idea of a public forum for design criticism, discussion, and debate. Bill's devotion to *Design Observer* was unwavering and absolute: he believed in its promise and its purpose, in our writers and their ideas, and in design itself as a vital cultural force. He loved *Design Observer*, and he would have loved this book.

Bill quickly roped us both in, along with a forth partner, Rick Poynor, whose participation has taken many forms over the years—from editor to writer, critic to pundit, historian to futurist. In the early days of *Design Observer*, when comments were our life blood, Rick led the charge: this was a significant moment for publishing in general (and for design criticism in particular) marking a notable shift in—and foreshadowing of—a kind of inquiry that was spirited, social, and deeply participatory. Later, Rick's Exposure columns would demonstrate a criticality both verbal and visual, precisely the territory we had originally set out to embrace. For his enduring commitment to *Design Observer*, over so many years and in so many ways, we are hugely grateful to Rick Poynor.

Where commitment is concerned, there has been no one more dedicated than Betsy Vardell—our partner, our producer, and our patron saint. Betsy's tenure with *Design Observer* dates to the very beginning, which also bestows upon her the well-earned title of archivist. She has, on our watch, built our technology, developed our site, produced our conferences, managed our competitions, and supported this enterprise—and its participants—every day since we began. Without Betsy, it is fair to say that there would be no *Design Observer*, and our gratitude to her is endless.

In addition to the authors featured in this volume, there are many more to thank: nine hundred writers have contributed articles to *Design Observer* since we began publishing, and their names are all listed at the end of this book. We thank each and every one of them—as we do those who contributed nearly 30,000, thereby invigorating our thinking and adding to an impassioned and interactive social dynamic on our site.

We've been fortunate, too, to work with an extraordinary stable of editors, whose efforts—both individually and collectively—are reflected in the breadth of work we've published. Our thanks go to Eugenia Bell, Jade-Snow Carroll, Julie Lasky, Nancy Levinson, and Maya P. Lim, our youngest and newest recruit. Maya is our resident polymath, and her multiple contributions to this book—as editor, researcher, fact-checker, permissions-seeker, and design helper—deserve a special and sincere note of thanks.

Design Matters—Debbie Millman's award-winning podcast—has been a proud feature on our site for more than a decade, inspiring us to launch two more programs, *The Observatory* and *The Design of Business | The Business of Design*. We thank Debbie and her executive producer Curtis Fox, as well as our own terrific team of editors and producers: Annette Heist, Miranda Shafer, Julie Subrin, and the remarkable Blake Eskin. At the Yale Media Center, our thanks go to Tim Spencer, Mary Ellen Lyons, Donny Bristol, and Josh Bengston. Our

sponsors deserve a special mention, too: big thanks to Doug Powell at IBM, Cindy Chastain at Mastercard, Rob Giampietro at Google, and Paula Ximena Mejia at Wix for their gracious support. Our thanks, too, to our numerous guests, on all of our podcasts, who have shared their precious time with us over the years. At AIGA, our partner since 2016, we are grateful to Julie Anixter and Dana Arnett for their guidance and their leadership; to Laetitia Wolff and Lilly Smith for their editorial contributions; and to Deb Aldrich and Laura Des Enfants for their production support. We are indebted, too, to *Design Observer*'s sponsors, starting with Mark DiChristina at MailChimp, who believed in us when, frankly, he had no reason to do so. Our thanks also to David Rhodes at the School of Visual Arts for his multi-year commitment to our work, and to Eileen Gittins at Blurb for hers.

Design Observer has benefitted unquestionably from contributions by a number of core participants over the last decade-and-a-half. Michael Mossoba helped steer us forward at a crucial moment in our growth. Josh Sessler made sure to keep us out of copyright trouble. Teddy Blanks, Andrew Sloat, and Mike Errico have been frequent and beloved artistic collaborators. Steven Heller has been a guiding spirit, a steadfast supporter, and a devoted contributor. Sara Jamshidi helped direct our redesign efforts, and her commitment to many of our ancillary projects—including and especially with regard to our imprint, Observer Editions, and our special, if short-lived periodical *Observer Quarterly*—deserves a special note of thanks.

It bears mention that we both have day jobs, which means frequent adjustment (and occasional sacrifice) on the part of our valued peers. At Pentagram, our thanks to Tamara McKenna for her many kindnesses, and at Winterhouse—*Design Observer*'s physical home for many years—our thanks go to Geoff Halber, Alex Knowlton, Eileen Schmidt, and Kevin Smith.

At Yale, we wish to thank deans Edward Snyder, Anjani Jain, and Edieal Pinker for giving us the opportunity to teach and record at the School of Management. Thanks, too, to our administrative and strategic support team there: Heather Amero, Anna Bernath, and Justine Jarvie. Our TAs help in every way possible and deserve mention here as well: thanks to our students (and former students) Eddie Bearnot, Ruirui Kuang, and Tobby Yi.

We owe a huge debt of thanks to Victoria Hindley, our wonderful editor and friend at MIT Press, who believed in this project from the start: this book, in fact, was her idea. Gabrielle Bueno Gibbs makes us feel more organized than we are, and on that subject, this entire production would not have come to life without Jarrett Fuller—editor, designer, writer, critic, friend, and fellow crusader for design criticism. We are indebted to Jarrett for his unflagging dedication to this project, and for making us look so good on paper.

Finally, a word to our families: to Dorothy Kresz, Liz, Drew, and Martha Bierut, and to Malcolm and Fiona Drenttel: our deepest gratitude for sharing us for so long with our *Design Observer* family. It really does take a village—and you remain our dearest and most beloved villagers.

Michael Bierut and Jessica Helfand

Image Credits

pg. 4–8 Design Observer Archives

pg. 23 Jan Van Toorn

pg. 32 Courtesy Louise Sandhaus

pg. 44–49 © LSE Library

pg. 63 Mason Williams, *Bus* (1967). Silkscreen 123 1/2 x 434 in. (313.7 x 1102.4 cm); Other (Bus box) 5 x 17 1/4 x 15 in. (12.7 x 43.82 x 38.1 cm). The Museum of Contemporary Art, Los Angeles. Gift of Michael Asher.

pg. 66 Courtesy Random House

pg. 73 Photo by matcuz on Pixabay.com

pg. 76–77 Courtesy of Steven Heller

pg. 84 Courtesy Mark Lamster

pg. 92–97 Courtesy Eric Baker

pg. 103 Test Card F, courtesy of BBC.

pg. 106 John James Audubon, *American Flamingo (Phoenicopterus ruber)*, Havell plate no. 431, 1938. Watercolor, graphite, gouache, black ink, and pastel with glazes on paper, laid on card. Purchased for the Society by public subscription from Mrs. John J. Audubon. 1863.17.431. New-York Historical Society. Digital image created by Oppenheimer Editions.

Wikimedia Commons from the University of Pittsburgh

pg. 107 John James Audubon, *Golden Eagle (Aquila chrysaetos)*, Havell plate no. 181, 1833. Watercolor, pastel, graphite, black ink, and black chalk with touches of gouache and selective glazing on paper, laid on card. Purchased for the Society by public subscription from Mrs. John J. Audubon. 1863.17.181. New-York Historical Society. Digital image created by Oppenheimer Editions.

Wikimedia Commons from the University of Pittsburgh

pg. 116 Courtesy of the Queens Museum. Photo by Gary Gershoff.

pg. 128–133 Courtesy Timothy Young

pg. 141 ZUMA Press, Inc. / Alamy Stock Photo

pg. 156 Photo by Seph Lawless

pg. 168–173 © Les amis de Marcel Jacno travail documentaire Michel Wlassikoff, Olivier Jourdan et Eric Pascalis

pg. 179 Courtesy Standards Manual

pg. 189 Courtesy James Bridle

pg. 191 Military Images / Alamy Stock Photo

pg. 202 Courtesy Kenneth FitzGerald

Index